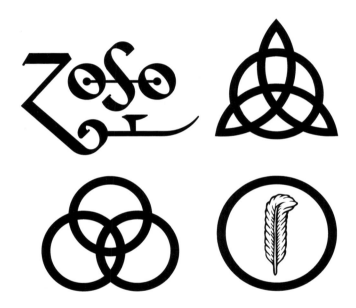

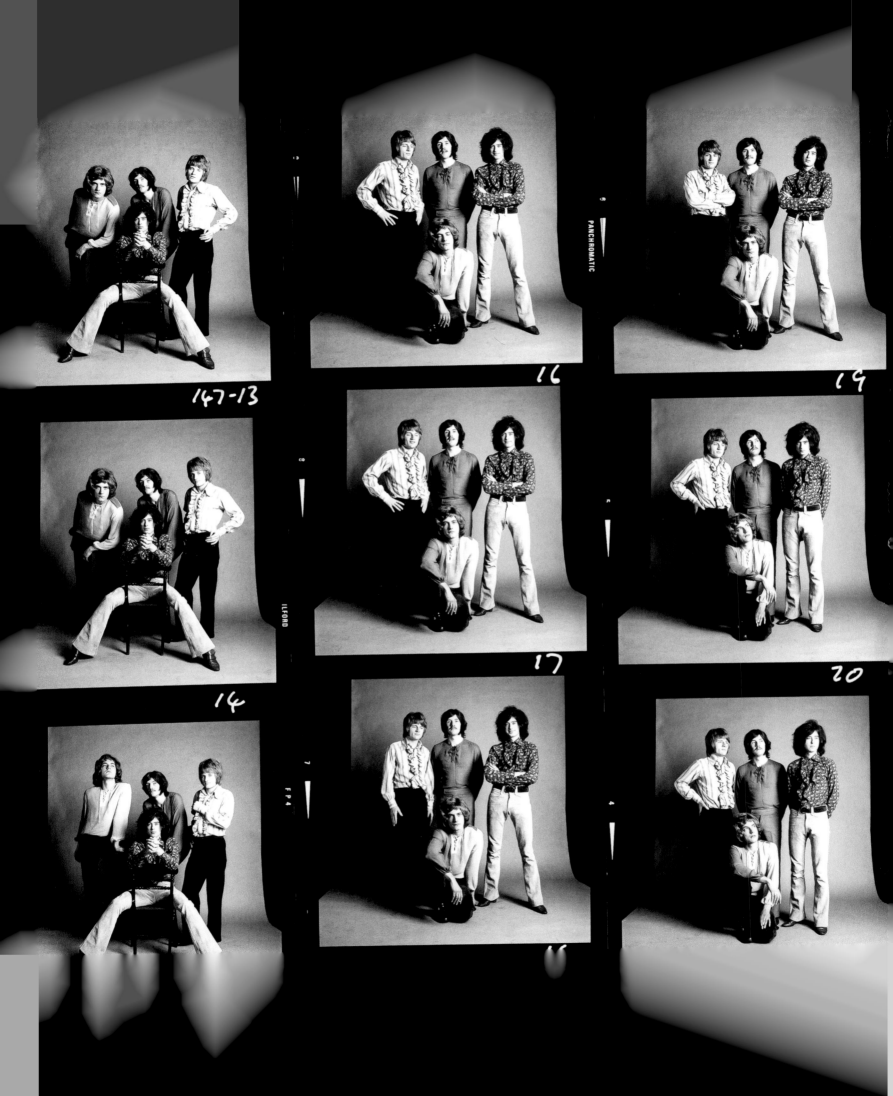

LED-ZEPPELIN

BY LED ZEPPELIN

REEL ART PRESS

CONTENTS

ralph j. gleason

1-16-69

Dear Ahmet:

Hope you had a lovely time in Nassau and hyped a lot of
distributors.

Since your myth-making machinery insists you paid
$200,000 for the Led Baloon (Confederate money?) perhaps
I should tell you a little inside dope (you will excuse the
expression).

You have sent out a lovelry package of photographs. They
are well designed, clearly printed and quite useable in
any newspaper.

Except for one important thing.

NONE OF THESE IDIOTS IS IDENTIFIED. !!!!!

The Led Baloon may insist on playing Cairo ,Illinois
and White Plains and it is possible that the Cairo Register
and the White Plains Reporter do not care about such things,
being grateful to you for any free 8x12 glossy. But as a
general rule, metropolitan daily newspapers have a
clear and distinct aversion to printing pictures of four
people in which none of them are indentified.

Always with your best interests at heart, your humble
servant and Baloneer,

2835 ASHBY AVENUE BERKELEY 5 CALIFORNIA

An affectionate, irreverent note from renowned music journalist Ralph J. Gleason
to his close friend, Atlantic Records founder Ahmet Ertegun.

To: Atlantic Recording Corp.
1841 Broadway
New York, N.Y. 10023

Feb. 3, 1969

Dear Sir:
 I recently purchased the new "Led Zeppelin" album recorded on your label and I would like to say that John Bonham, Robert Plant, Jimmy Page, and John Paul Jones are four of the most talented guys I've ever heard. I sincerely hope they continue their music. I've never heard anything yet that could match them. I've seen and heard a lot of great groups perform in Hollywood and around in the greater Los Angeles area but I've never heard anything that could out-do "Led Zeppelin." Stick with them. They're great and are on their way to being the best!

 Sincerely,
 Alan Alexander

An encouraging letter sent to Atlantic Records by an early Led Zeppelin fan, Alan Alexander.

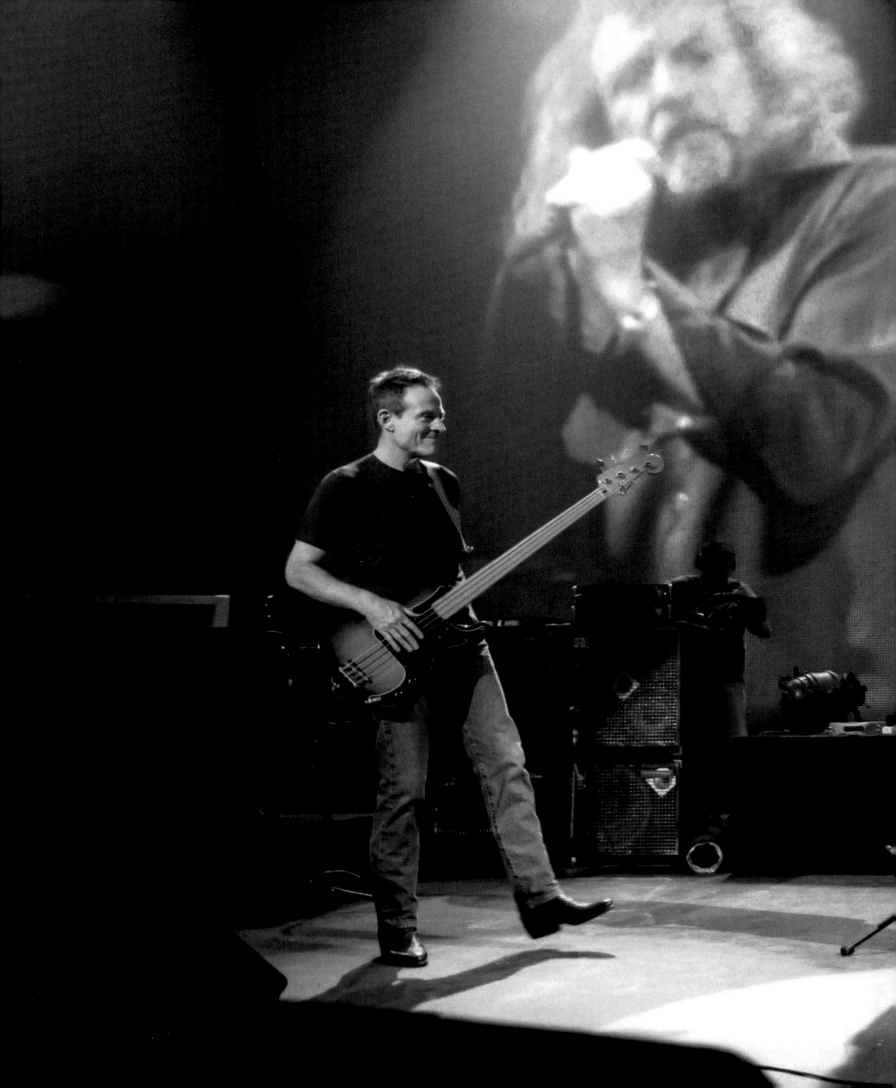

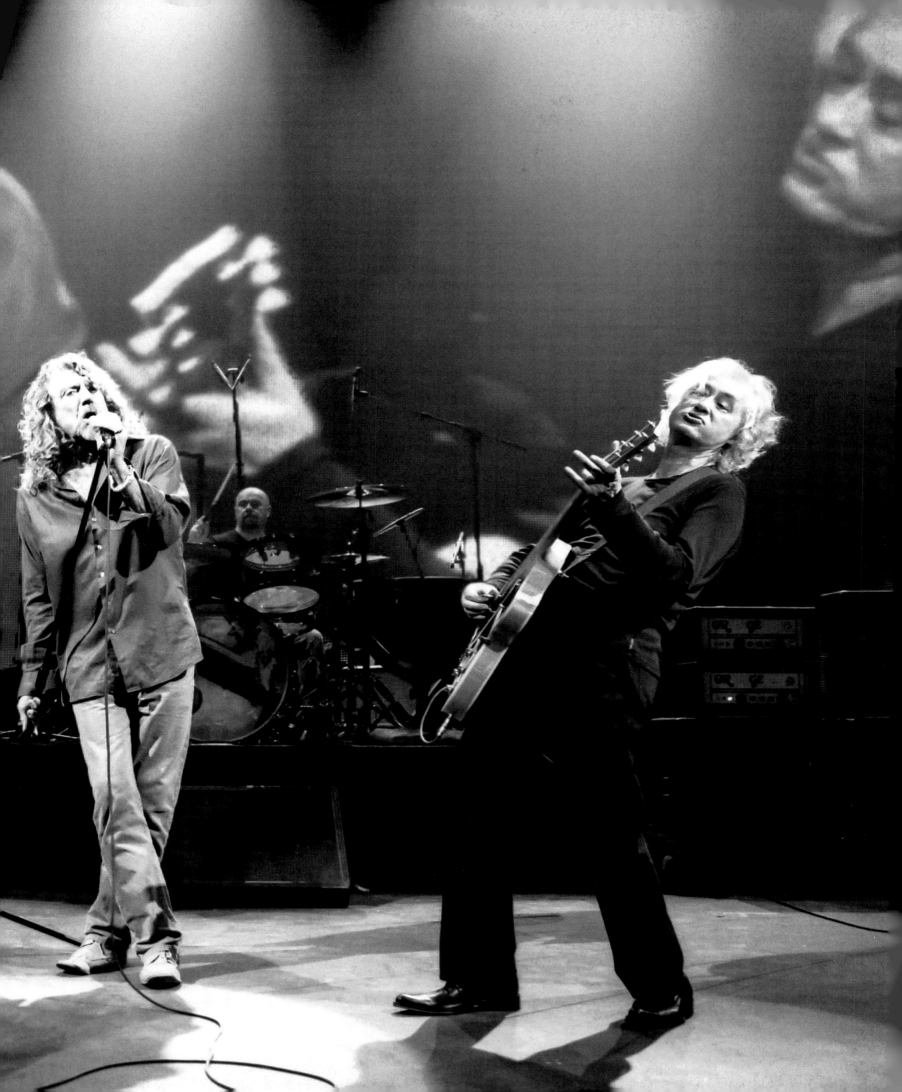

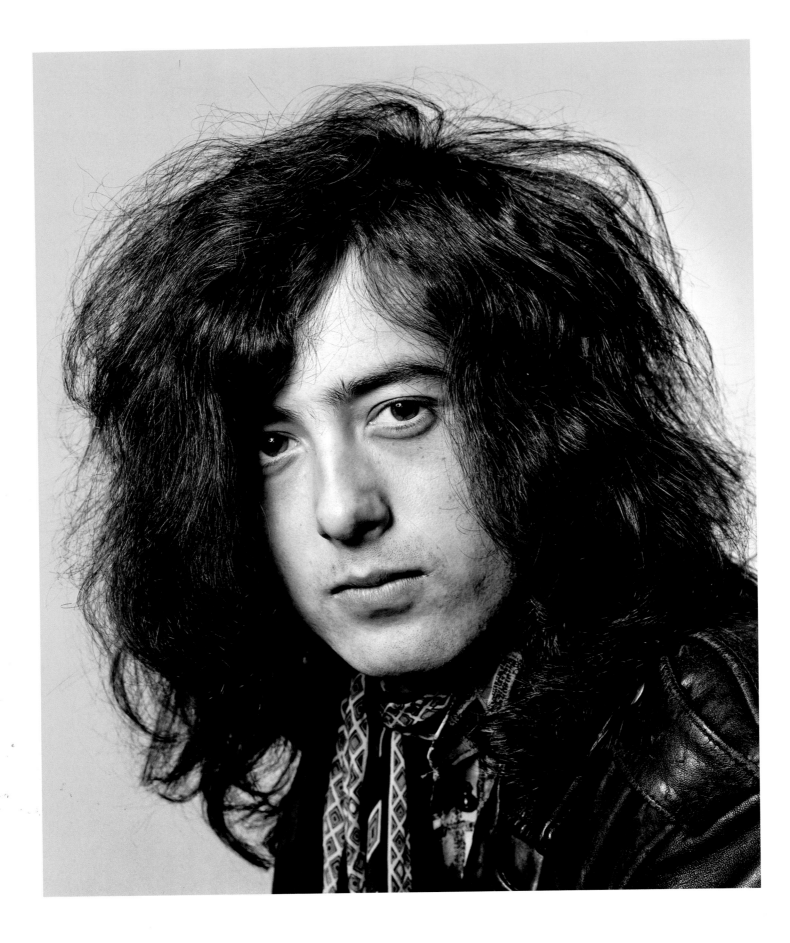

JIMMY PAGE
Prologue

The first rehearsal was planned in a basement in Gerrard Street, London. Our equipment was set up and after tuning up there was a count in and we began to play together.

At the end of that number I believe each and every one of us had a musical communion like no other. It would be a life-changing experience. We agreed to embark on extensive rehearsals.

ROBERT PLANT
Prologue

John and I had been kicking around the dance halls and clubs together and apart, rolling and tumbling for what seemed years. Two big, noisy fish swimming against the stream. John's amazing technique and showboating, my relentless ceaseless wail. Our youth and confidence. A powerhouse. We could clear a dance floor in seconds. We were not an easy fit for other musical threads.

So what chance a small rehearsal room in Chinatown. The doors flew back. These guys were exotic, stylish, mature and they played like a dream. Like a dream we could only have imagined. Crescendo to pin drop, silence to full glorious eruption. They operated on a different level, so much depth and knowledge. It was here or there that John and I found a home for our constant, surging growth …

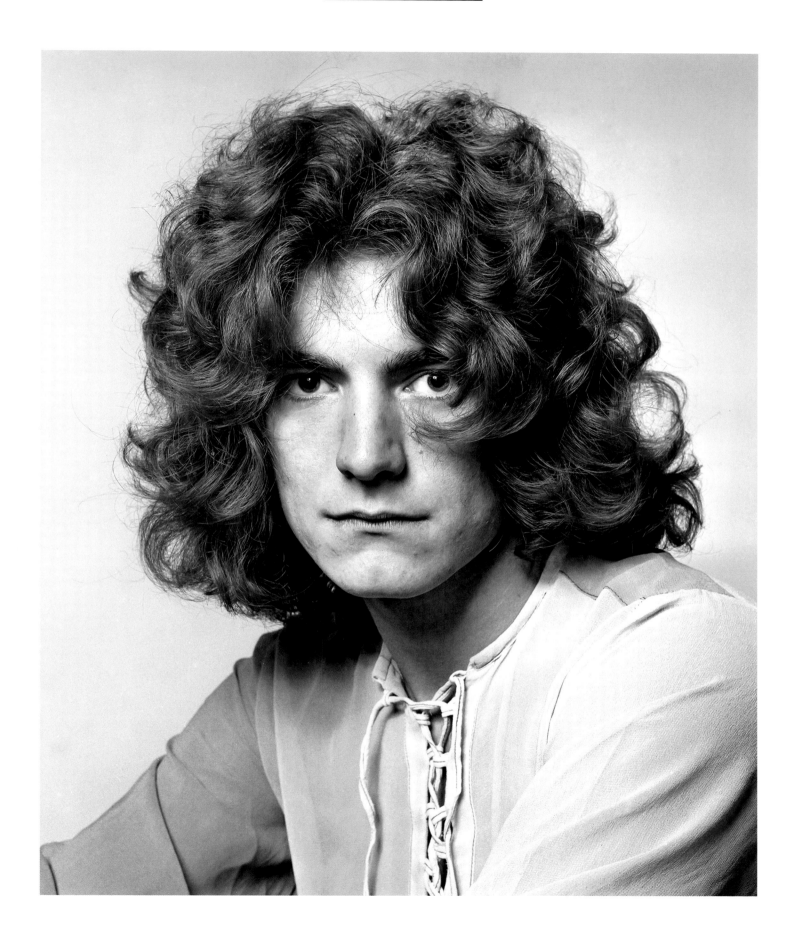

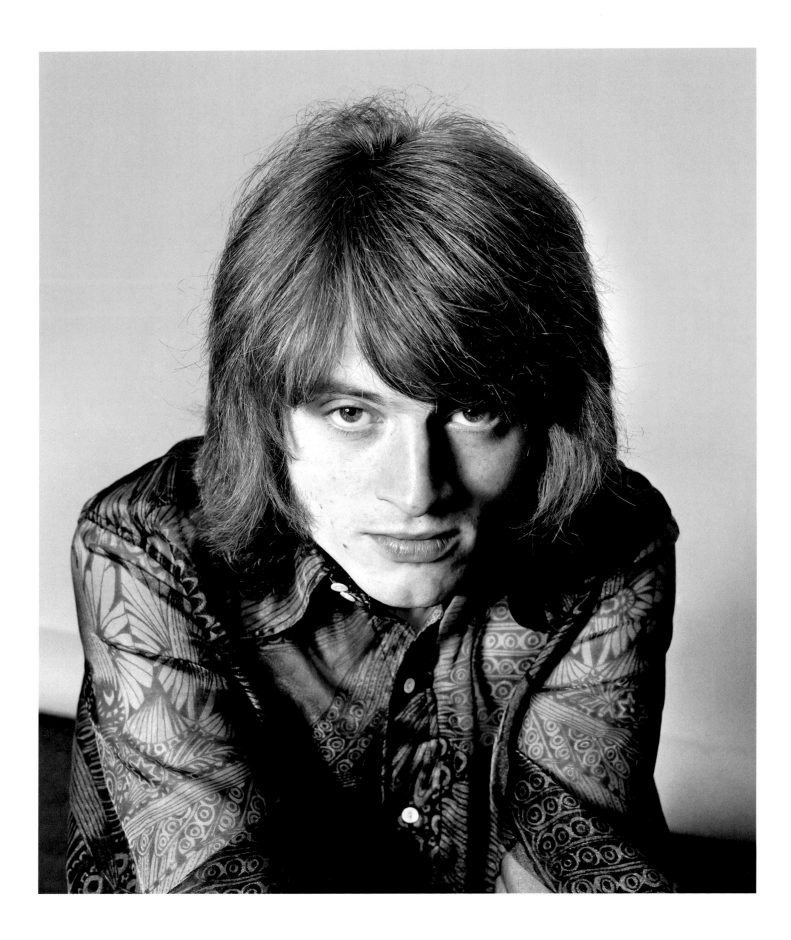

JOHN PAUL JONES
Prologue

From the moment we first played together in a tiny rehearsal room, lined wall to wall with amplifiers, I knew that I was about to be involved in something very special. The energy generated by the four musicians was immediate and the connection magical, and although we had no notion of what the future would hold for us, there was a heady sense of anticipation and excitement.

What followed always had our music at its heart, and these photos show some of that remarkable journey. It was fast, it was frenetic, it was unprecedented. We did things our way and, at the core of everything, was this astonishing musical bond between us. The fans got what we were doing immediately, and as word spread about the band, that noise turned from a cheer to a roar.

JOHN BONHAM
Prologue

The playing was good, even the first time we played together. There's a feeling, you know when you're playing in a group whether it's going to be any good or not and it was good, very good indeed. And it went on from there.

I was pretty shy ... the best thing I could do in a situation like that was not to say much and just soldier along and suss it all out. We had a good play that day and it went quite well, it got together very quickly. We made the album straight after coming back from Scandinavia. How long had we been together then, a month? By that time, I don't think I had any idea the group was going to achieve what it did. You could tell it was going to be a good group, you know. Not to be flash about it ... but I am.

—

Interview from 1971

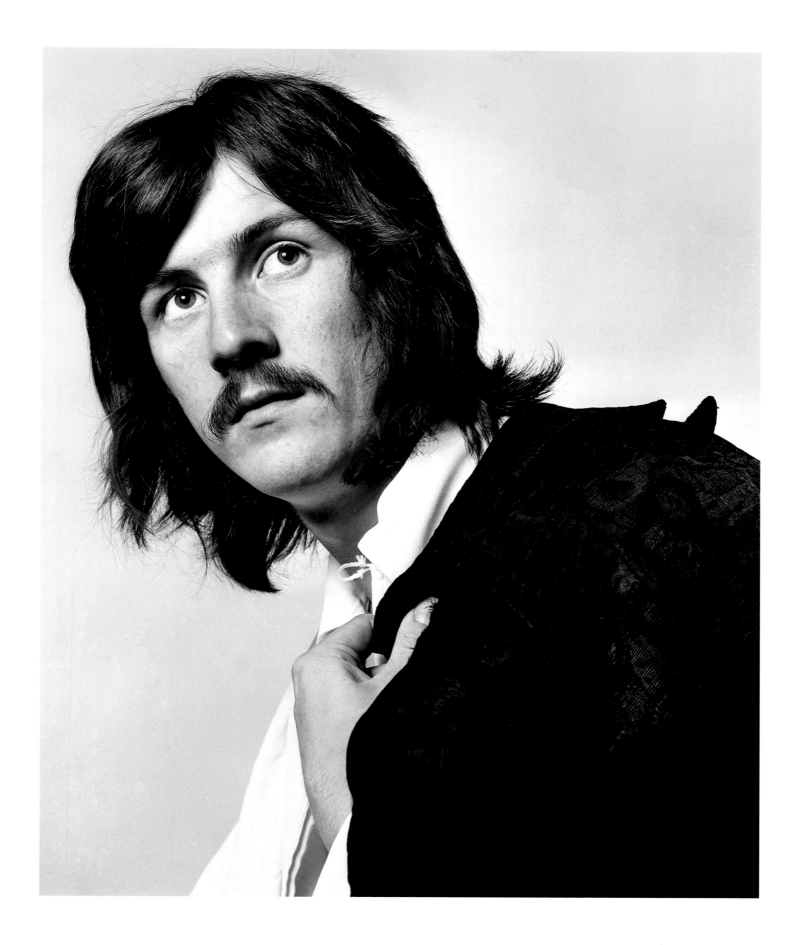

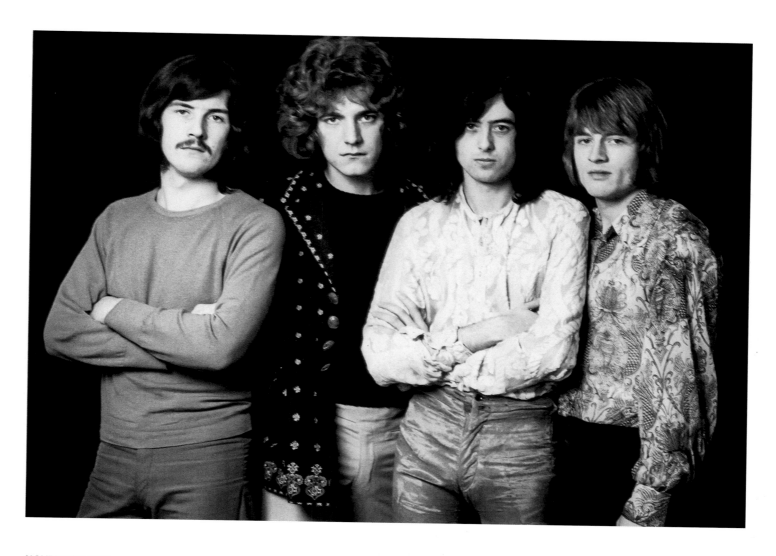

NOVEMBER 1968

London, UK

LED ZEPPELIN

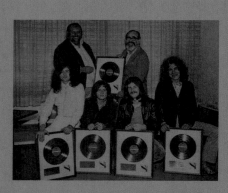

LED
ZEP
THE
JANUA

THE BOST
53 BERKELEY ST. 3.

Tickets: Krackerjacks, Head

LED ZEP
"Good
Bad T
b/w
"Communi
Breakdo
Atlantic #2
Produced by Jimm

FROM THE HIT
"LED ZEPPELIN
Atlantic SD-8216

October 30, 1968

MEMO FROM S. WEISS

TO: JERRY WEXLER

Dear Jerry:

We have arranged for Jimmy Page to be in
New York for the contract signing on November 11th.
He will also bring the eight track tapes with him
so same may be re-mixed if Jimmy and yourself so
decide.

Since you were kind enough to agree to pay
Jimmy's fare here, shall I book the ticket and send
the bill or would you prefer that I arrange this through
someone at Atlantic. Thank you.

Warmest regards,

Sincerely,

KONTRAKT

TIL ARRANGØREN

Følgende engagement er i dag afsluttet gennem Bendix Music: ET/lj

ARRANGØRENS NAVN: Gladsaxe Teen Club, v/hr. Lars Abel

ENGAGEREDES NAVN: The Yardbirds

LOKALETS OG BYENS NAVN: Egegårdsskolen, Gladsaxe

DATO: Lørdag den 7. september 1968

PROGRAMMET OMFATTER: 1 optræden a 30 min. Tidspunkt efter aftale.

HONORAR KR.: 7.000,00 SKISER KR.: syvtusinde

TRANSPORT KR.: Inklusiv

SÆRLIGE BEMÆRKNINGER:

København, d. 15. august 1968

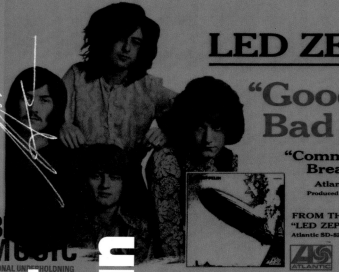

BENDIX MUSIC
INTERNATIONAL UNDERHOLDNING

BLUNEVANG 16
2700- BRØNSHØJ-KØBENHA
(01) *91 46 11

gramadresse:
NDIXMUSIC, KØBENHA

LED ZEPPELIN 2...
OW FLYING!

ATLANTIC

BENDIX MUSIC
for engagerede

LED ZEPPELIN by Led Zeppelin

Ramble on.

Leaves are fallin' all around
Its time I was on my way

Thanks to you I'm much obliged for such
a pleasant stay

And now its time for me to go
The autumn moon lights my way

For now I smell the rain and with it
pain

NINETEEN SIXTY EIGHT

—

SIXTY NINE

19 69 — 19 68

Led Zeppelin

Atlantic Records

ATLANTIC

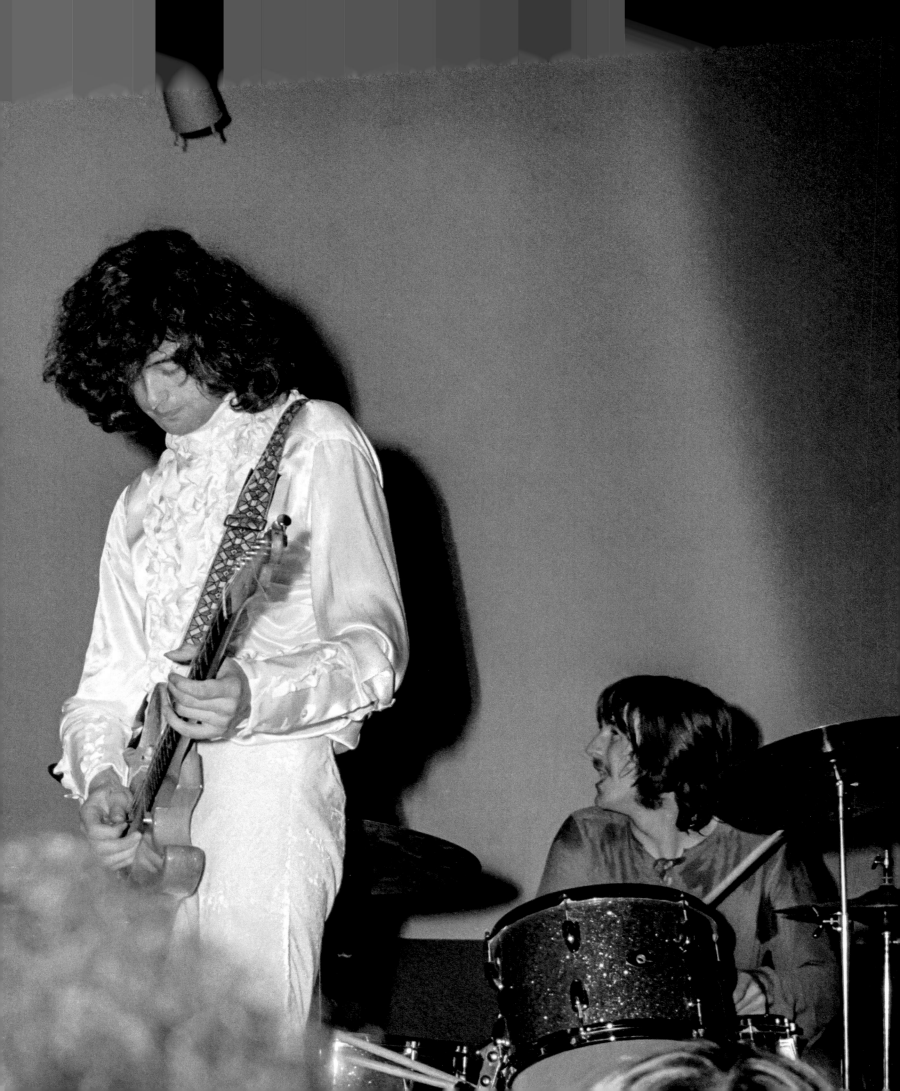

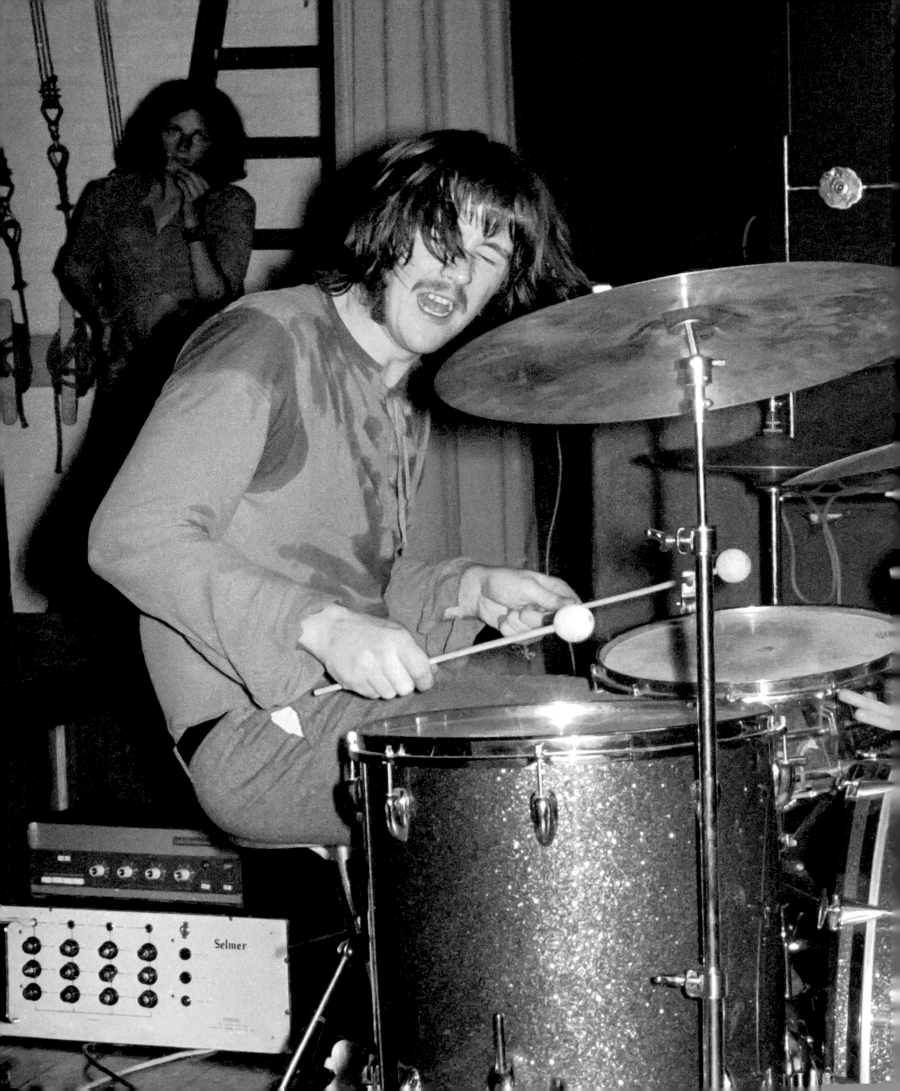

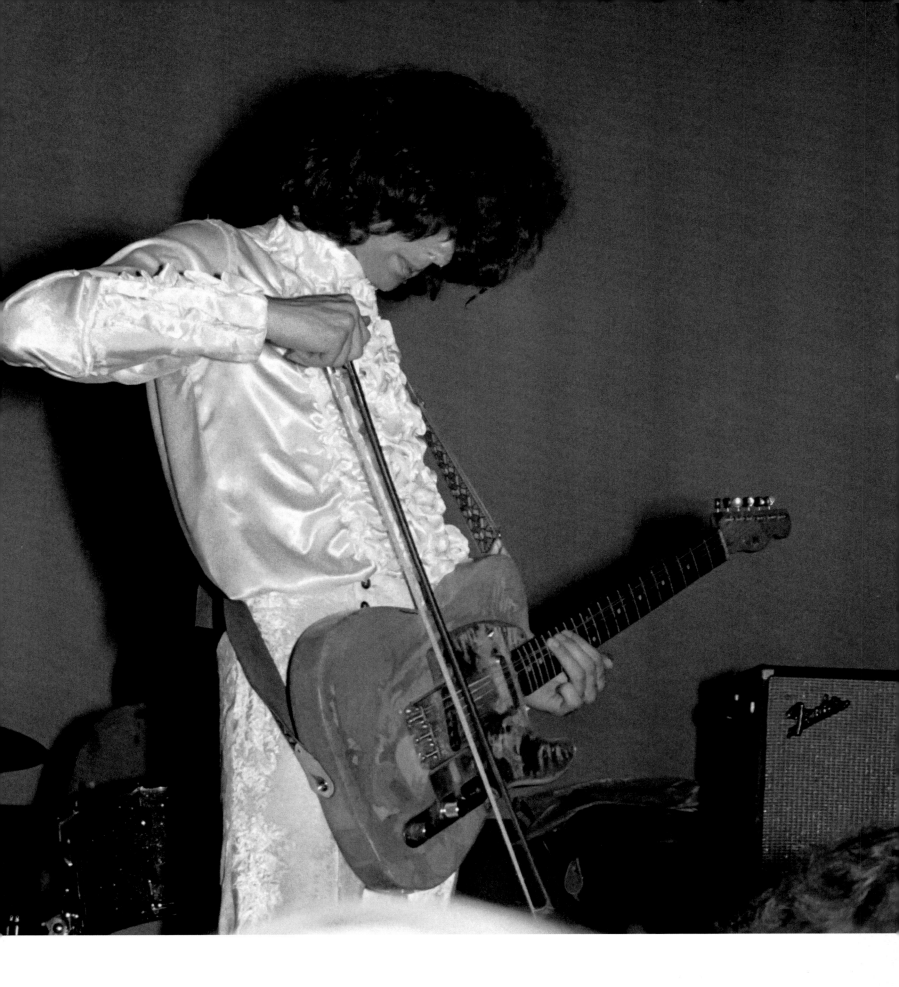

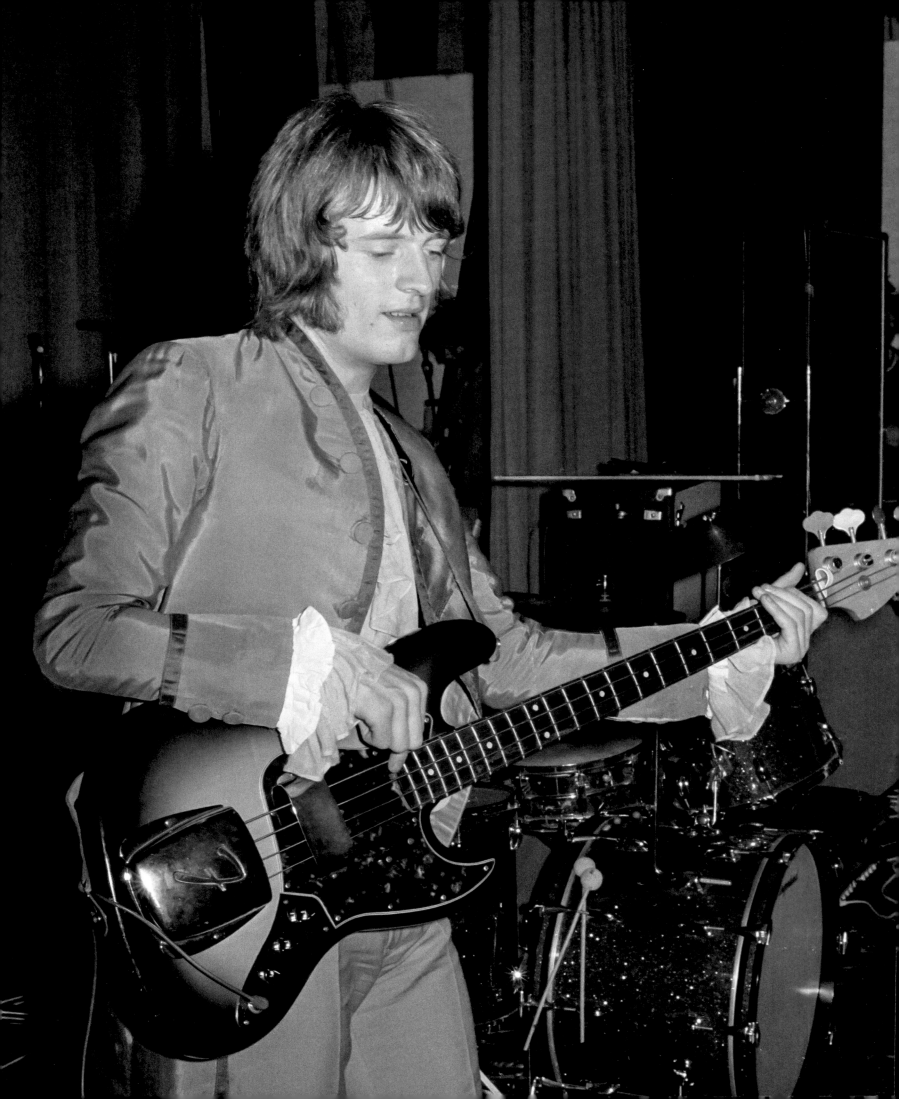

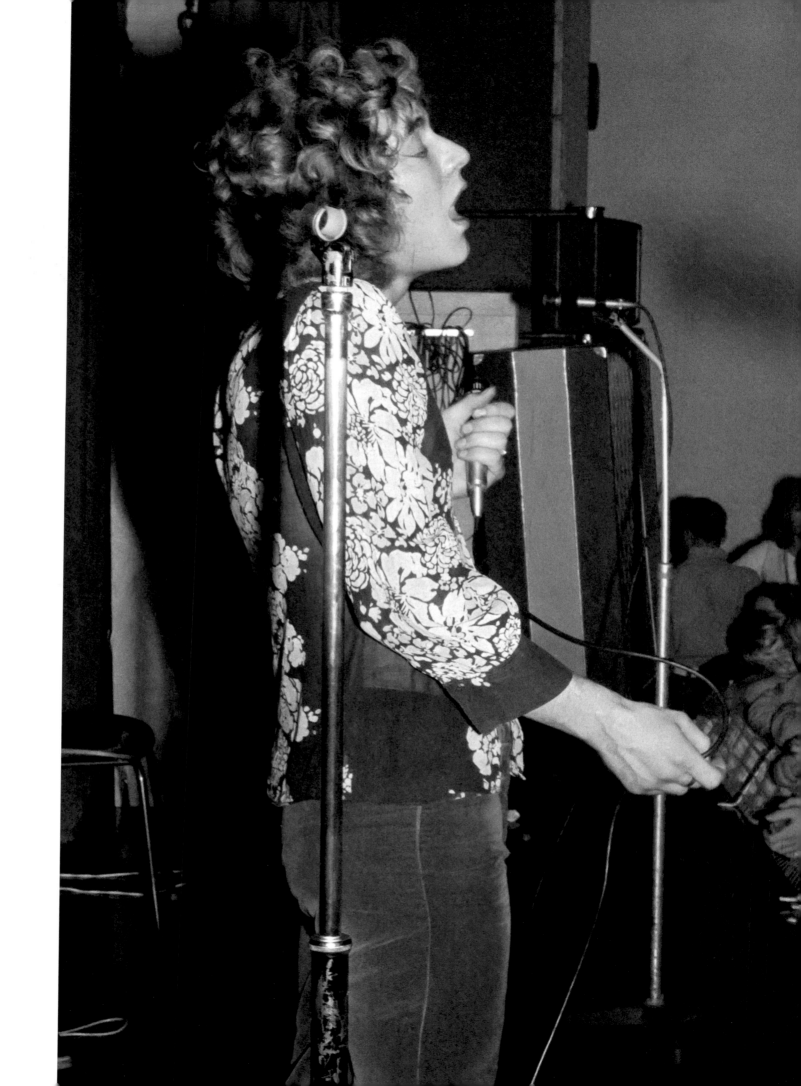

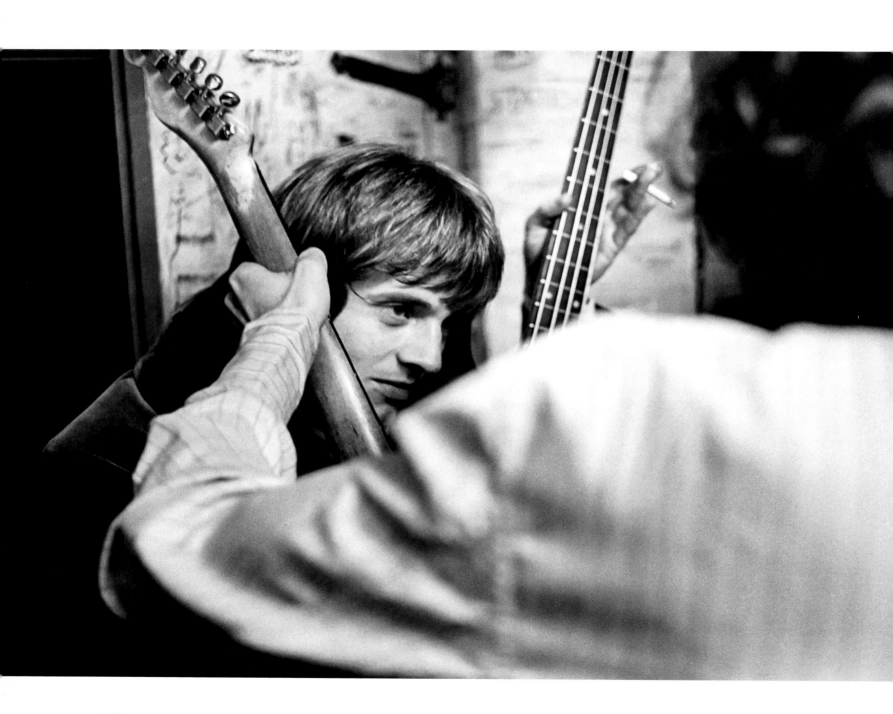

18 OCTOBER 1968

Marquee Club, London, UK

[28—32]

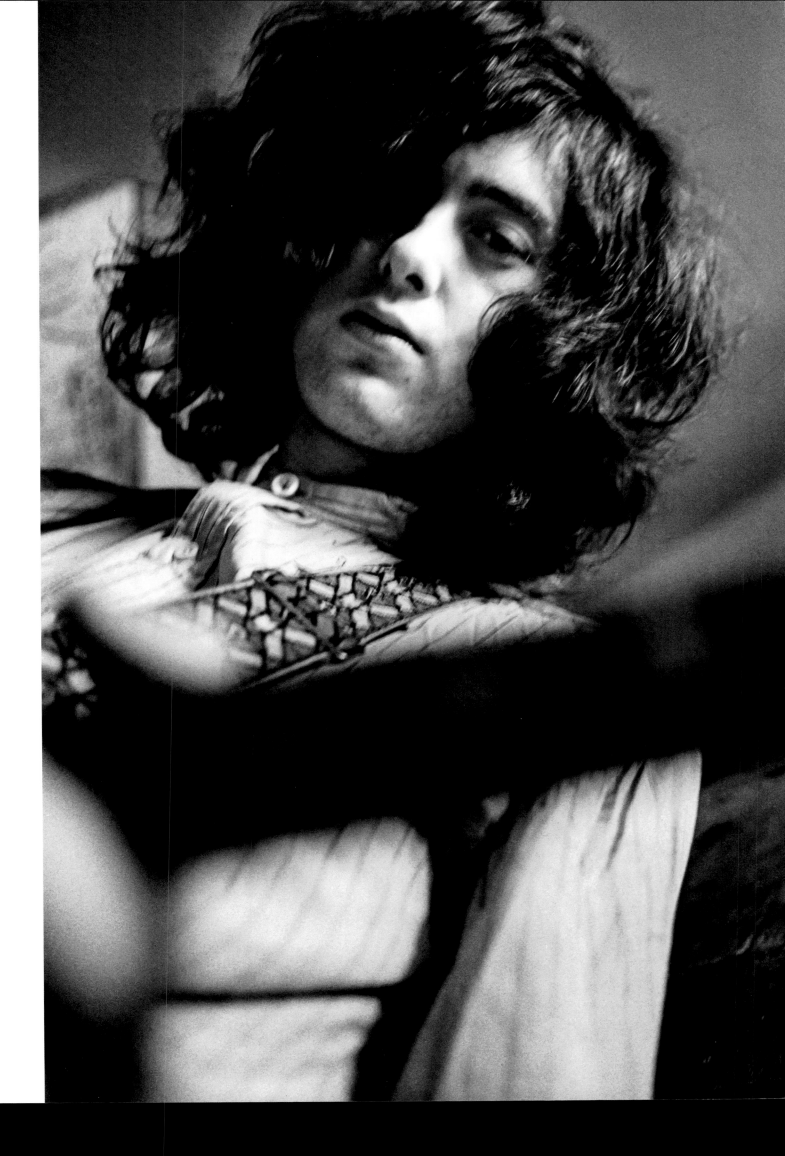

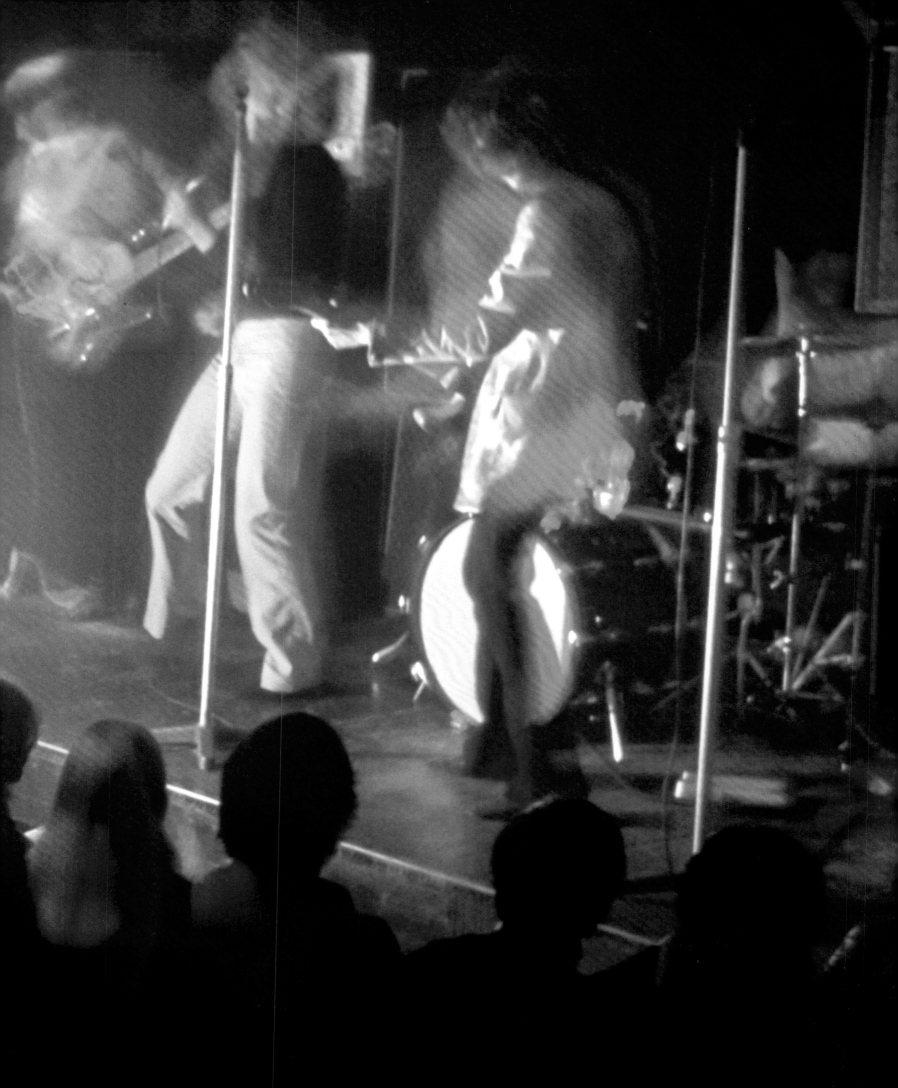

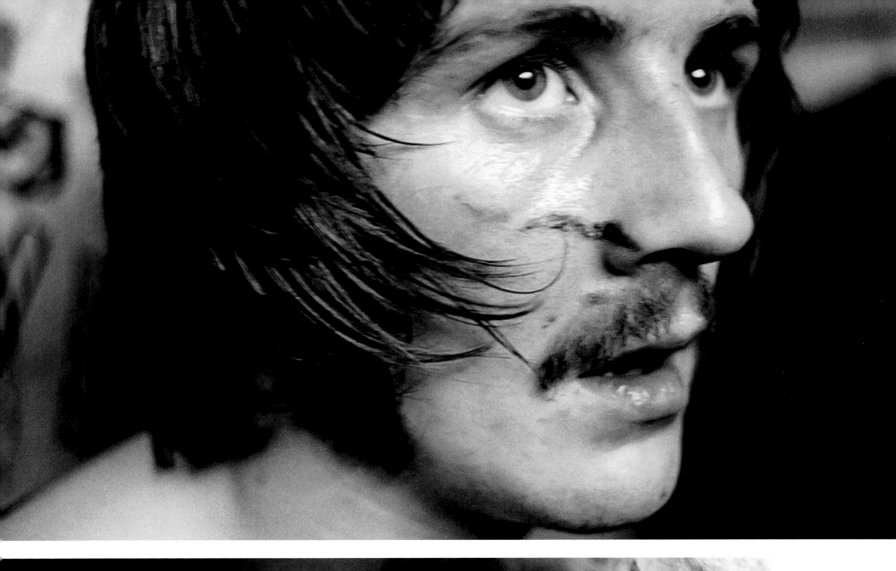

BACKSTAGE AFTER THE SHOW, JOHN SAID THE CUT ON HIS FACE WAS FROM HIS CYMBALS. THAT GOES TO SHOW THE PASSION OF THAT MARQUEE GIG, IMAGINE HOW WE WERE ALL PLAYING.

JIMMY PAGE

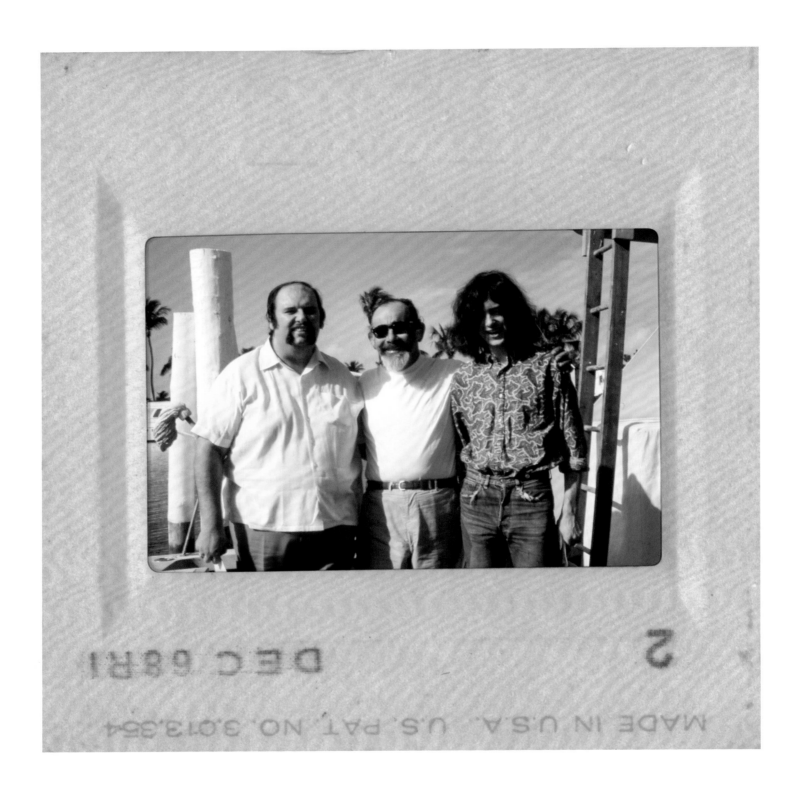

NOVEMBER 1968

Miami, Florida, USA

With Peter Grant and Jerry Wexler

[above]

11 NOVEMBER 1968

Atlantic Records office, New York, New York, USA

With Peter Grant and Ahmet Ertegun

[right]

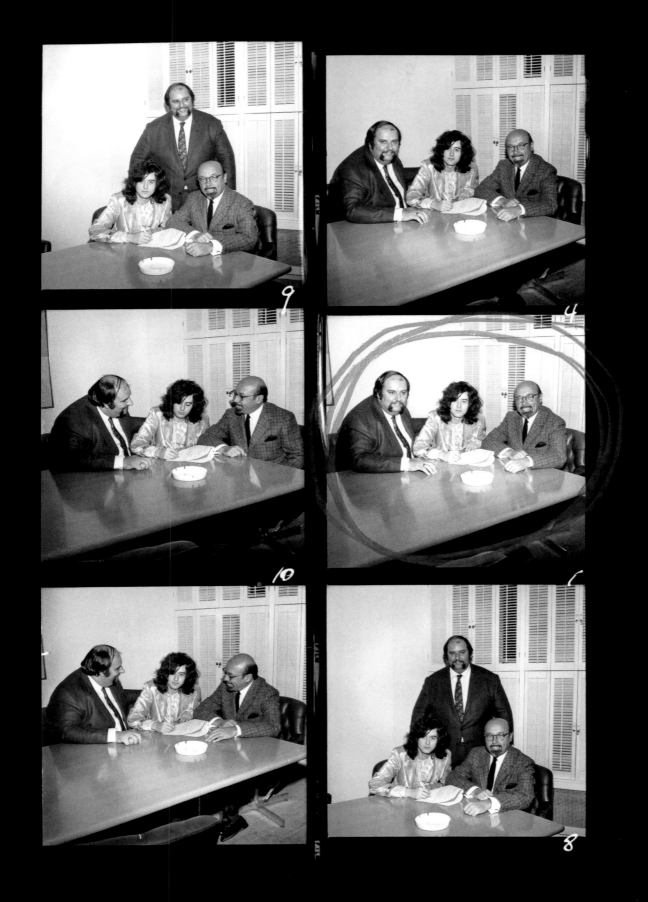

I HAVE A GIG SHEET OF THE FIRST FOUR GIGS ON THE AMERICAN TOUR AND AFTER THAT 'TO BE ARRANGED'. IT WAS BRILLIANT. WHO KNEW WHERE WE WERE GOING?

26 DECEMBER 1968

Denver Auditorium Arena, Denver, Colorado, USA

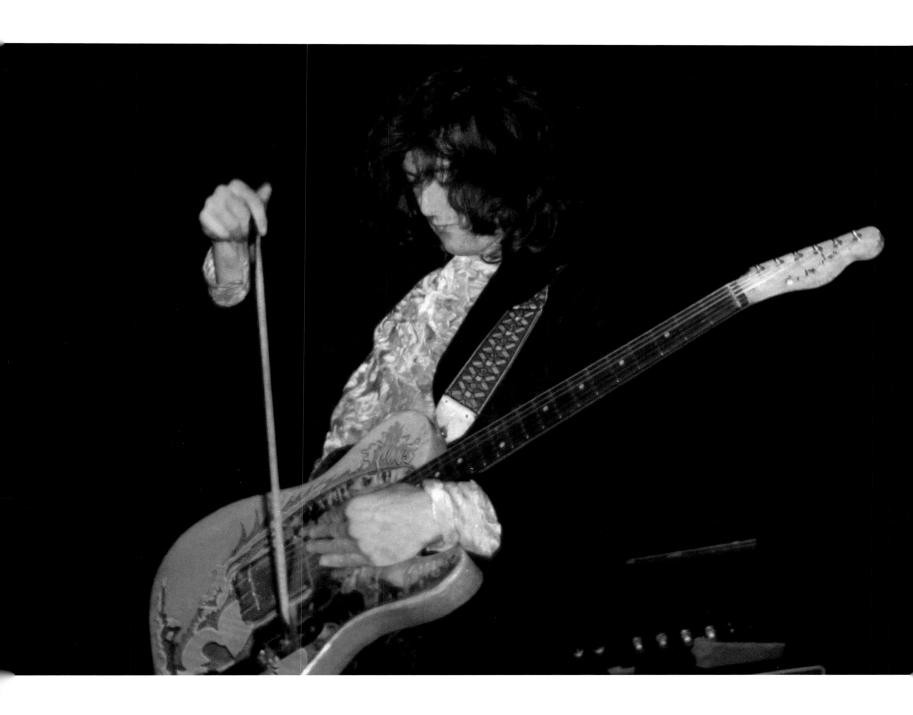

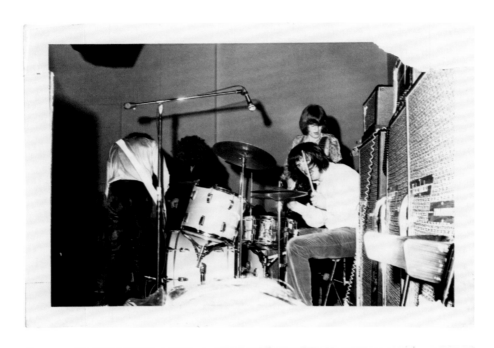

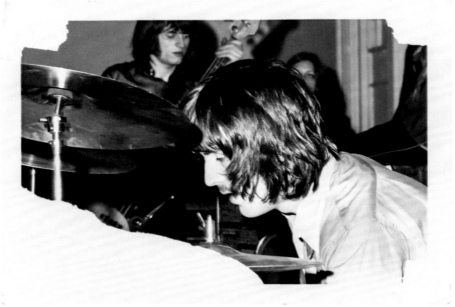

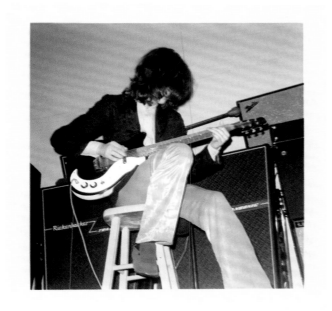

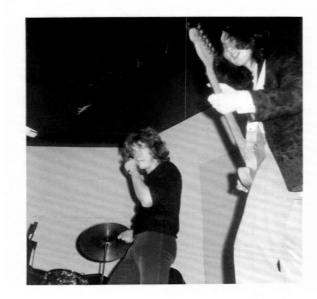

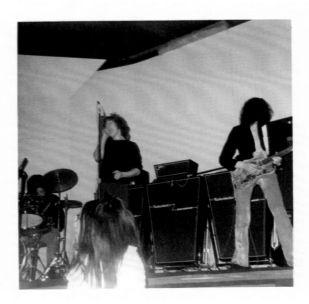

JANUARY 1969

Whisky a Go Go, West Hollywood, California, USA

[above]

Boston Tea Party, Boston, Massachusetts, USA

[left]

14 JANUARY 1969

San Francisco, California, USA

[40—41]

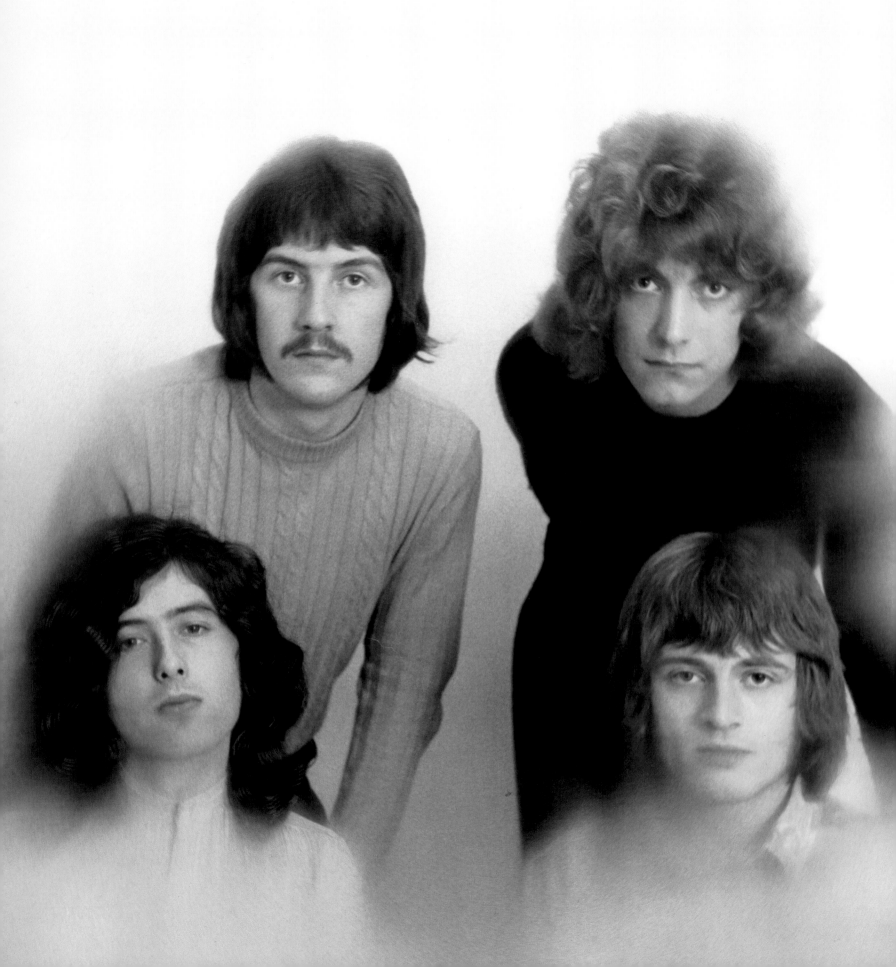

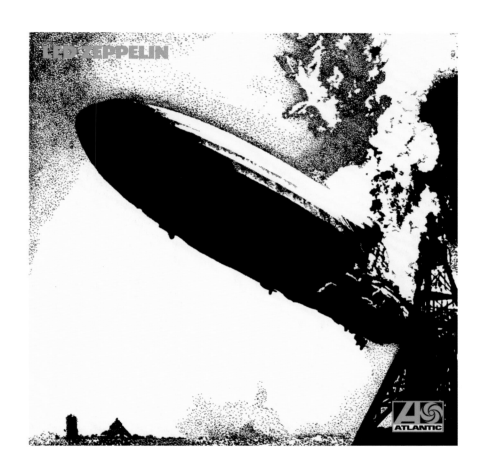

LED ZEPPELIN
12 January 1969 – US & Canada
28 March 1969 – UK

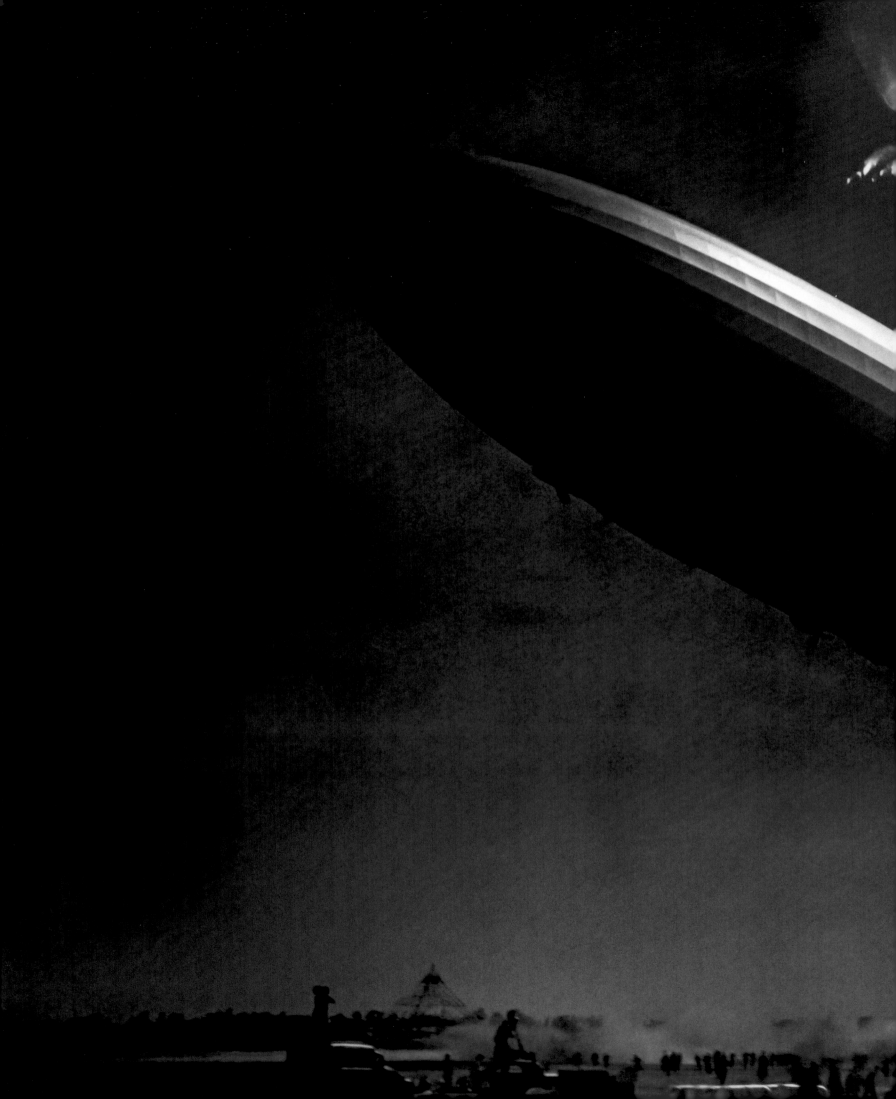

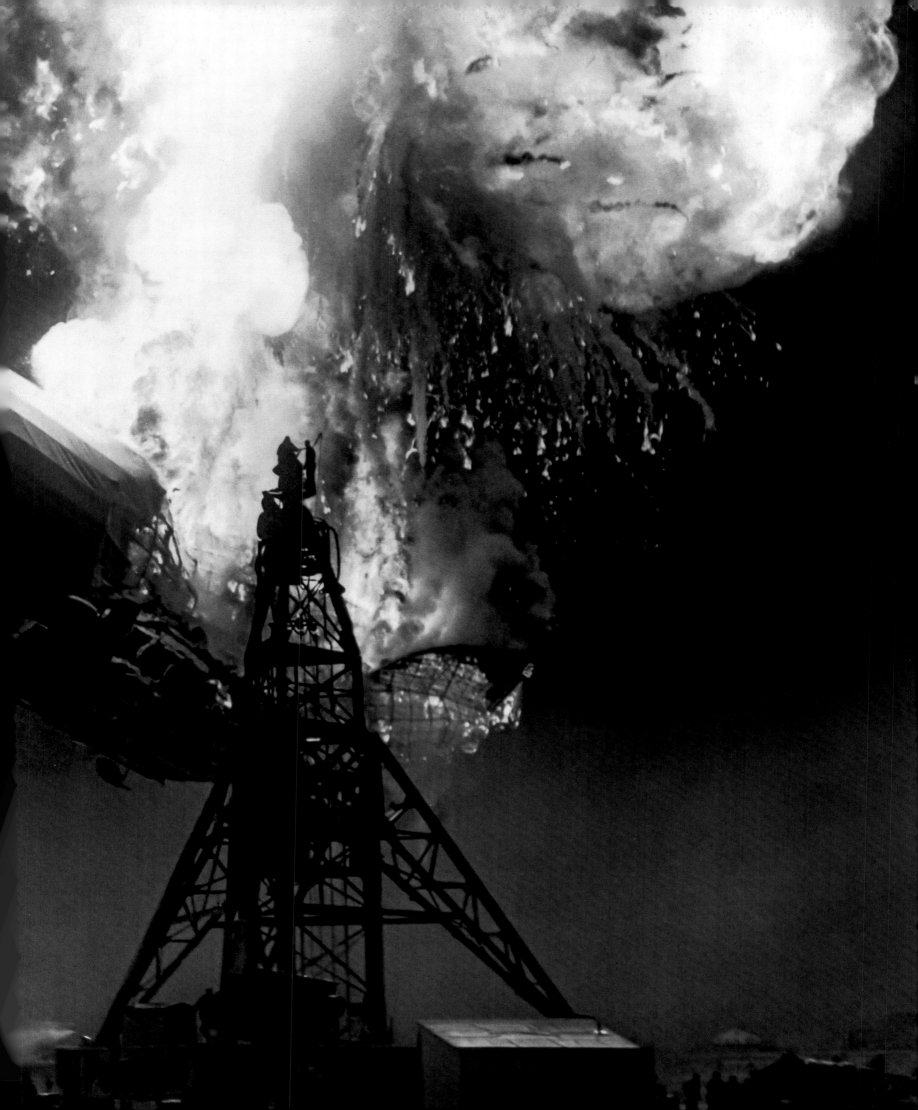

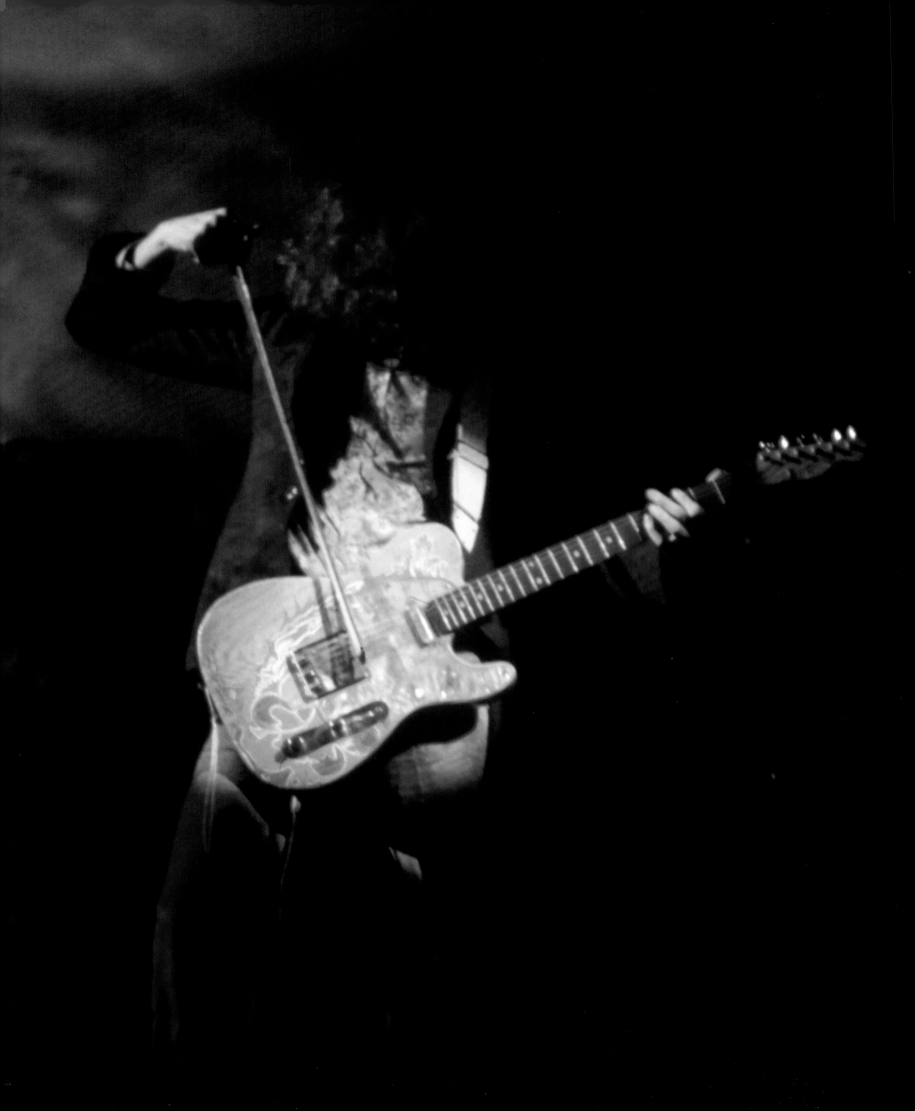

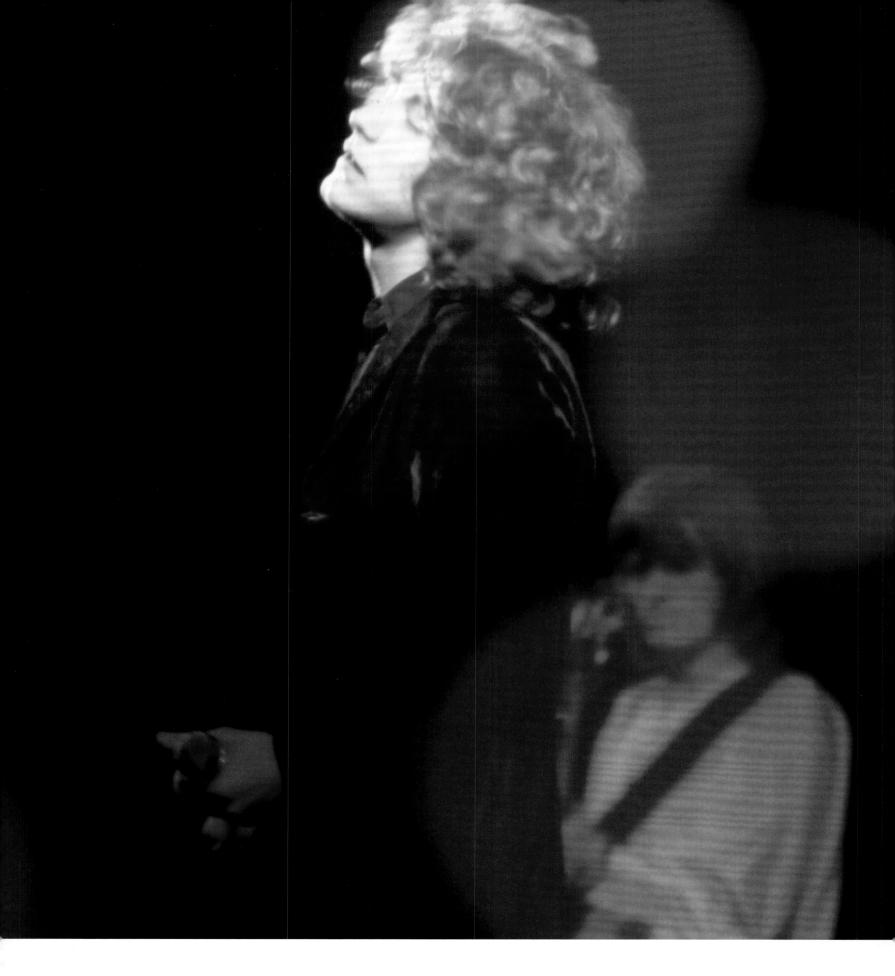

31 JANUARY & 1 FEBRUARY 1969

Fillmore East, New York, New York, USA

<div align="right">

15 FEBRUARY 1969

Thee Image Club, Miami, Florida, USA

[48—49]

</div>

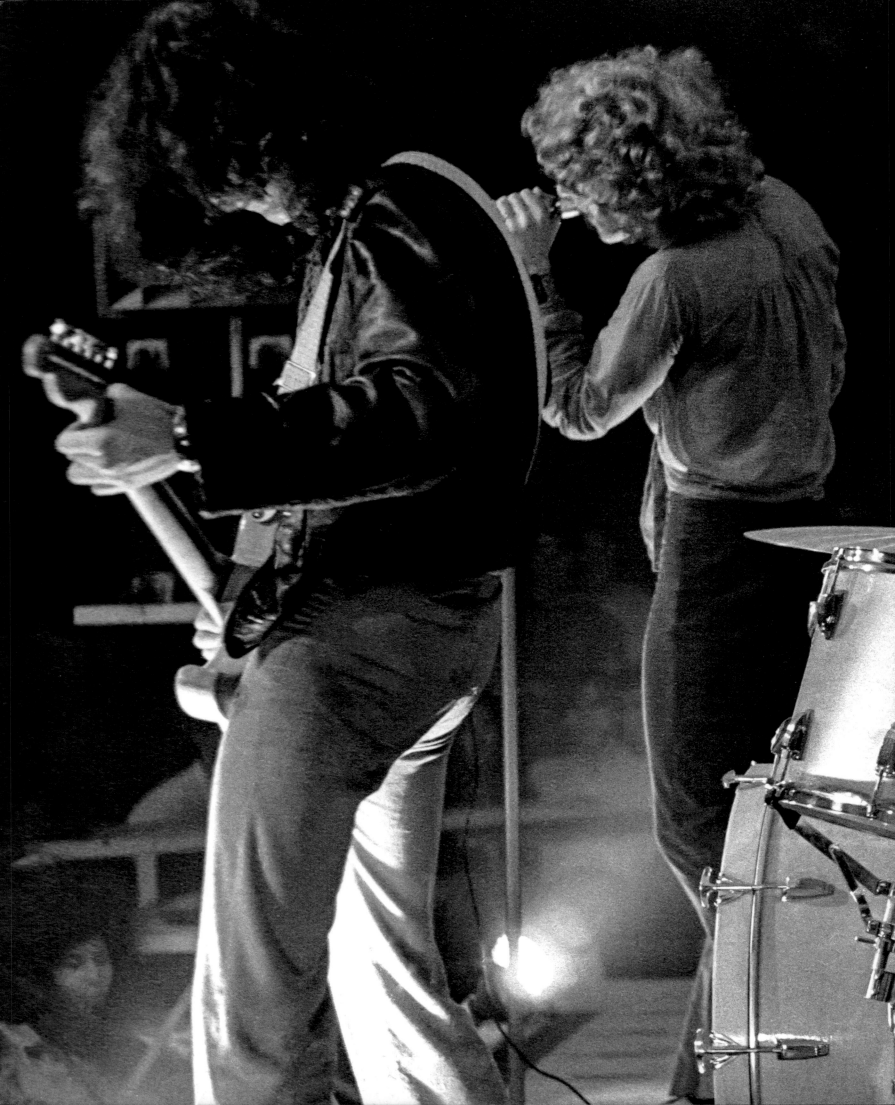

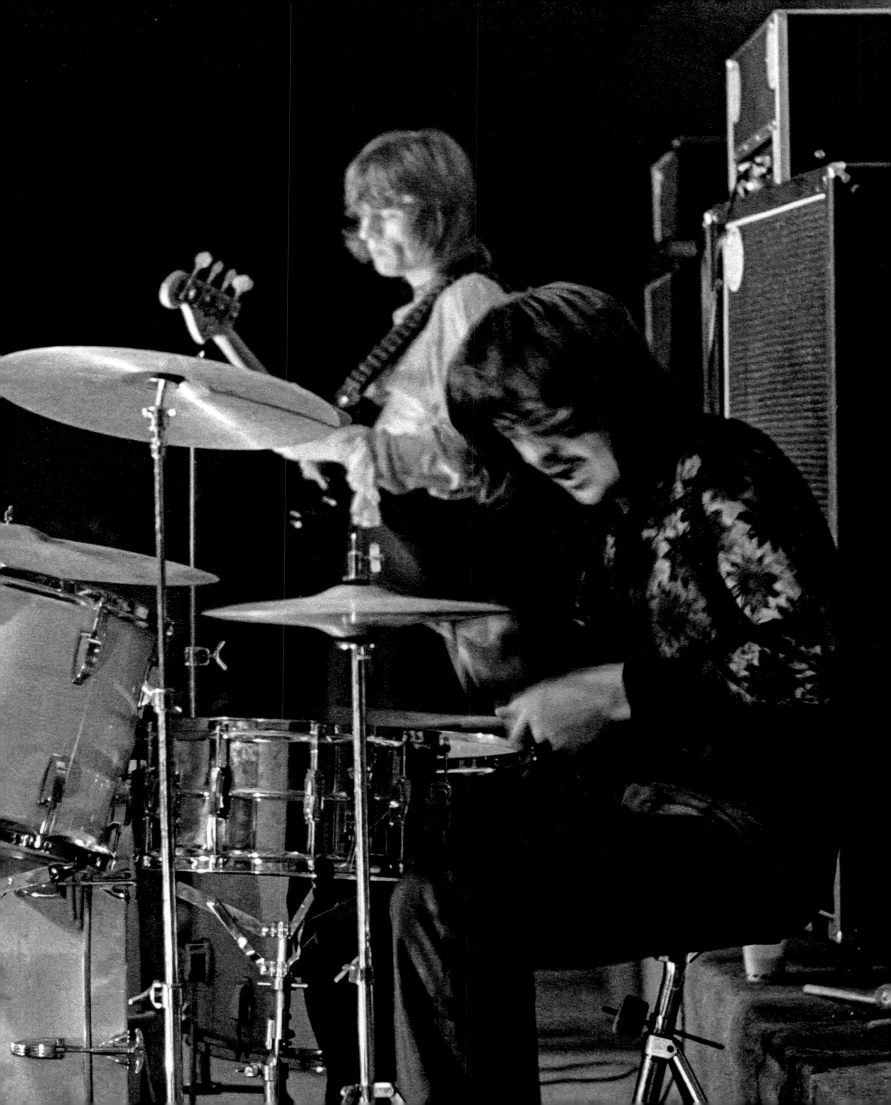

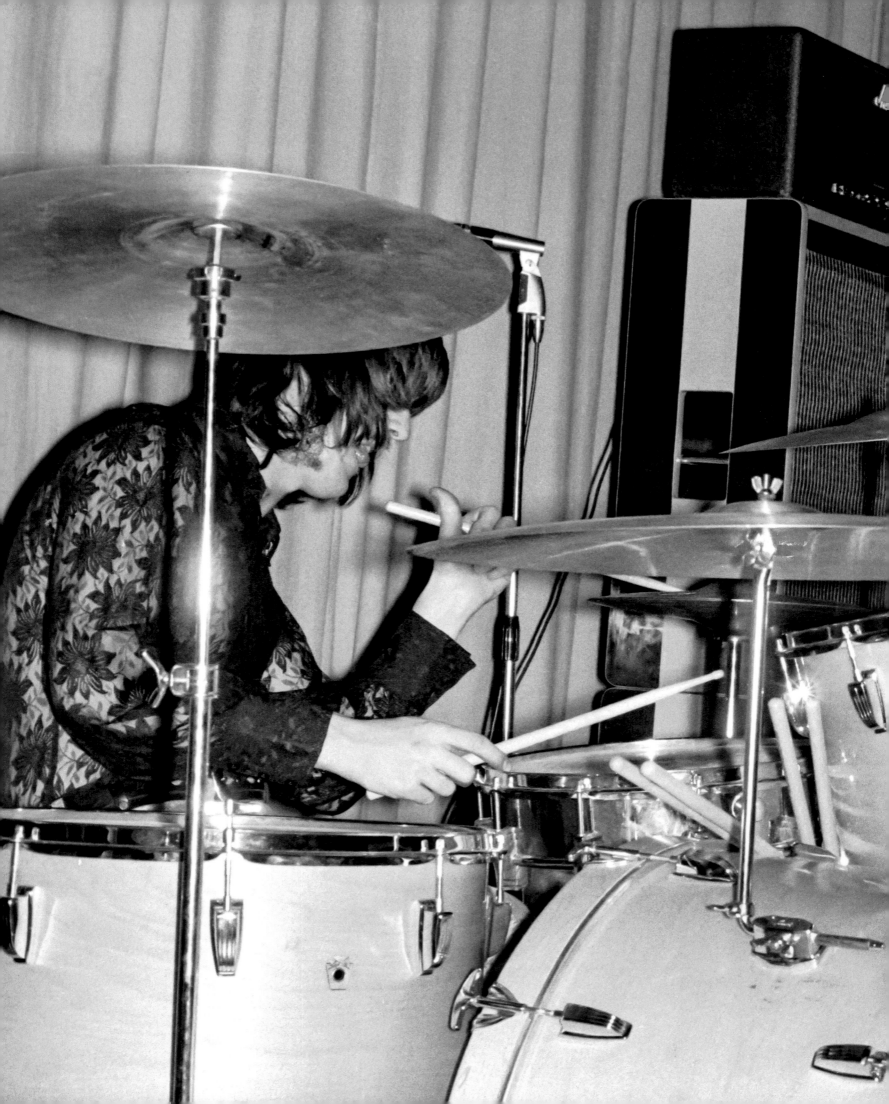

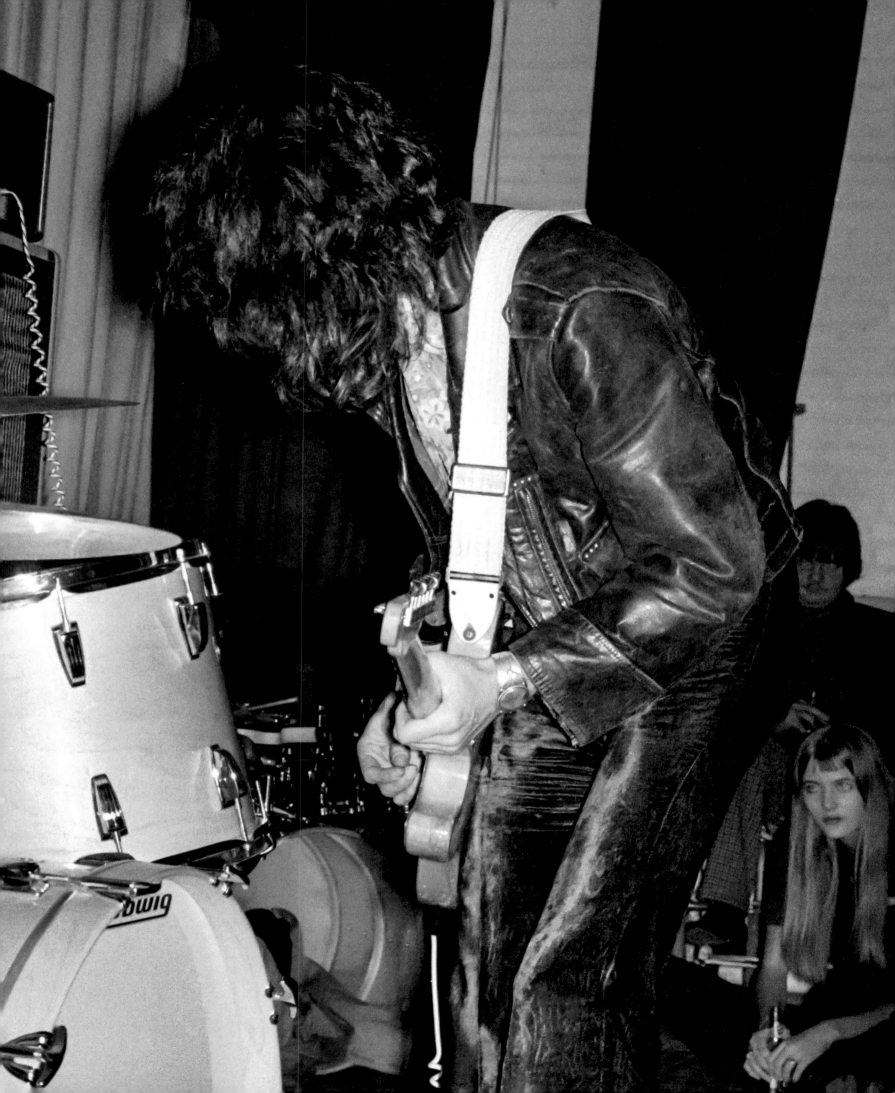

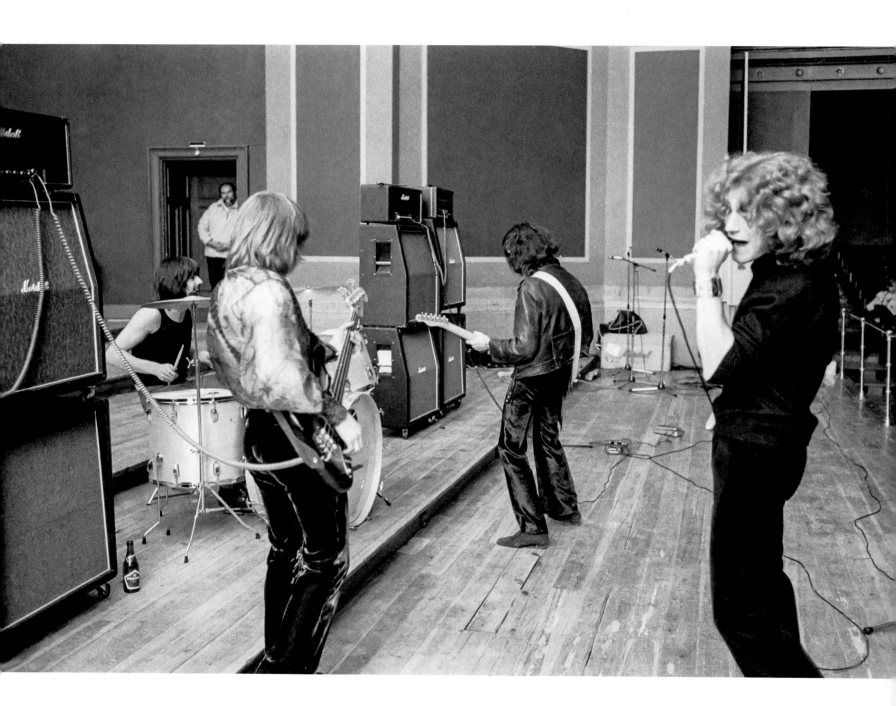

15 MARCH 1969

Teen Club, Gladsaxe, Denmark

[50—51]

14 MARCH 1969

Uppsala University Hall, Uppsala, Sweden

[above]

25 MARCH 1969

'Supershow', Staines, UK

[right]

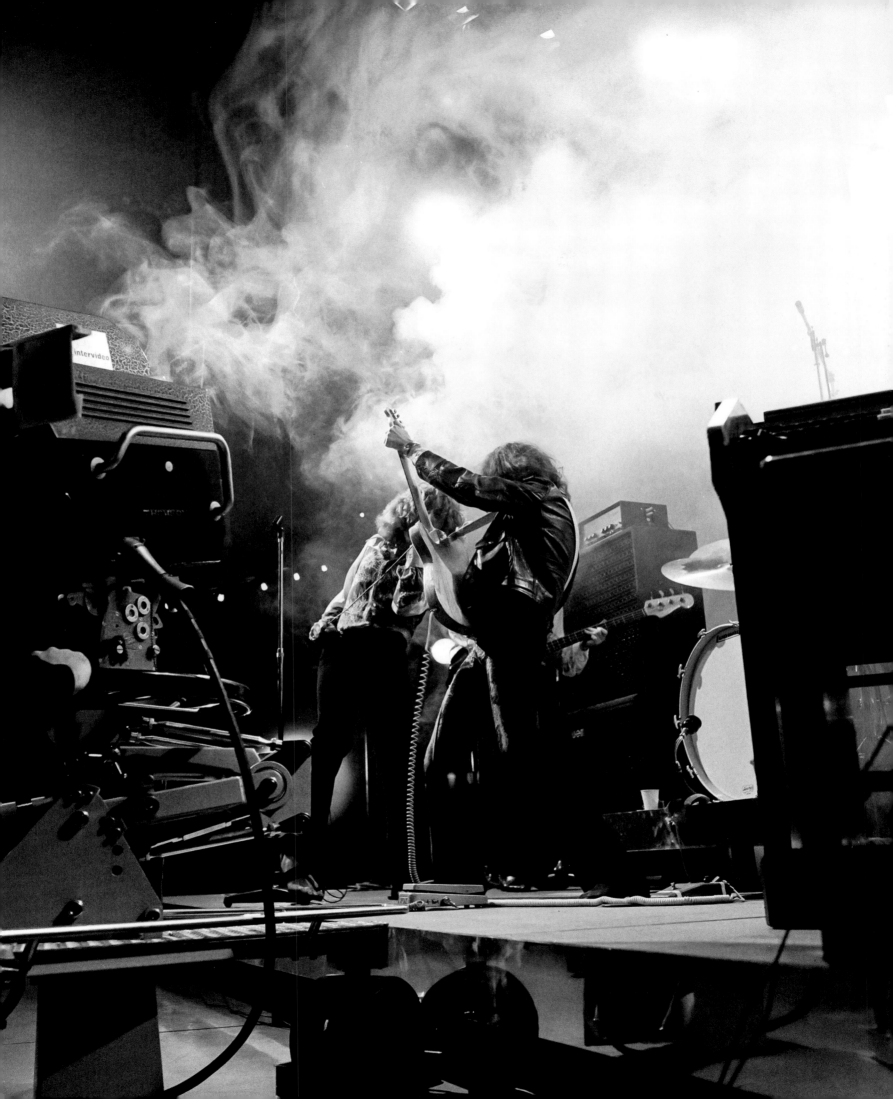

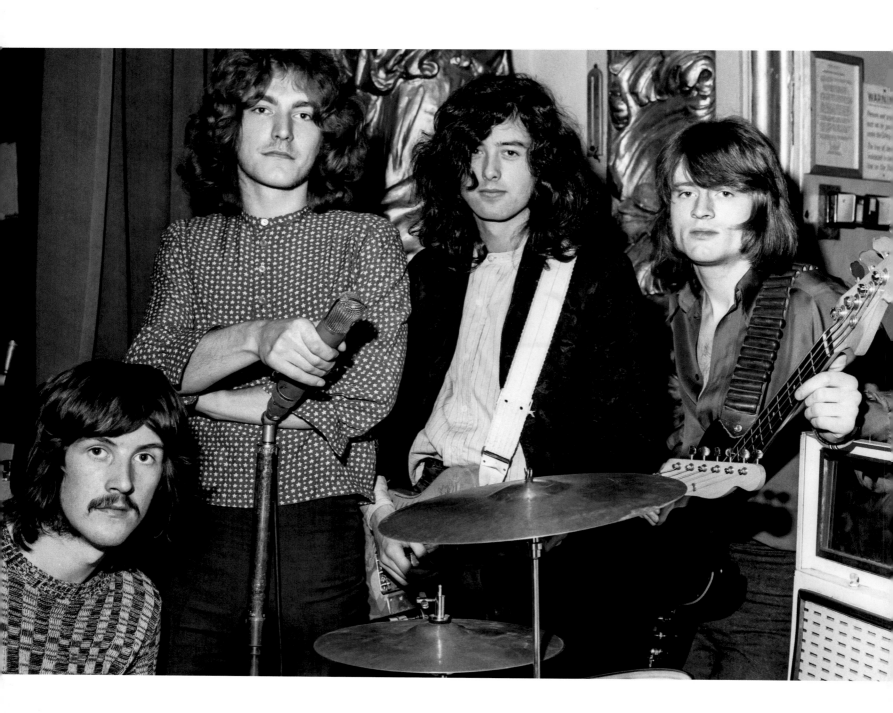

3 MARCH 1969

BBC 'Top Gear', Playhouse Theatre, London, UK

[above]

8 APRIL 1969

Bluesville 69 Club / The Cherry Tree, Welwyn Garden City, UK

[55—57]

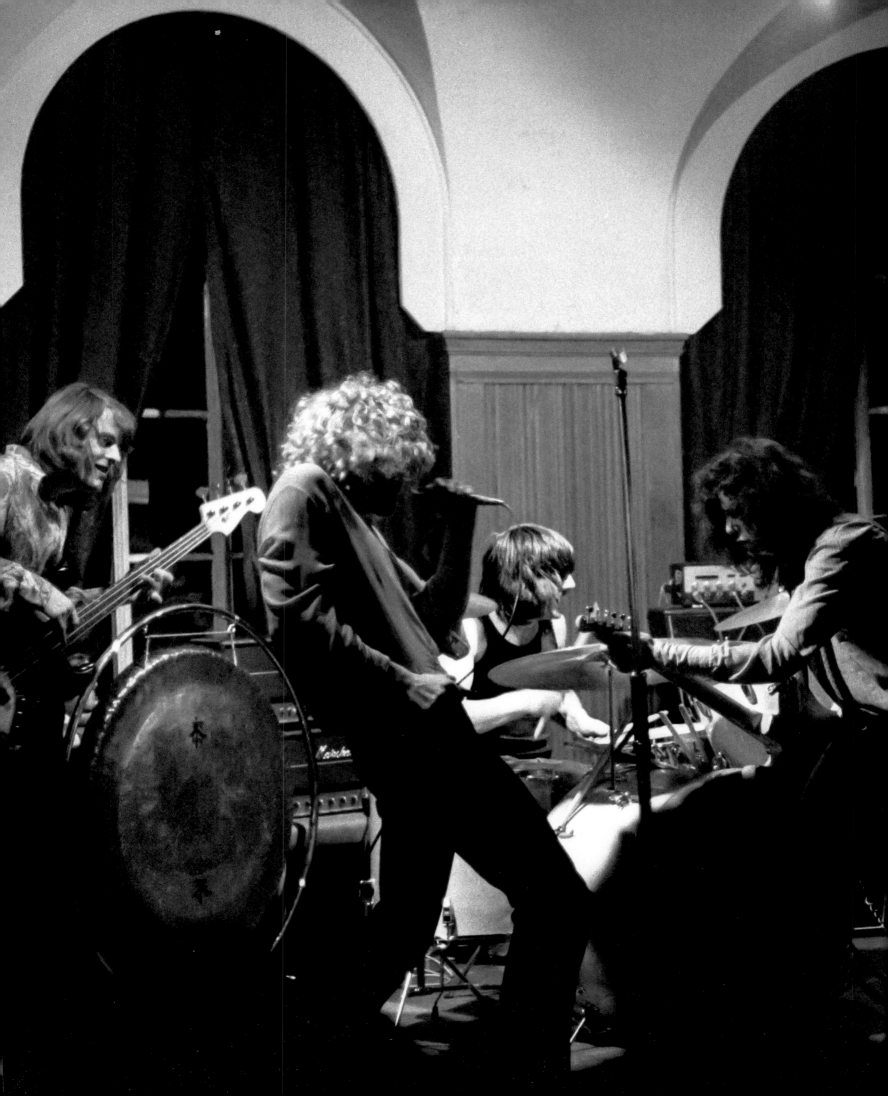

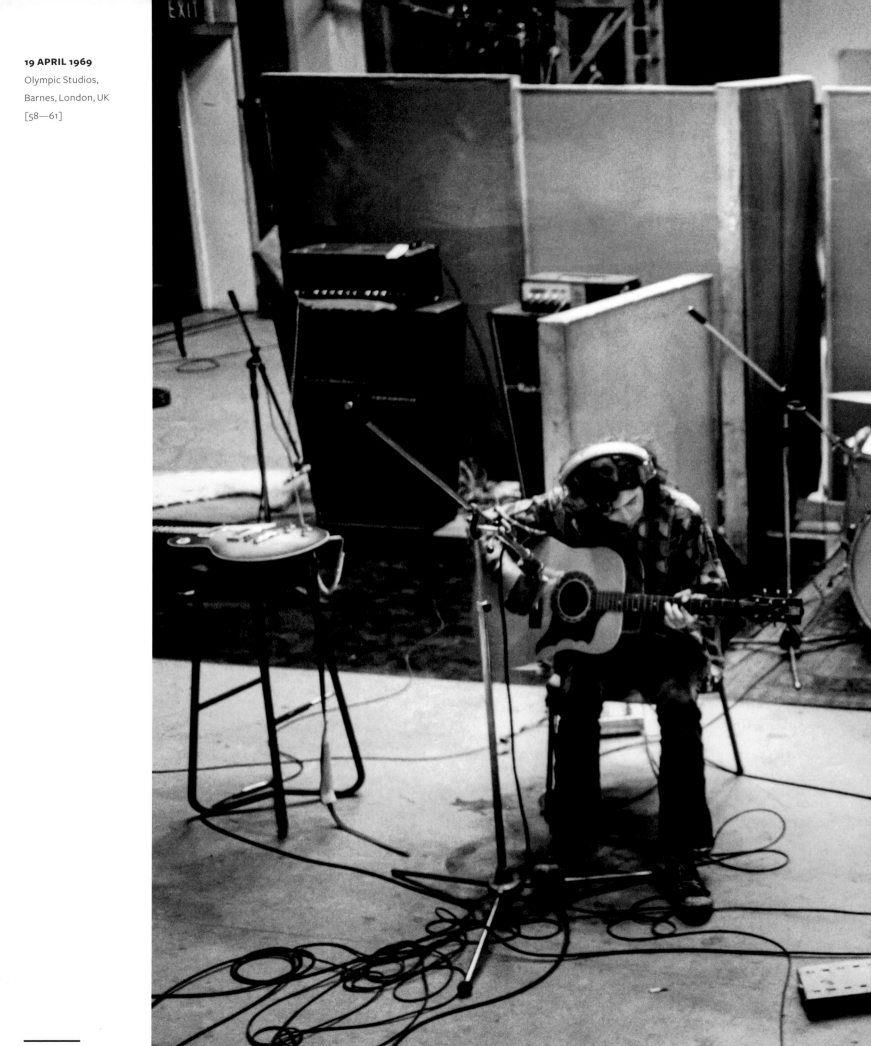

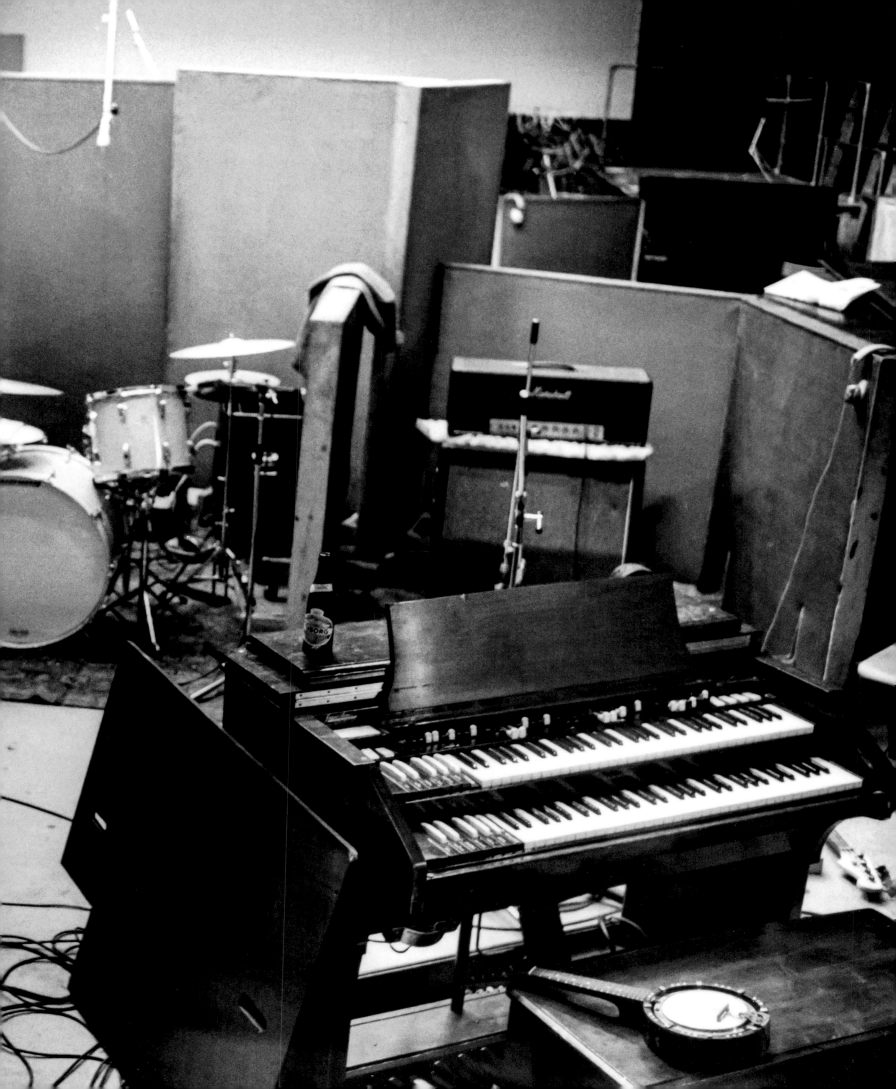

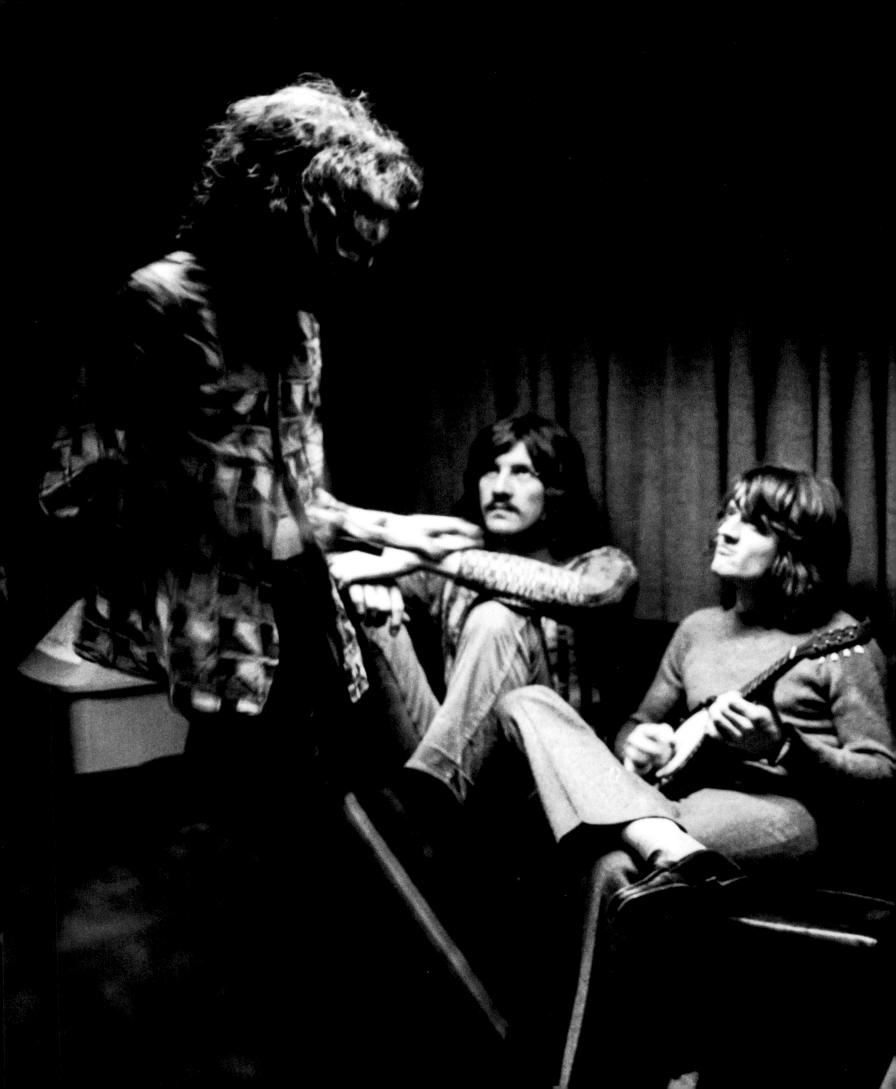

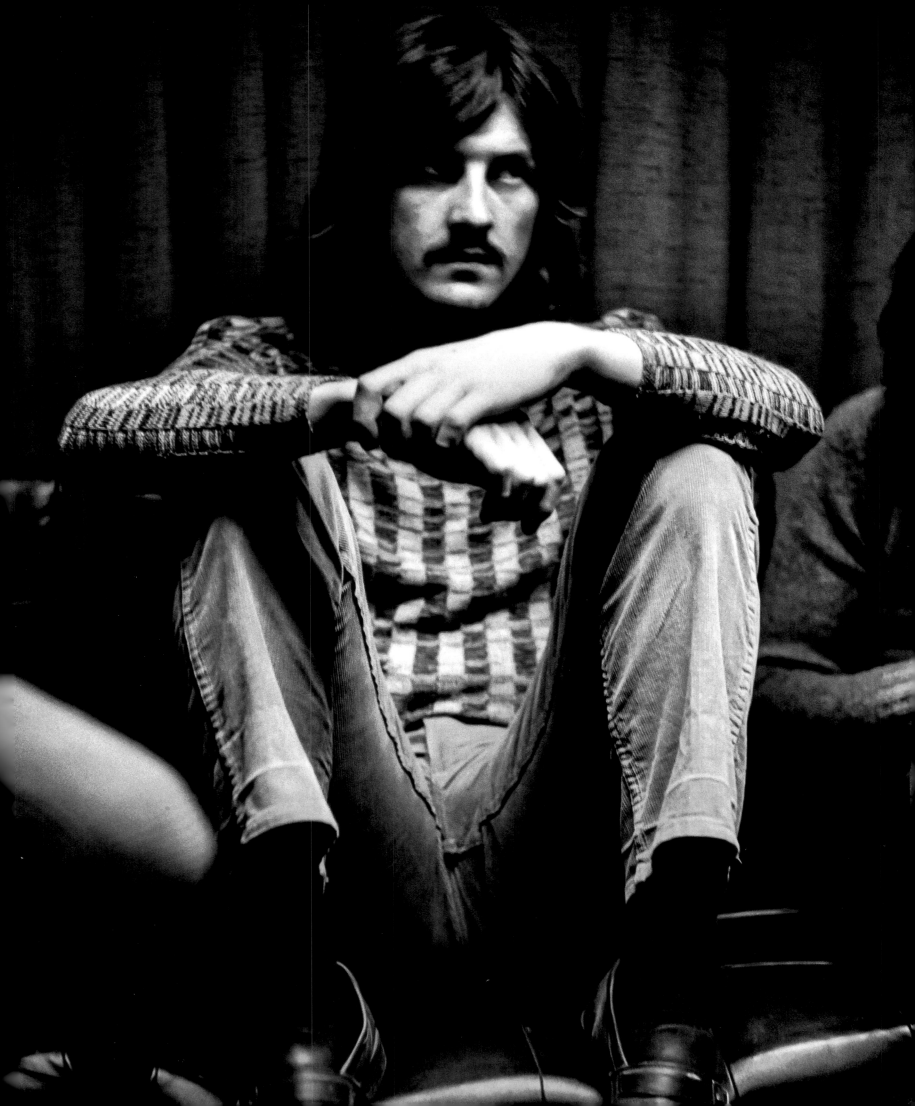

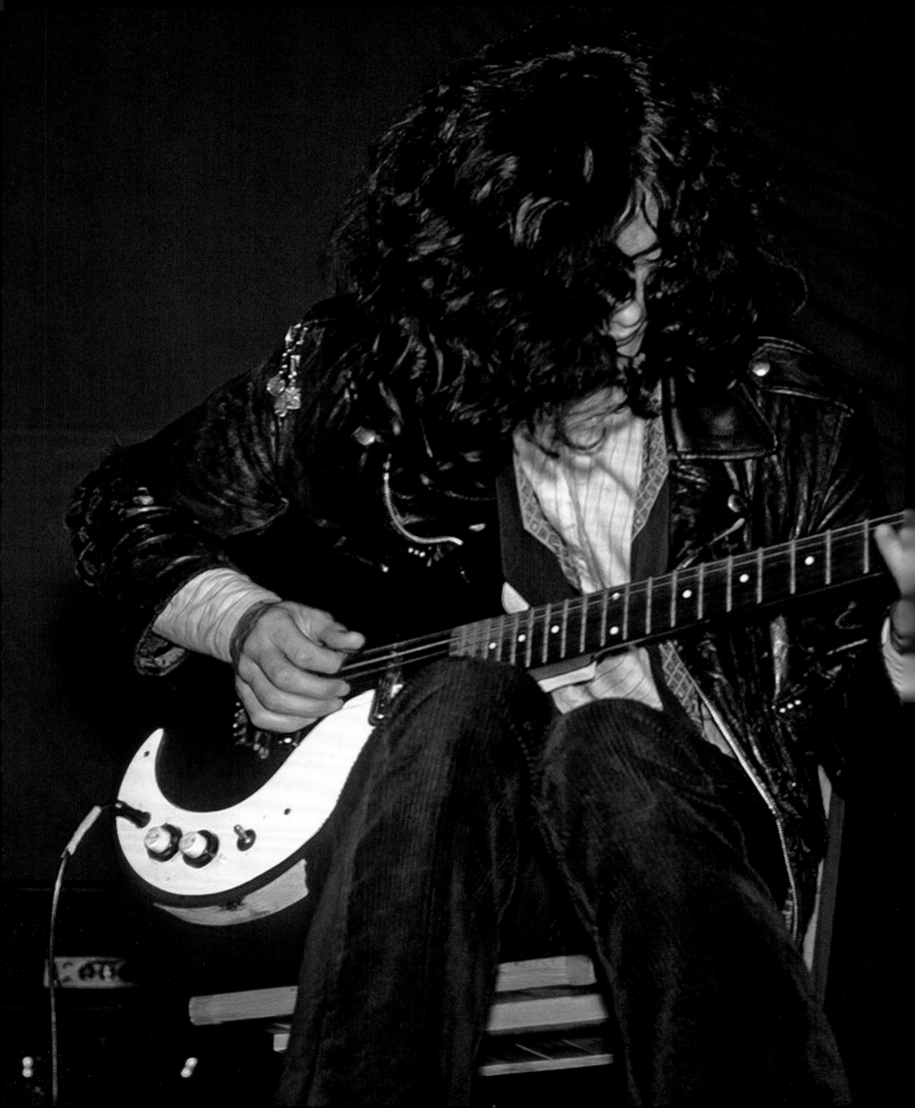

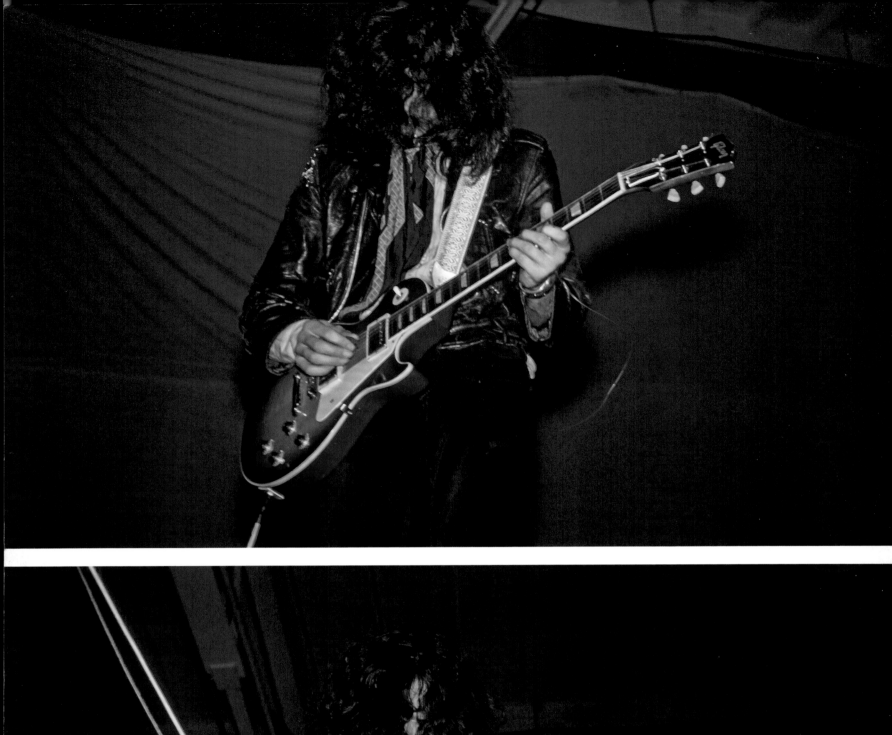
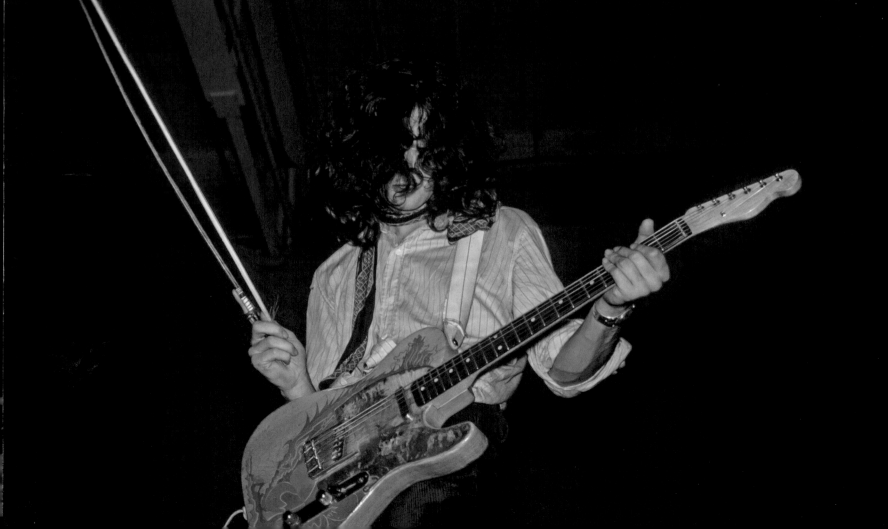

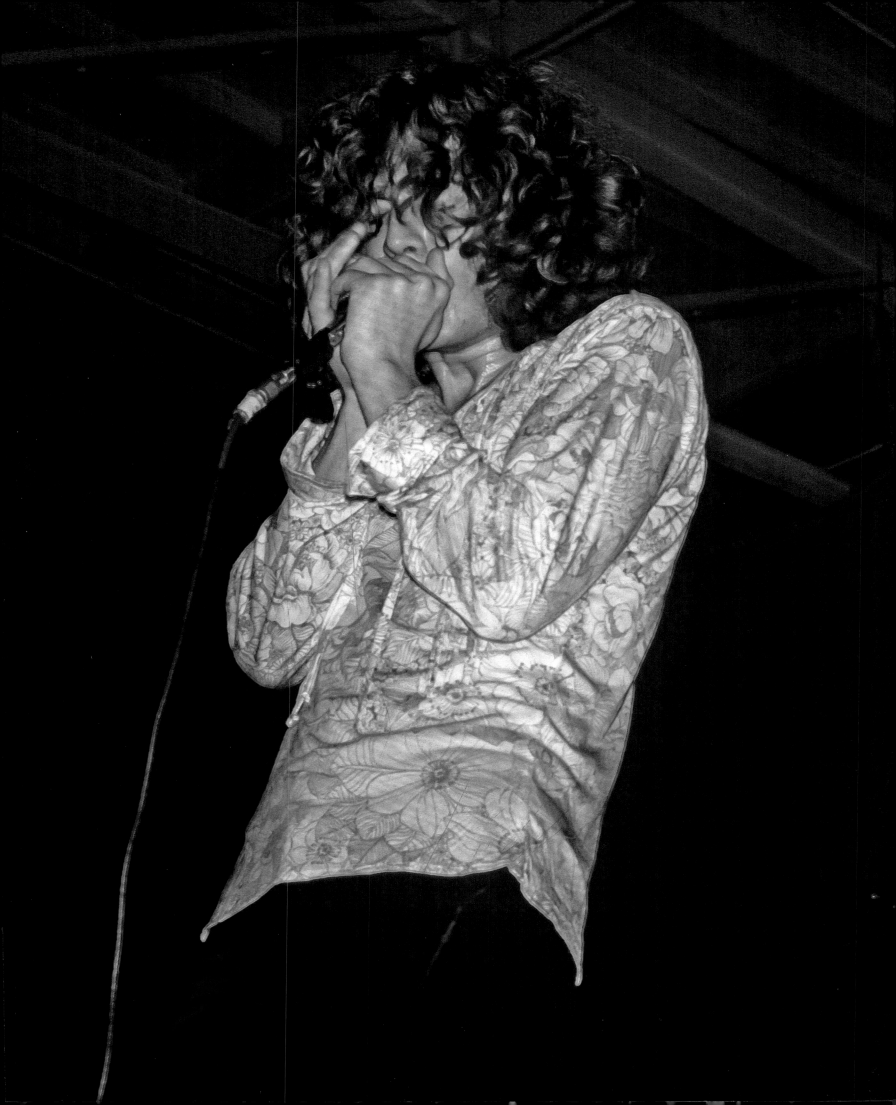

WE KNEW HOW GOOD WE WERE. THE WAY THE ALCHEMY BONDED AND THE WAY THE BAND WAS TO SHOWCASE EACH OF US AS A SERIOUS MUSICIAN. CERTAINLY THE LIVE SITUATION CREATED AN EXTRA ELEMENT. A FIFTH ELEMENT.

16 MAY 1969

Grande Ballroom, Detroit, Michigan, USA

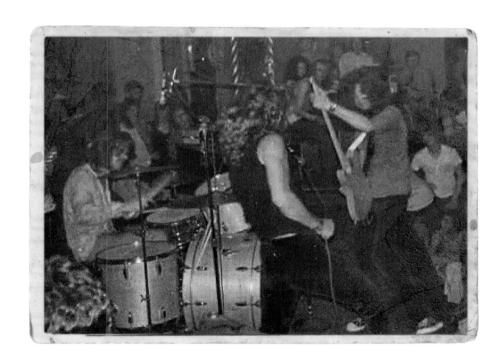

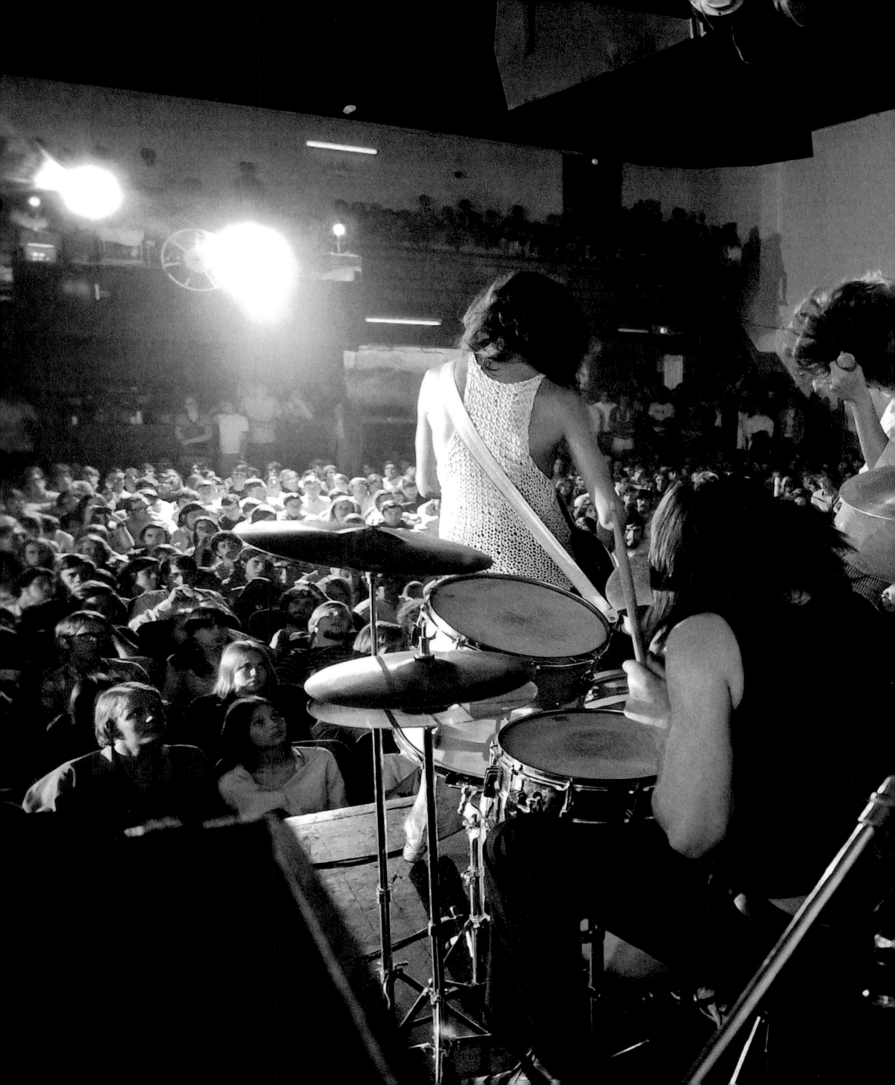

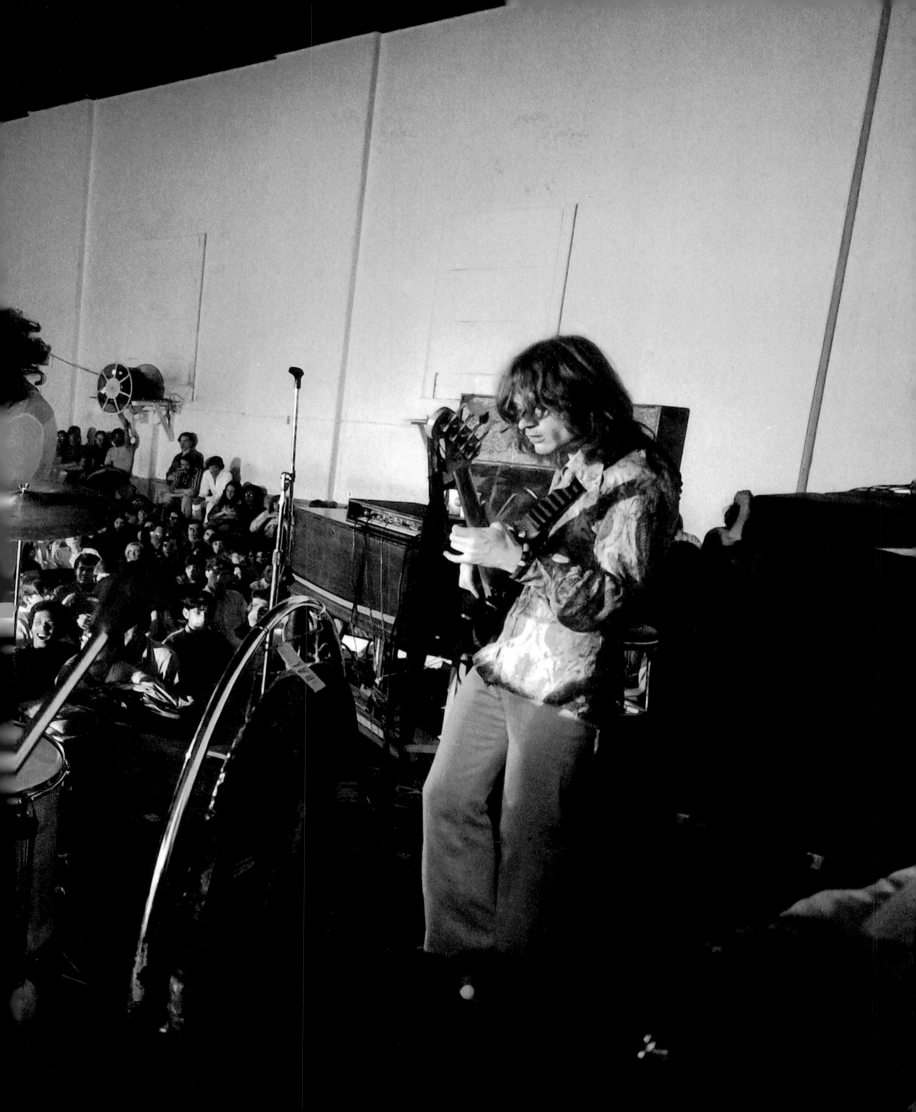

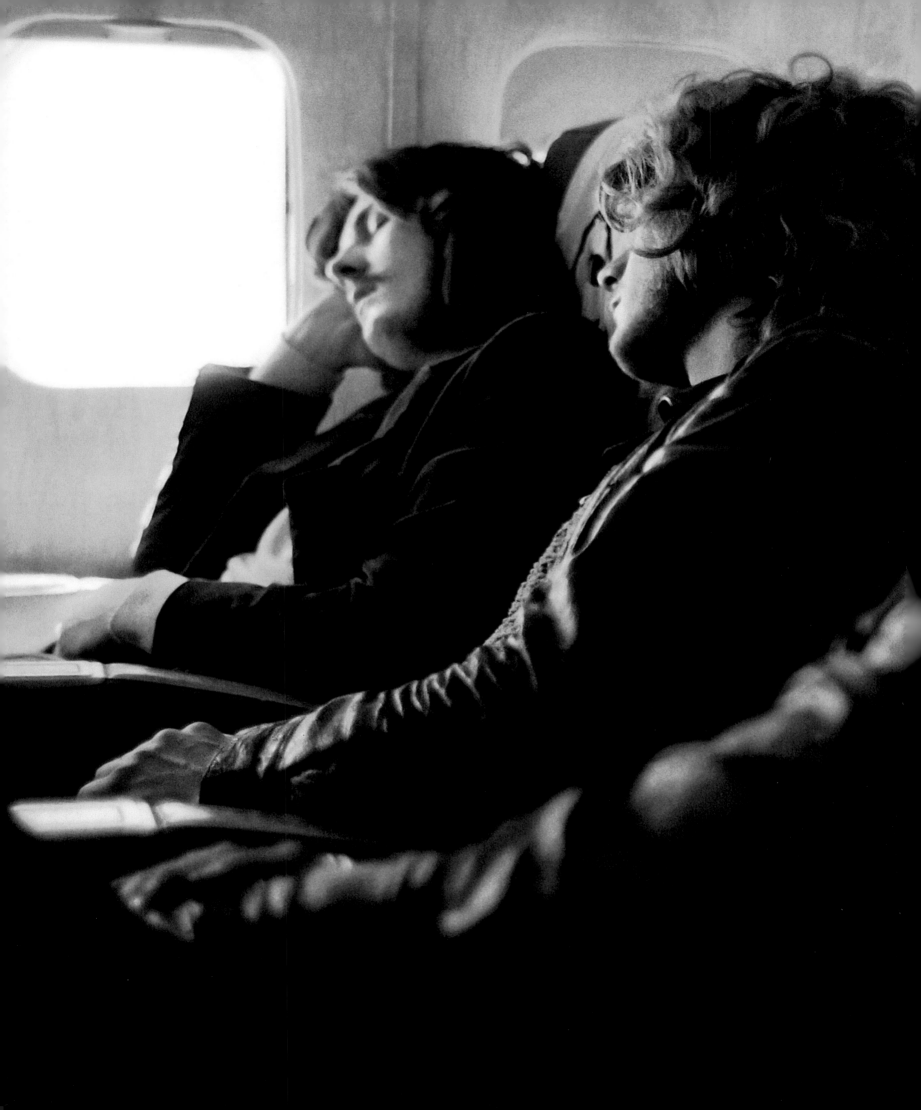

27-29 MAY 1969
Boston Tea Party,
Boston,
Massachusetts, USA
[68—69]

MAY 1969
Boston,
Massachusetts, USA
With roadie
Clive Coulson
[left]

71

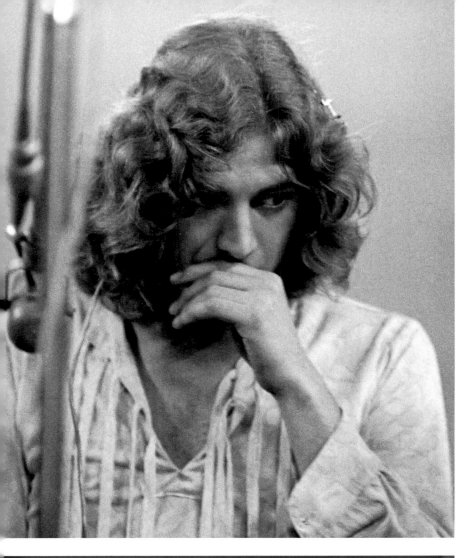
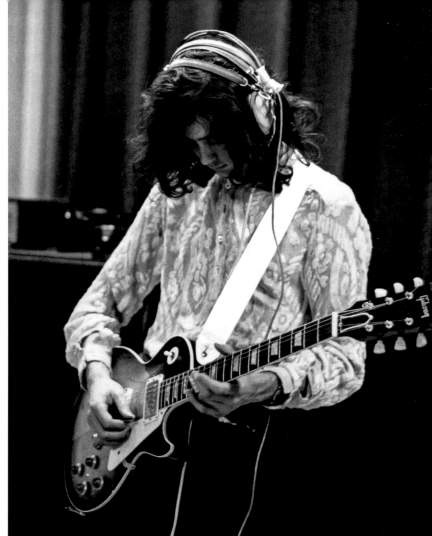
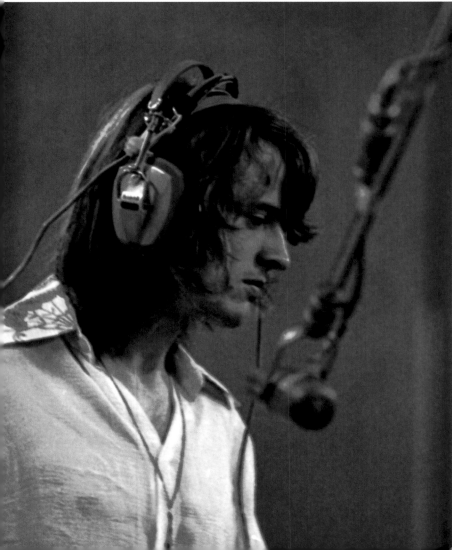
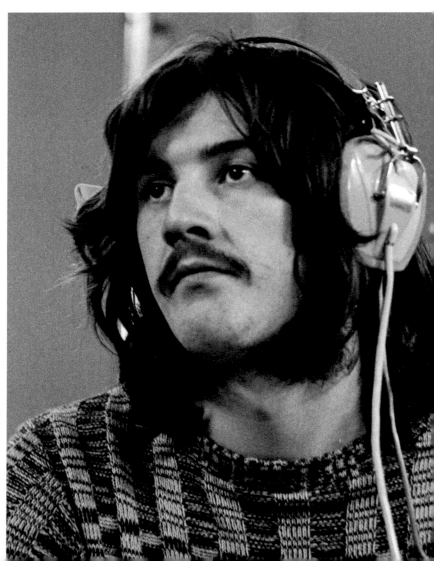

THE MAIN MENTALITY FROM SESSIONS WAS NOT TO WASTE TIME IN THE STUDIO. YOU REHEARSE IN THE REHEARSAL ROOM AND YOU RECORD IN THE STUDIO, WHICH SEEMS OBVIOUS.

JOHN PAUL JONES

APRIL / MAY 1969

A&M Studios, Los Angeles, California, USA

[left]

MAY 1969

Mystic studio, Los Angeles, California, USA

[74—75]

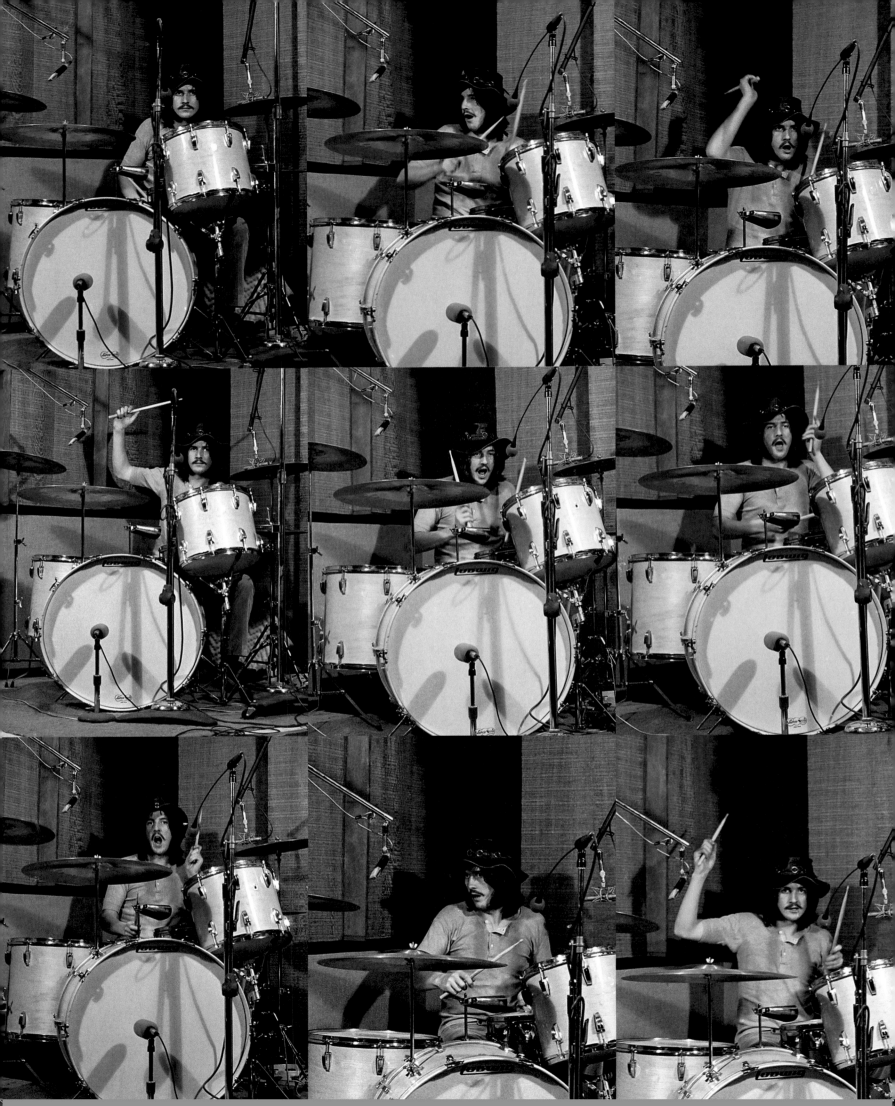

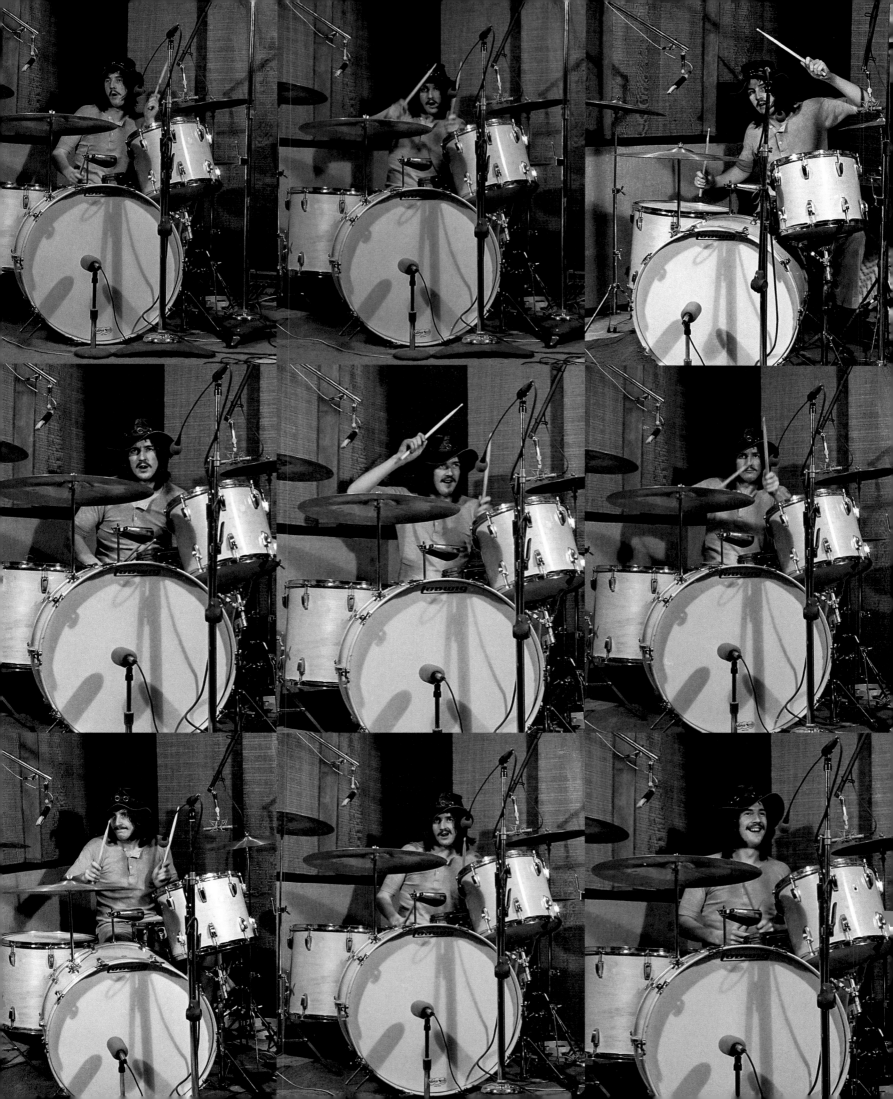

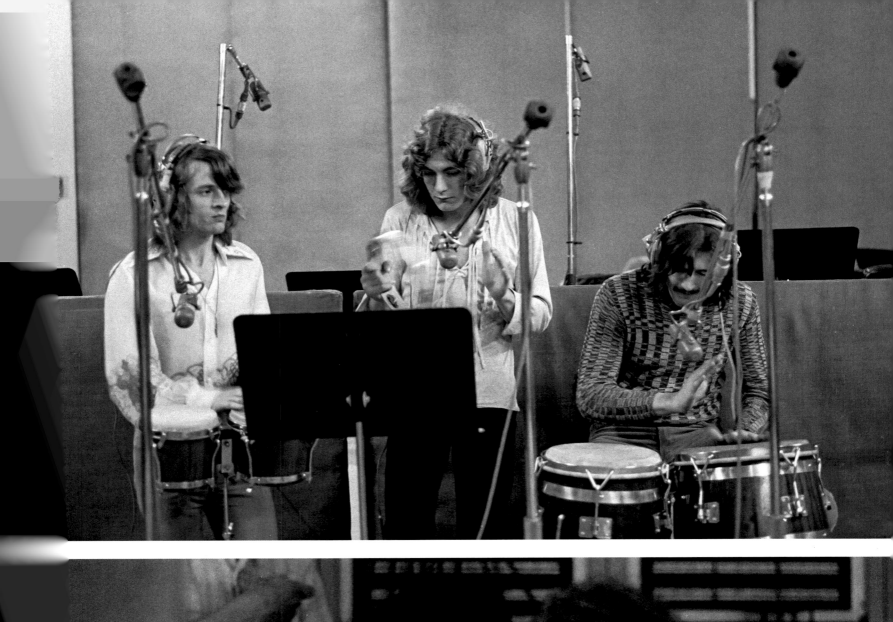
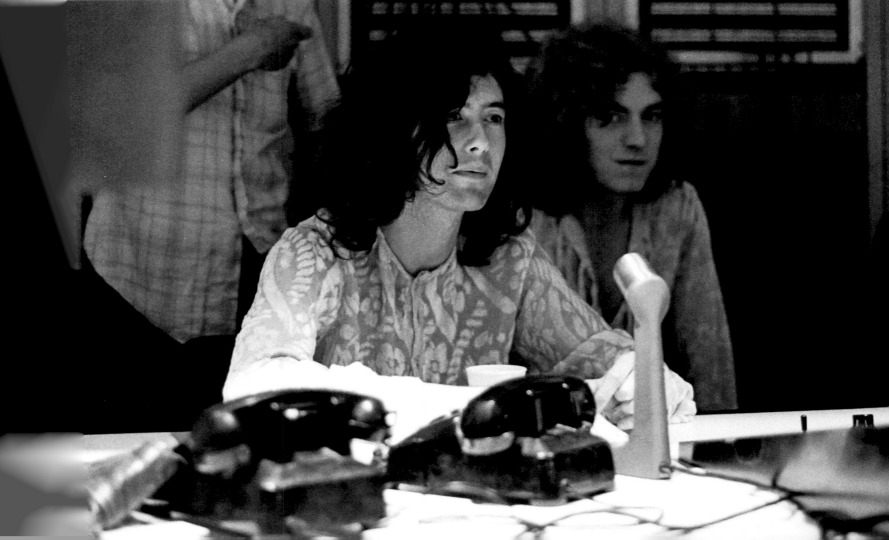

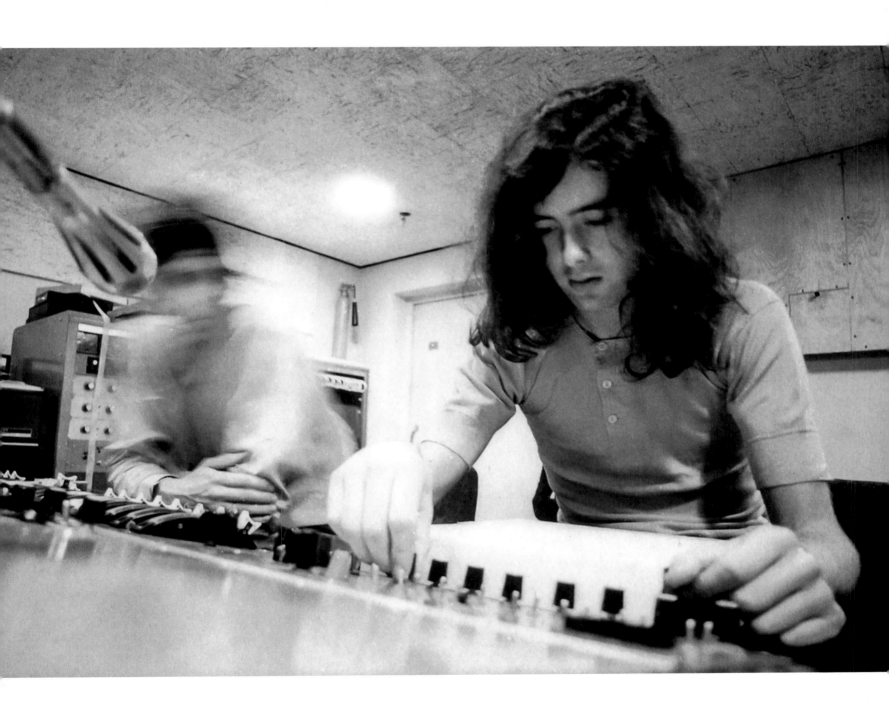

25 JUNE 1969

Morgan Studio, London, UK

[above]

APRIL / MAY 1969

A&M Studios, Los Angeles, California, USA

[left]

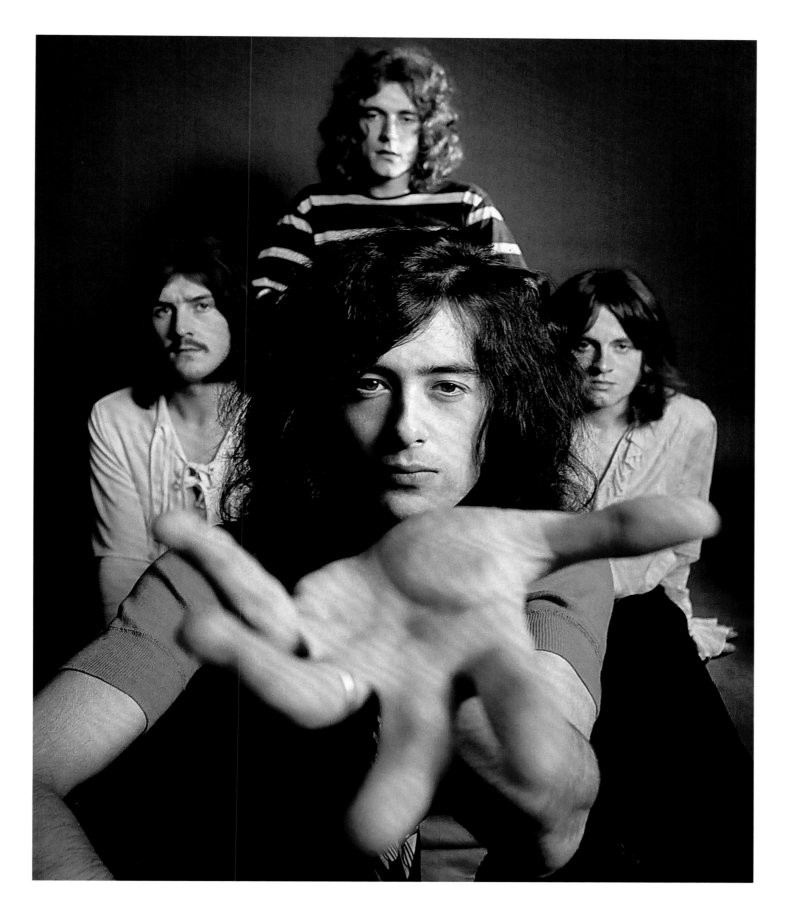

MAY 1969

Los Angeles, California, USA

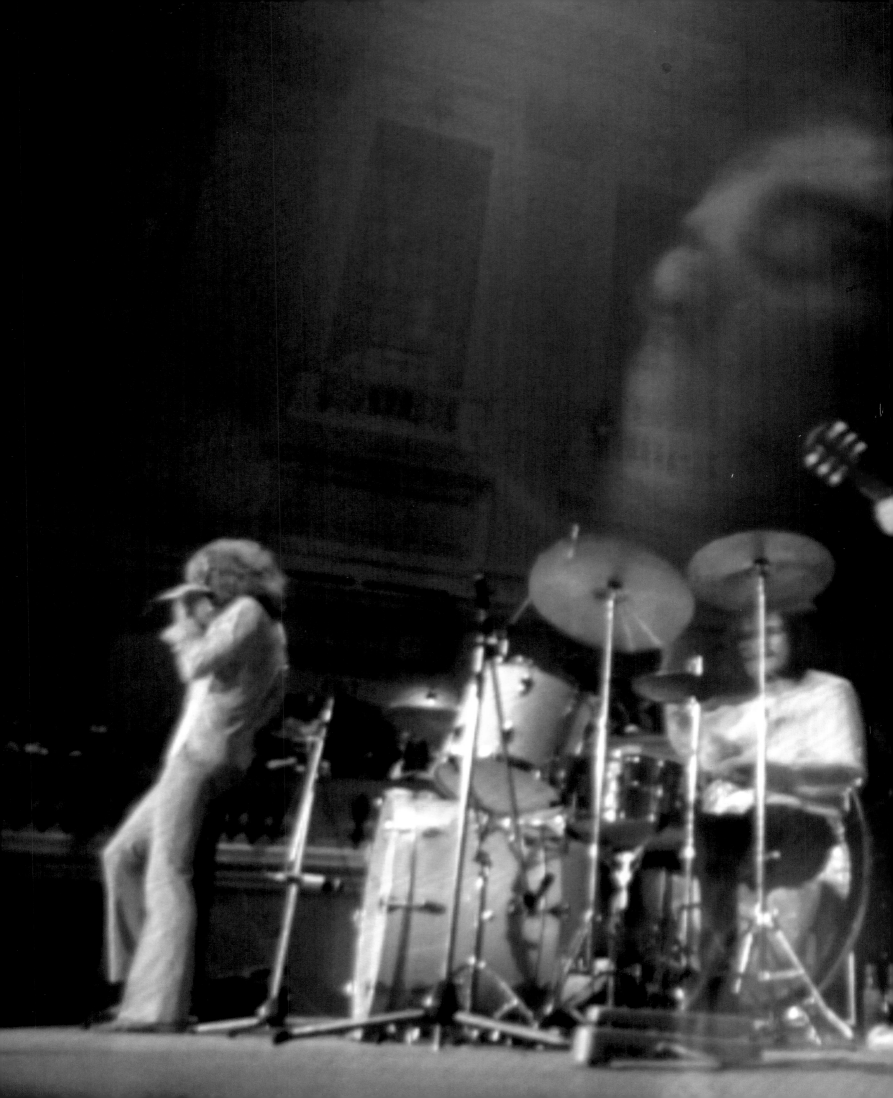

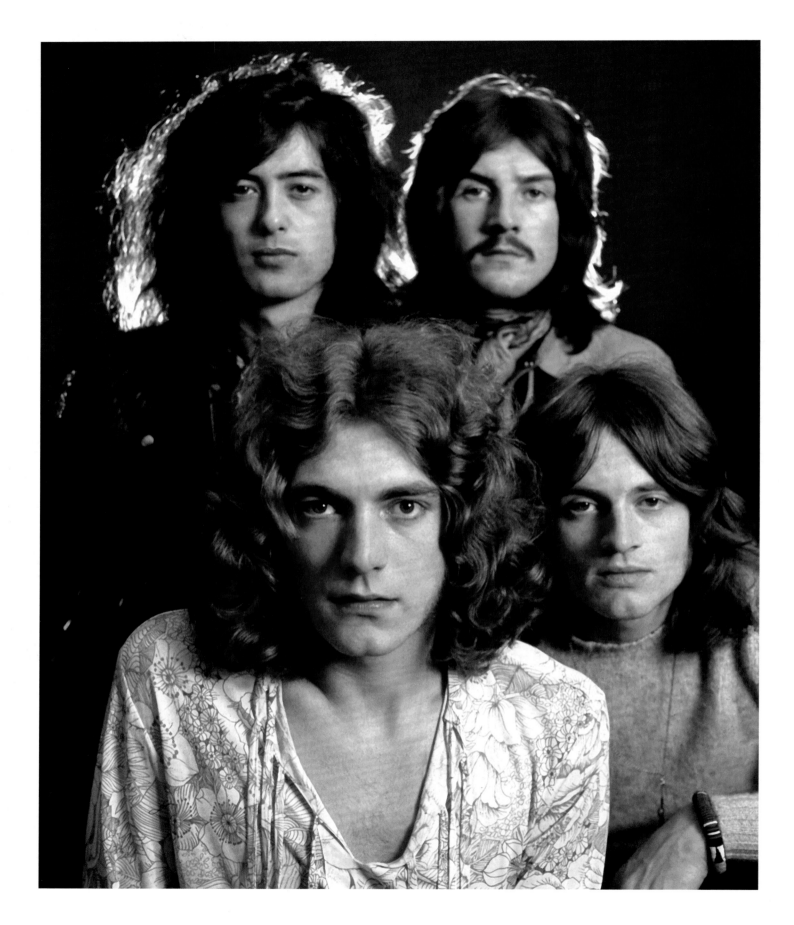

MAY 1969

Los Angeles, California, USA

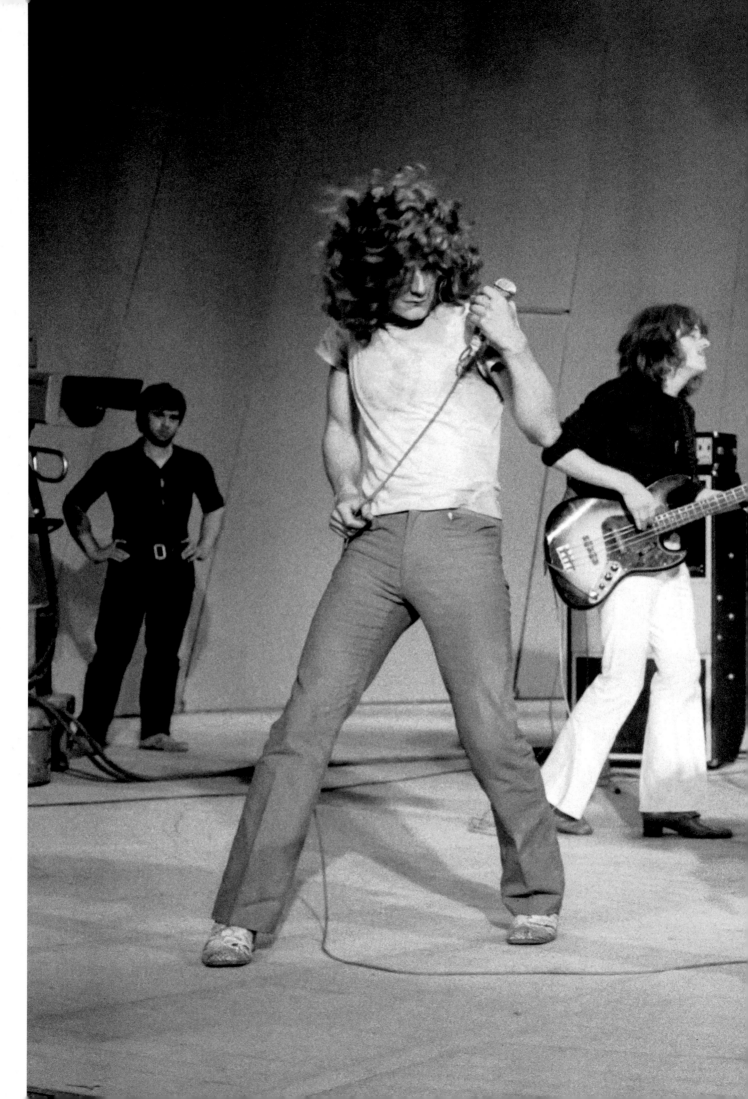

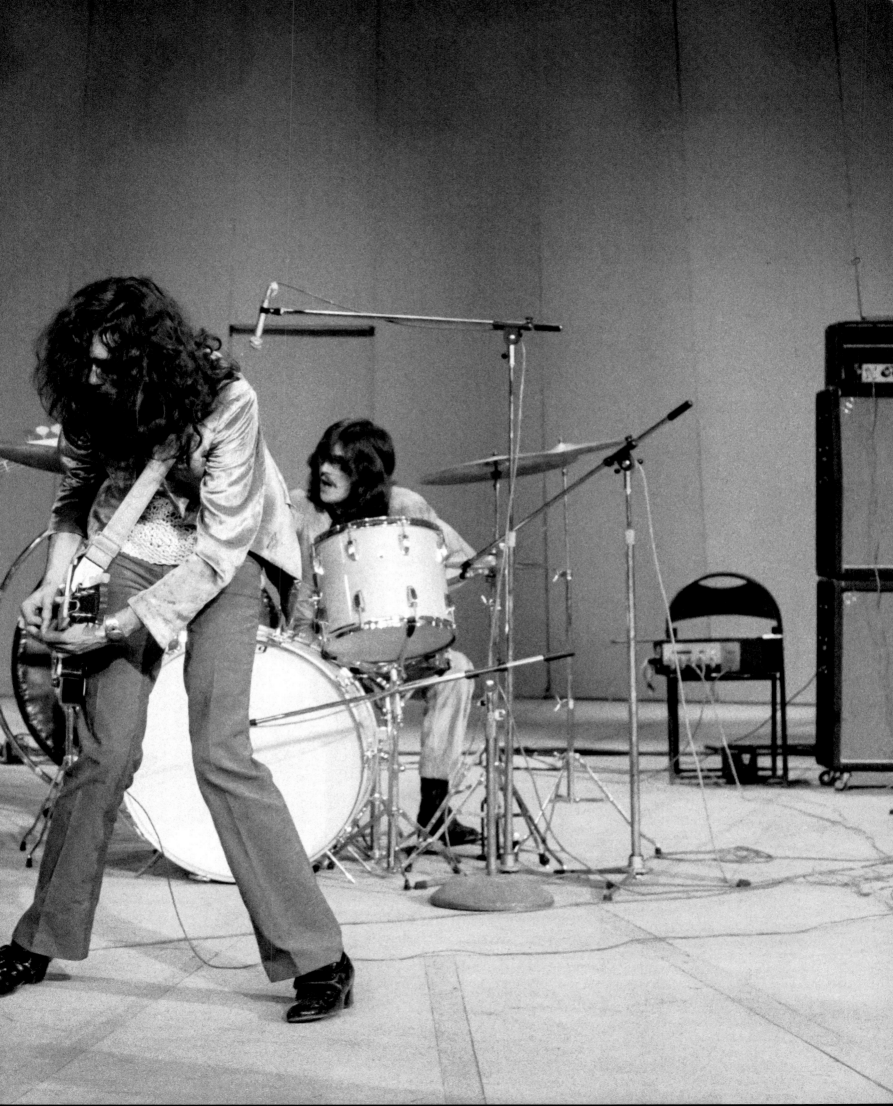

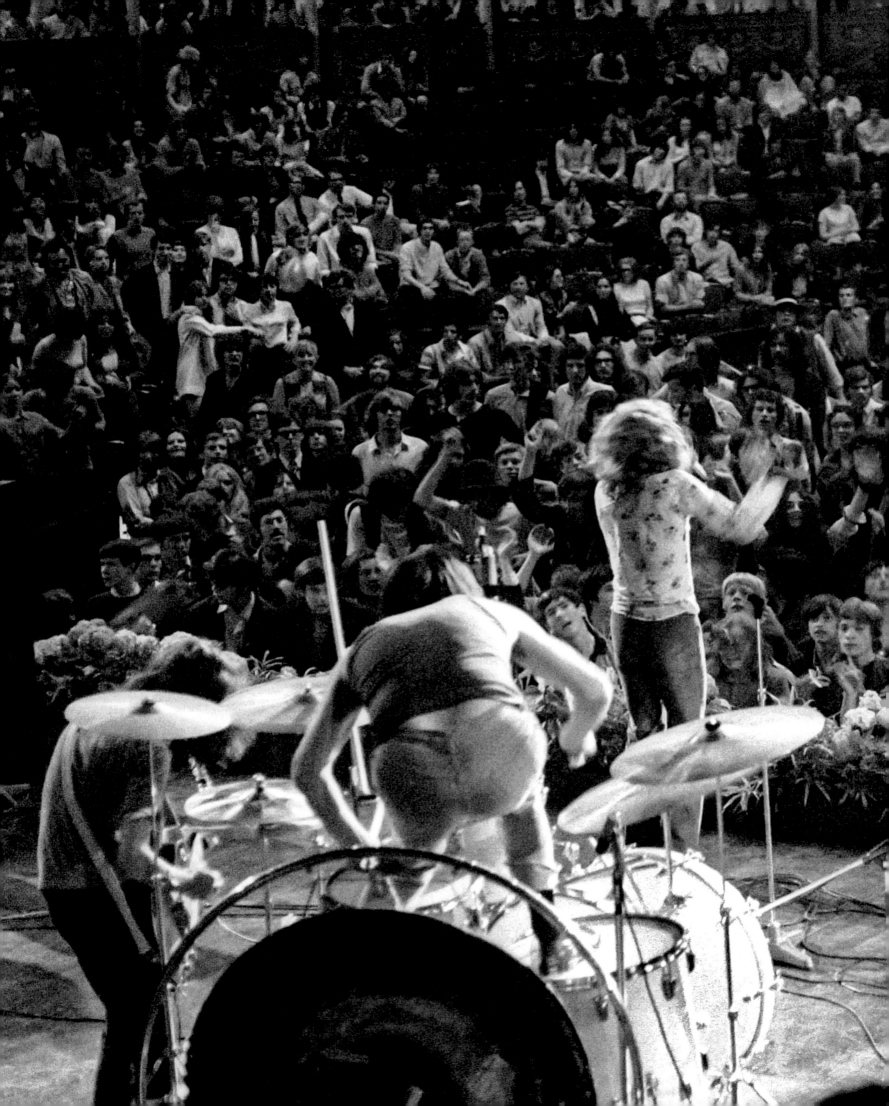

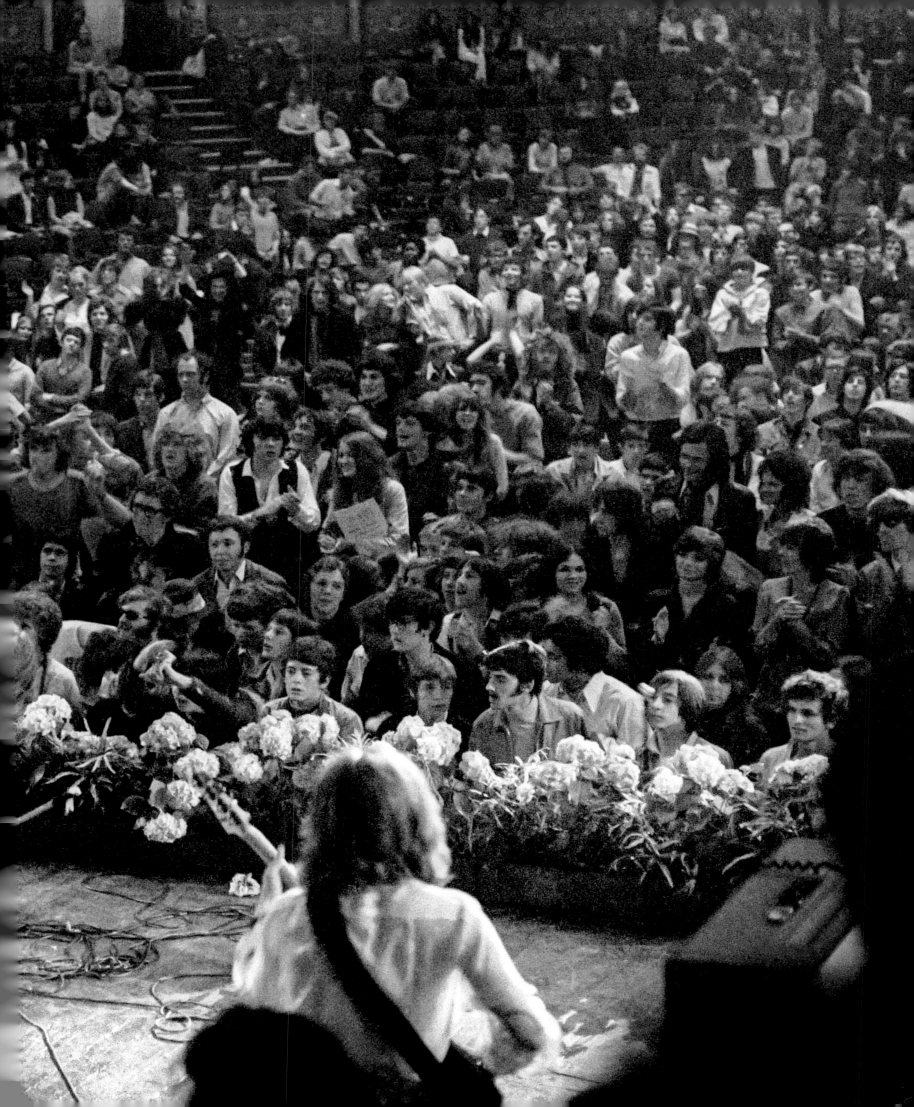

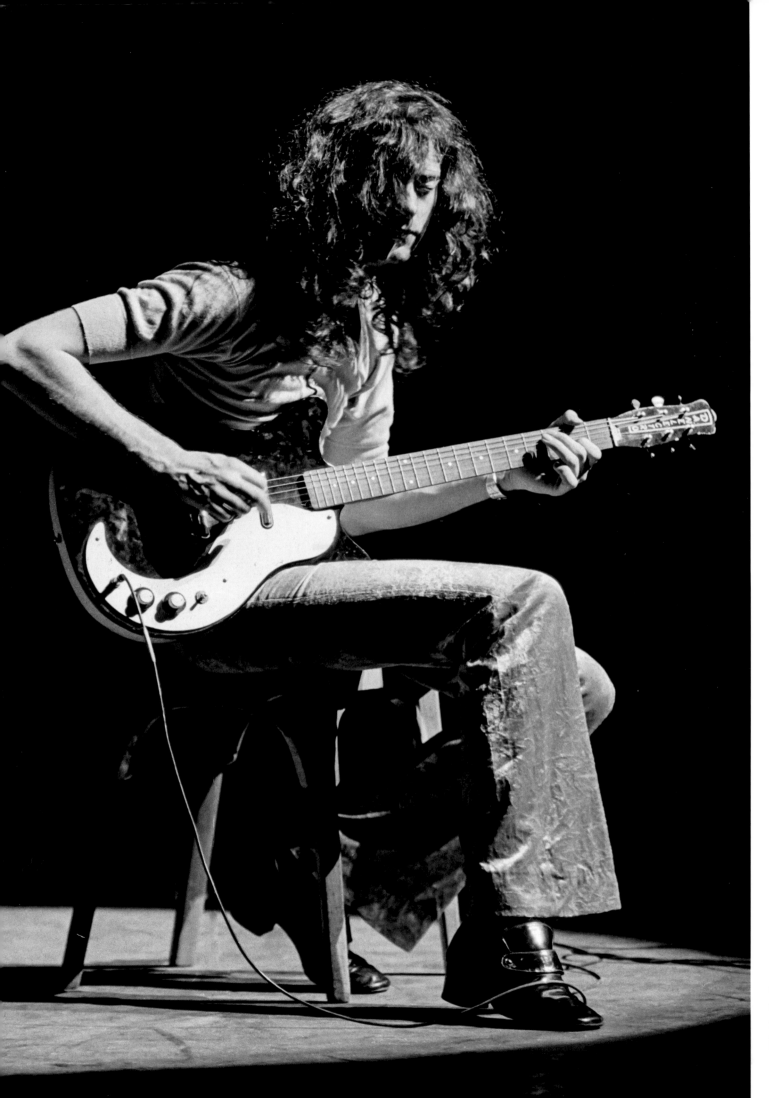

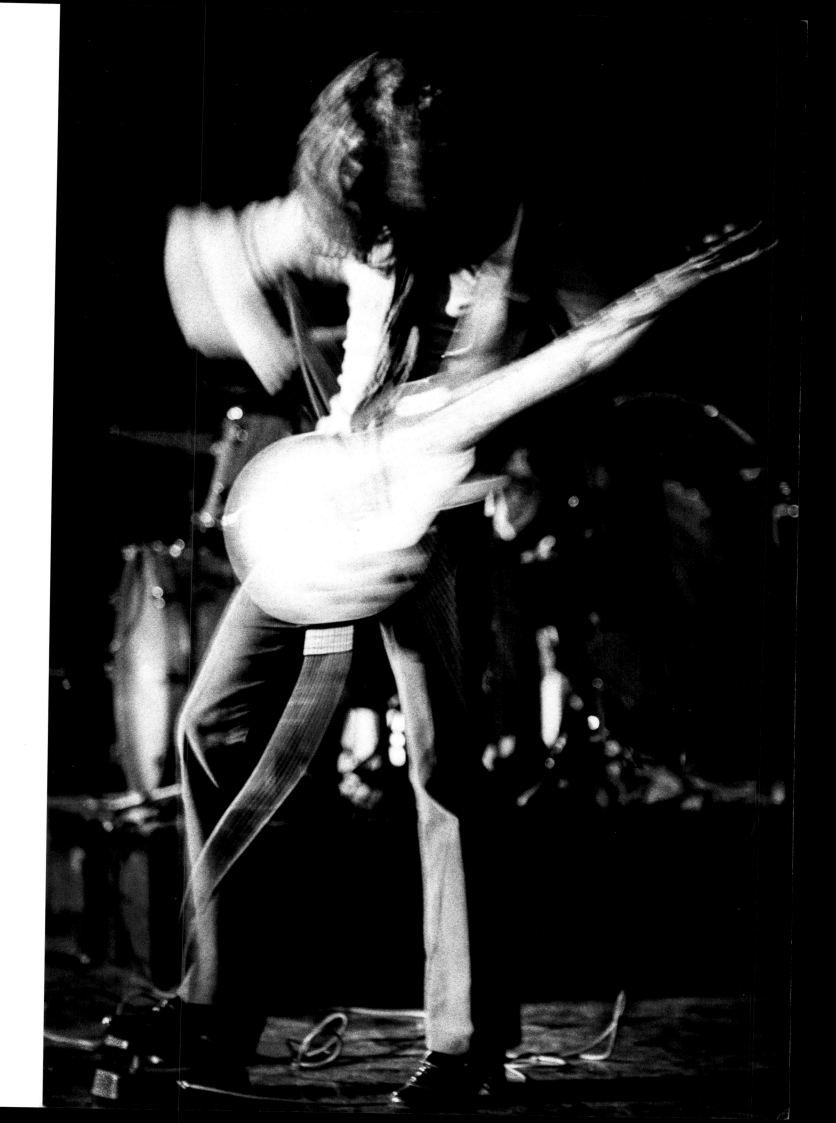

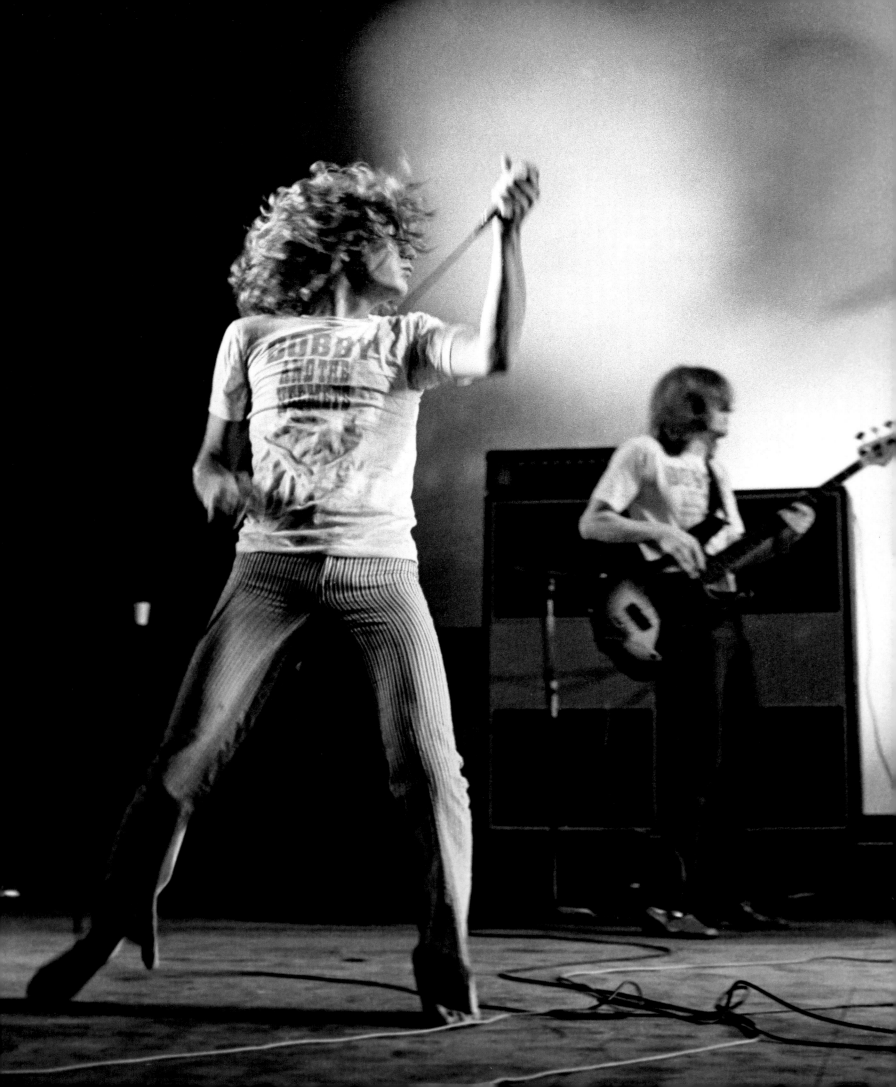

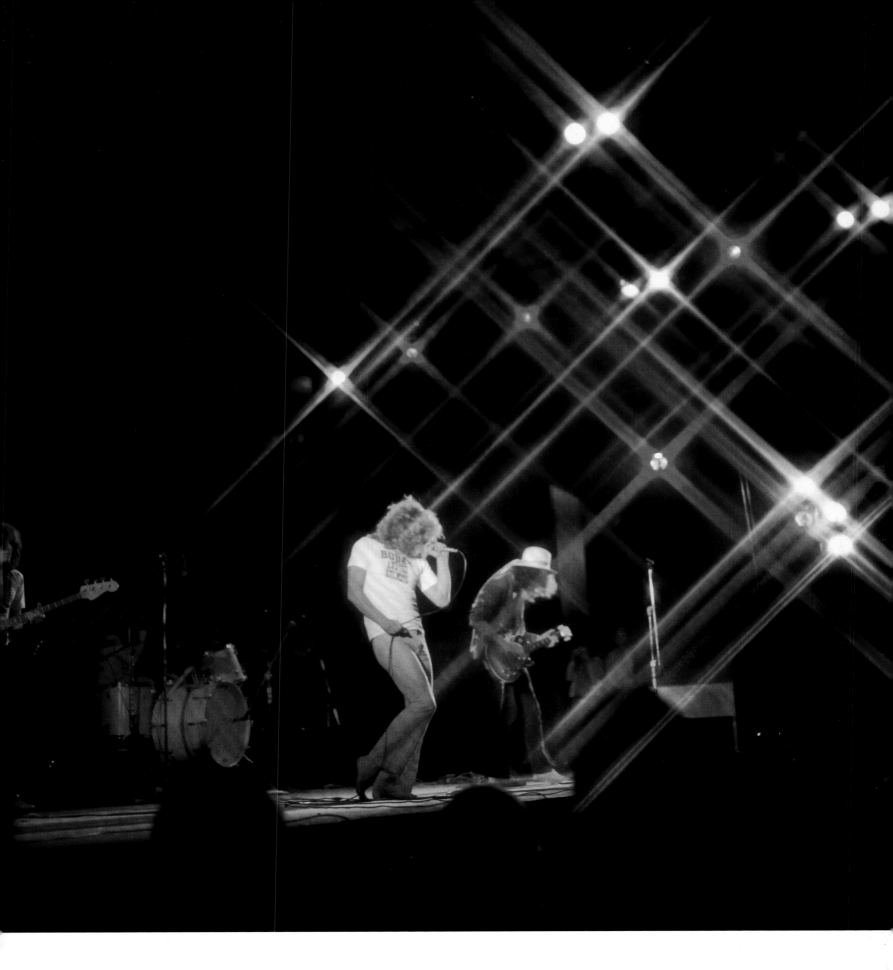

6 JULY 1969

Newport Jazz Festival, Newport, Rhode Island, USA

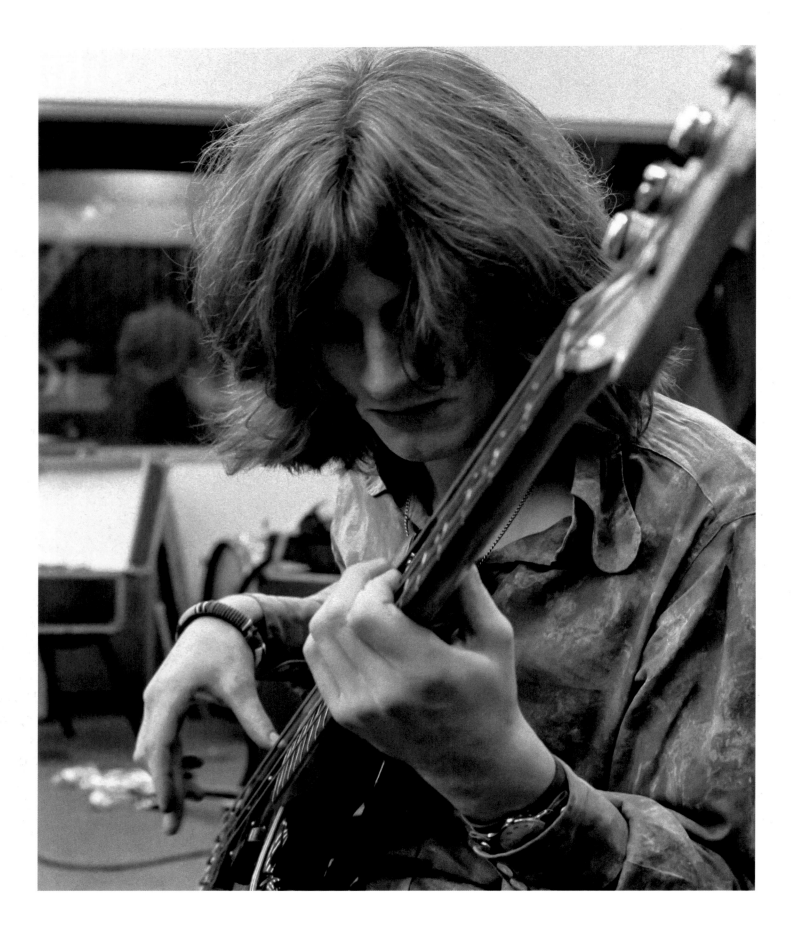

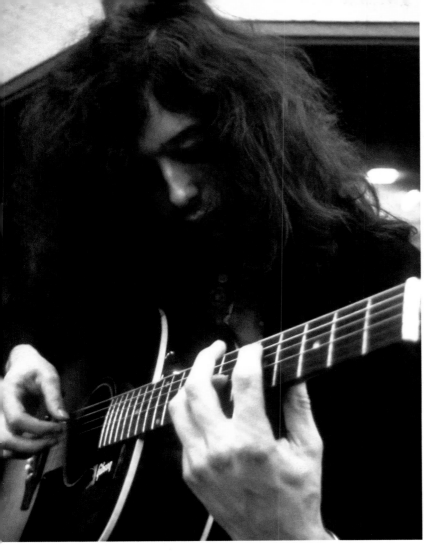
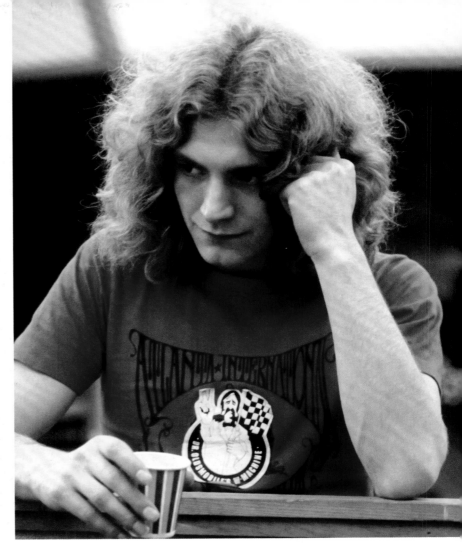
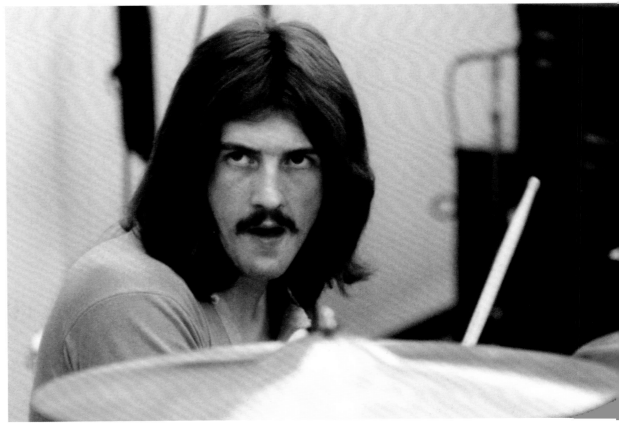

AUGUST 1969
A&R Studios, New York, New York, USA

QUITE OFTEN I FEEL THAT WORDS AND VOICE GET IN THE WAY OF WHAT'S REALLY GOING ON, I ALMOST HAVE TO ARRIVE AT A DIAGONAL TO CONTRIBUTE TO THE MUSIC.

10 OCTOBER 1969

L'Olympia, Paris, France

[97—101]

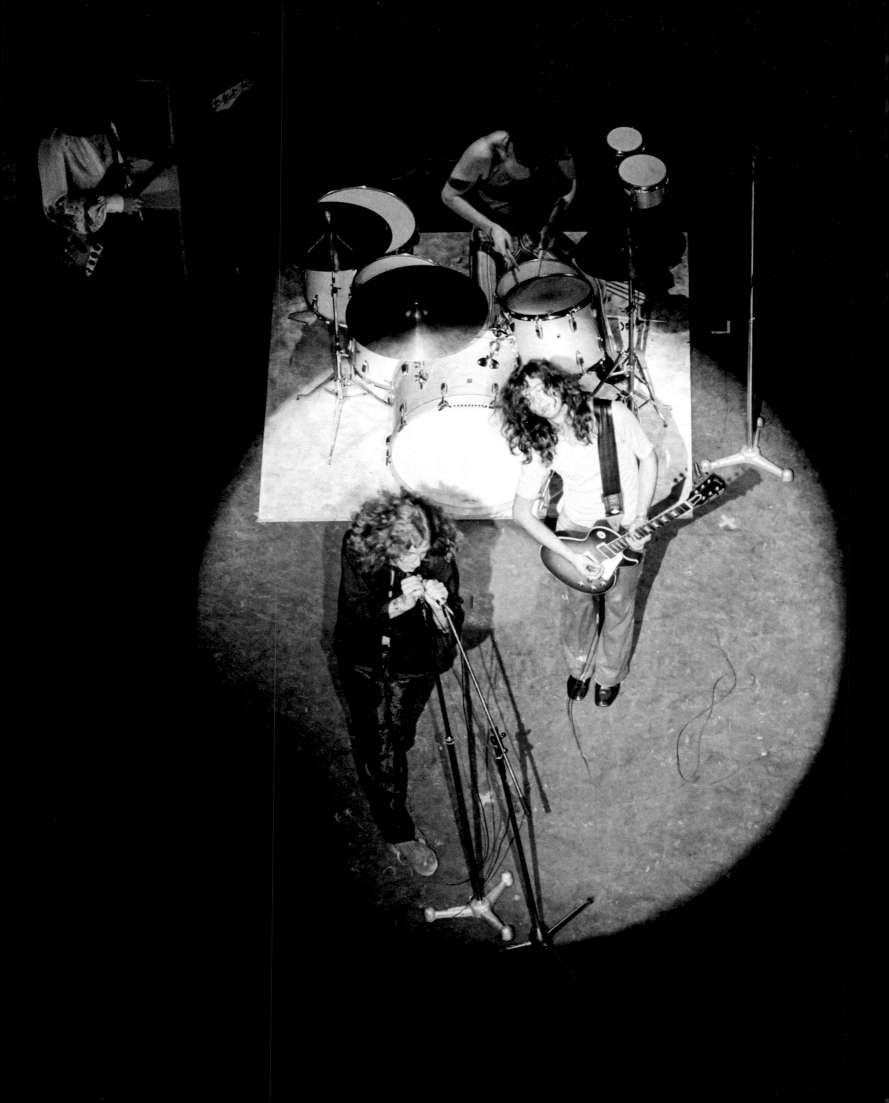

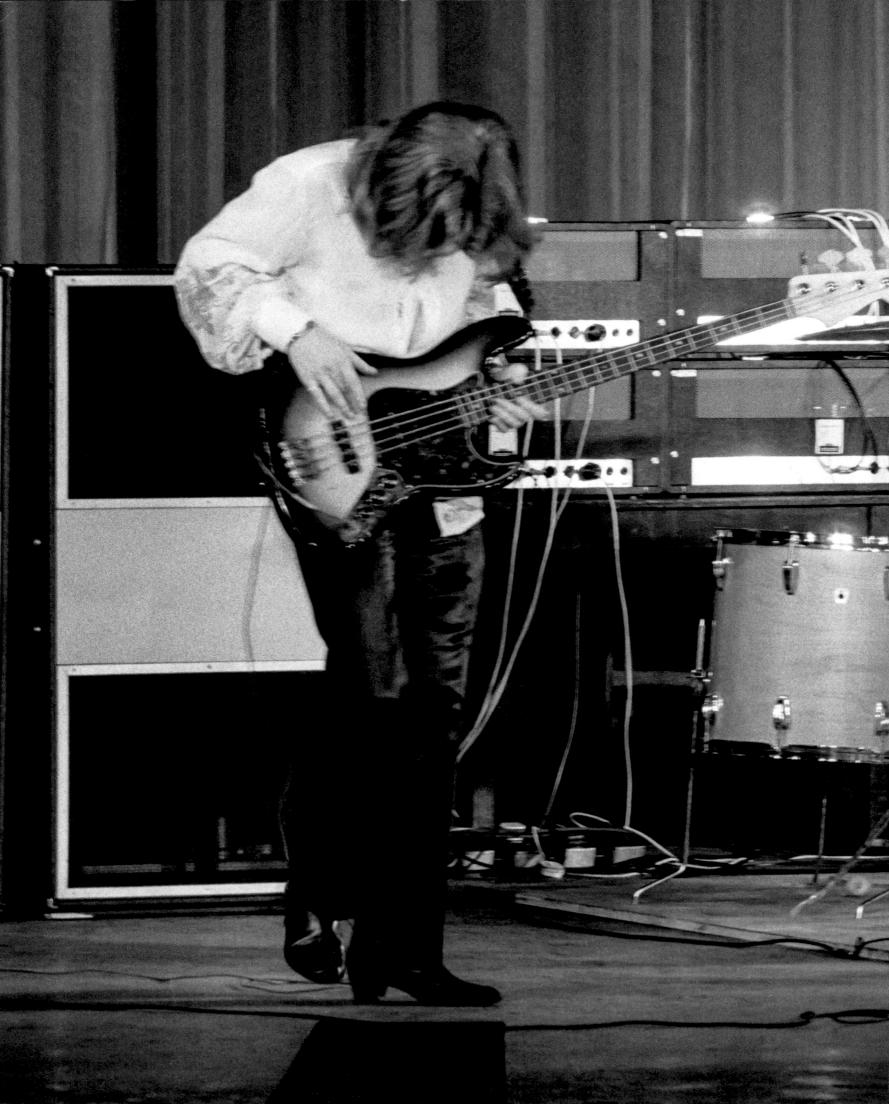

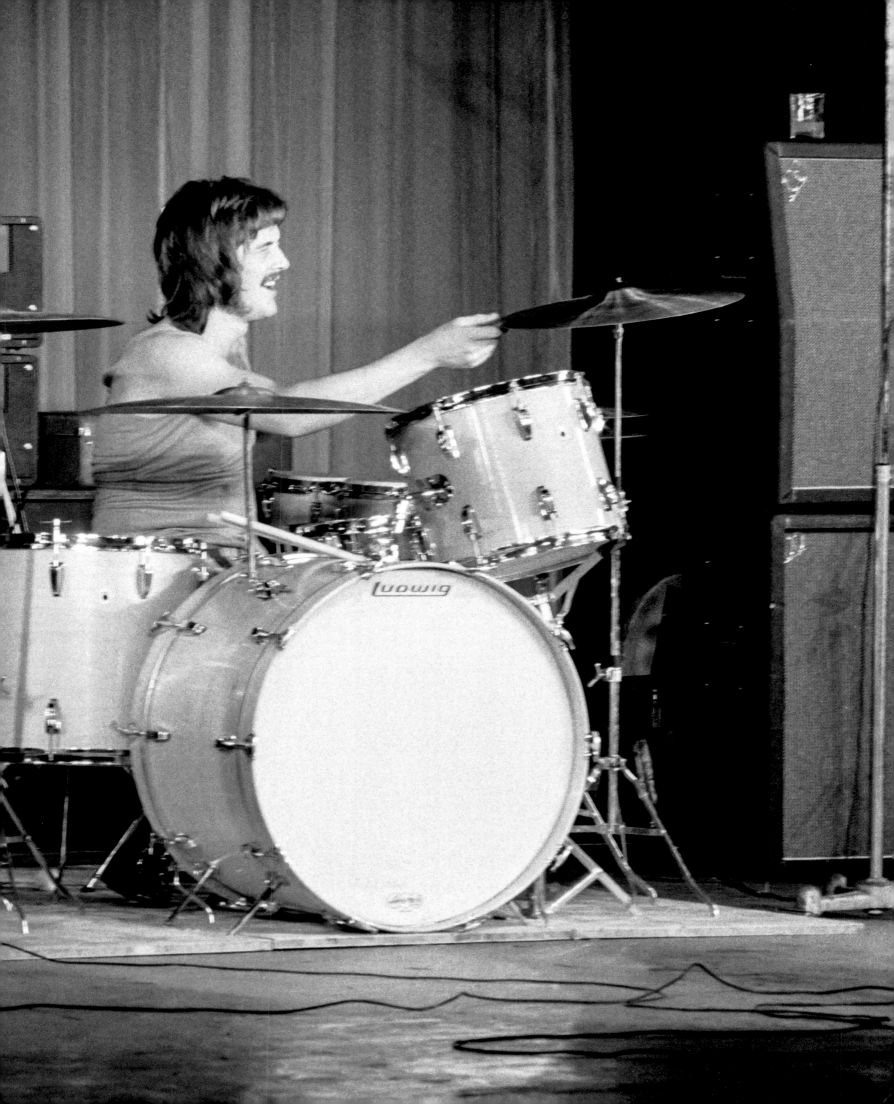

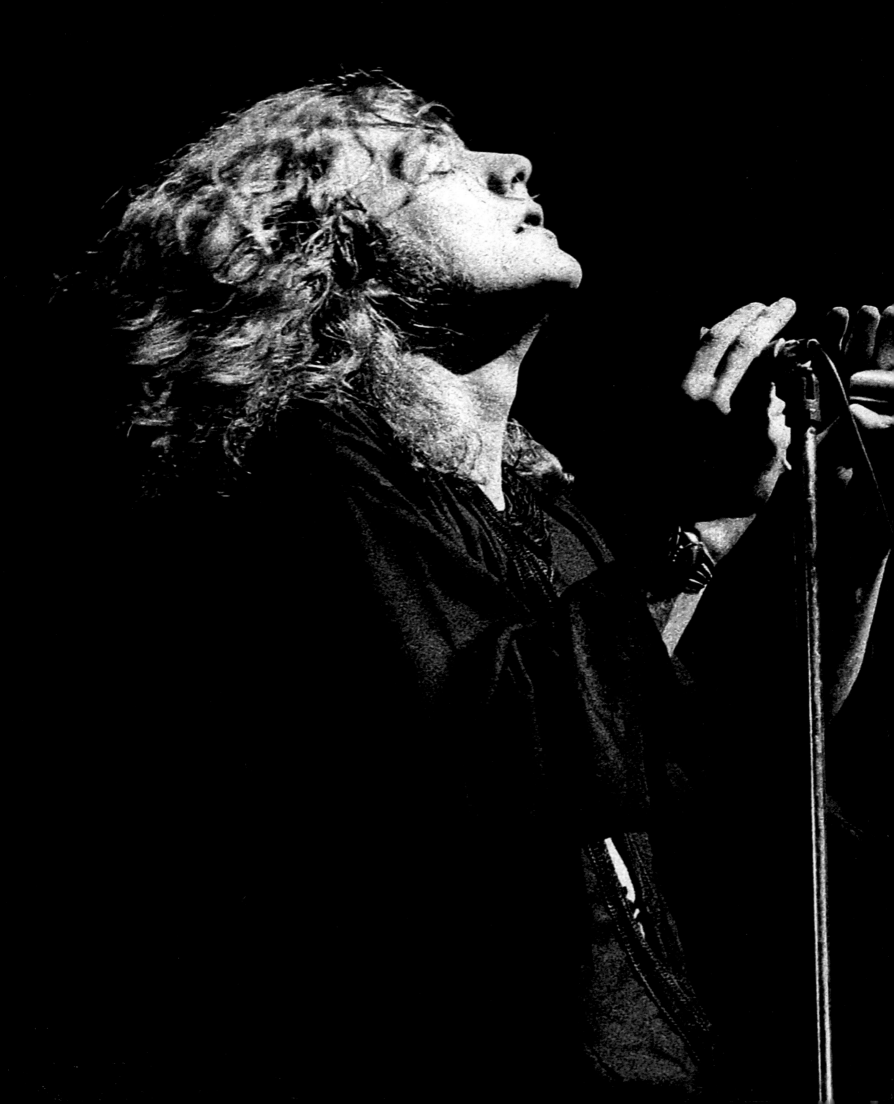

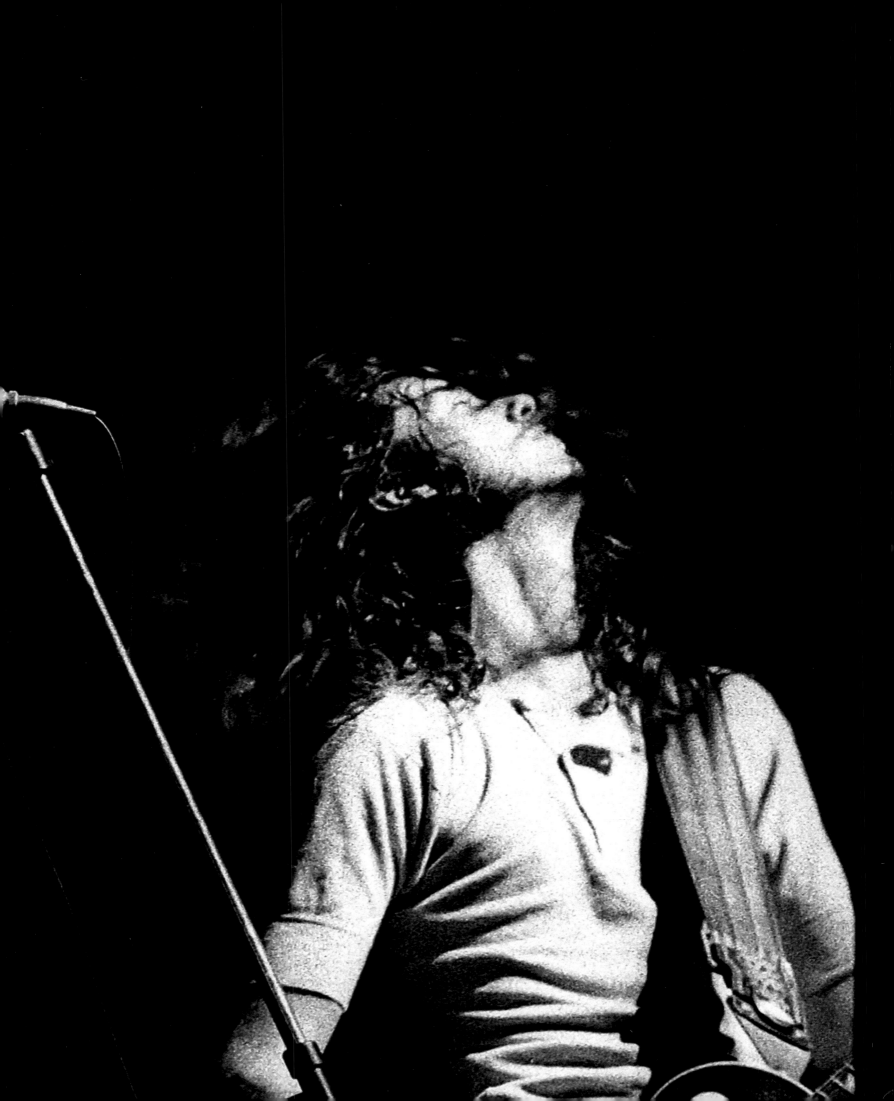

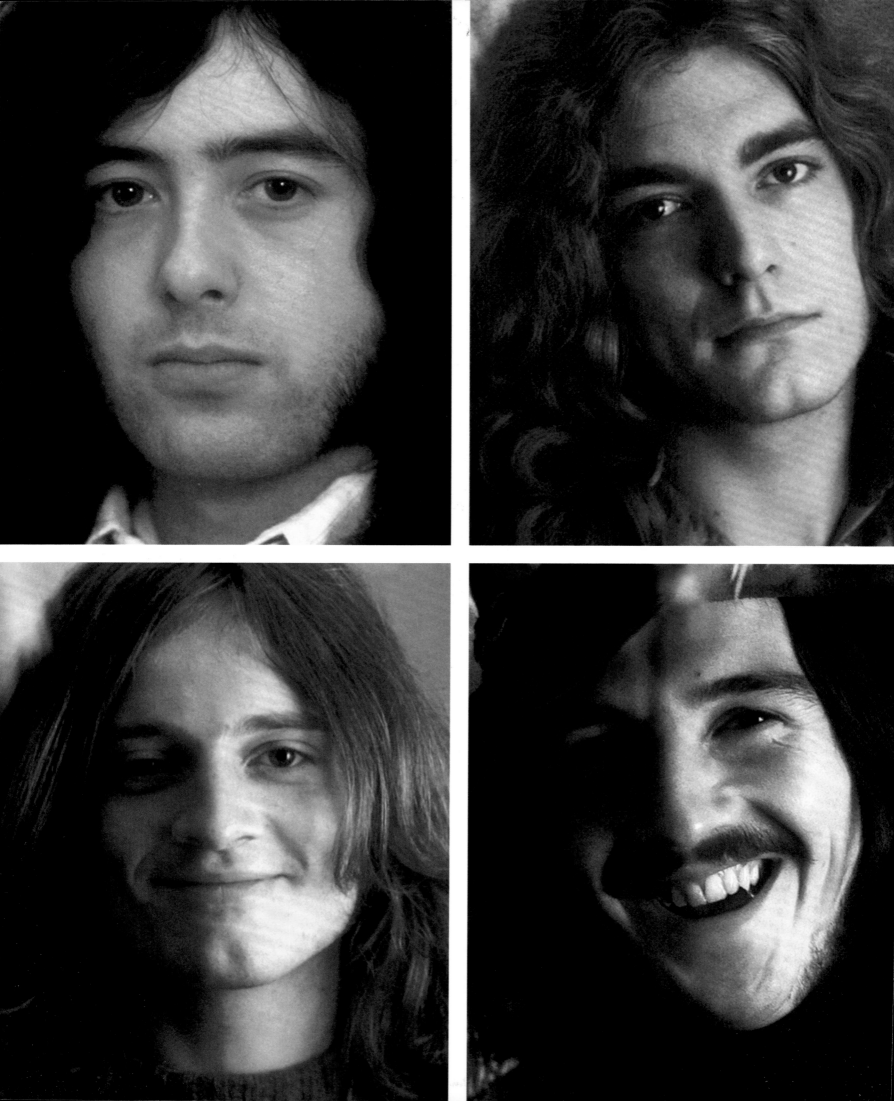

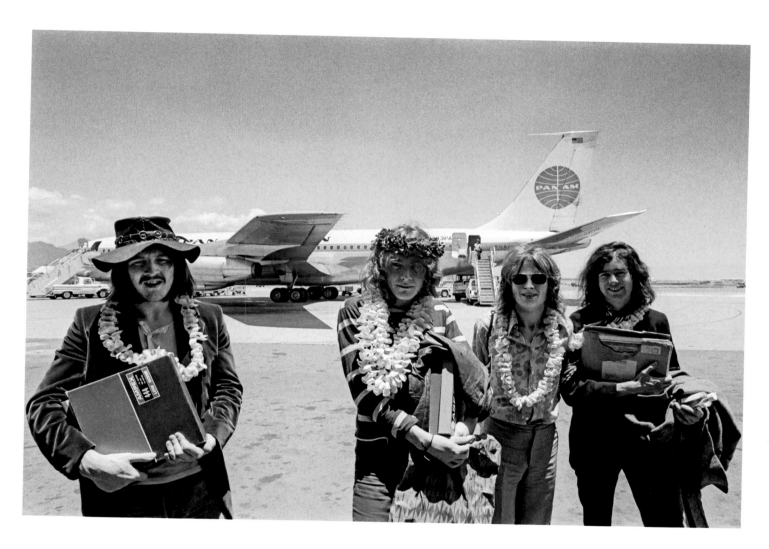

12 MAY 1969

Honolulu, Hawaii, USA

[above]

OCTOBER 1969

New York, New York, USA

[left]

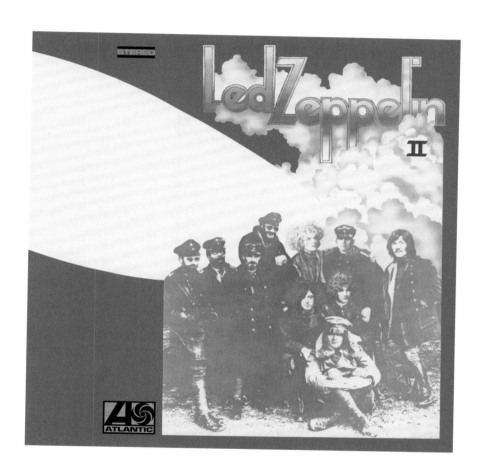

LED ZEPPELIN II

22 October 1969

NINETEEN SEVENTY

—

SEVENTY THREE

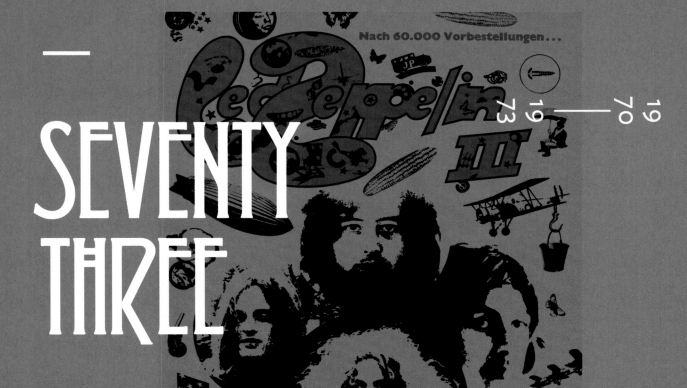

19
73 — 19
70 — 19
70

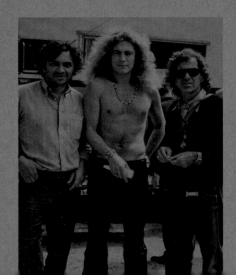

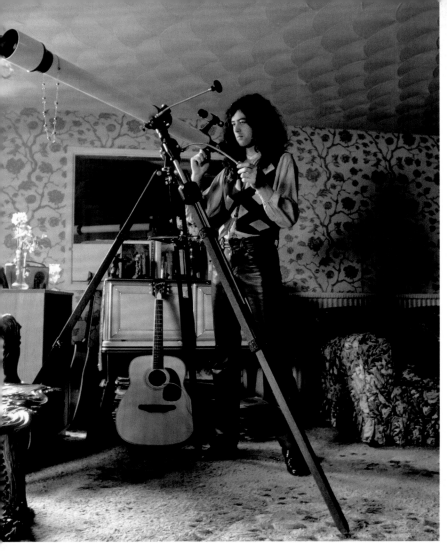

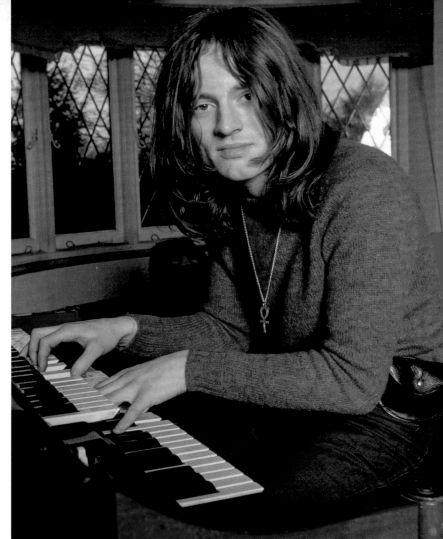

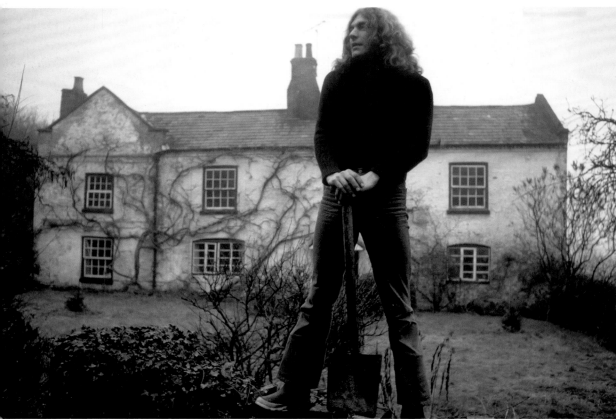

JANUARY 1970

Led Zeppelin at their homes, UK

[108—111]

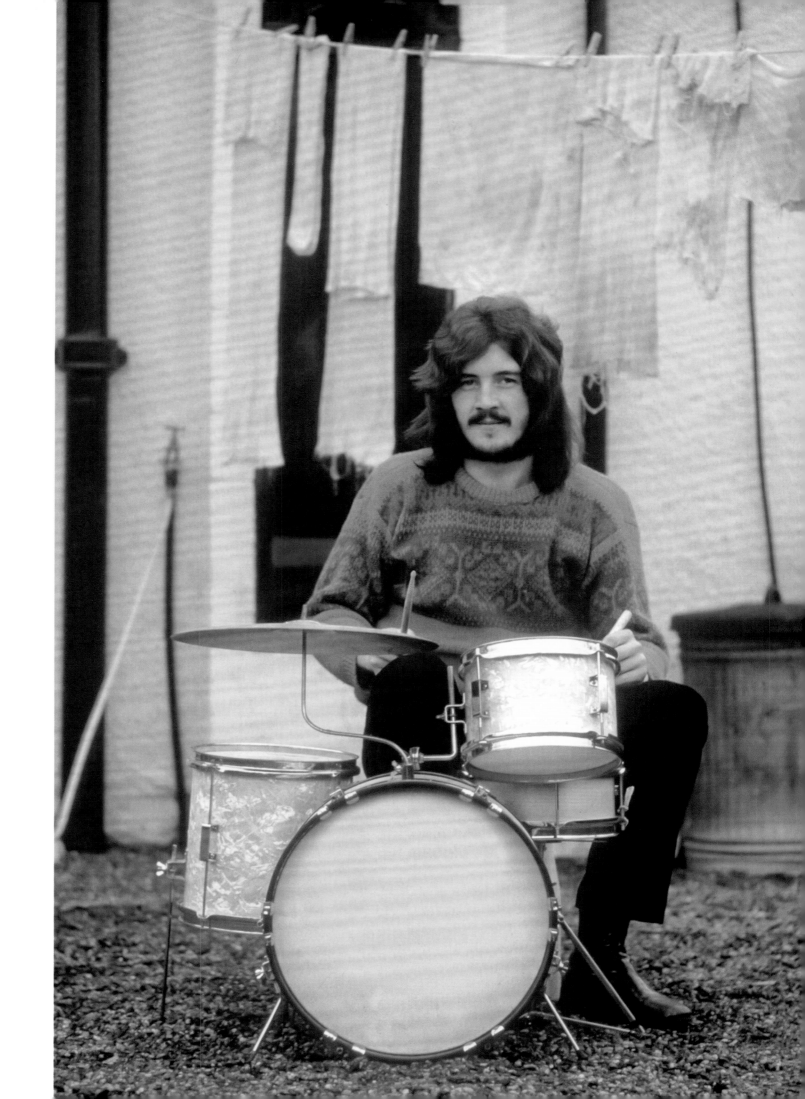

THE RIVERSIDE LOUNGE
AT PANGBOURNE, WHERE
'WHOLE LOTTA LOVE' AND
'WHAT IS AND SHOULD NEVER BE'
WERE ROUTINED. THERE WAS A
PARTICULAR ENERGY ABOUT THAT
HOUSE AND I WAS QUITE A CATALYST
FOR EVERYTHING THAT WENT ON.

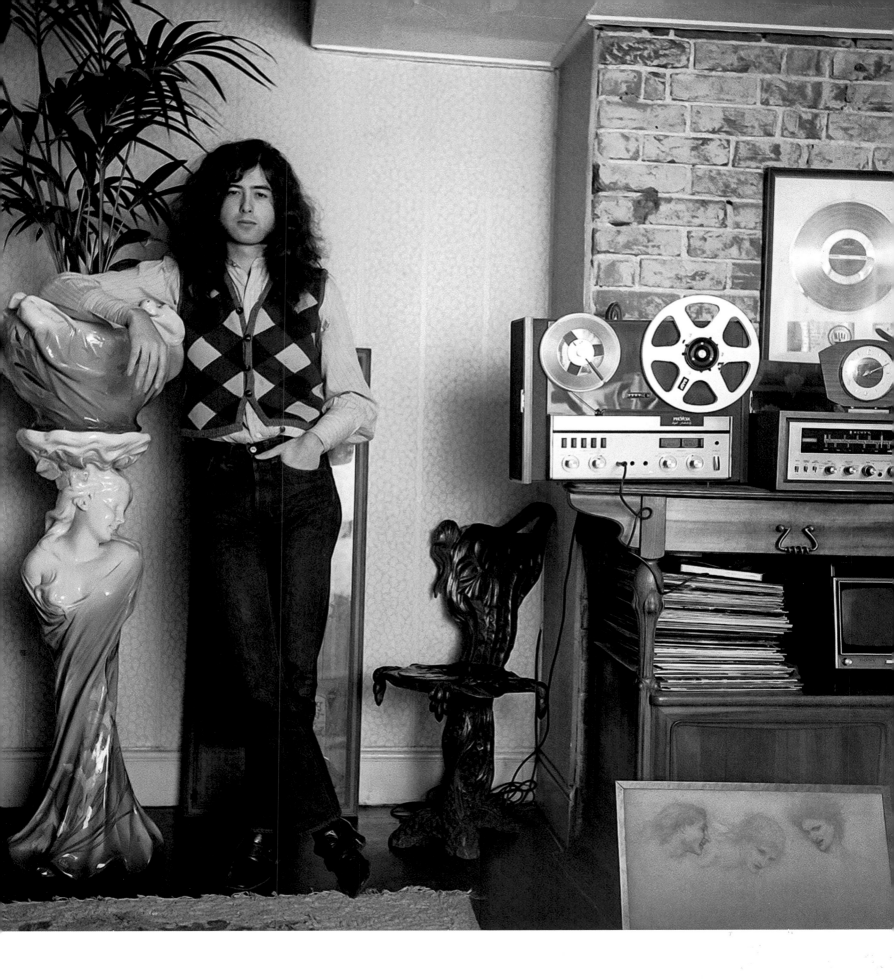

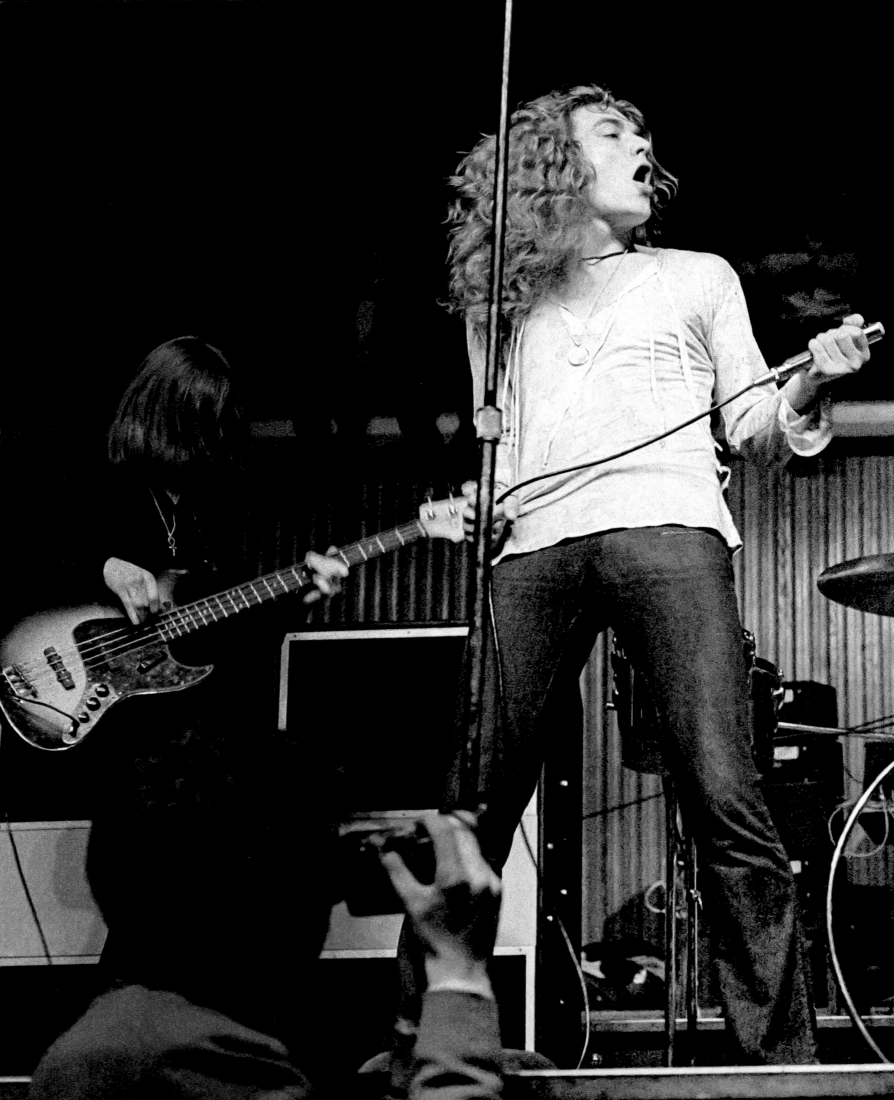

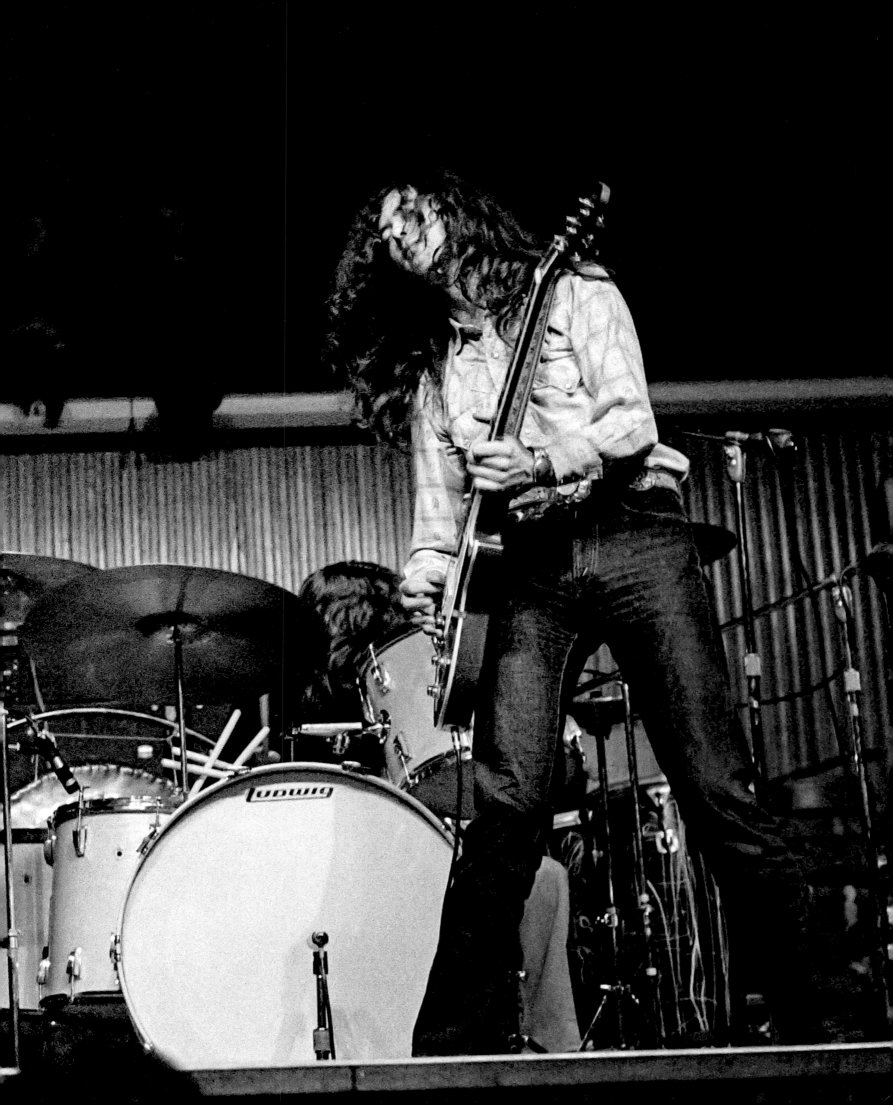

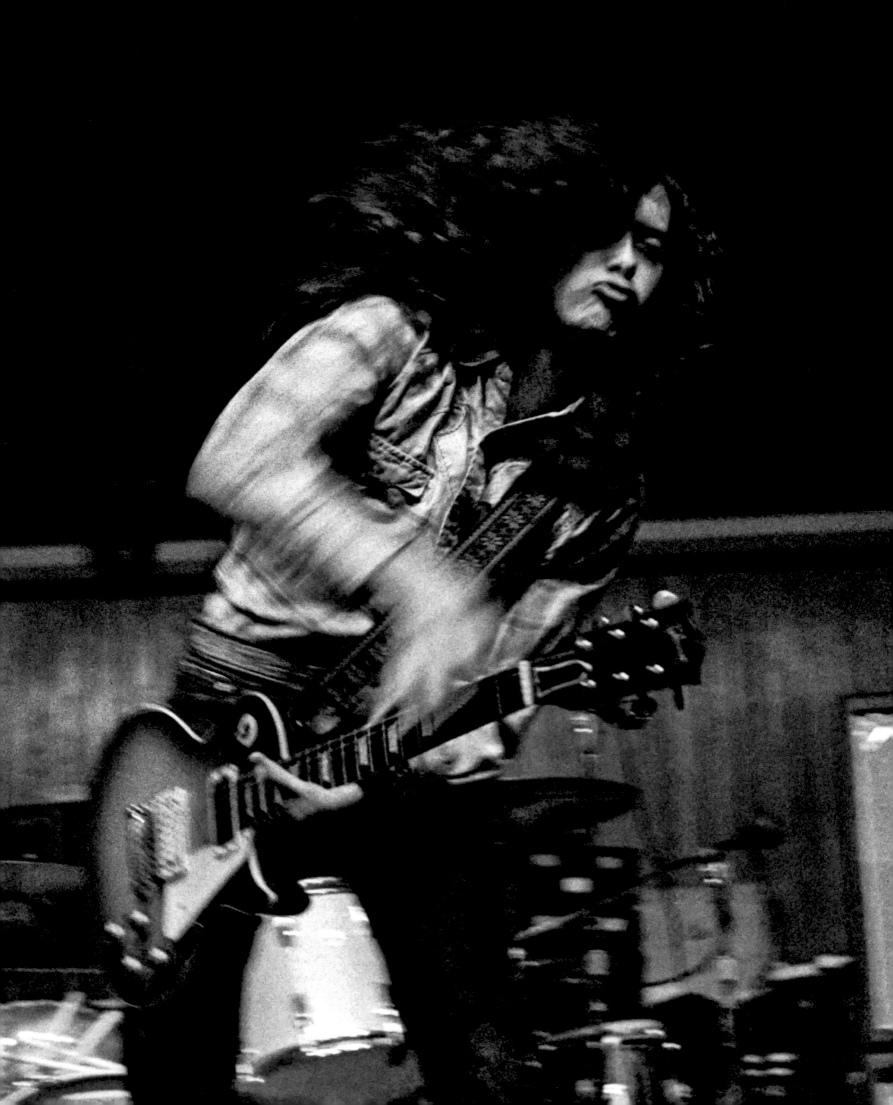

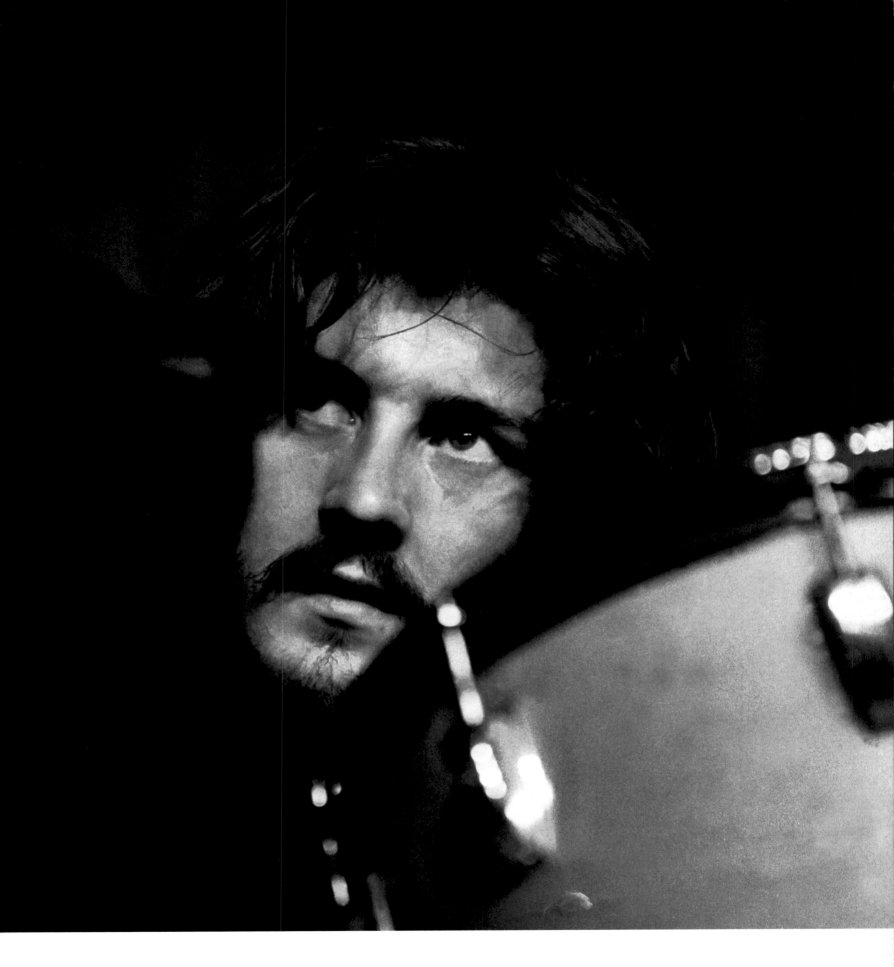

28 FEBRUARY 1970

K.B. Hallen, Copenhagen, Denmark

[112—115]

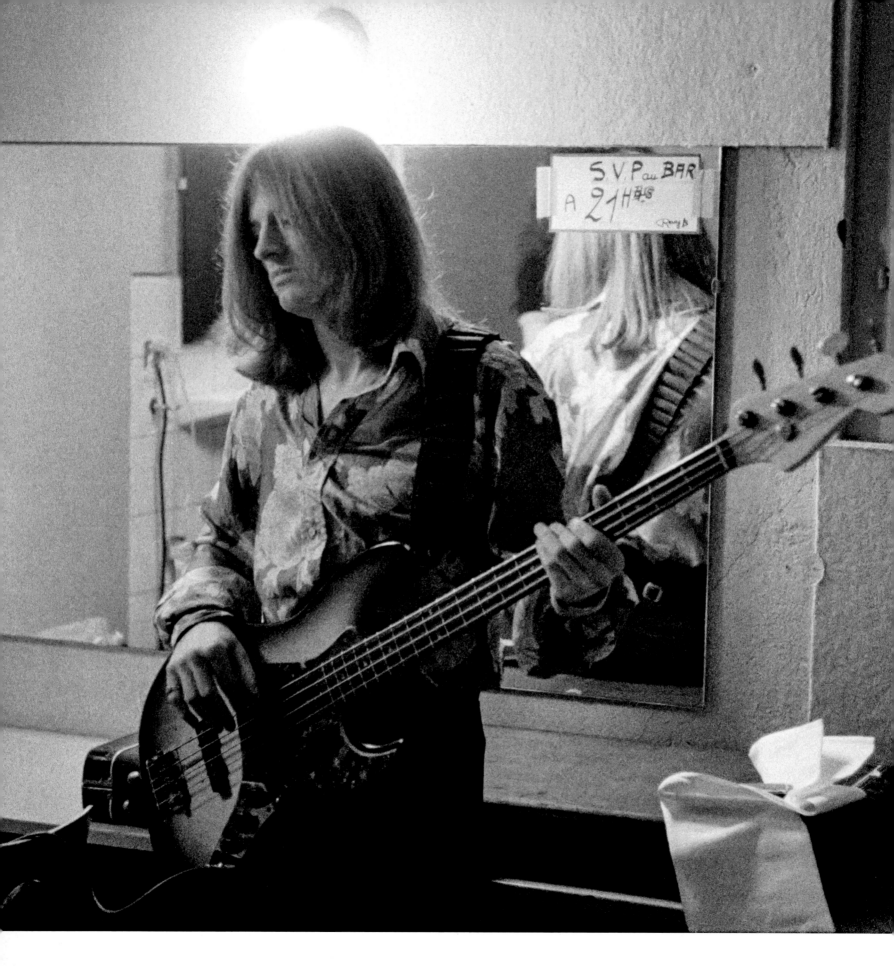

7 MARCH 1970

Montreux Casino, Montreux, Switzerland

[116—119]

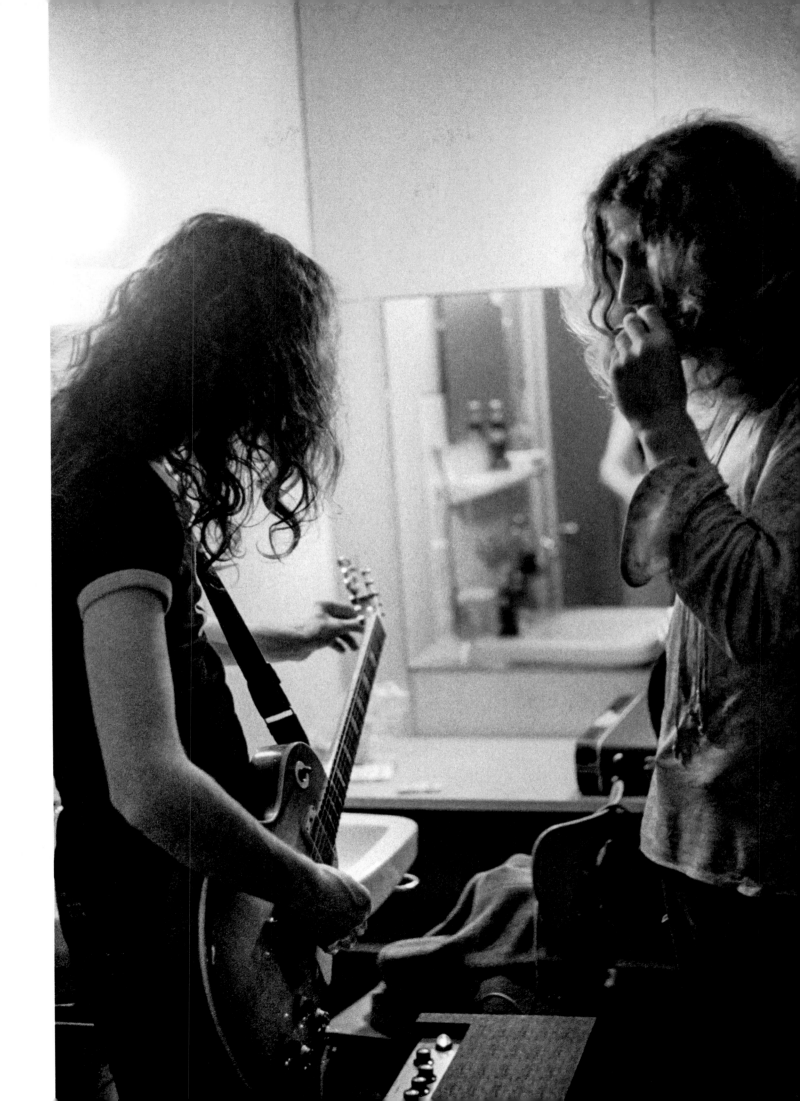

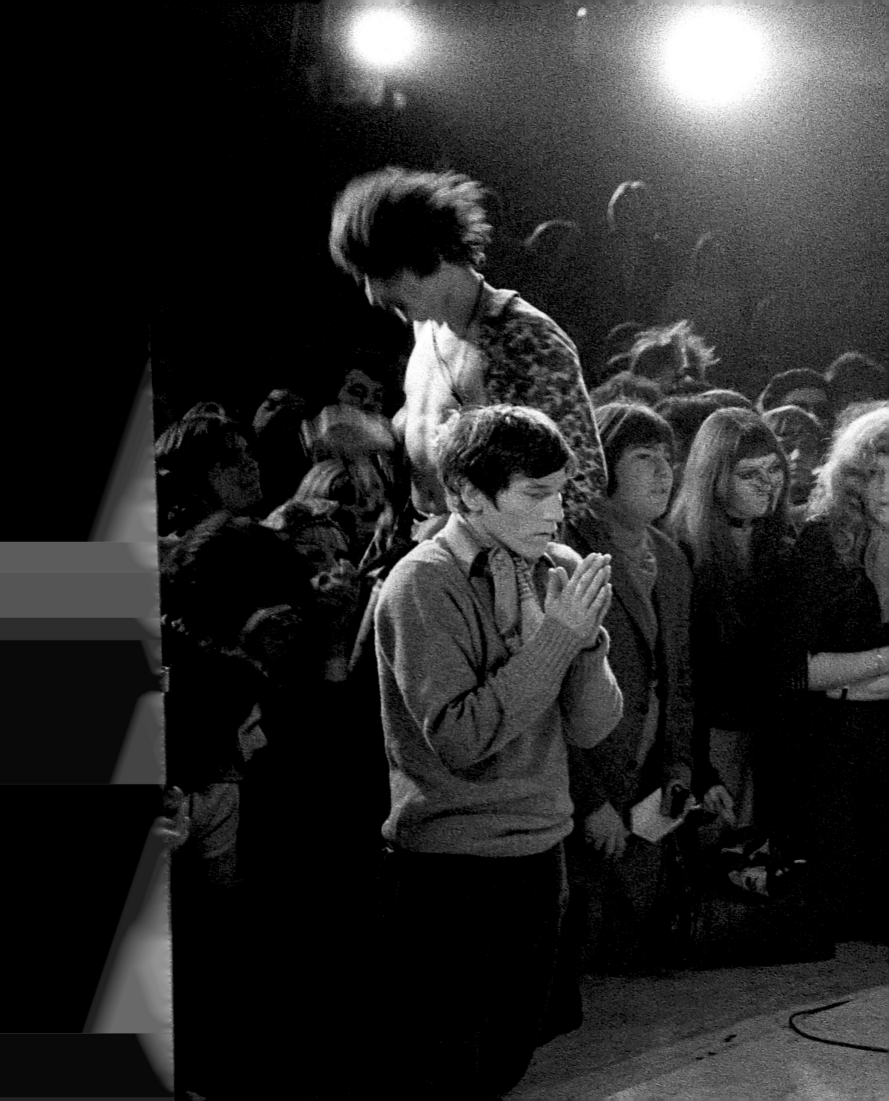

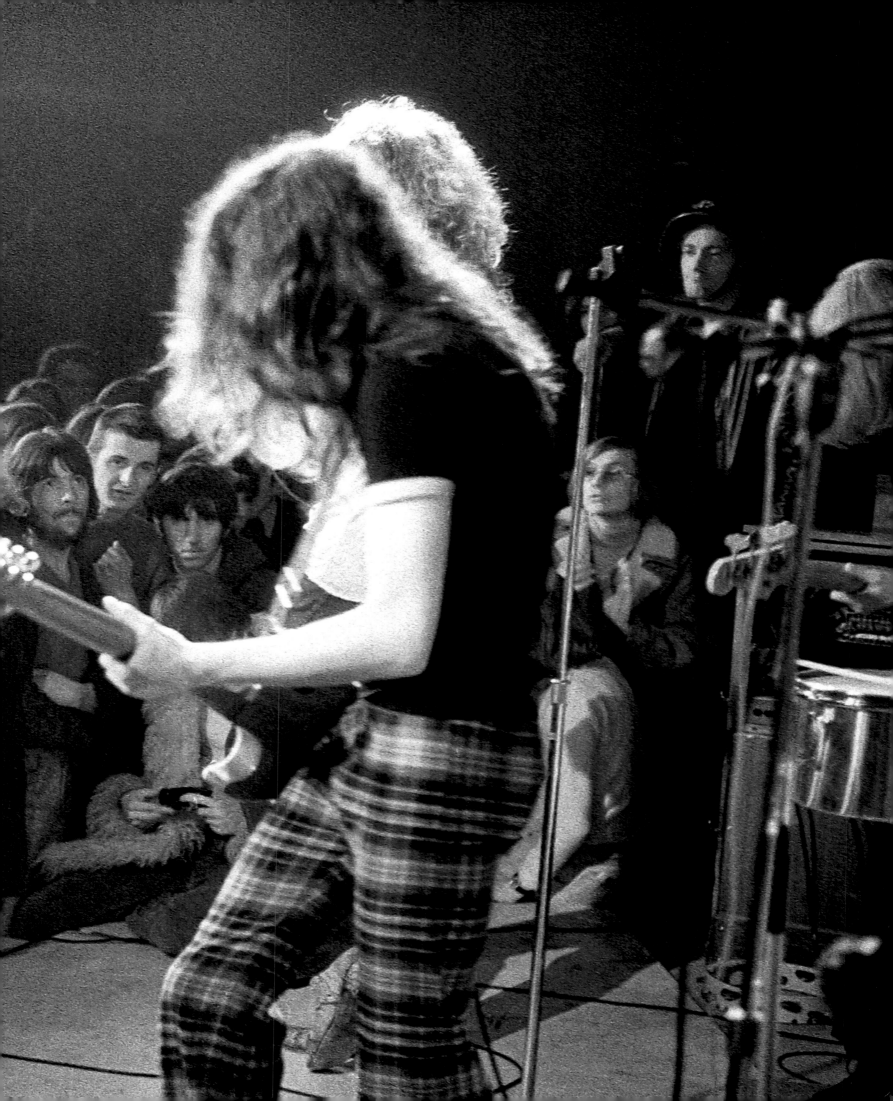

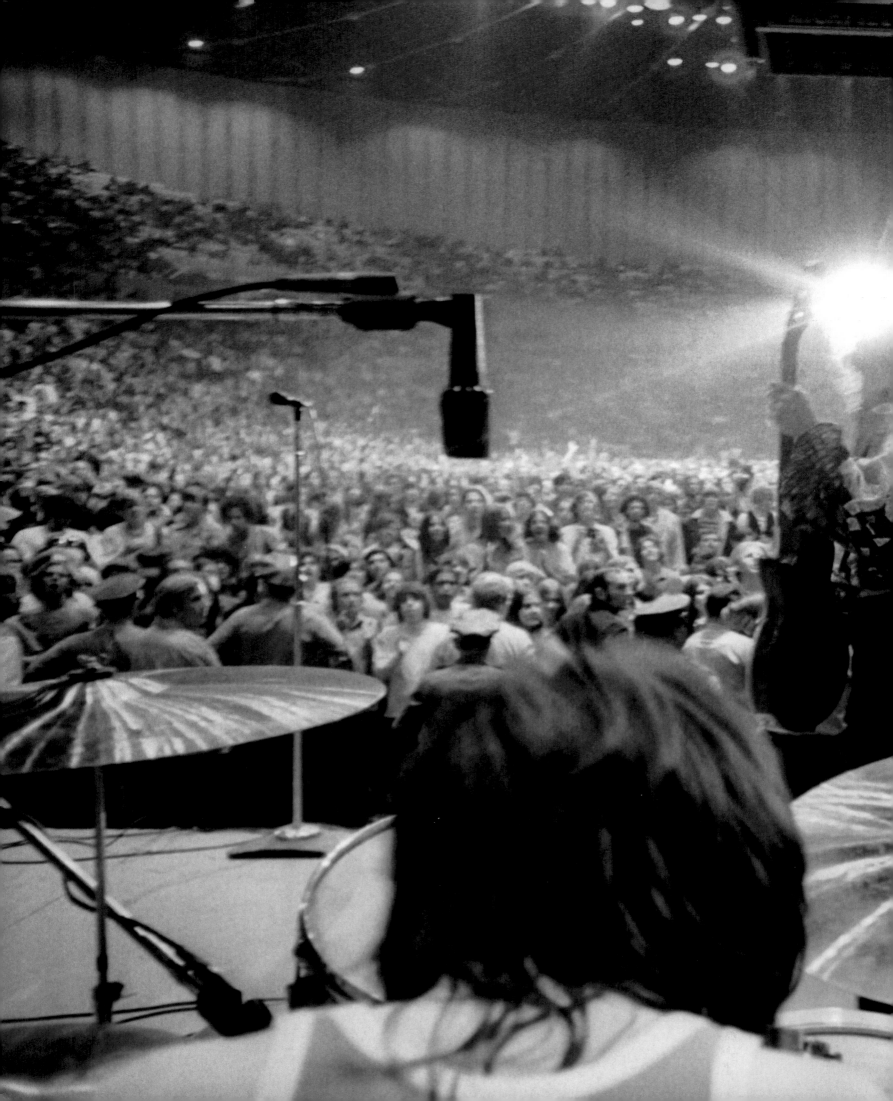

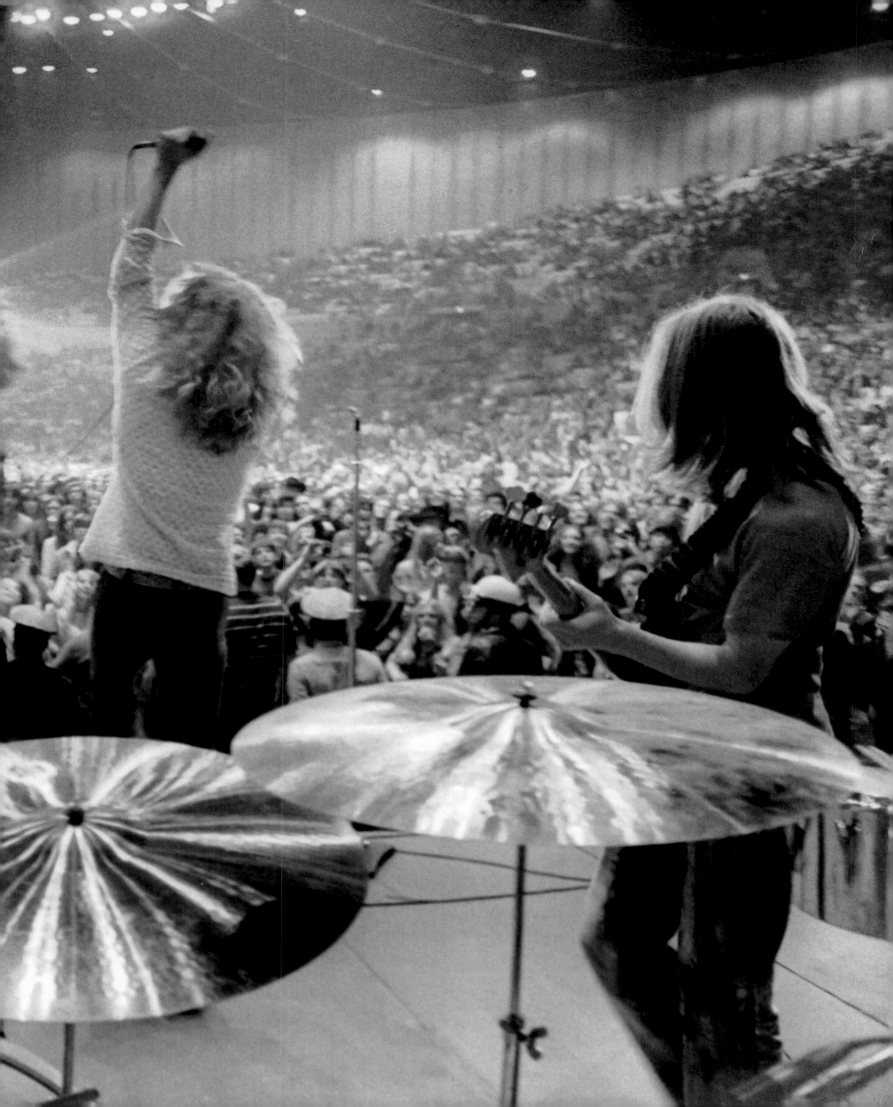

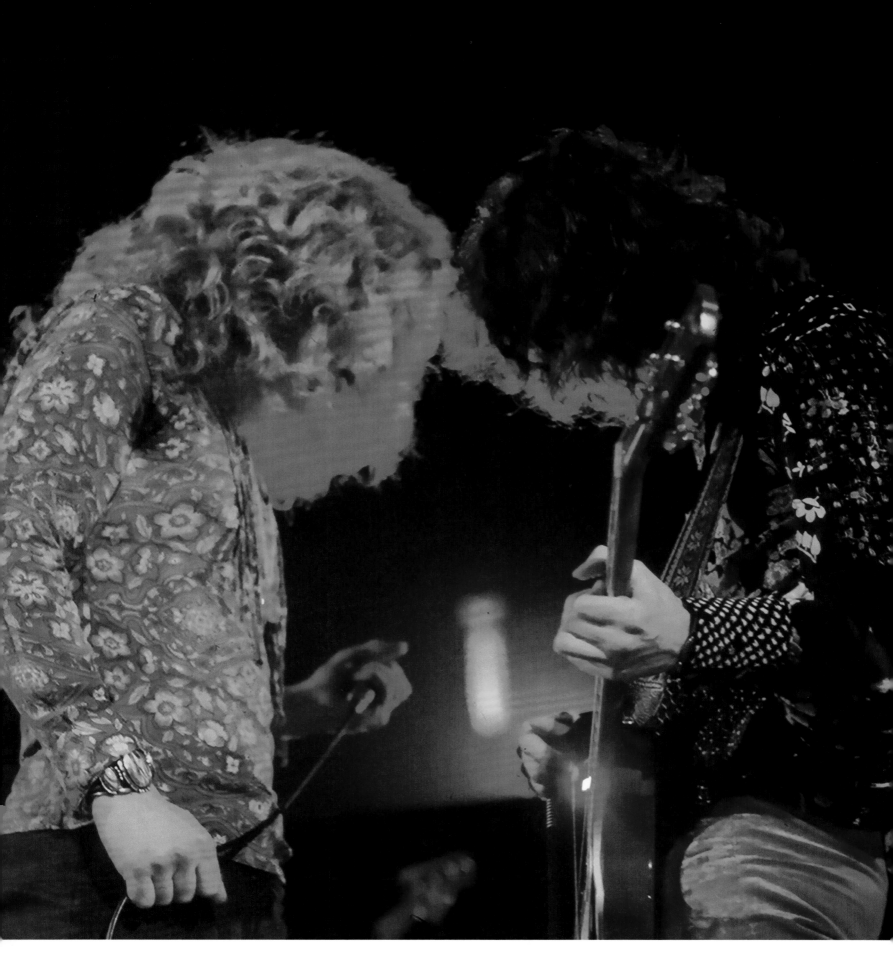

27 MARCH 1970

The Forum, Los Angeles, California, USA

[120—121]

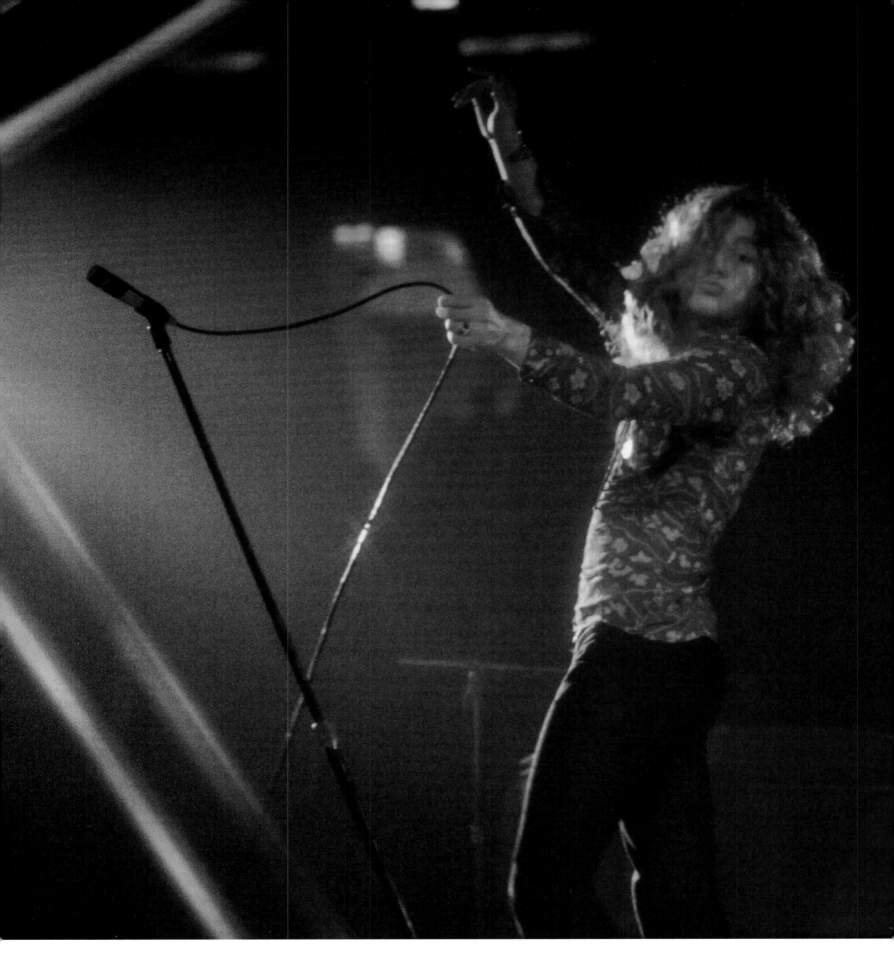

31 MARCH 1970

The Spectrum, Philadelphia, Pennsylvania, USA

[122—125]

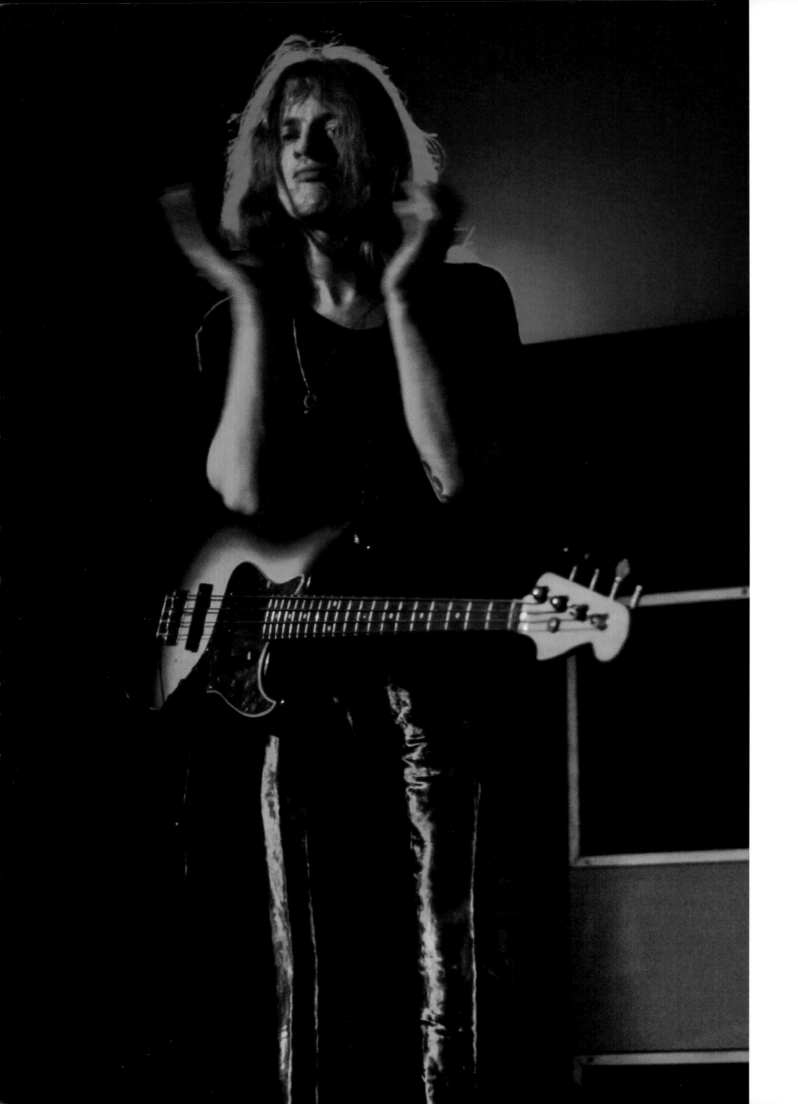

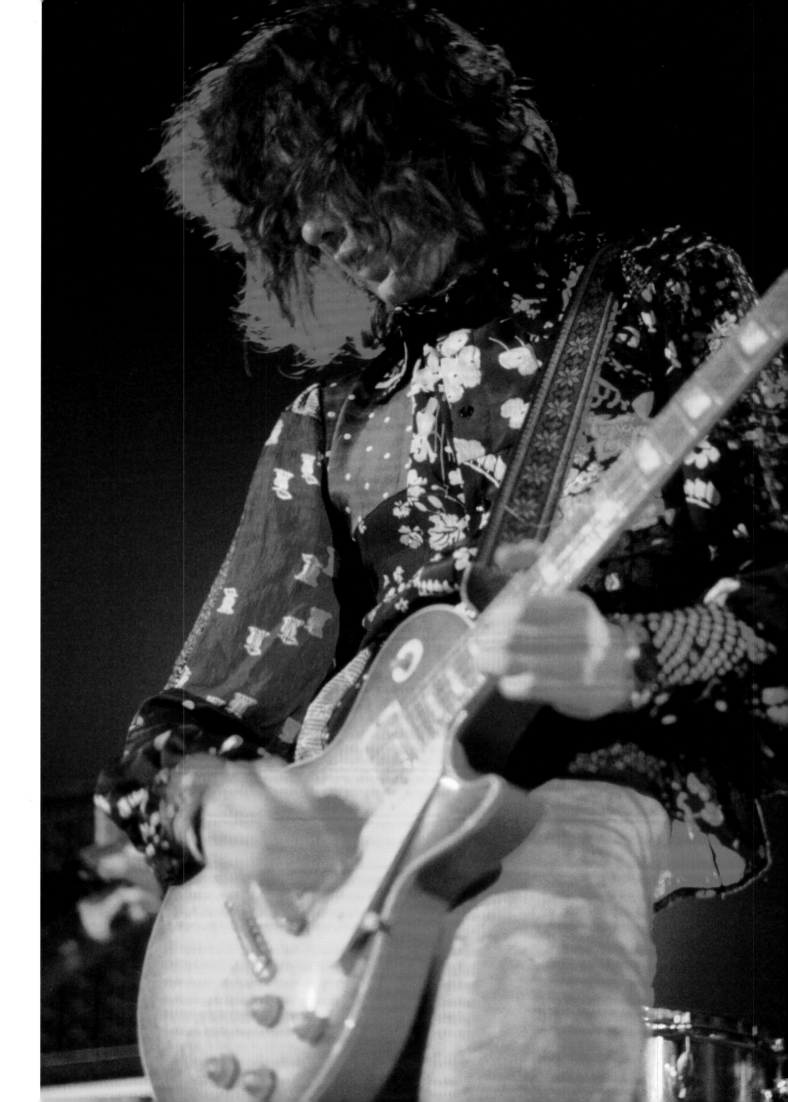

IF WE WEREN'T ON THE ROAD I WAS WRITING. I LIVED IT, † WAS MY LIFE. I WAS ALWAYS THINKING ABOUT WHAT WAS GOING TO COME NEXT AND WHAT WOULD BE GOOD FOR THE NEXT ALBUM.

JIMMY PAGE

8 APRIL 1970

J. S. Dorton Arena, Raleigh, North Carolina, USA

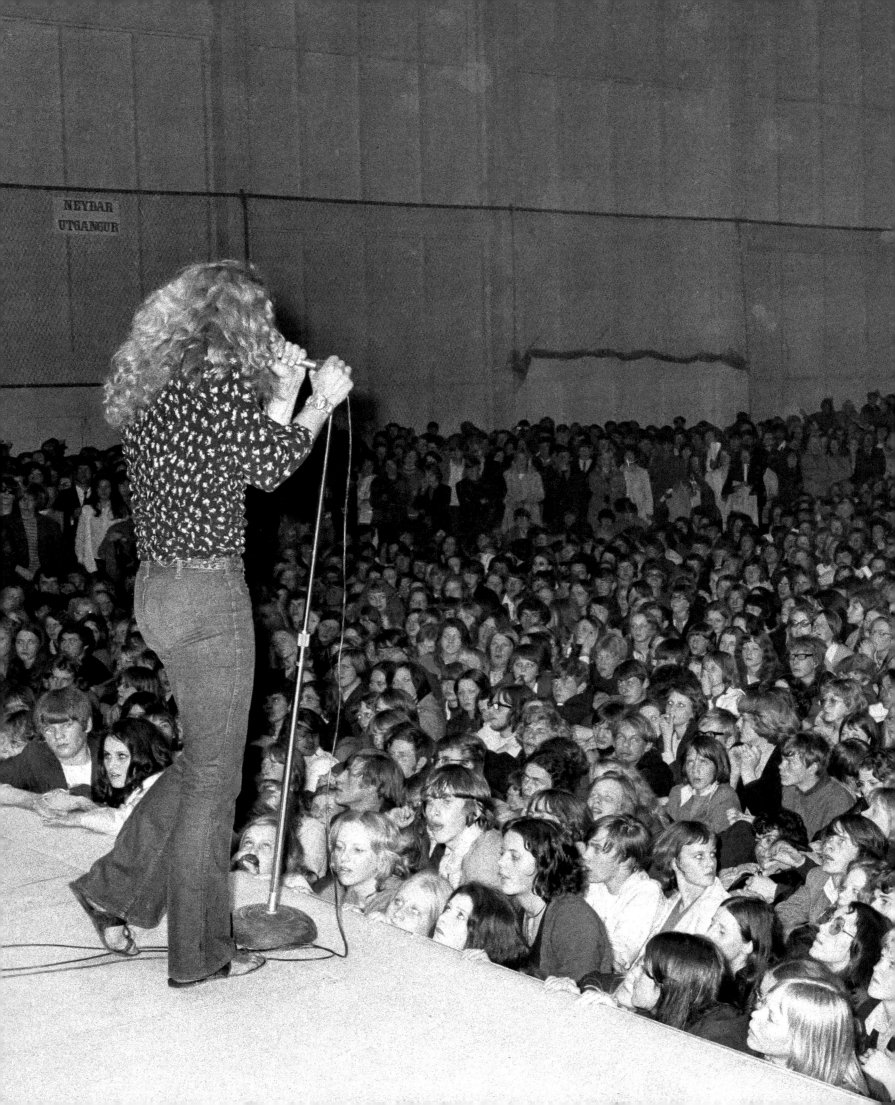

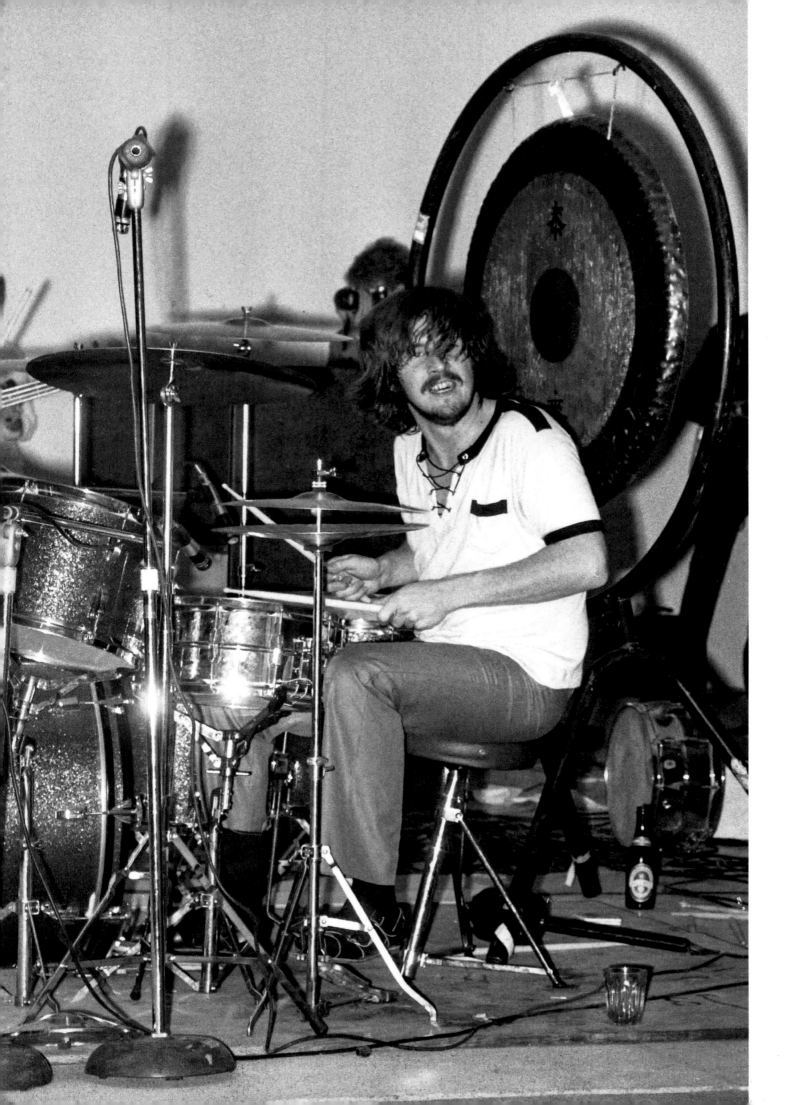

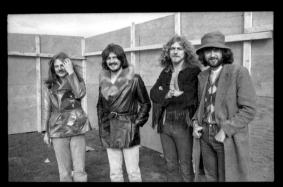 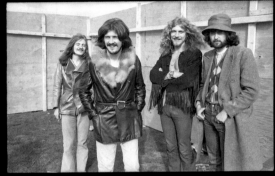 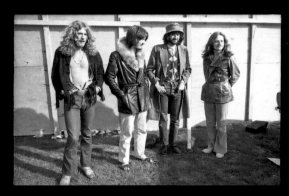

→ 6 → 6A → 7 → 7A → 8 → 8A

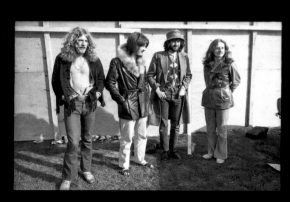 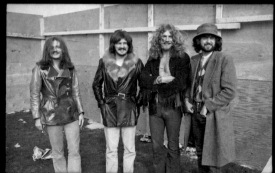 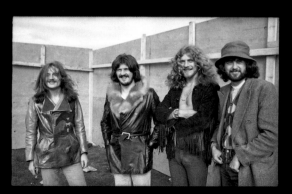

→ 3 → 3A → 4 → 4A → 5 → 5A

I ARRIVED BY HELICOPTER BECAUSE I LEFT ⸶ LATE. SETTLING IN TO LAND I SEE HELLS ANGELS ROARING IN, THE LEAD ANGEL SAID, 'WE'RE YOUR TRANSPORT'. I ARRIVED AT THE GIG ON THE BACK OF A HOG WITH A COWBOY HAT. ONE OF MY BETTER ENTRANCES.

JOHN PAUL JONES

28 JUNE 1970

Bath Festival of Blues, Shepton Mallet, UK

[132—137]

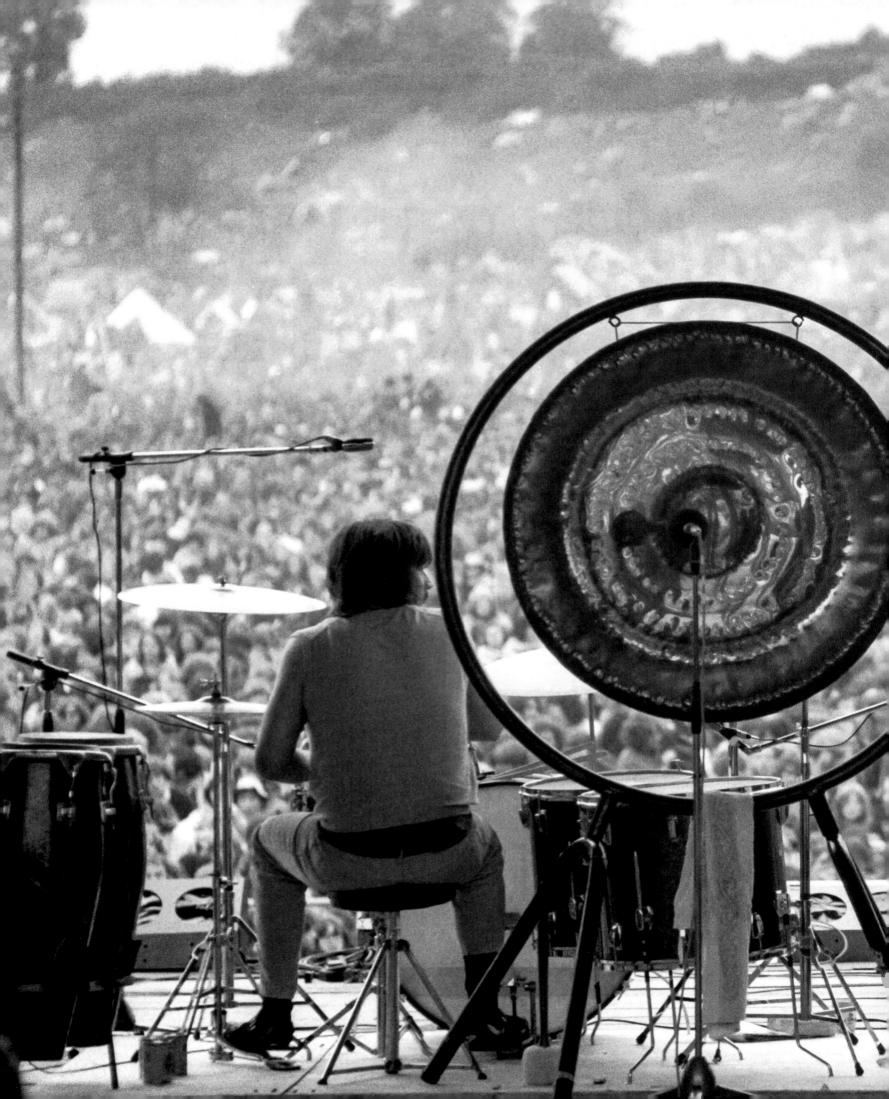

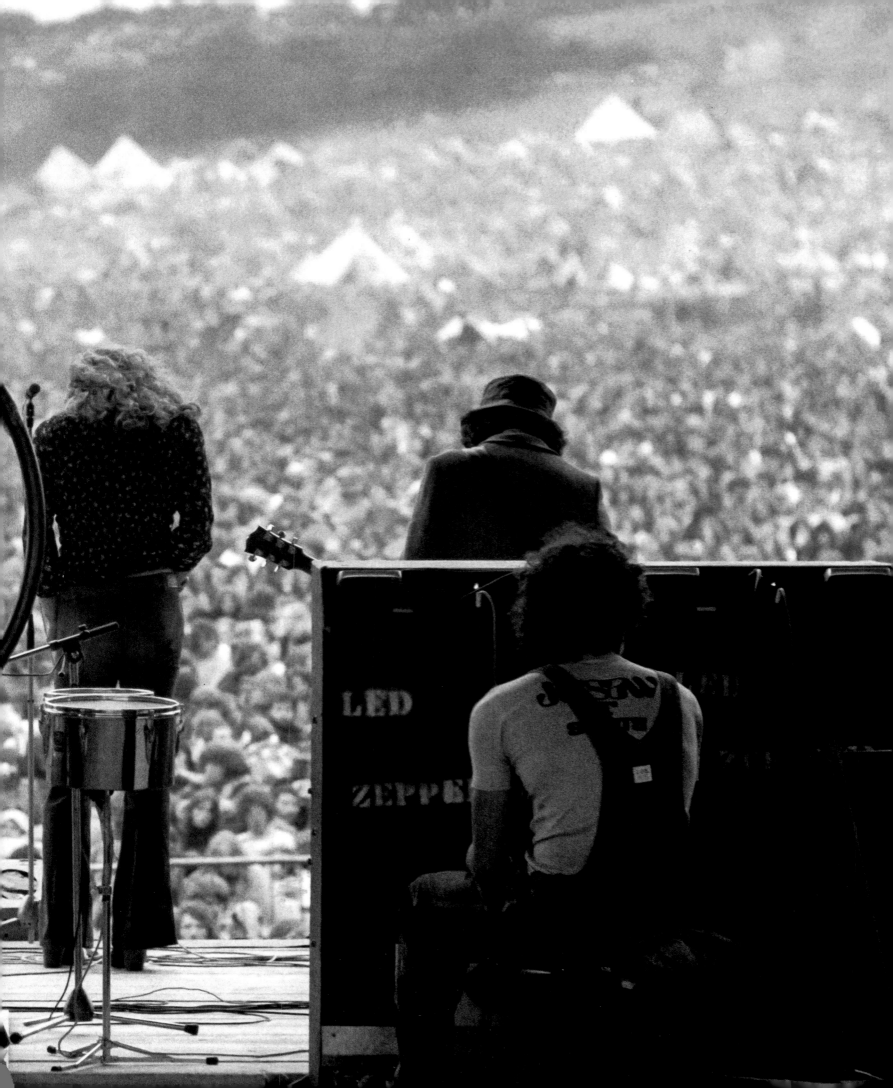

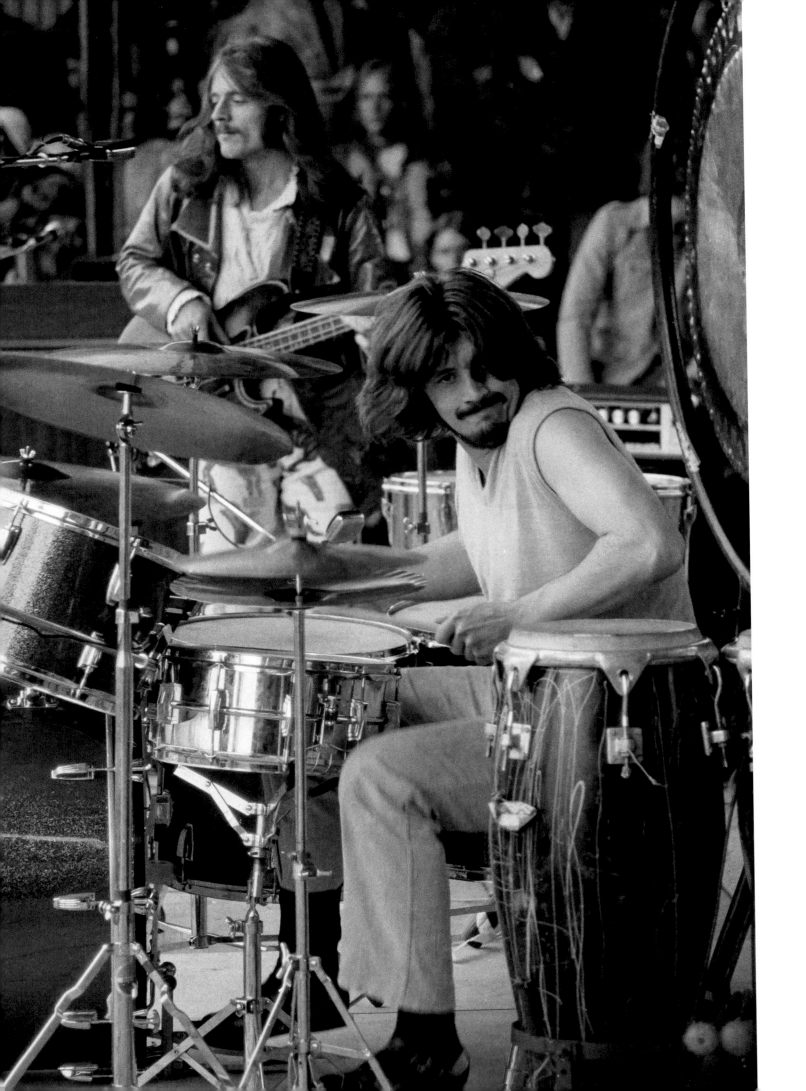

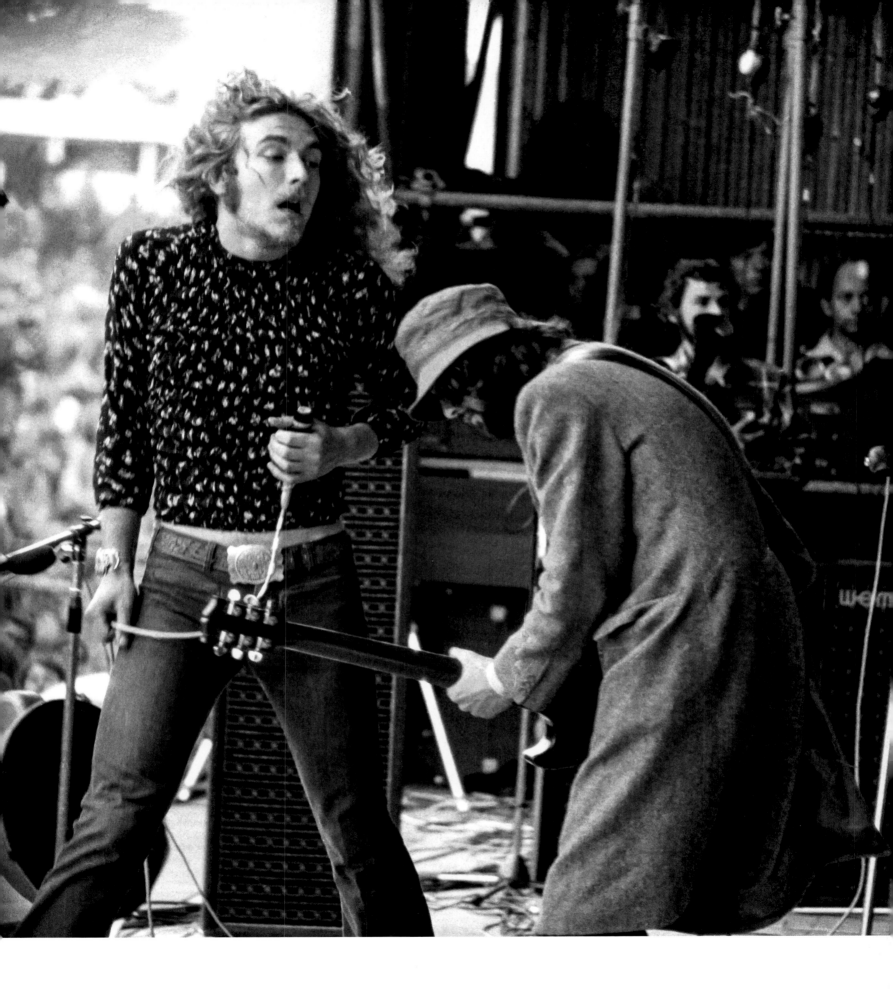

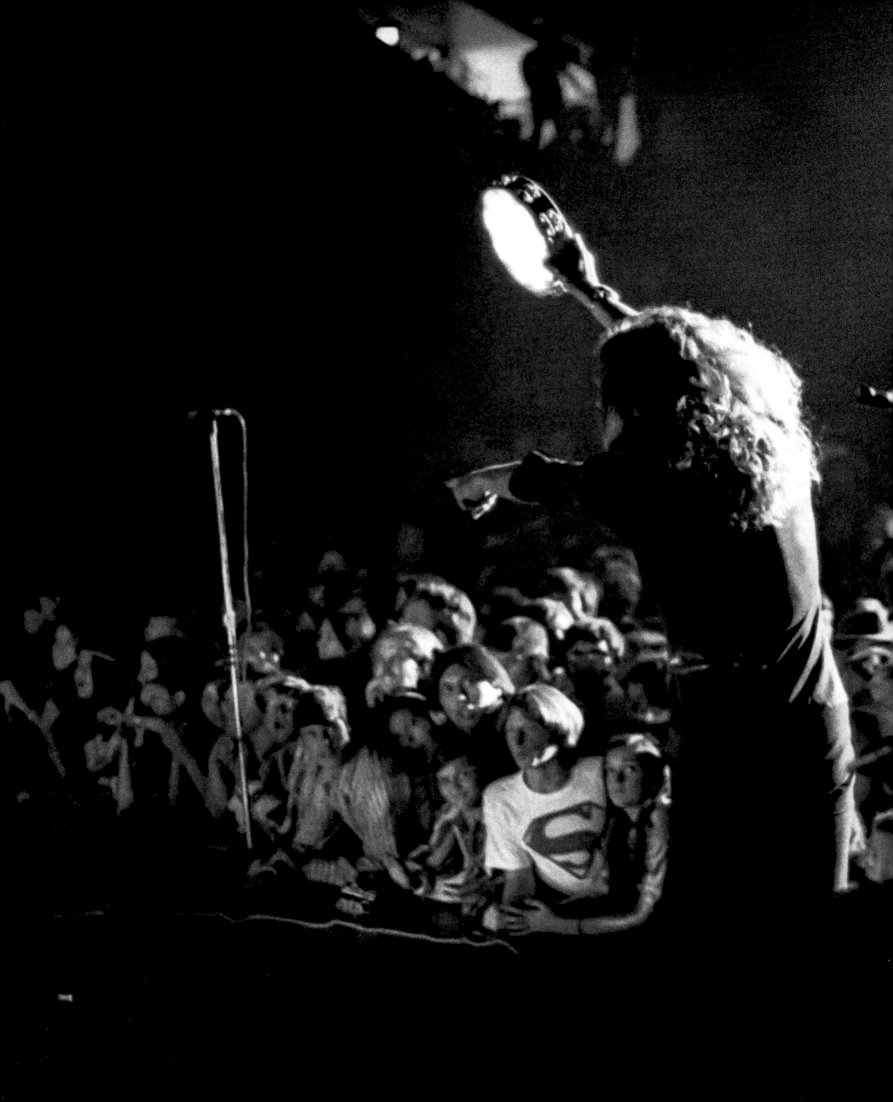

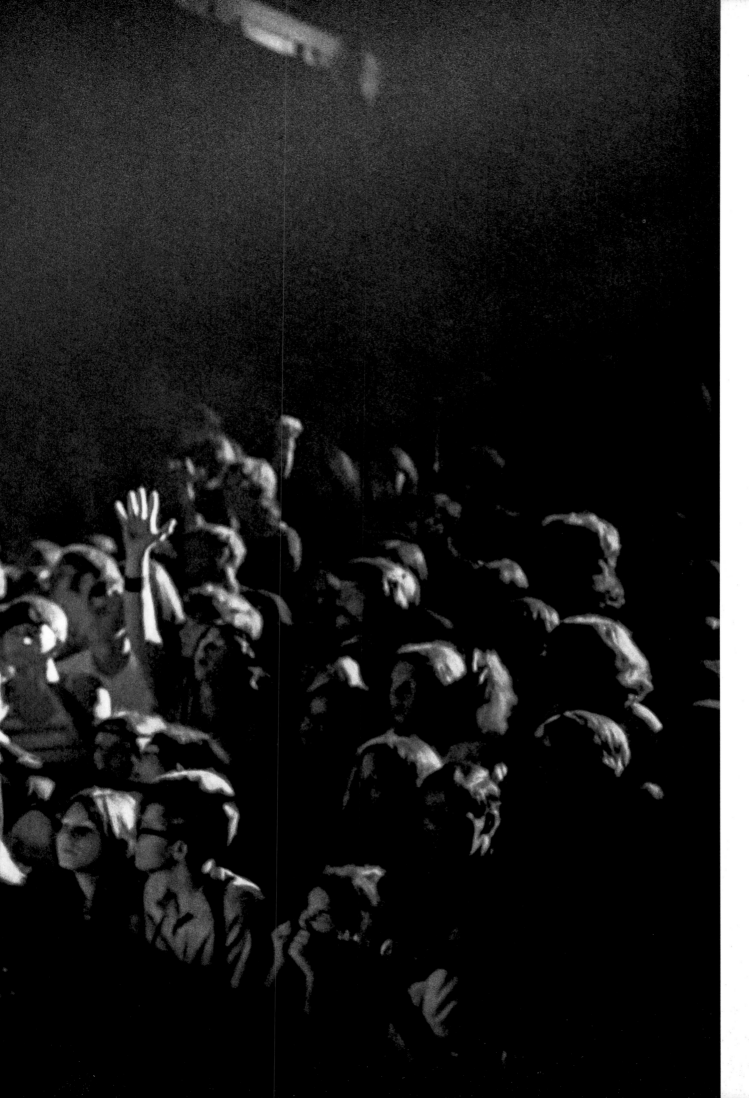

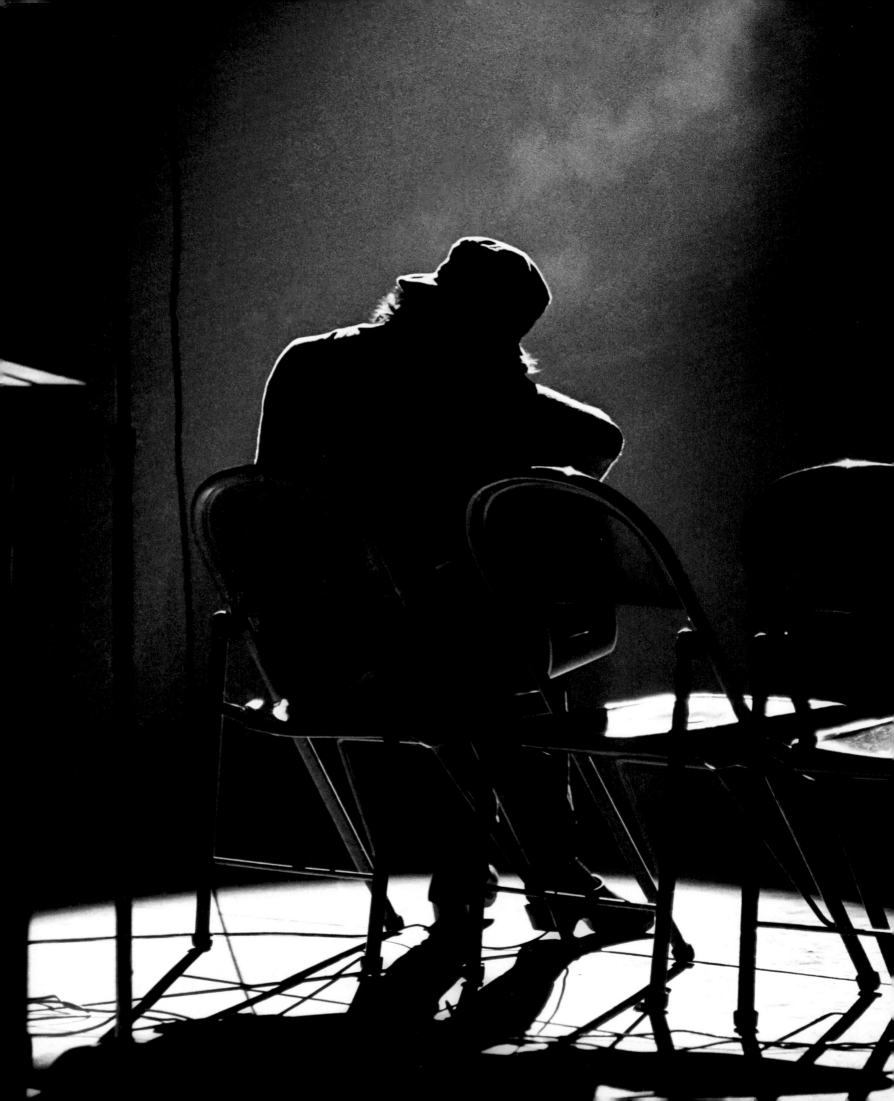

IT WAS NICE TO SIT DOWN AND JUST BE ACOUSTIC. JIMMY WROTE MOST OF HIS ELECTRIC RIFFS AND ALL THE SONGS ON THAT ACOUSTIC.

JOHN PAUL JONES

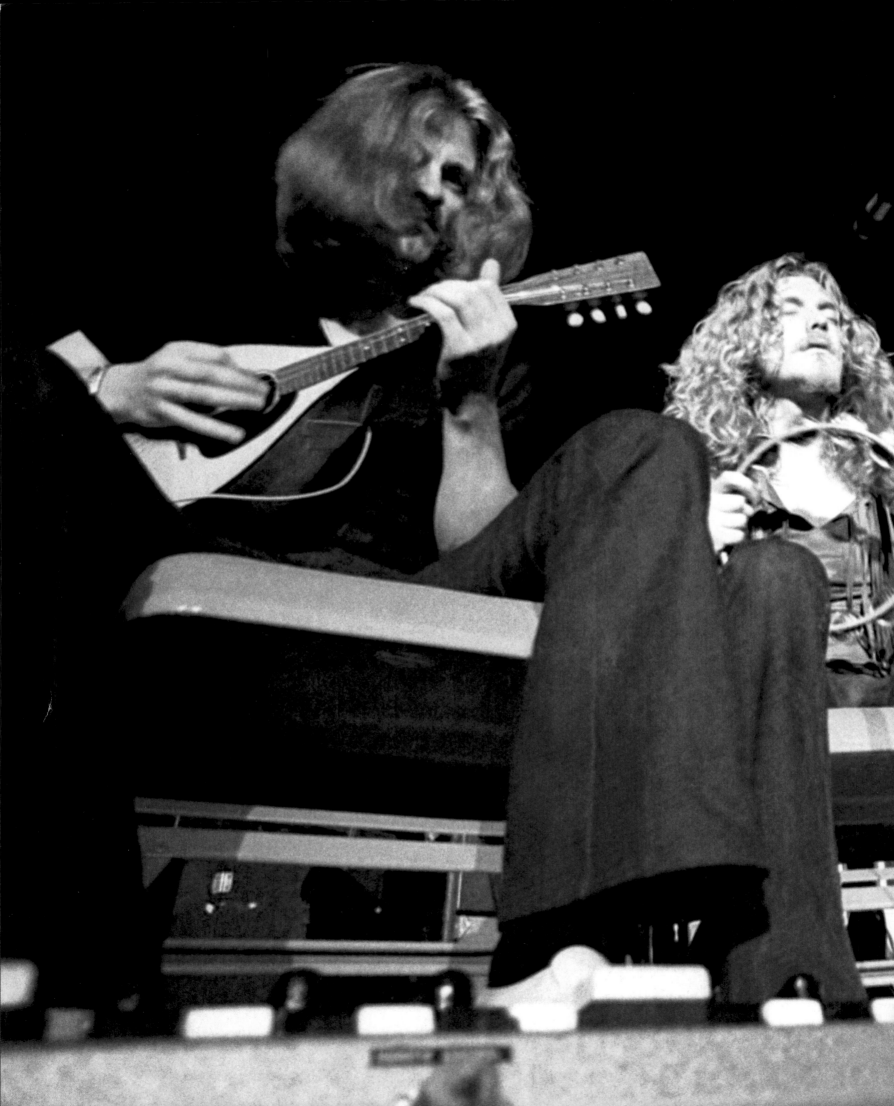

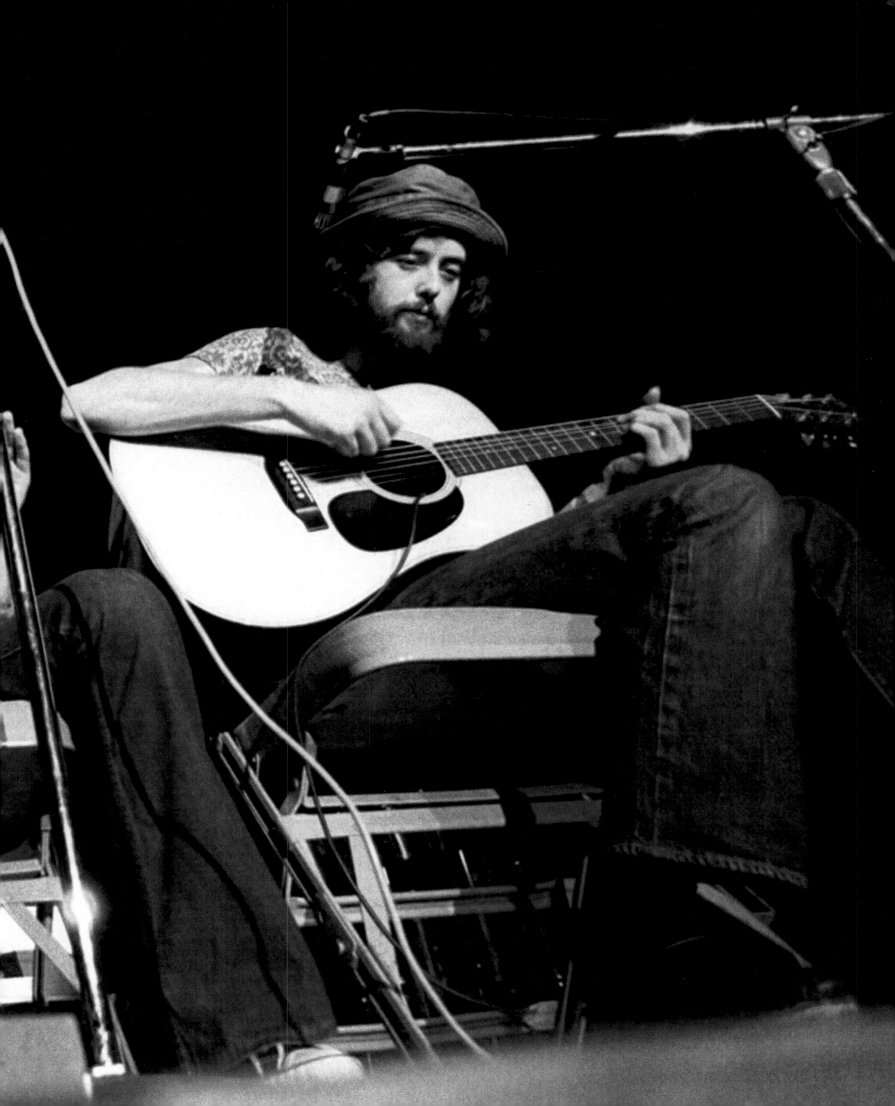

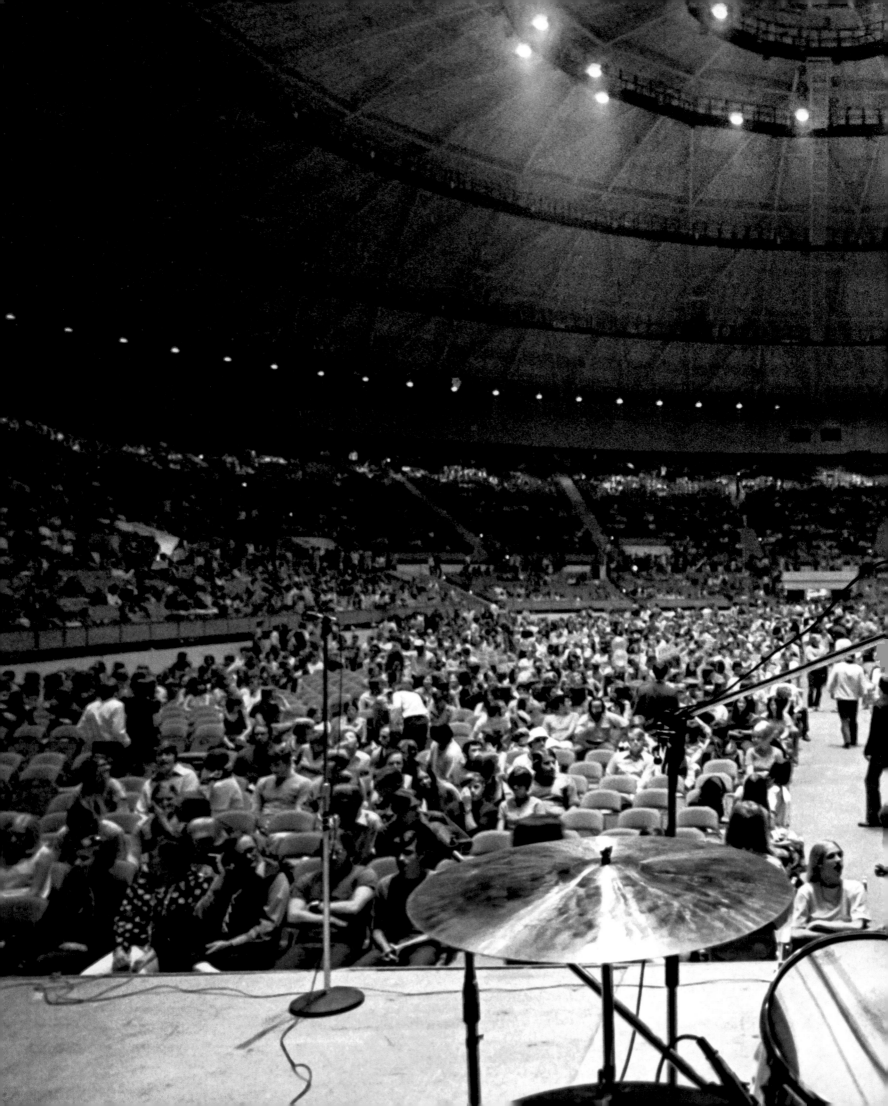

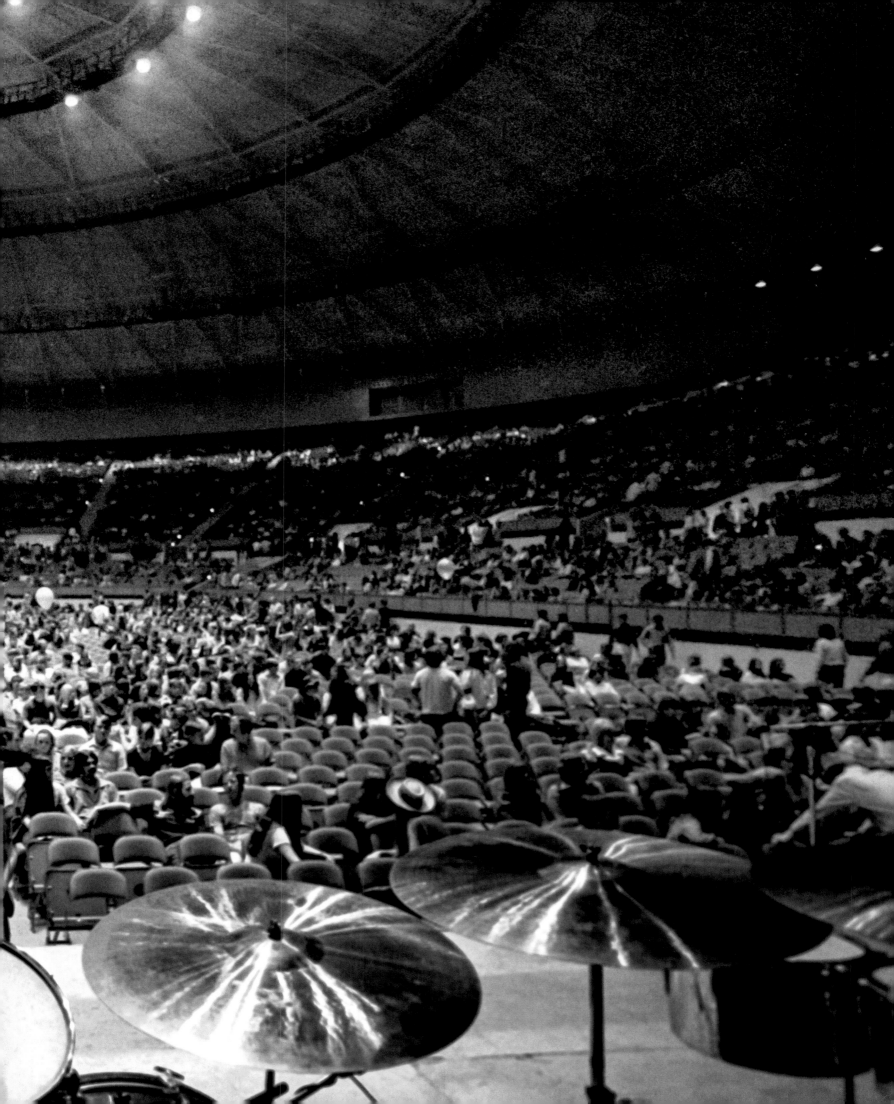

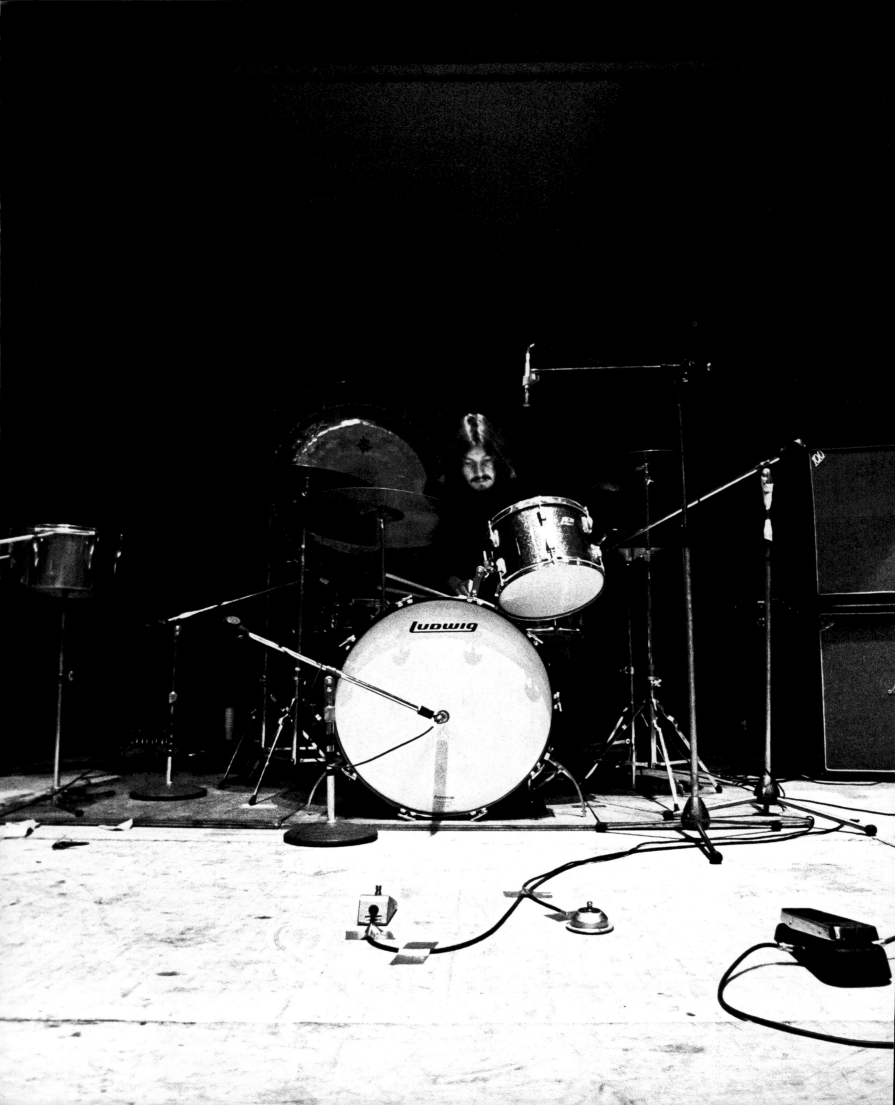

JOHN DIDN'T PRACTISE OR SIT AROUND IN HIS ROOM THINKING ABOUT DRUMMING, HE JUST DID ⊦ AND WAS MAGNIFICENT.

ROBERT PLANT

22 AUGUST 1970

Tarrant County Arena, Fort Worth, Texas, USA

[144—149]

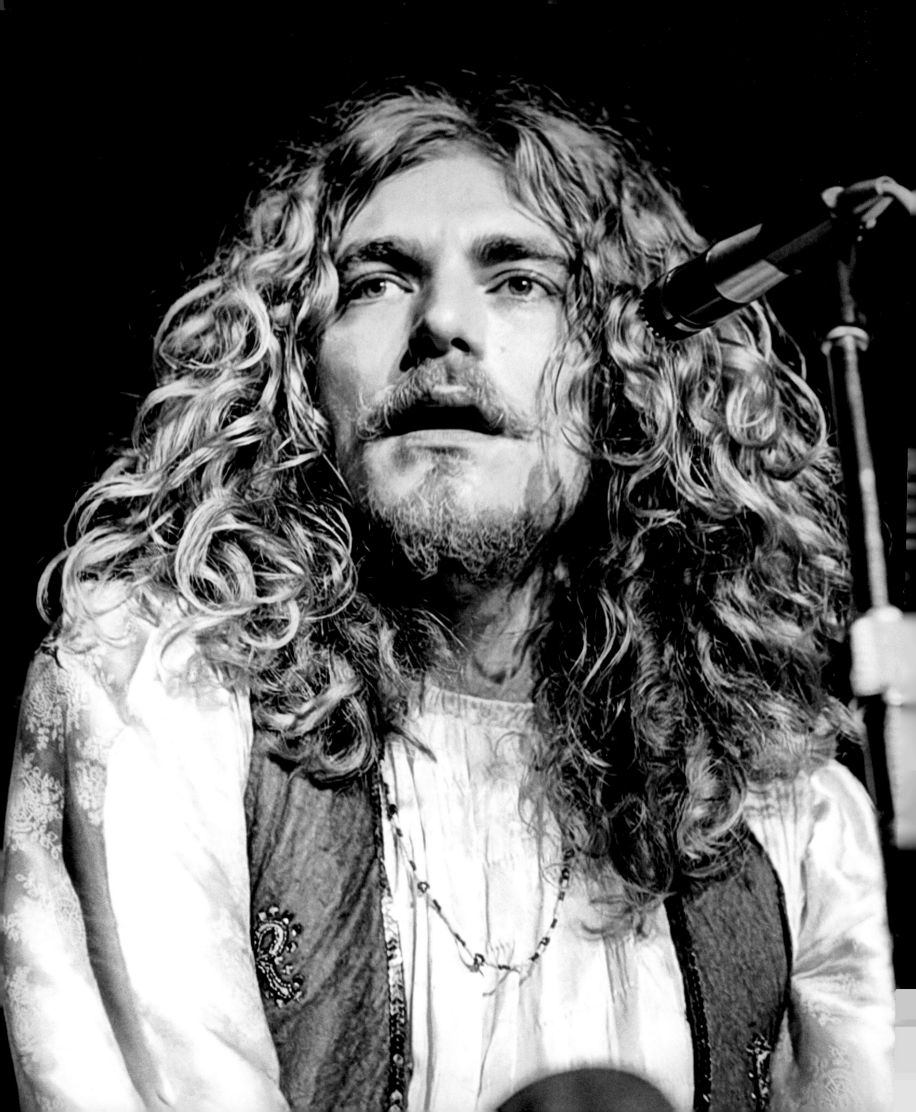

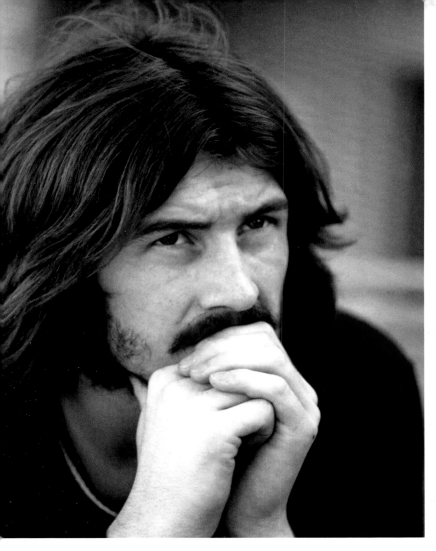

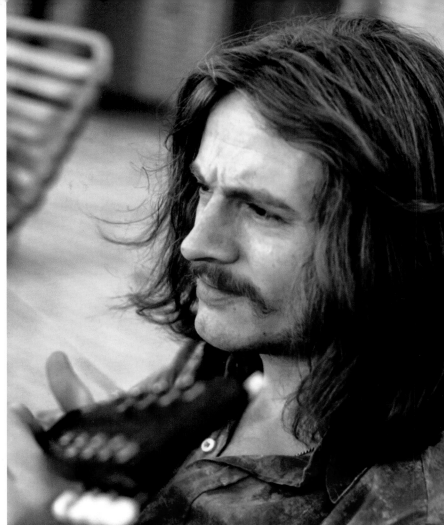

AUGUST 1970
Cabana Motor Hotel, Dallas, Texas, USA

Caught you smiling at me
thats the way it should be
like a leaf to to a tree
— Sofine

All the good times we've had
I sung love so glad
always laughing never sad — Sofine

Cause you treated me kind
well I gave you my mind
thats what others couldn't find
— Sofine

keep on running away
fearing what they would say
if they found us this way
— Sofine

So what is there to do?
Cause your hearts warm & true
Gotto keep on loving you
— Sofine

maybe some day In time
As we move down the line
what we seek we shall find
— Sofine

You, I make us one
You " " two
he makes us three
thats too much for me

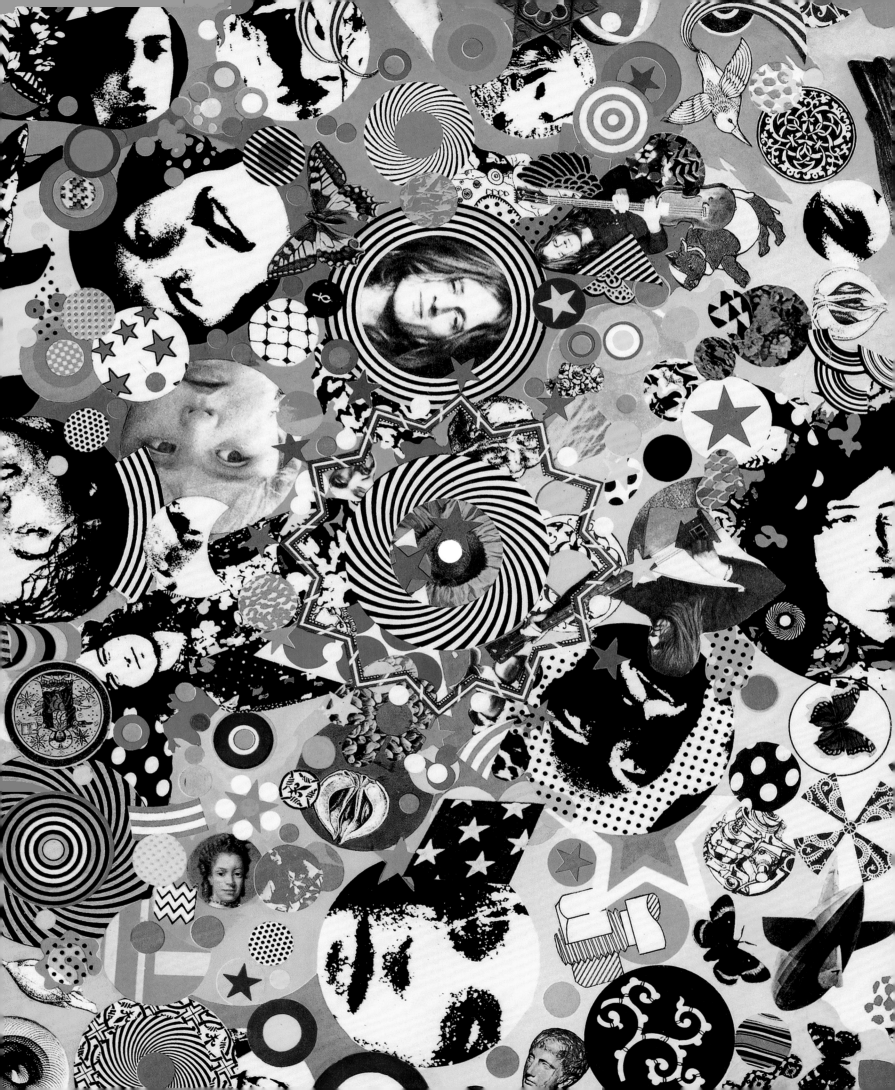

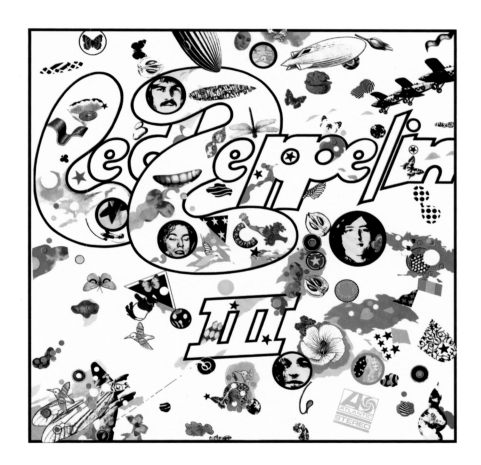

LED ZEPPELIN III

5 October 1970

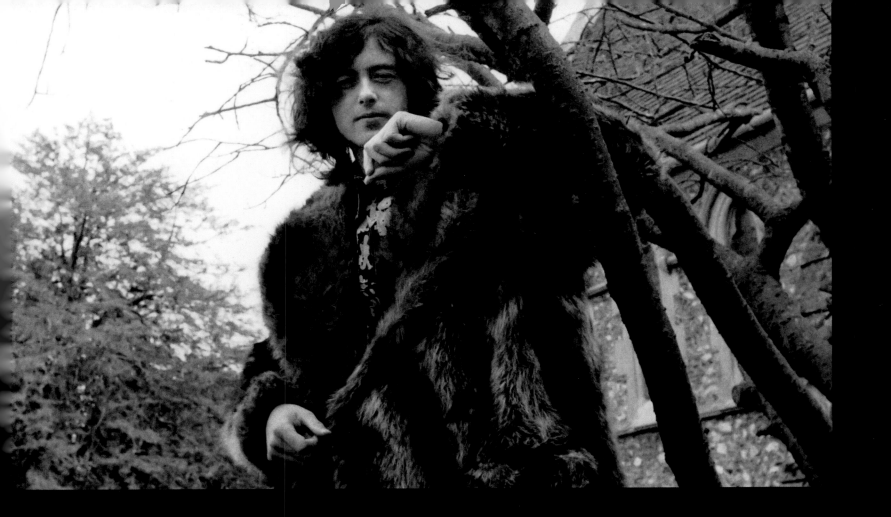

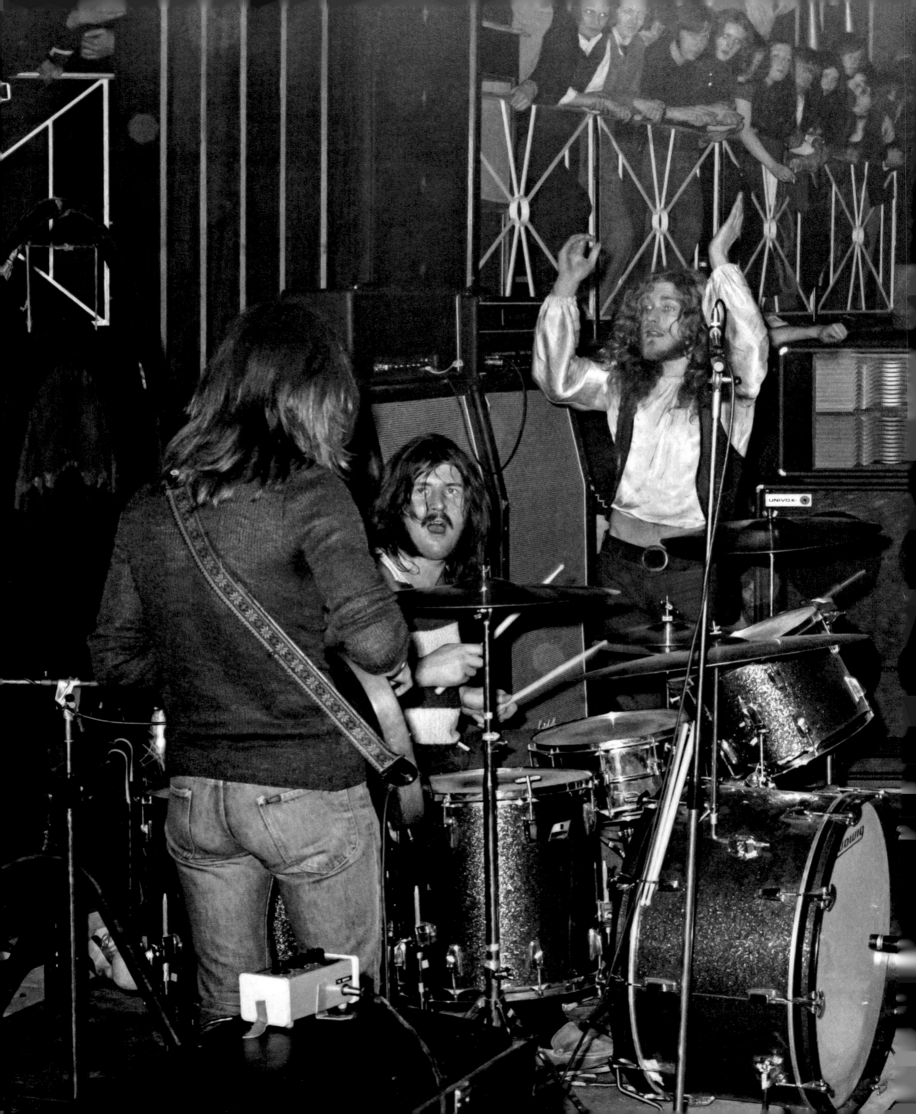

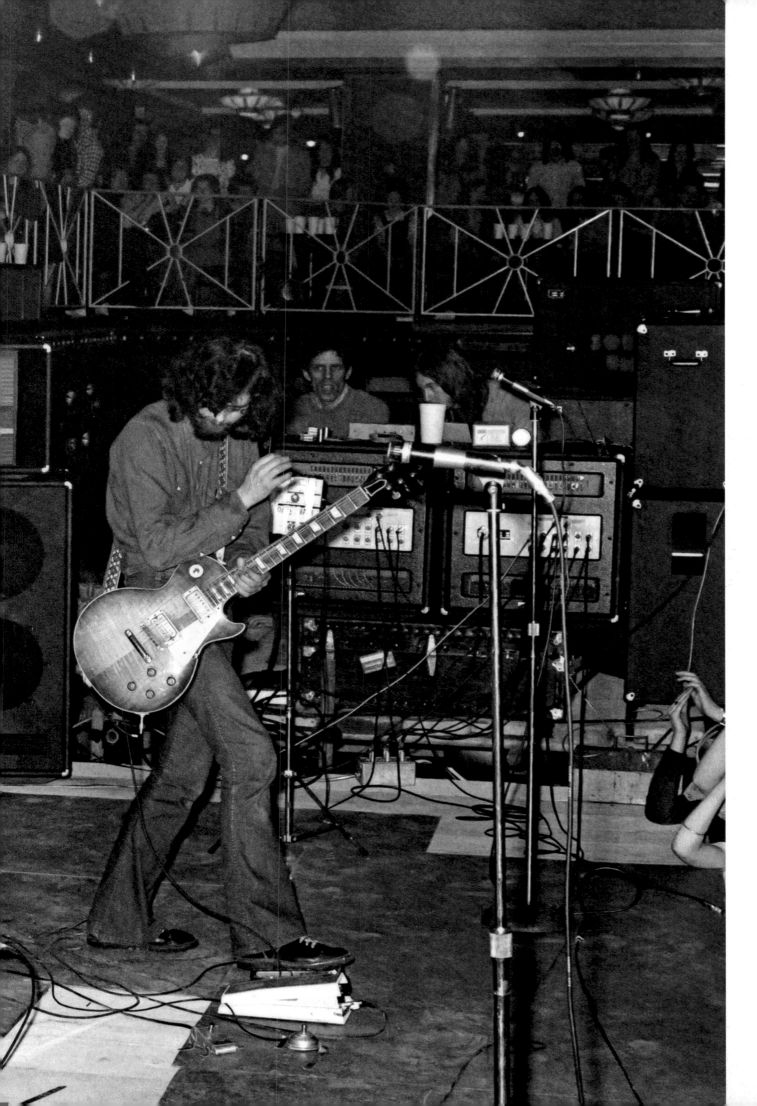

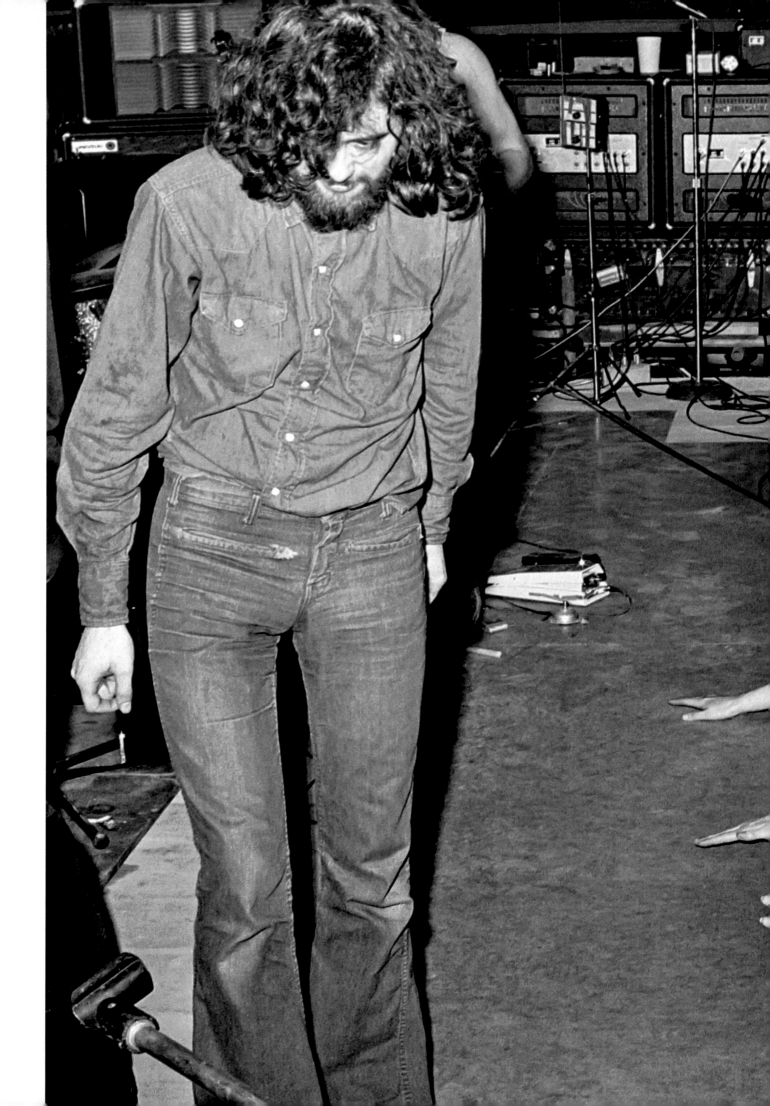

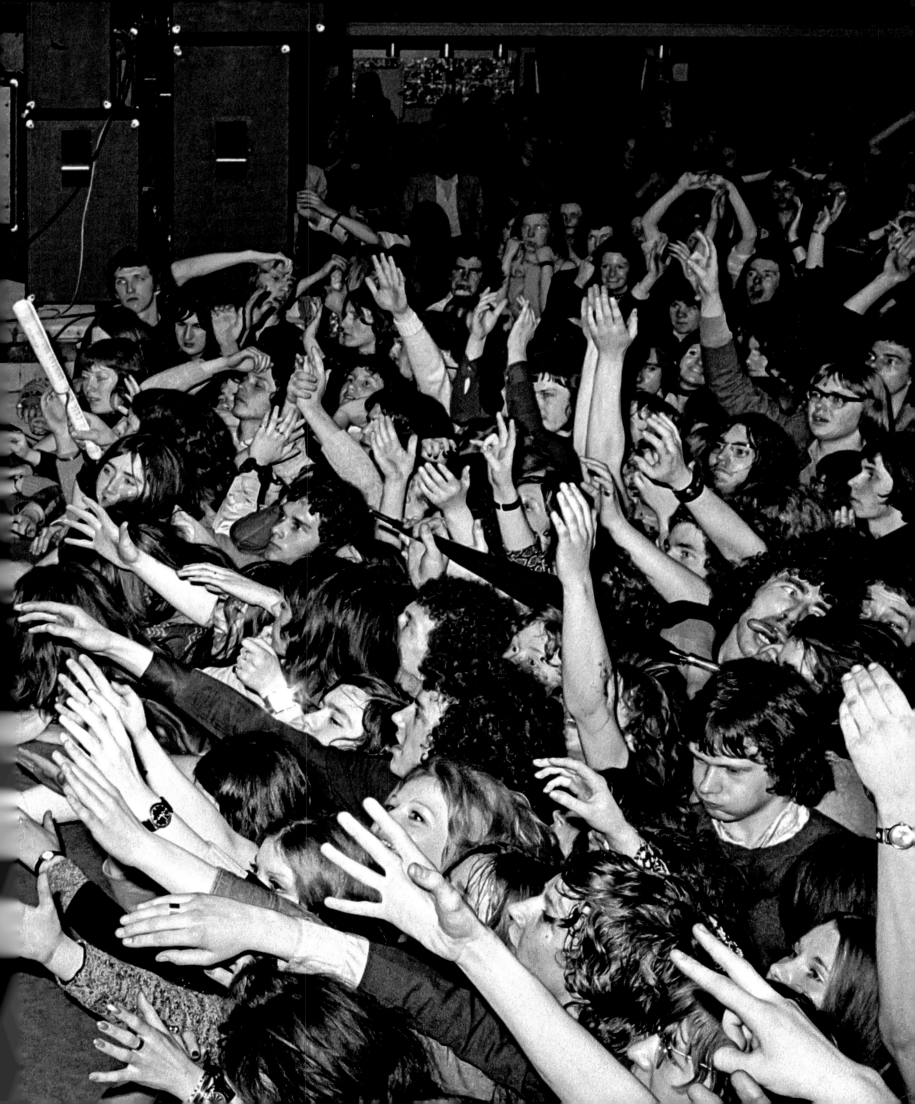

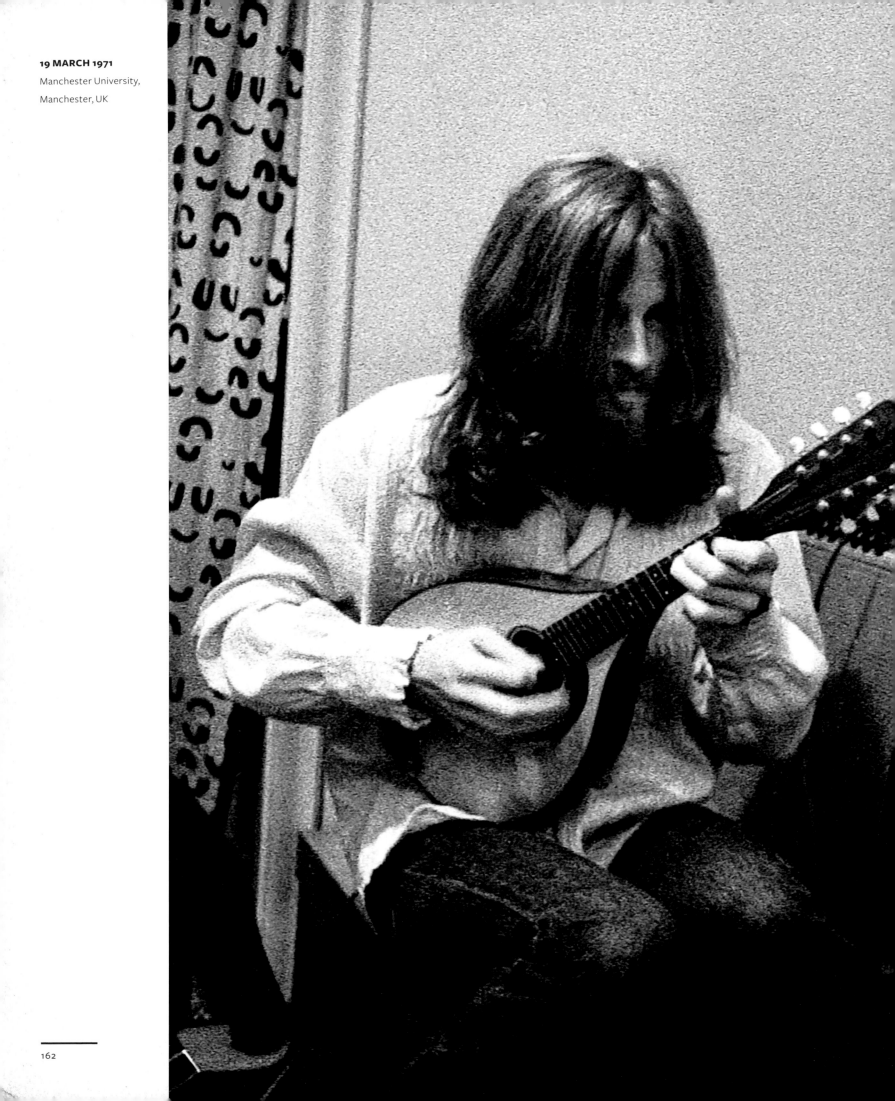

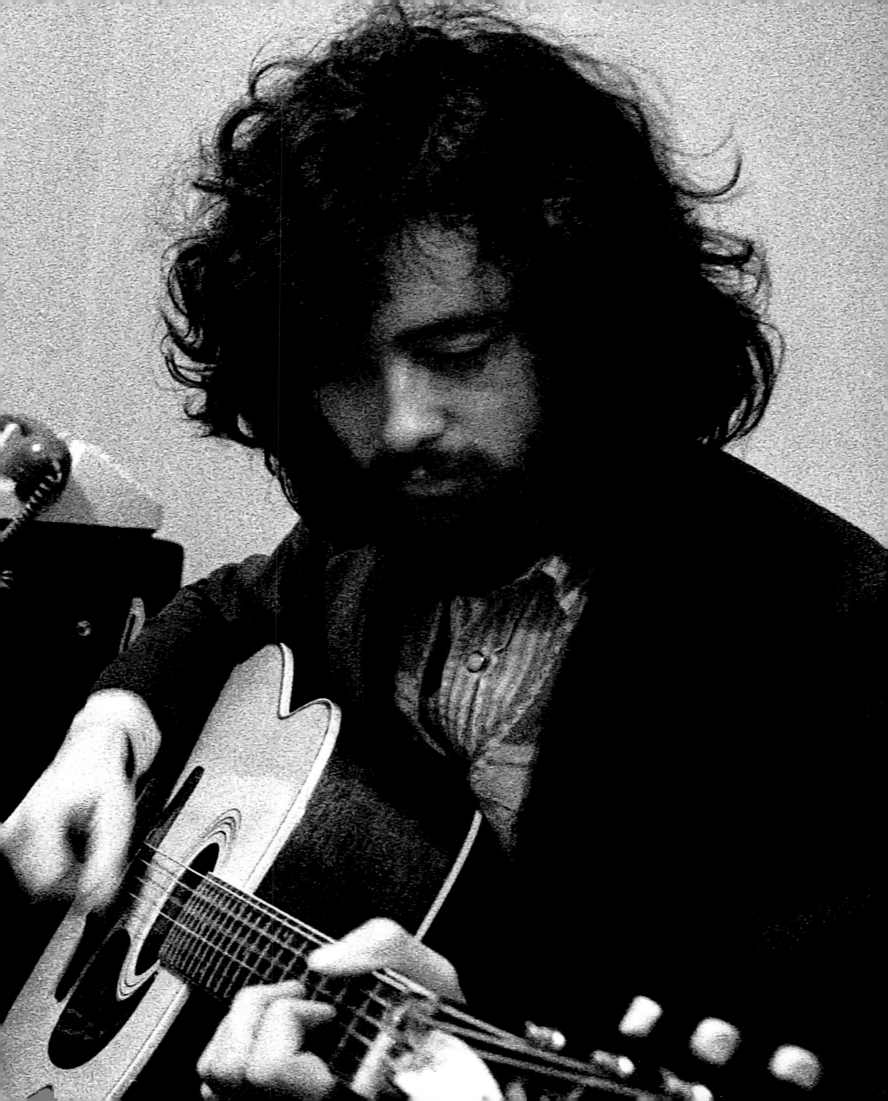

WE TENDED TO TREAT EVERY SHOW AS SPECIAL. IT WASN'T LIKE, WE'RE PLAYING HERE SO LET'S NOT BOTHER. THIS IS A SHOW, WE'VE GOT TO DO OUR BEST.

5 JULY 1971
Velodromo Vigorelli, Milan, Italy
[right]

3 SEPTEMBER 1971
Madison Square Garden, New York, New York, USA
[166—167]

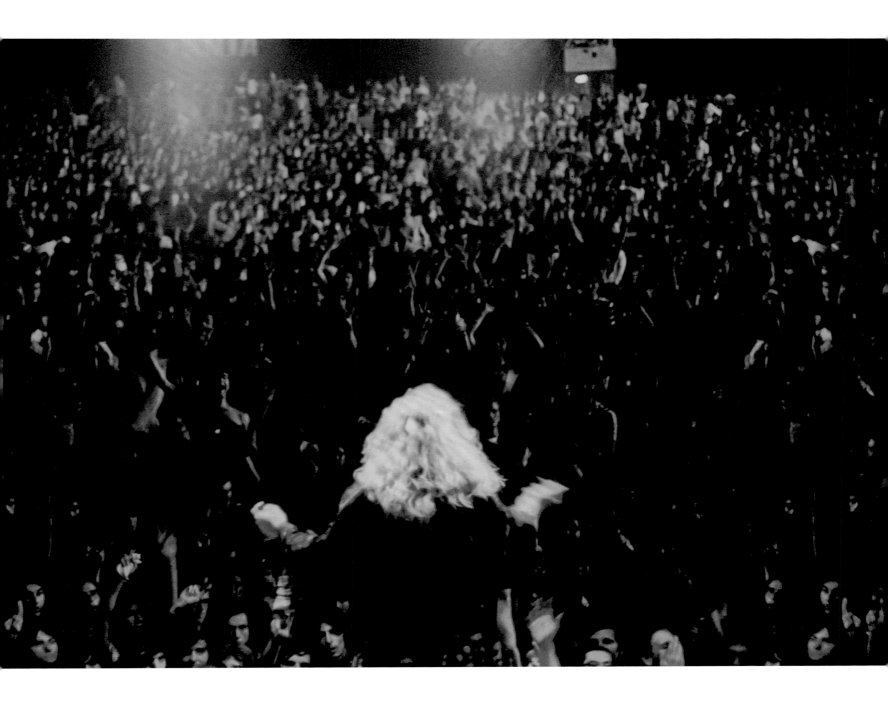

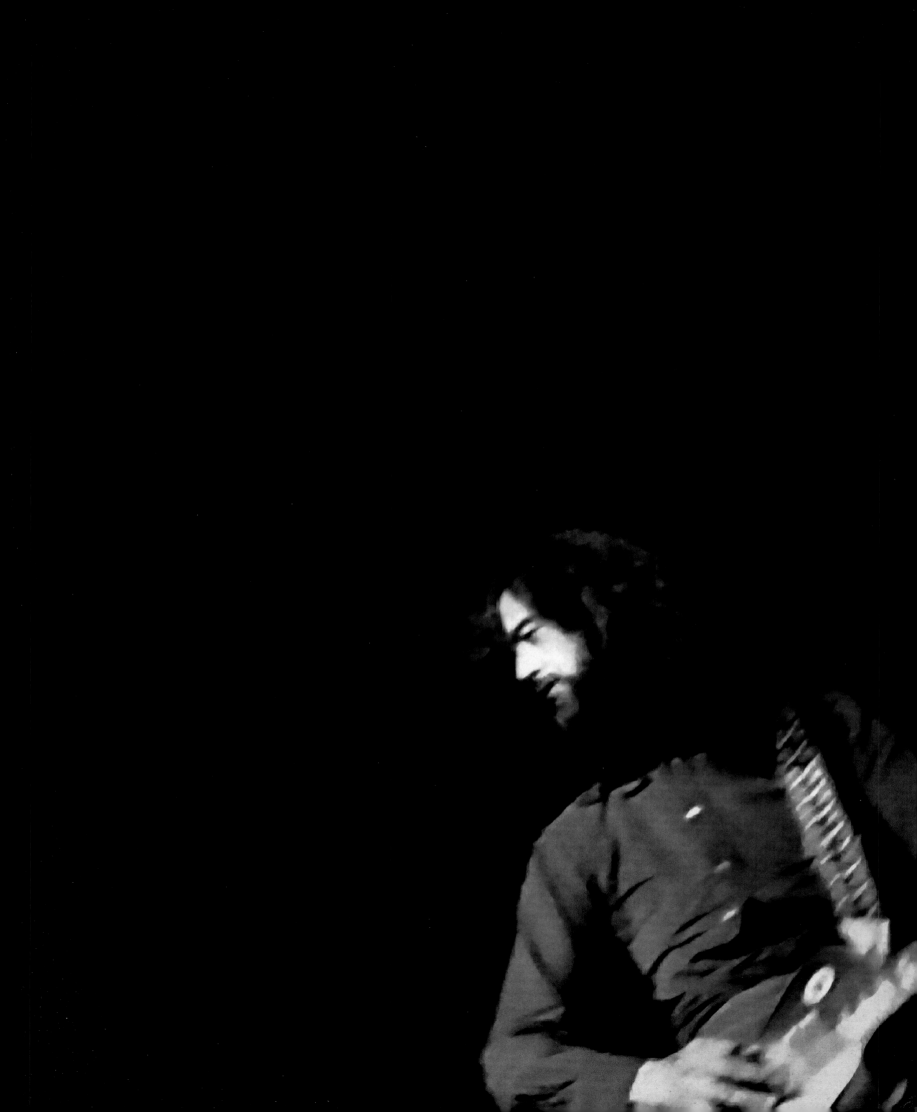

WE LISTENED TO EACH OTHER'S PLAYING, THAT WAS A REALLY IMPORTANT THING. THAT'S WHY I COULD MUTATE AND CHANGE THE PERSPECTIVE WITHIN A NUMBER AT ANY GIVEN POINT BECAUSE EVERYONE WAS THERE LISTENING AND RESPONDING TO CUES.

16 & 17 SEPTEMBER 1971

Civic Auditorium, Honolulu, Hawaii, USA

[169—171]

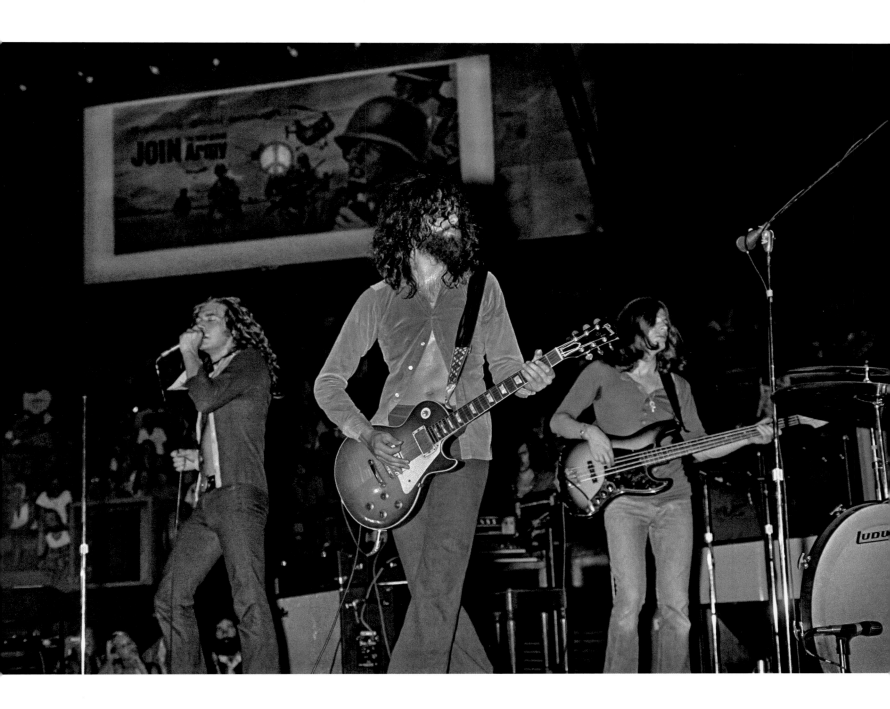

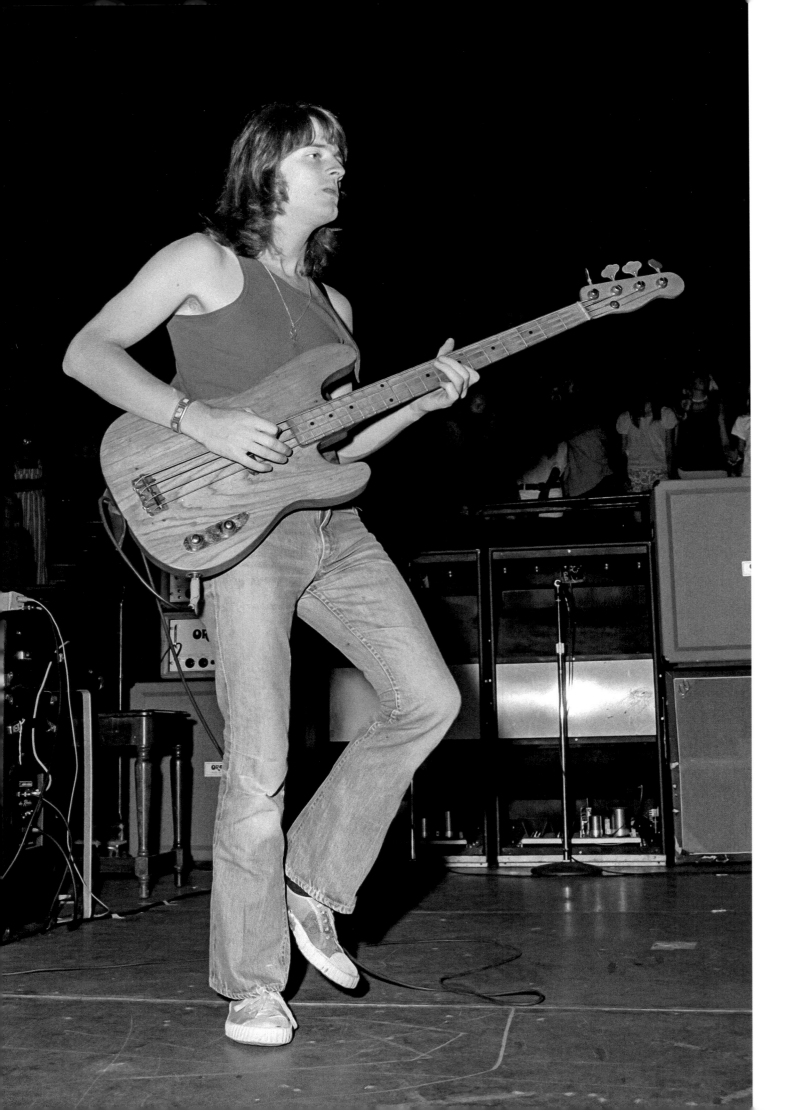

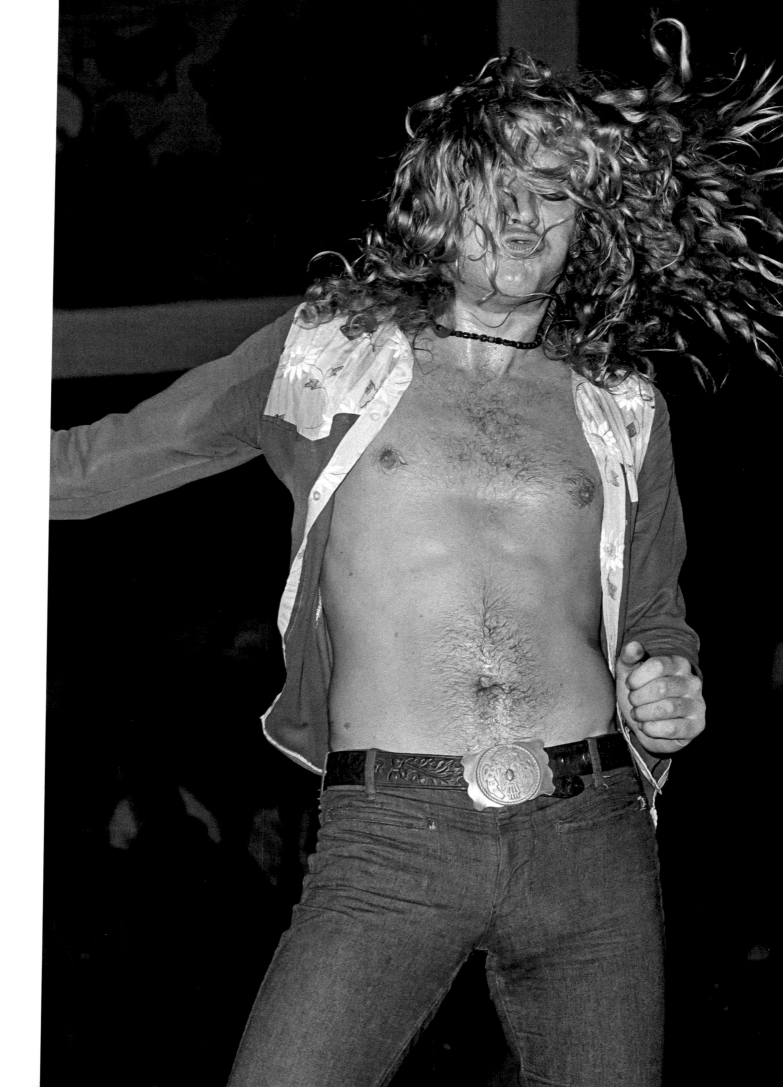

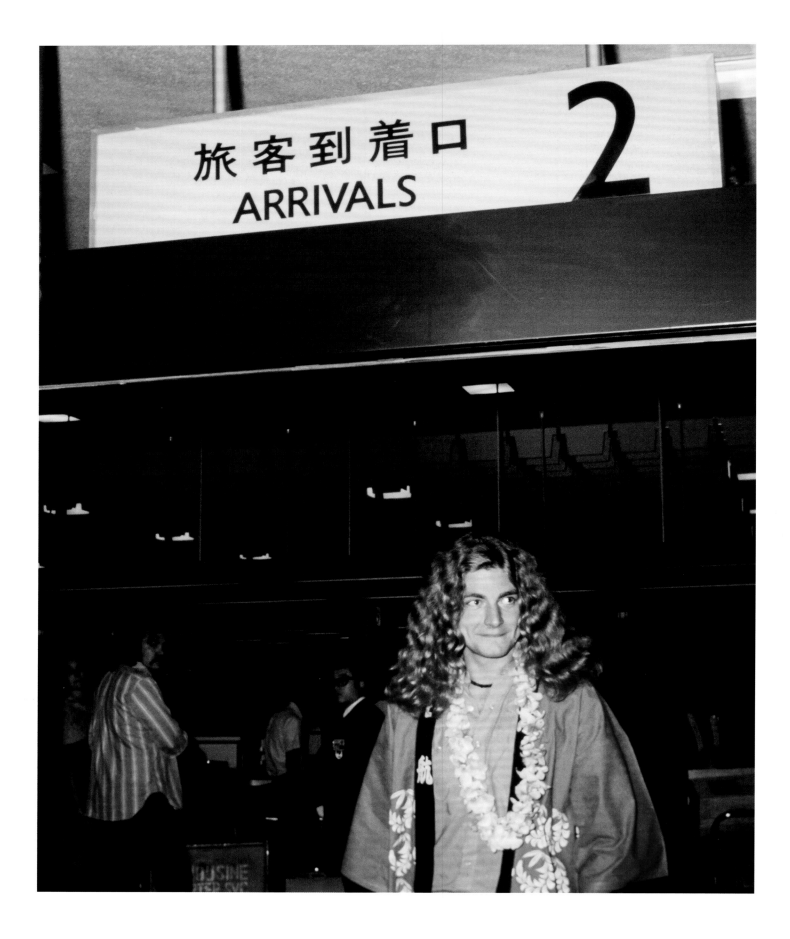

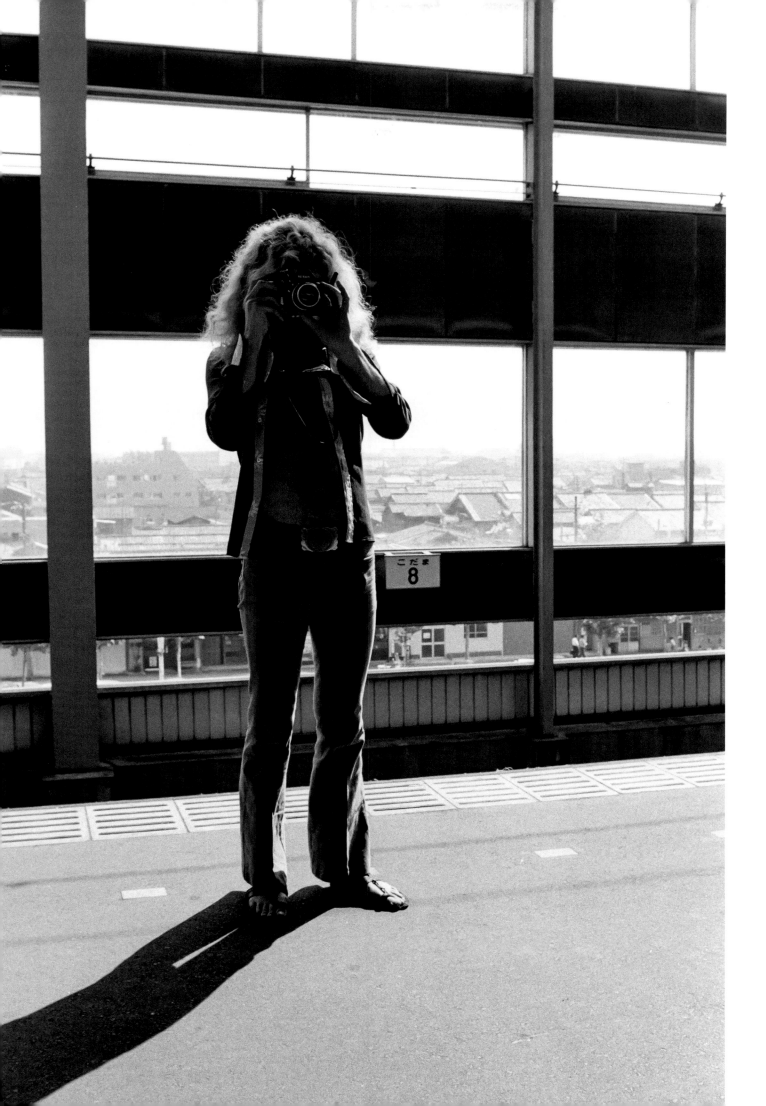

SEPTEMBER 1971
Haneda Airport,
Tokyo, Japan
[far-left]

Kyoto, Japan
[left]

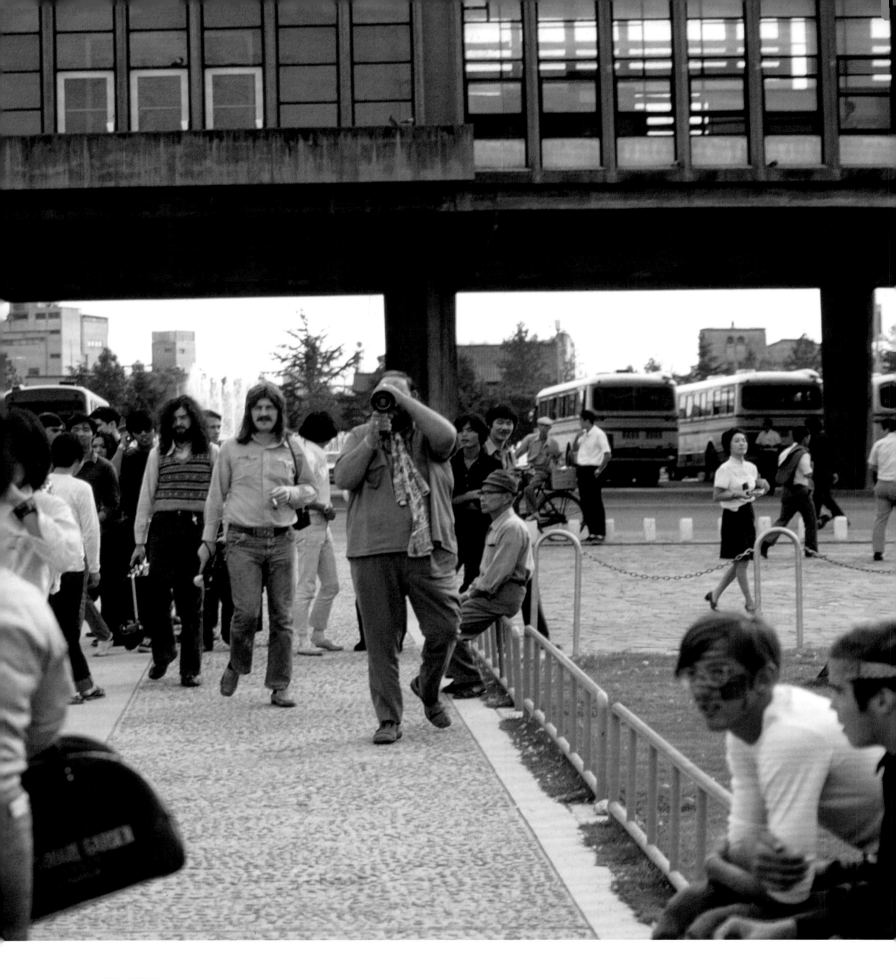

SEPTEMBER 1971

Hiroshima Peace Memorial Park, Hiroshima, Japan

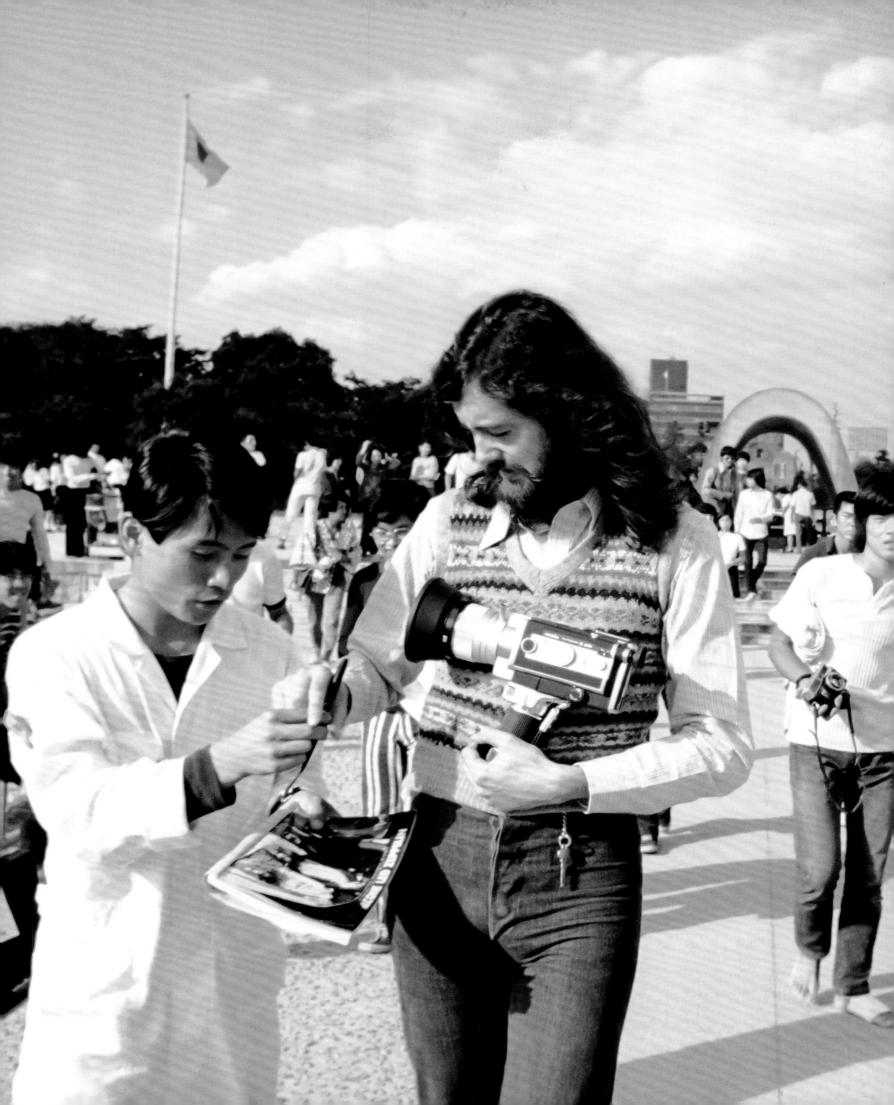

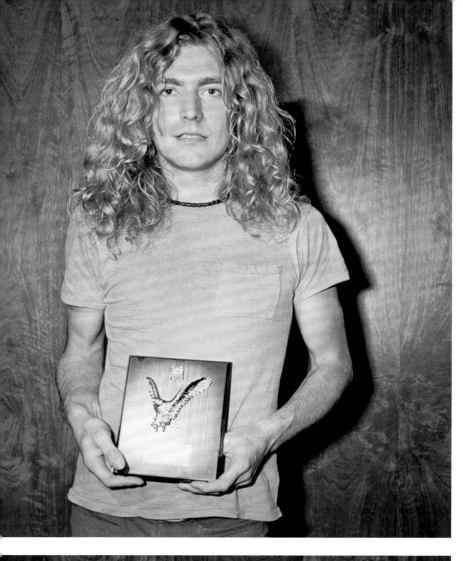
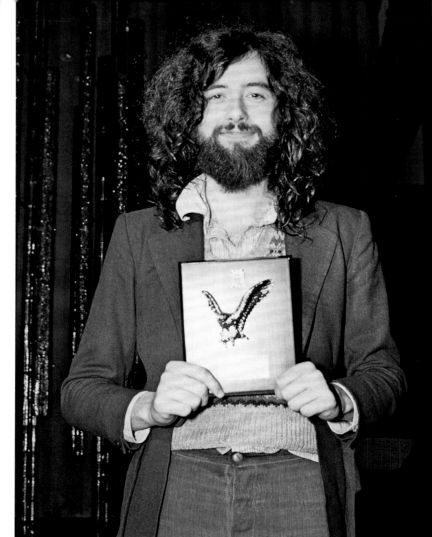
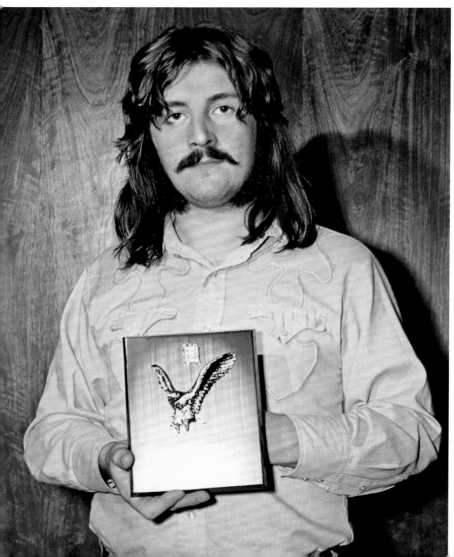
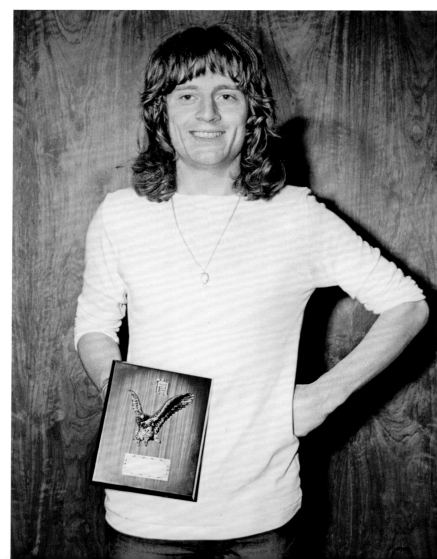

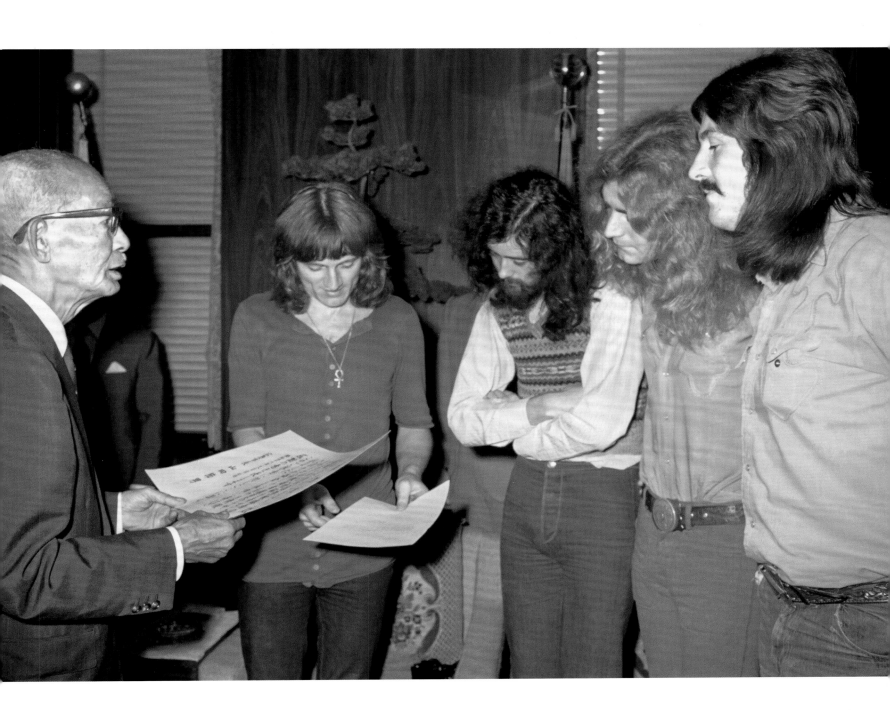

SEPTEMBER 1971

Hiroshima, Japan

[above]

Music Life Awards, Tokyo, Japan

[left]

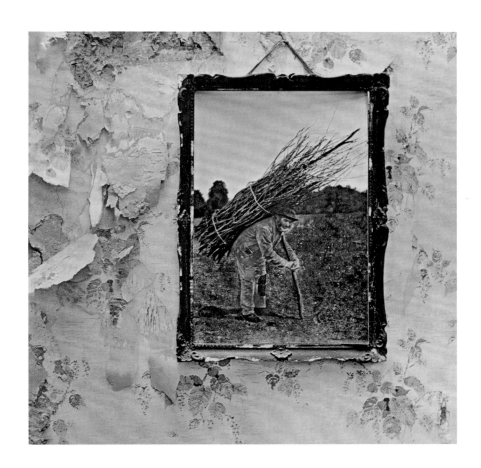

LED ZEPPELIN IV

8 November 1971

JIMMY PAGE

WE COULD NEVER FULFIL THE DEMAND OF THE AMOUNT OF PEOPLE THAT WANTED TO COME AND SEE US, ɫ WAS DICTATED BY THE SIZE OF THE VENUE WE WERE PLAYING AT.

20 NOVEMBER 1971

Empire Pool, Wembley, London, UK

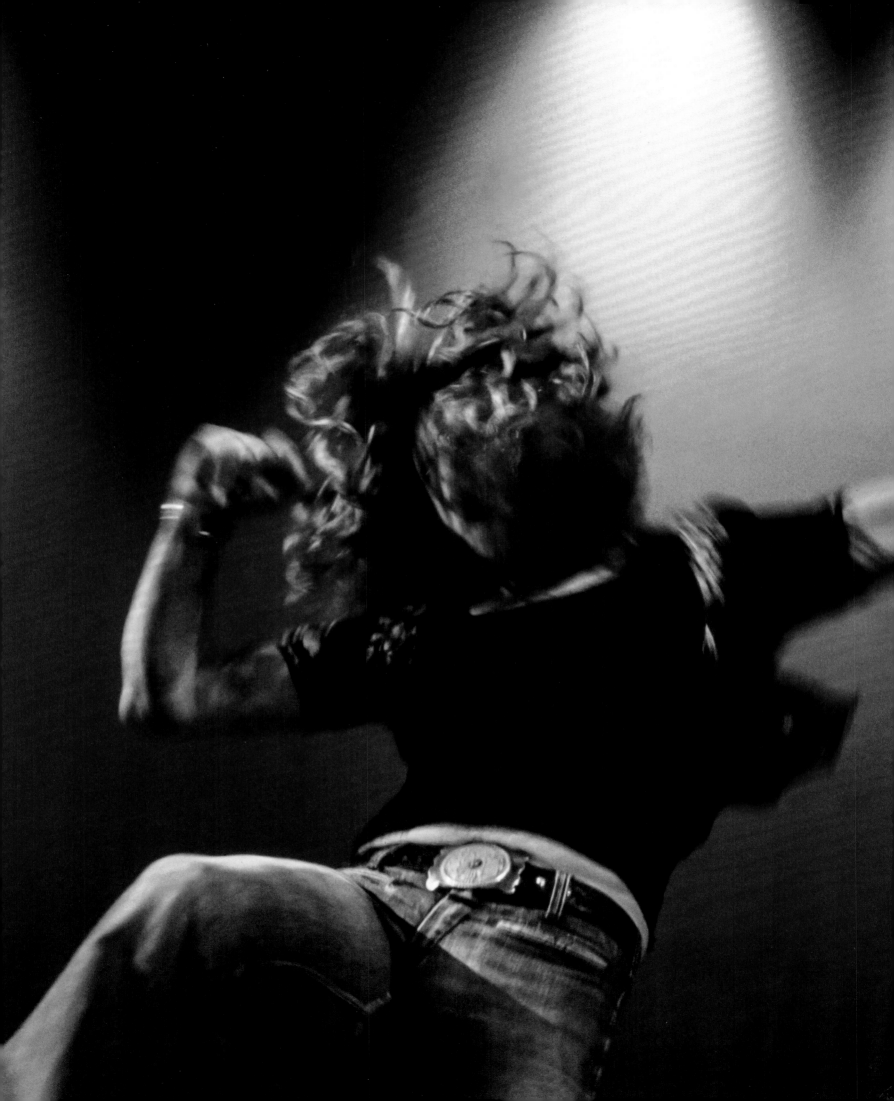

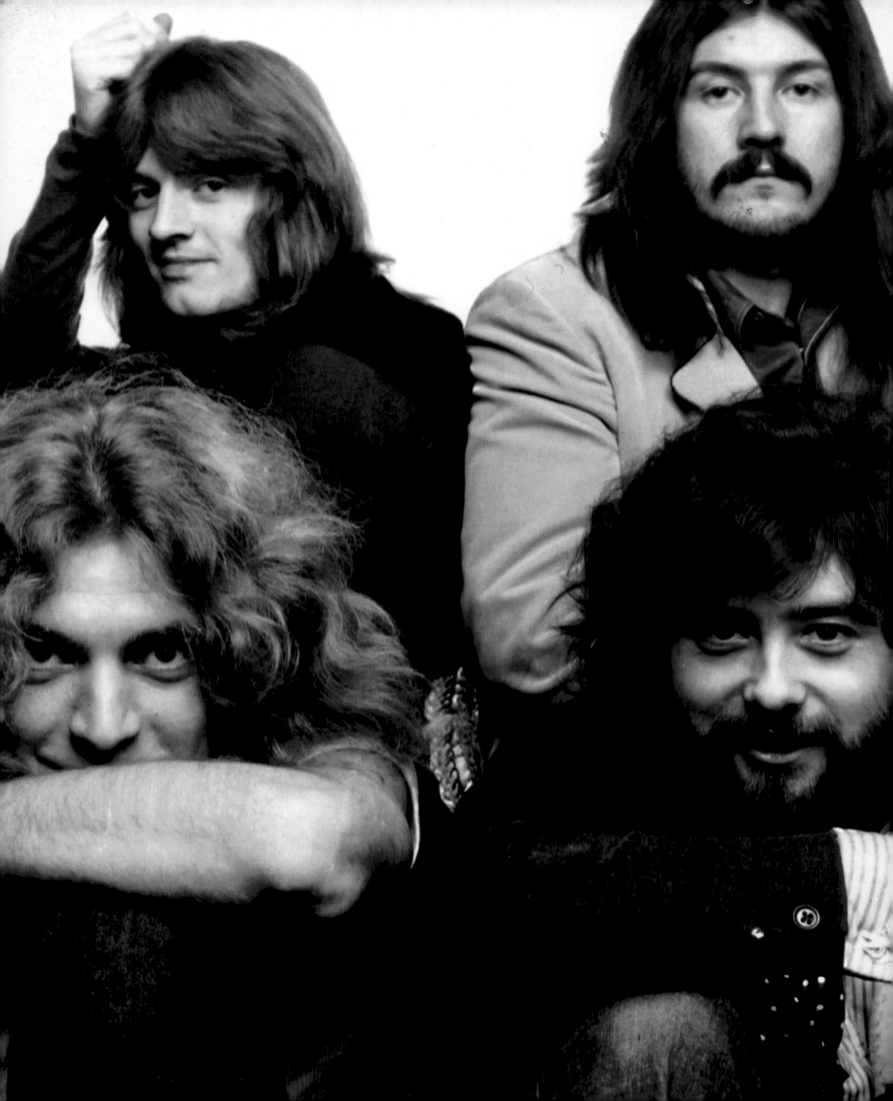

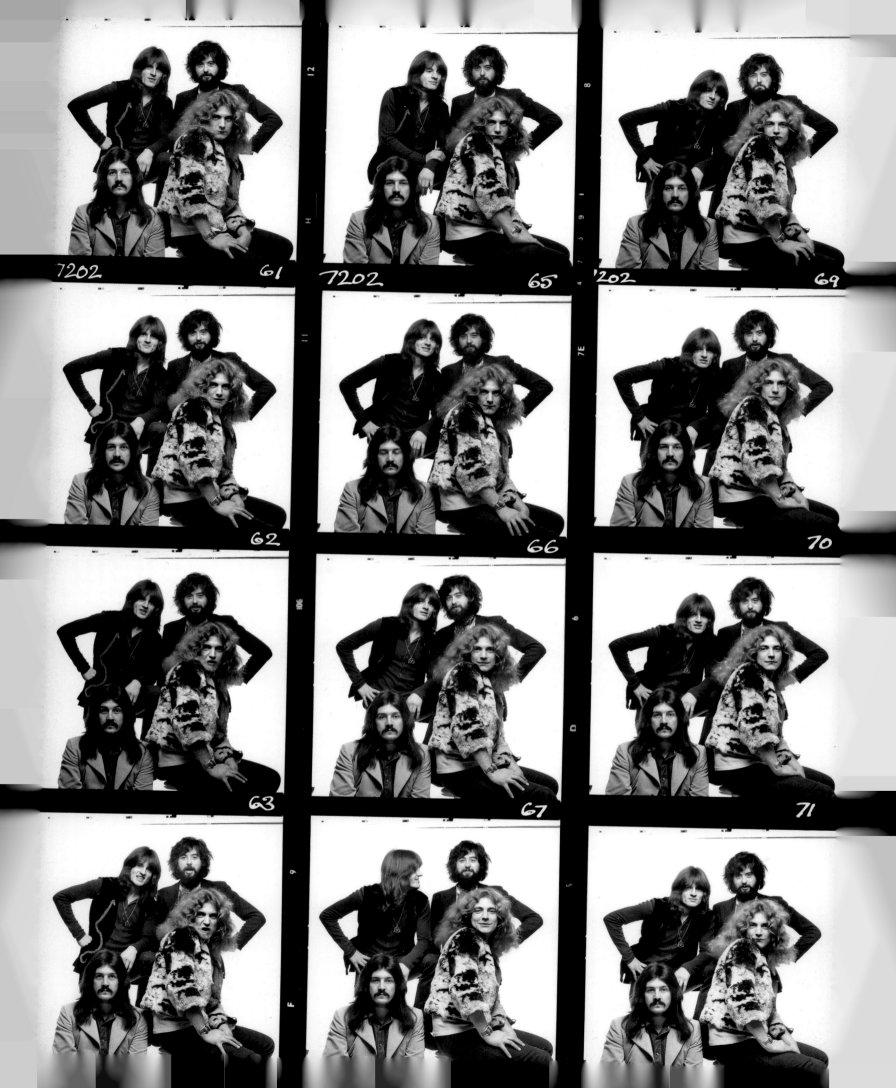

7202 61
7202 65
7202 69
62
66
70
63
67
71

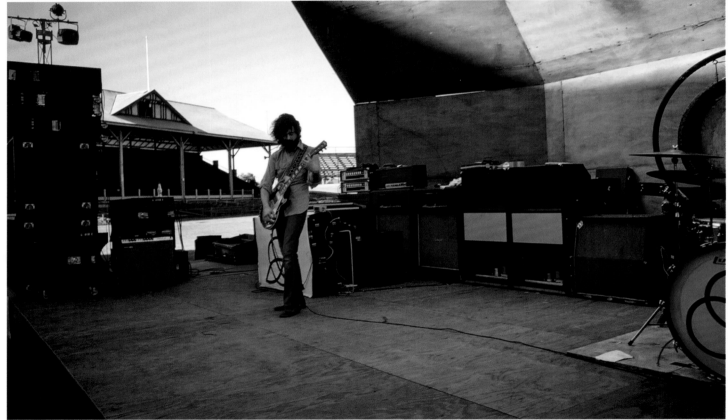

20 FEBRUARY 1972

Kooyong Stadium, Melbourne, Australia

[184—185]

16 FEBRUARY 1972

Subiaco Oval, Perth, Australia

Soundcheck

[above and top-right]

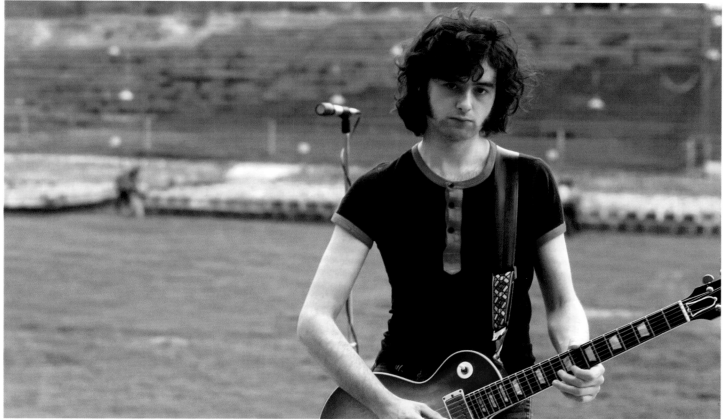

25 FEBRUARY 1972

Western Springs Stadium, Auckland, New Zealand

Soundcheck

[bottom]

20 FEBRUARY 1972

Kooyong Stadium, Melbourne, Australia

[188—189]

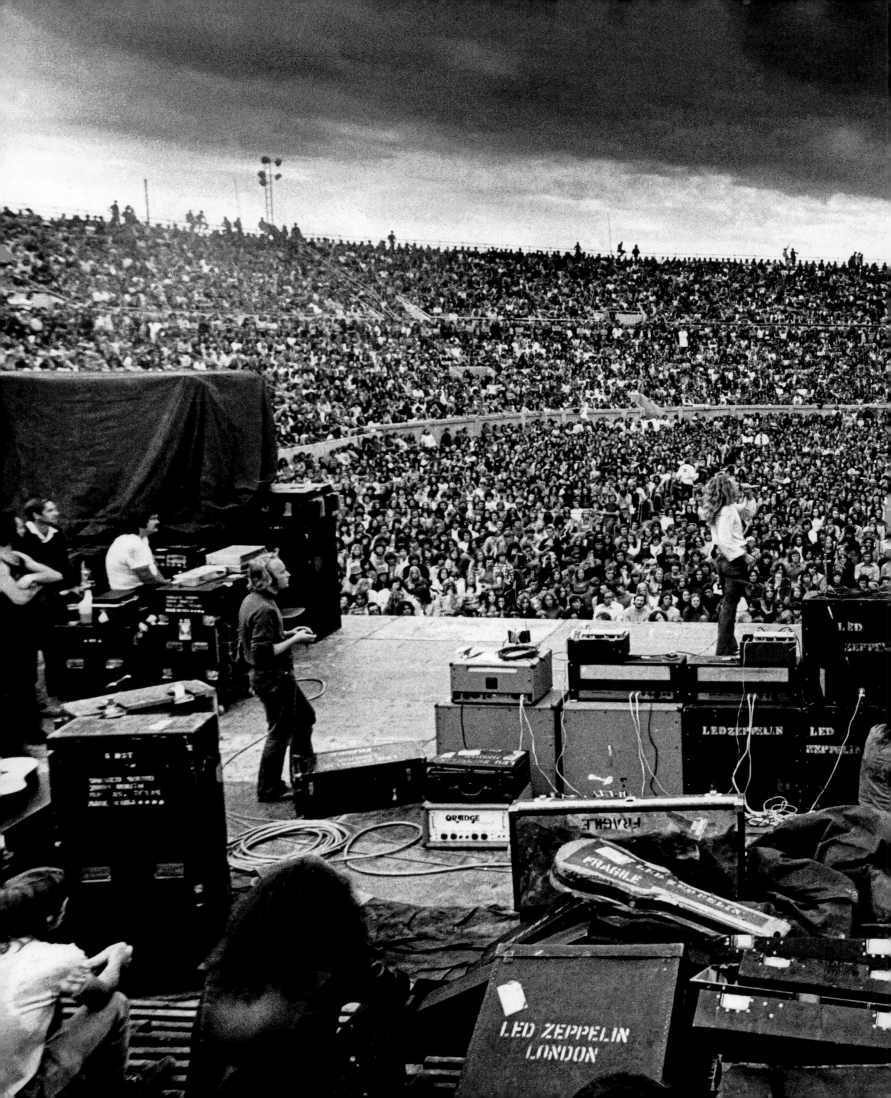

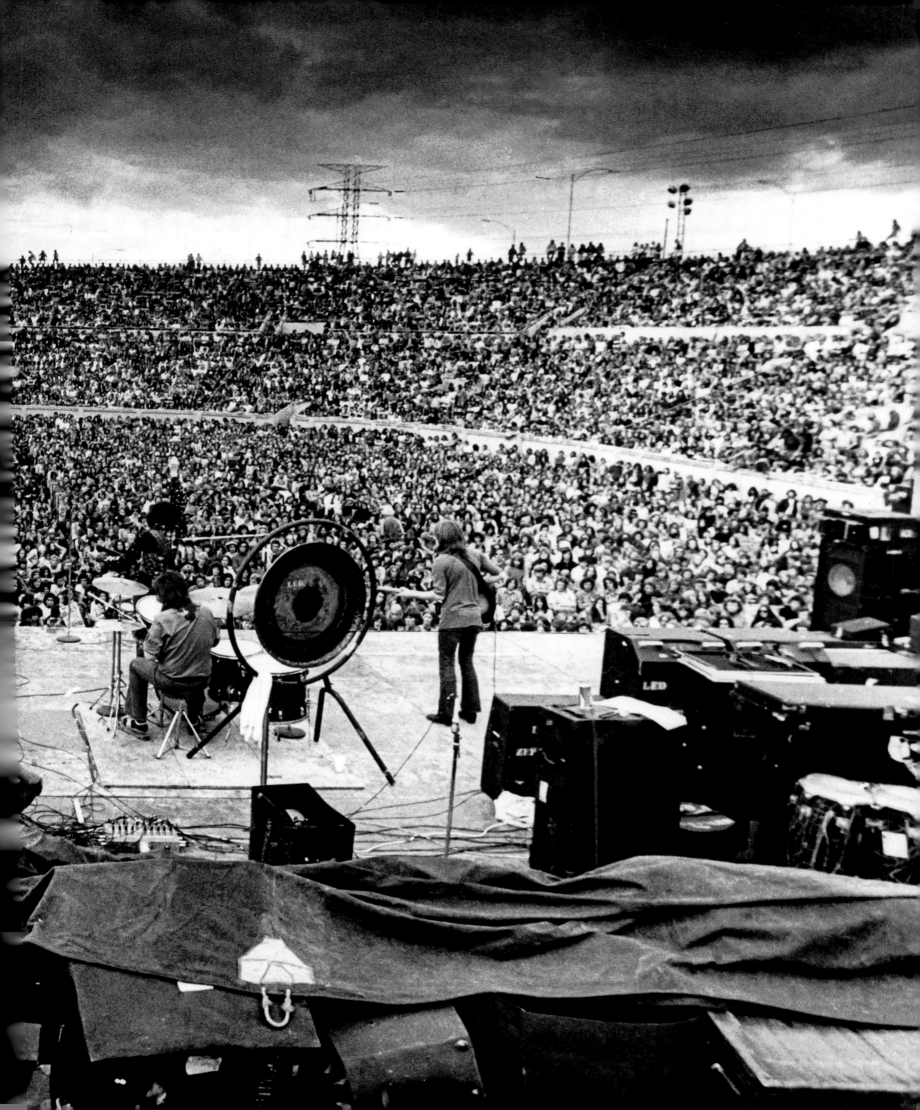

THE THING ABOUT LOCATION RECORDING IS THAT THERE IS NO TIME RESTRAINT, YOU CAN BE CREATIVE AND INVENTIVE, YOU HAVE THE EQUIPMENT THERE INDEFINITELY.

ROBERT PLANT

MAY 1972

Stargroves, Hampshire, UK

[190—193]

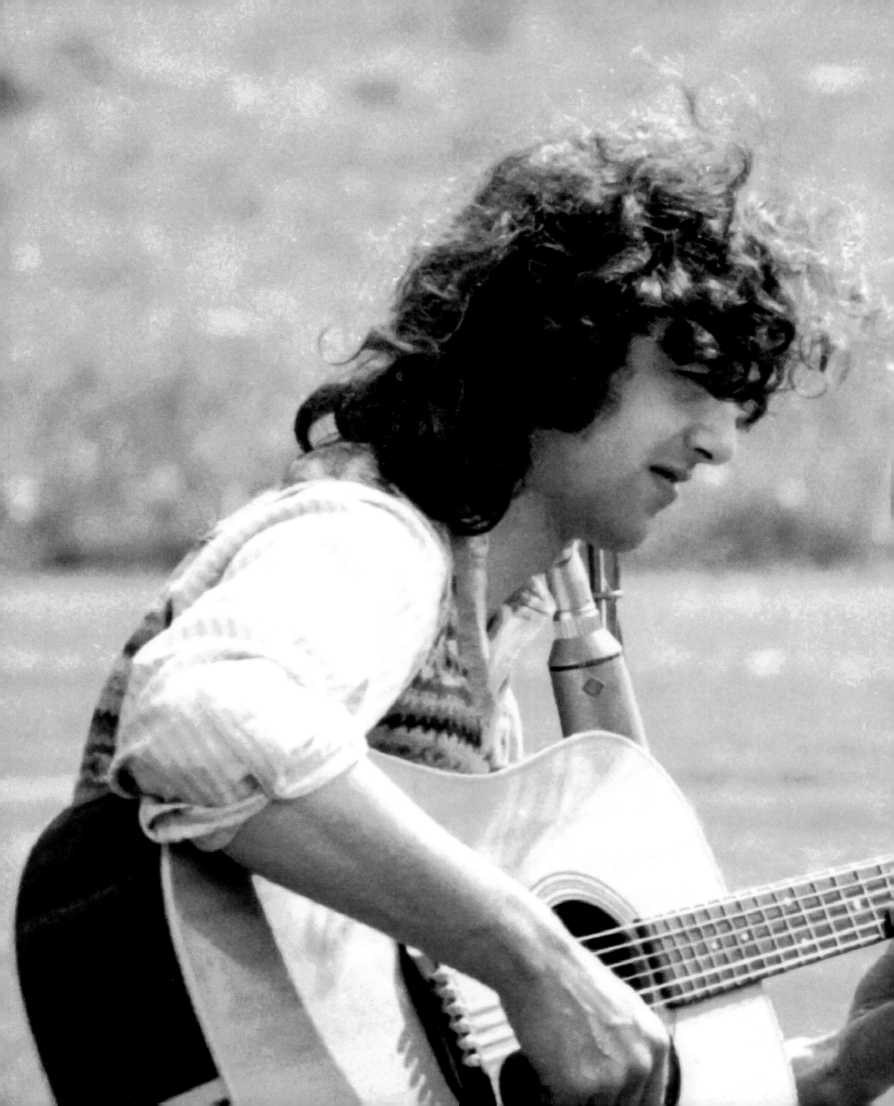

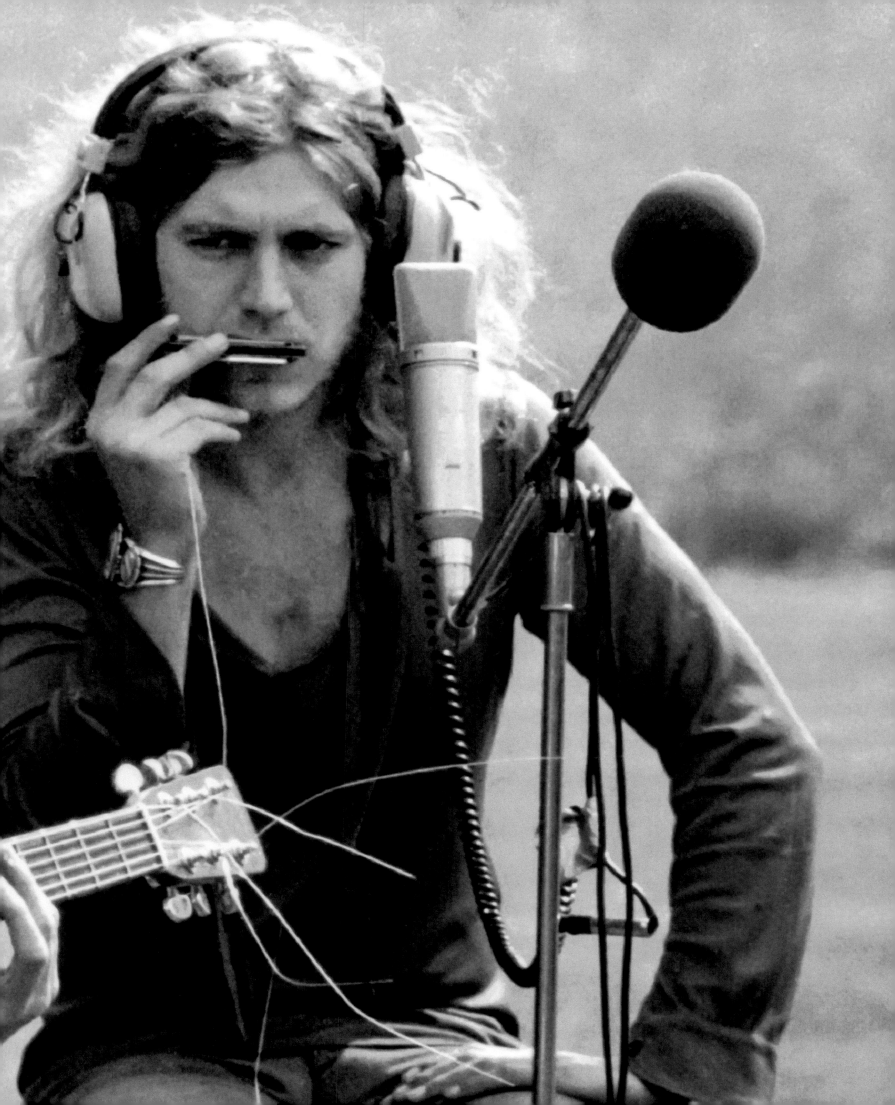

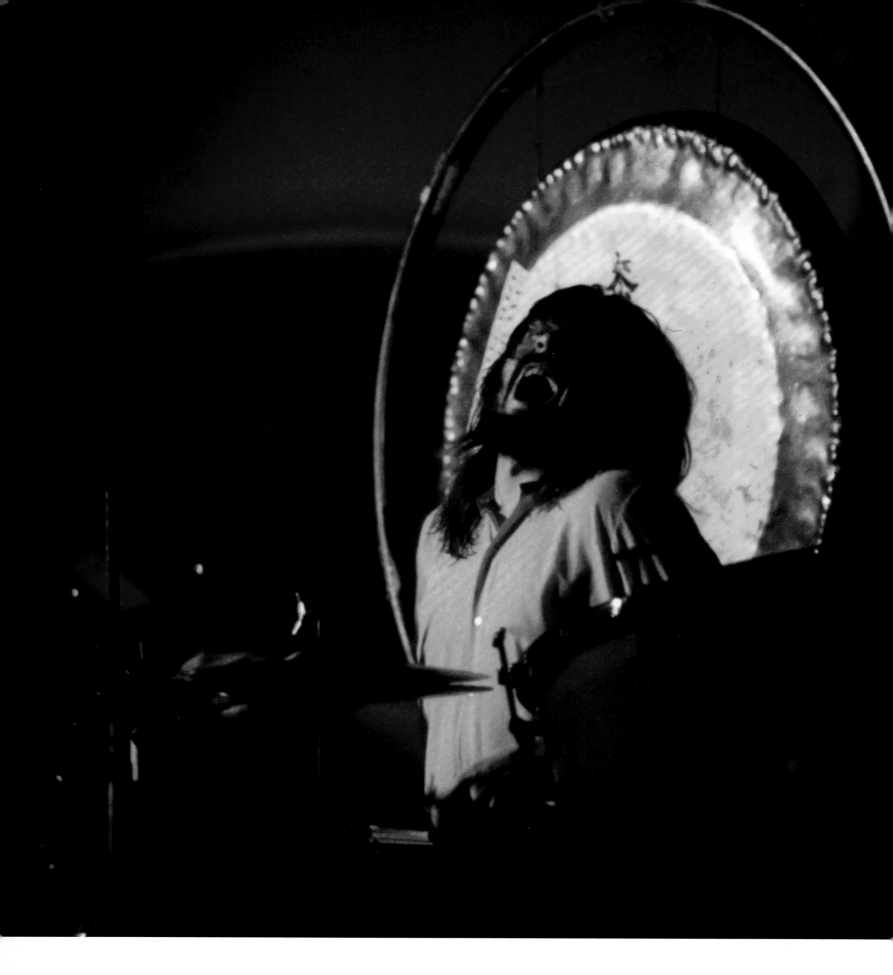

29 OCTOBER 1972

Pavillon, Montreux, Switzerland

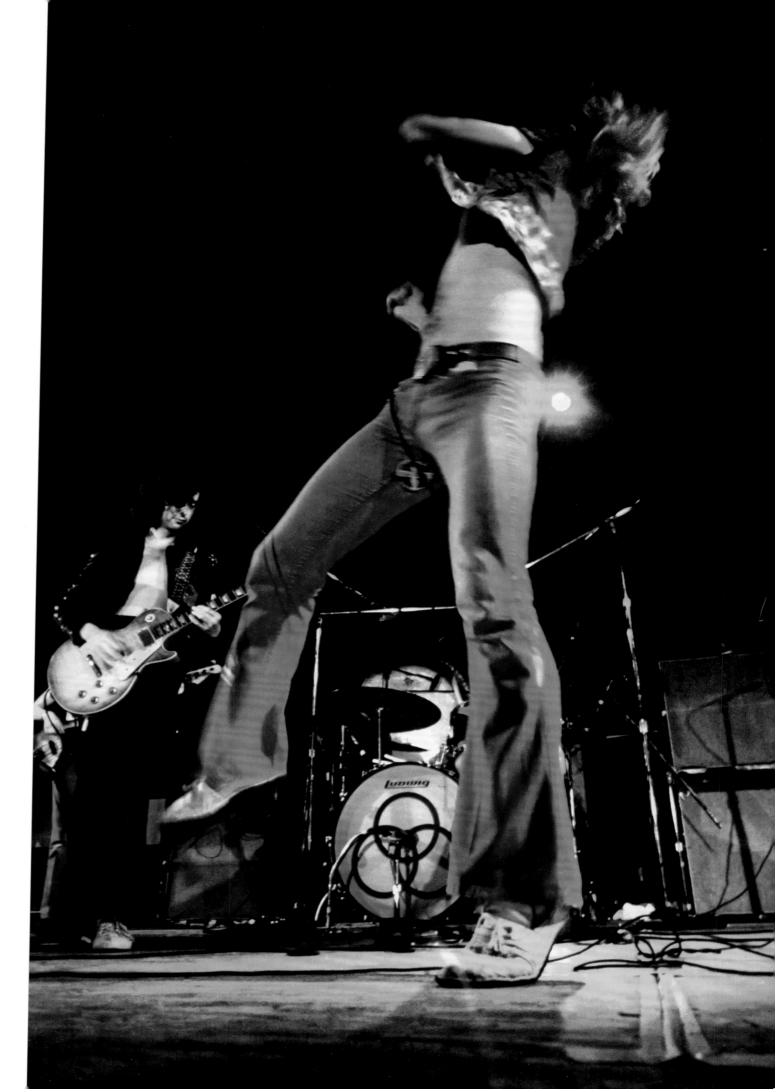

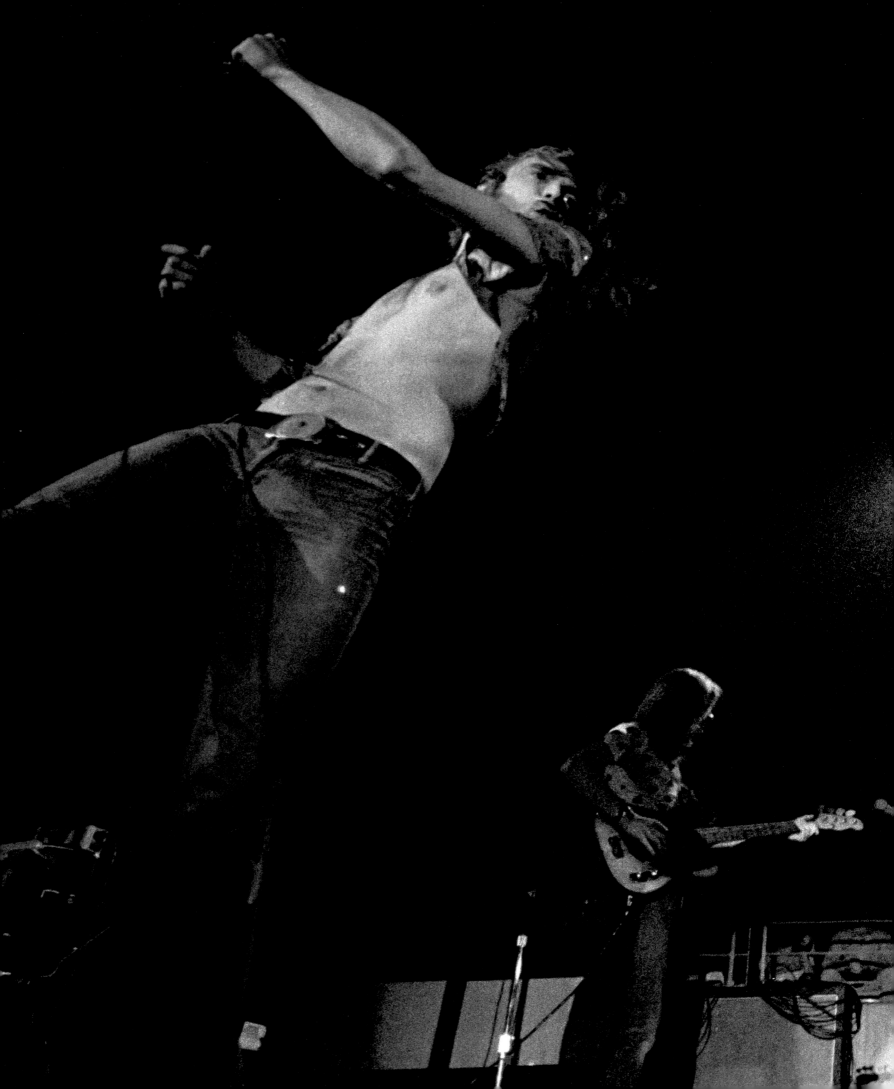

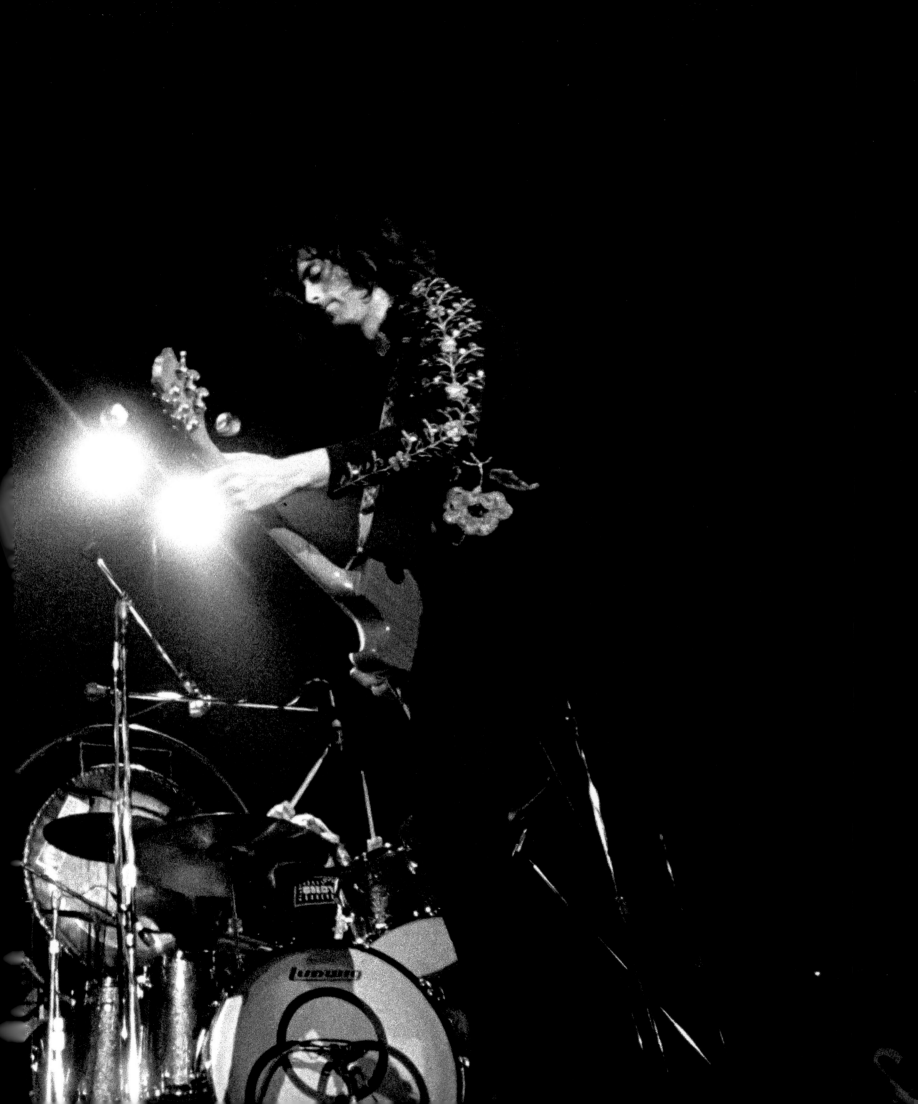

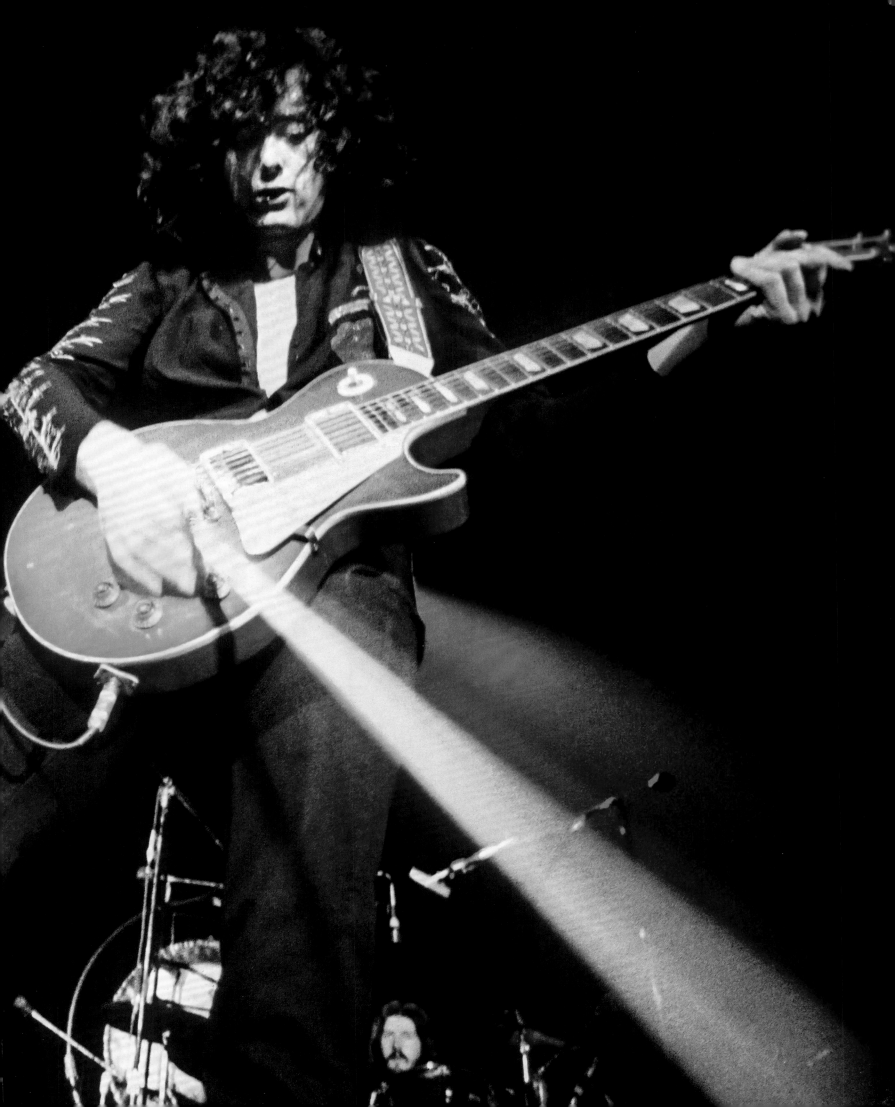

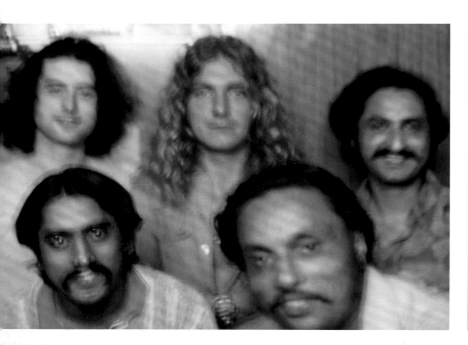

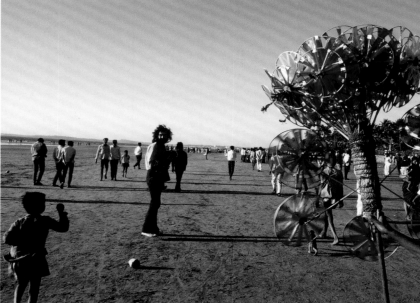

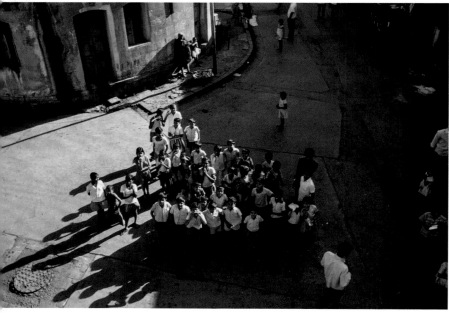

OCTOBER 1972

Bombay, India

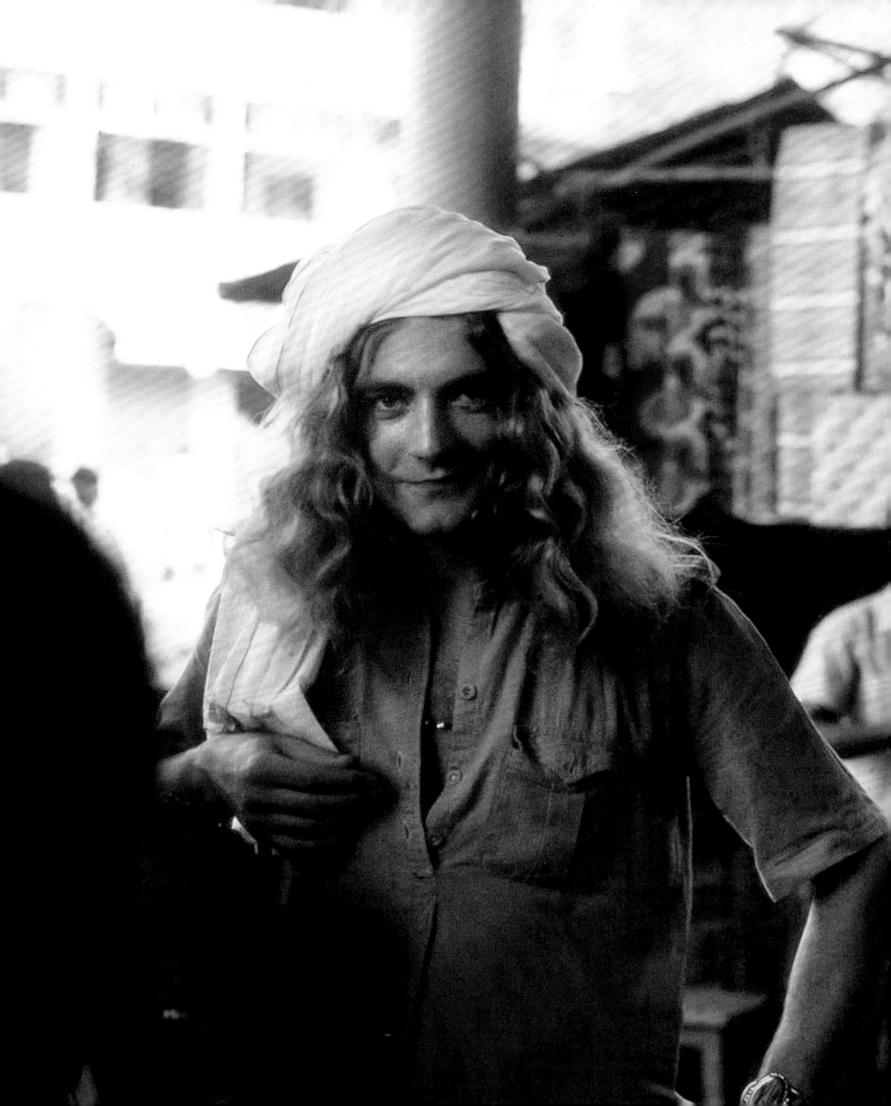

JOHN PAUL JONES

BECAUSE PA EQUIPMENT WAS SO LIMITED, WE TRIED TO GET AS MUCH COMING FROM THE STAGE AS POSSIBLE AND JUST HOPE IT WENT FURTHER. ROBERT HAD TO SING OVER THAT BUT HE WAS A YOUNG LAD WITH STRONG VOCAL CHORDS.

30 JANUARY 1973

Preston Guild Hall, Preston, UK

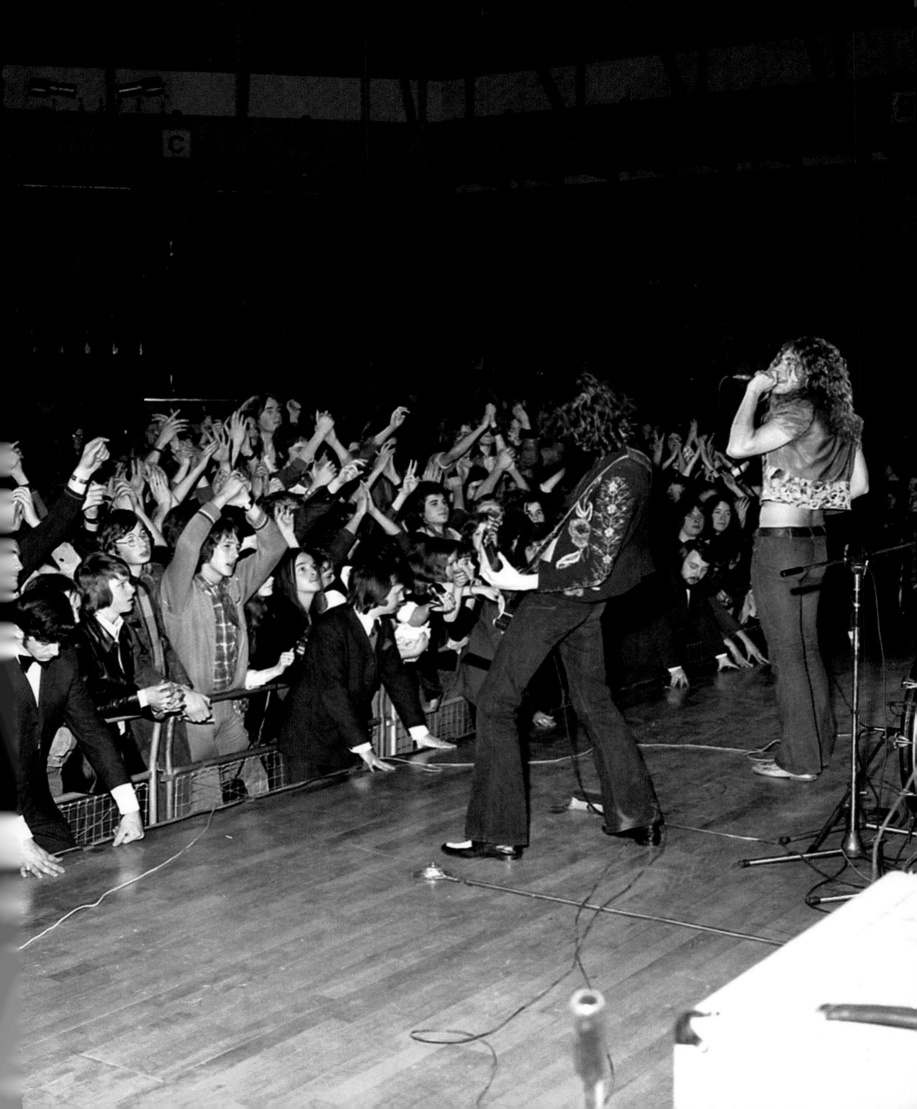

HOUSES OF THE HOLY

26 March 1973

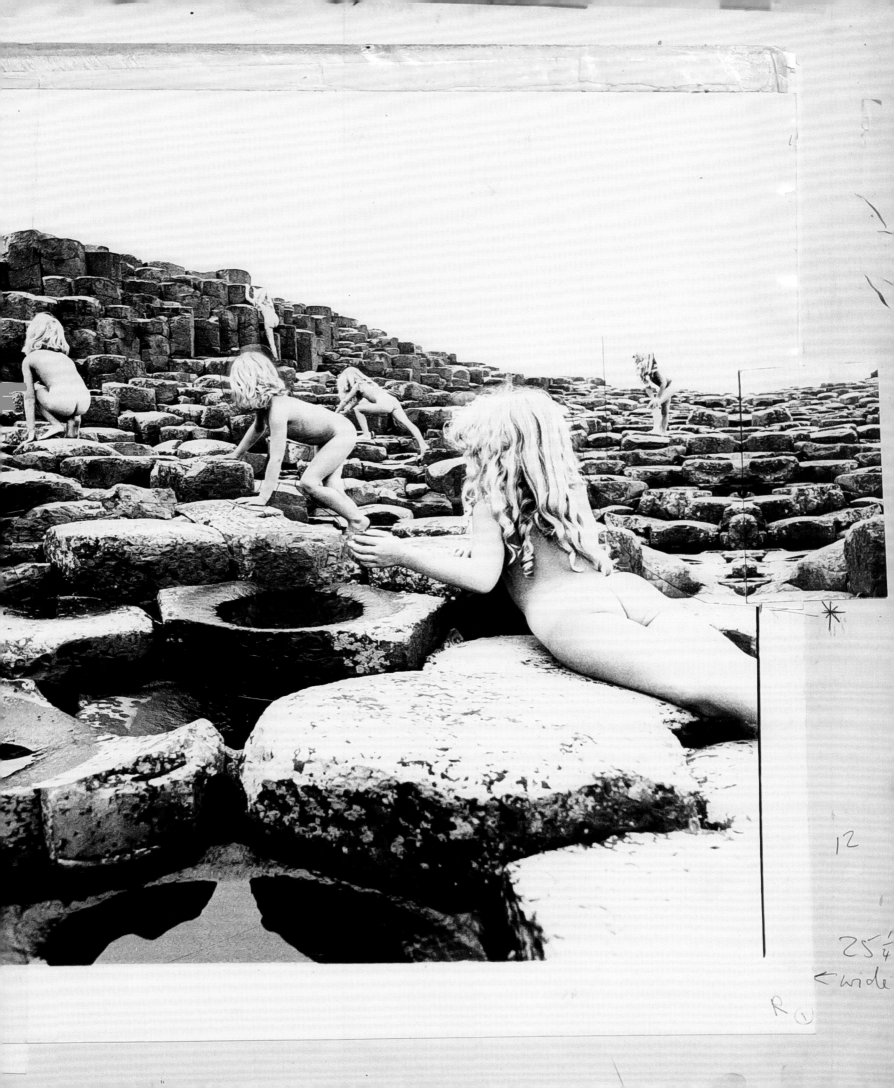

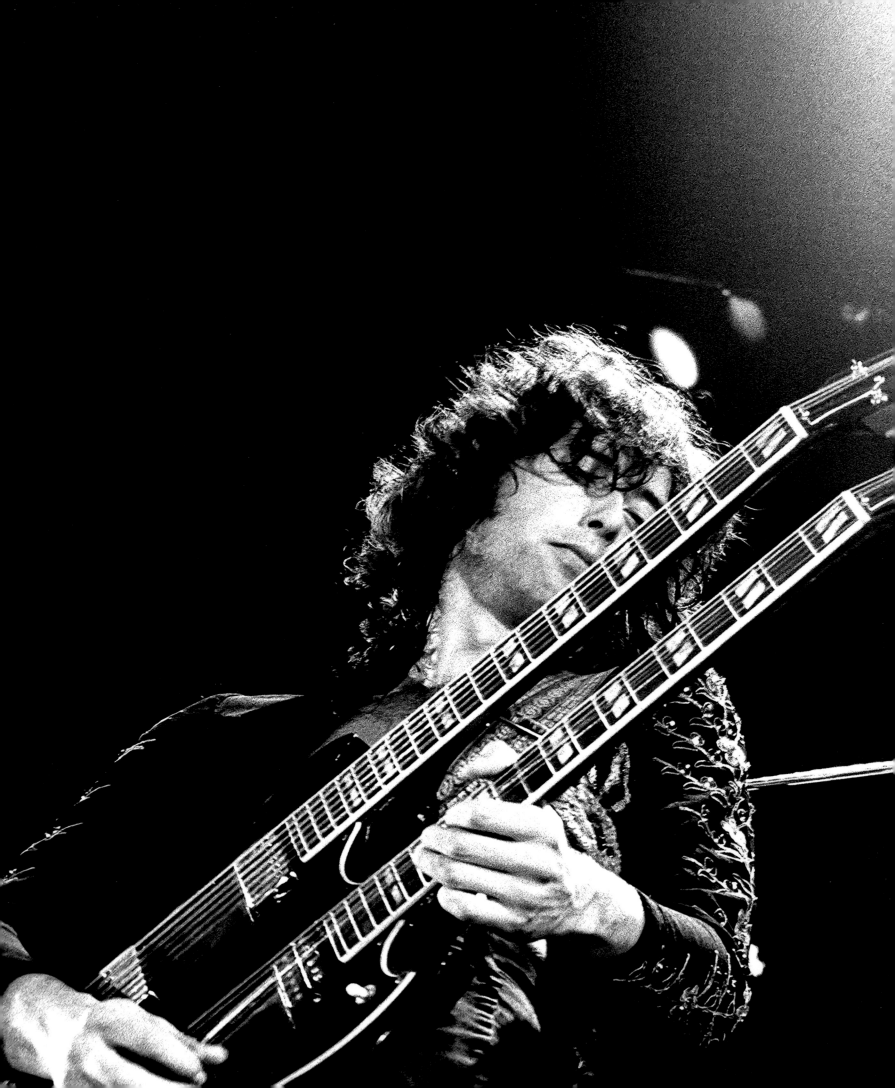

'STAIRWAY' WAS THE SONG THAT DEMANDED THAT GUITAR, I DON'T THINK ANYONE HAD APPLIED IT LIKE THIS IN A LIVE SITUATION AND MADE IT SO ICONIC.

JIMMY PAGE

31 MAY 1973

The Forum, Los Angeles, California, USA

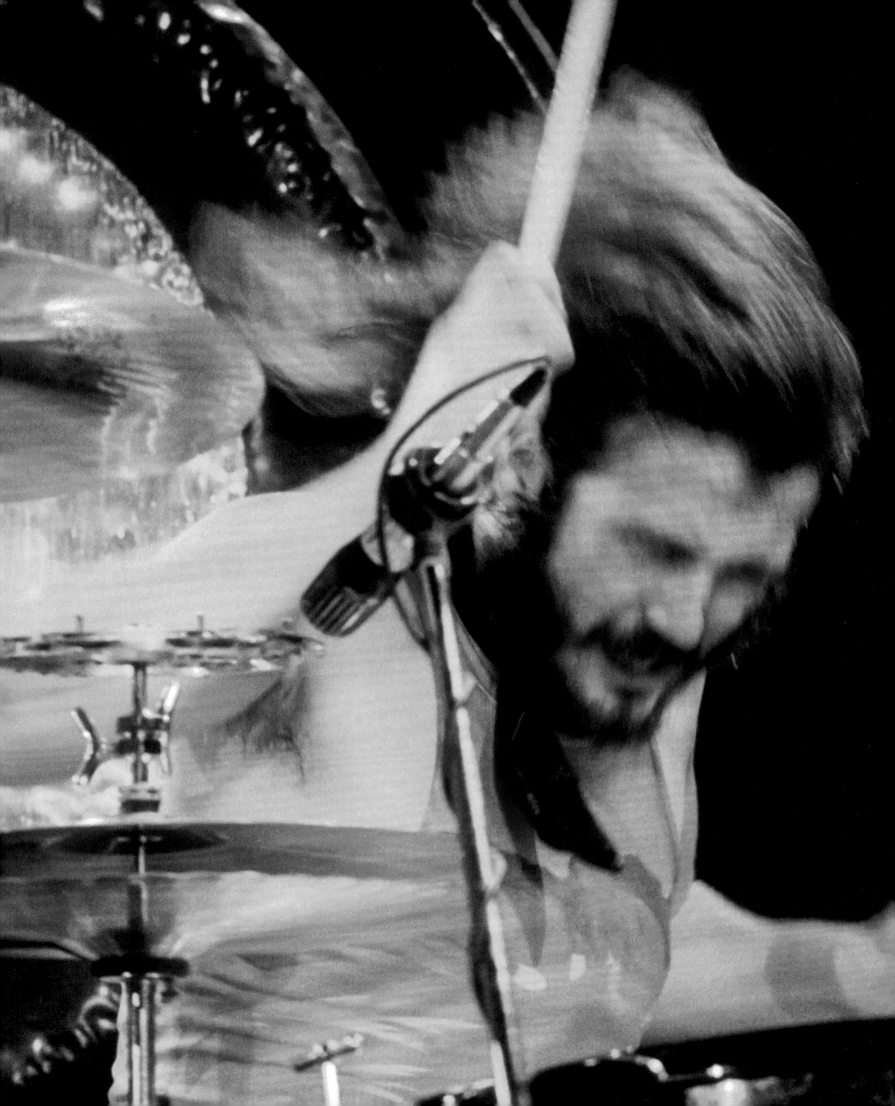

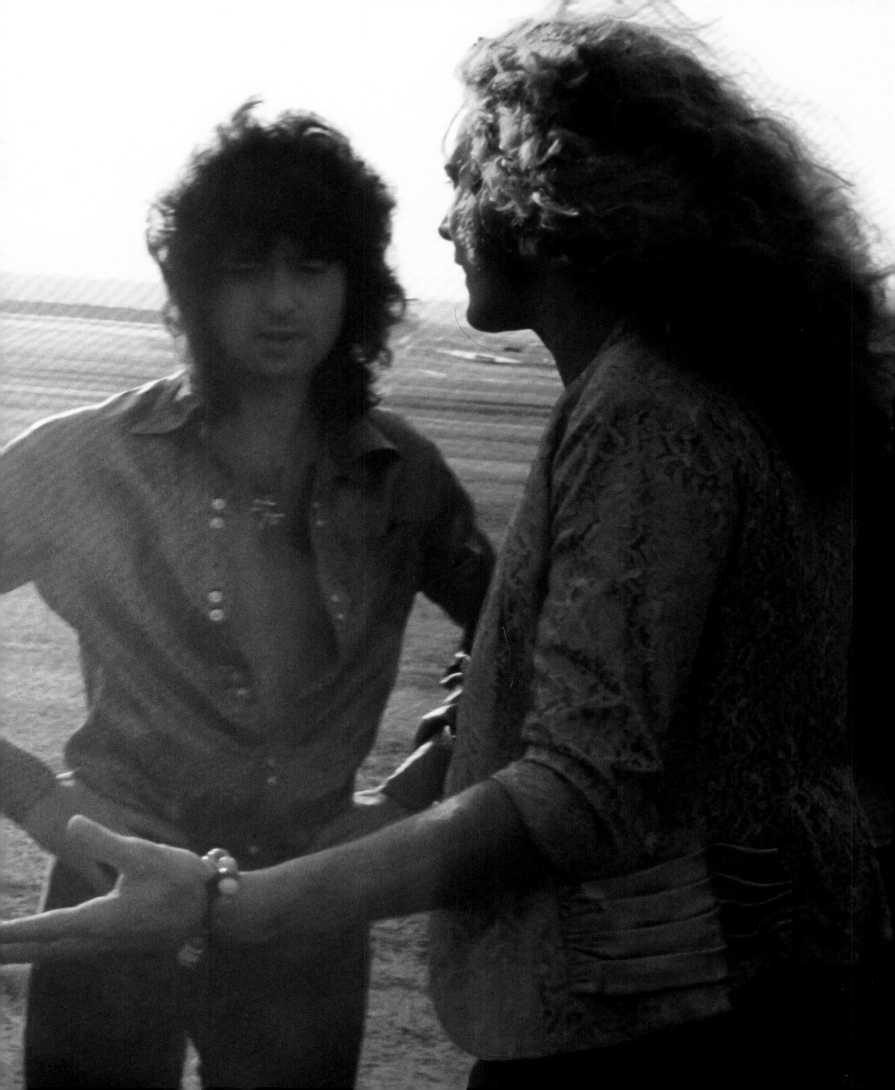

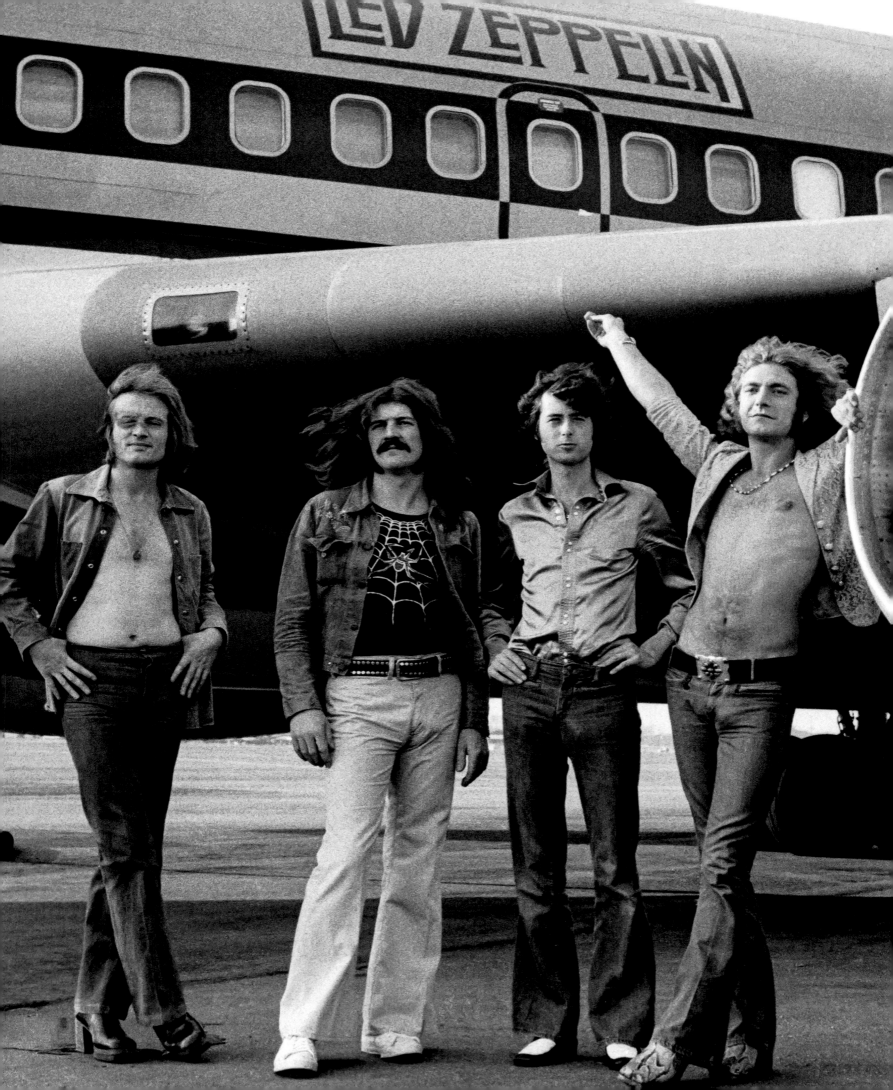

HAVING OUR OWN PLANE WAS PRACTICAL, LITERALLY JUST TO GET AROUND. YOU COULD LEAVE YOUR HOTEL LATE-ISH, GET ON THE PLANE, DO THE GIG AND GET BACK, THEN YOU WOULDN'T HAVE TO CHECK-IN, CHECK-OUT, GET ON THE ROAD; ALL THAT SORT OF STUFF.

JOHN PAUL JONES

24 JULY 1973

Teterboro Airport, New Jersey, USA

[212—214]

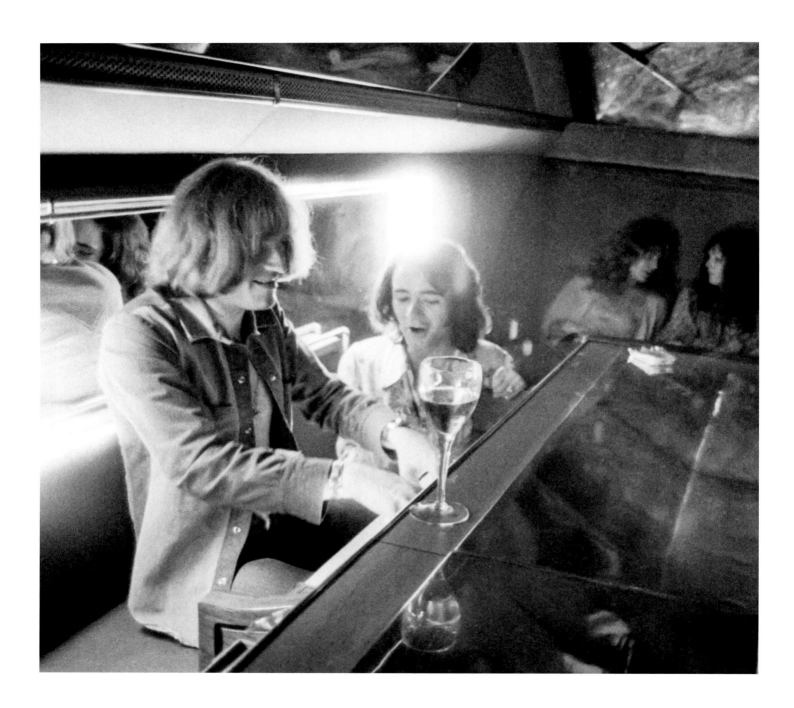

24 JULY 1973
On-board the Starship flying to Pittsburgh, USA
With BP Fallon

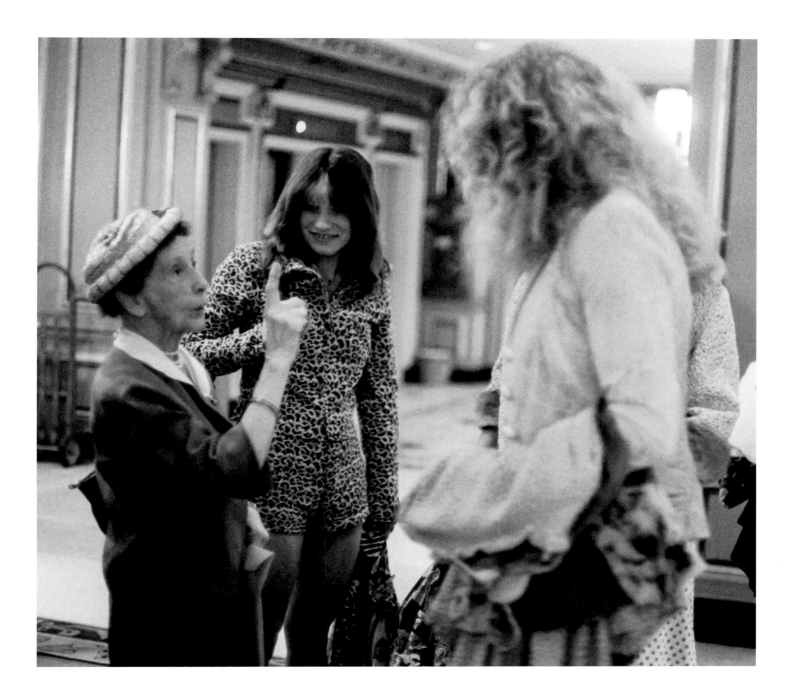

24 JULY 1973

Drake Hotel, New York, New York, USA

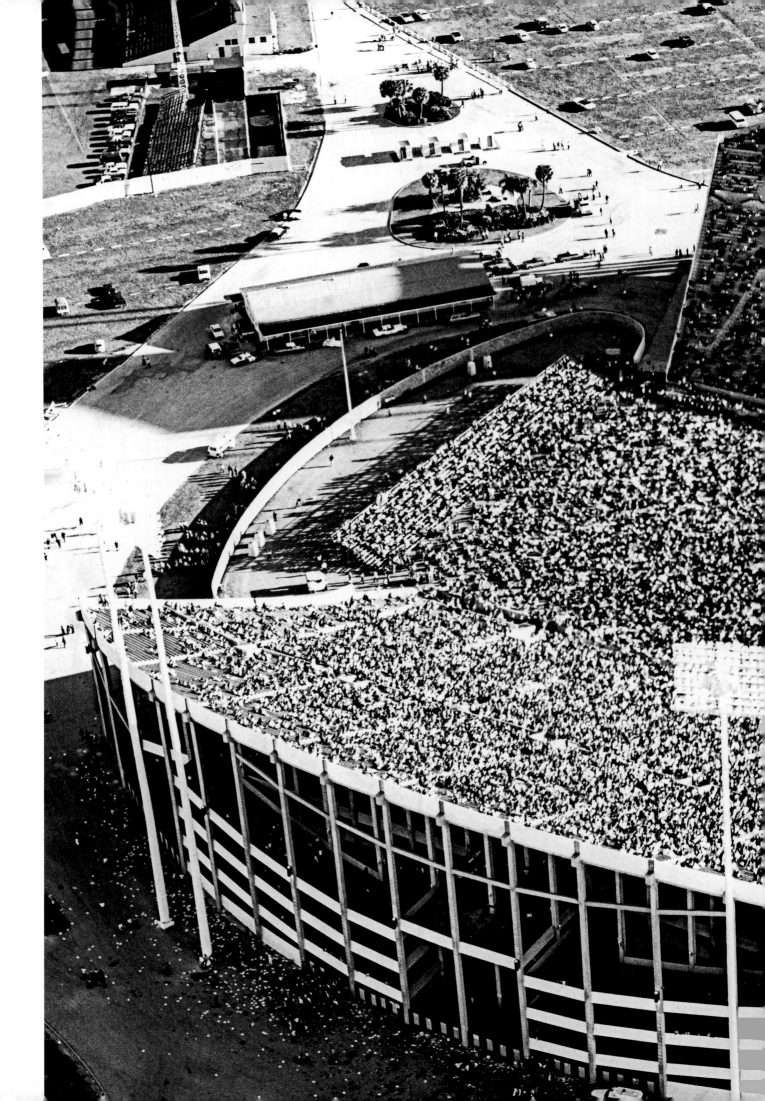

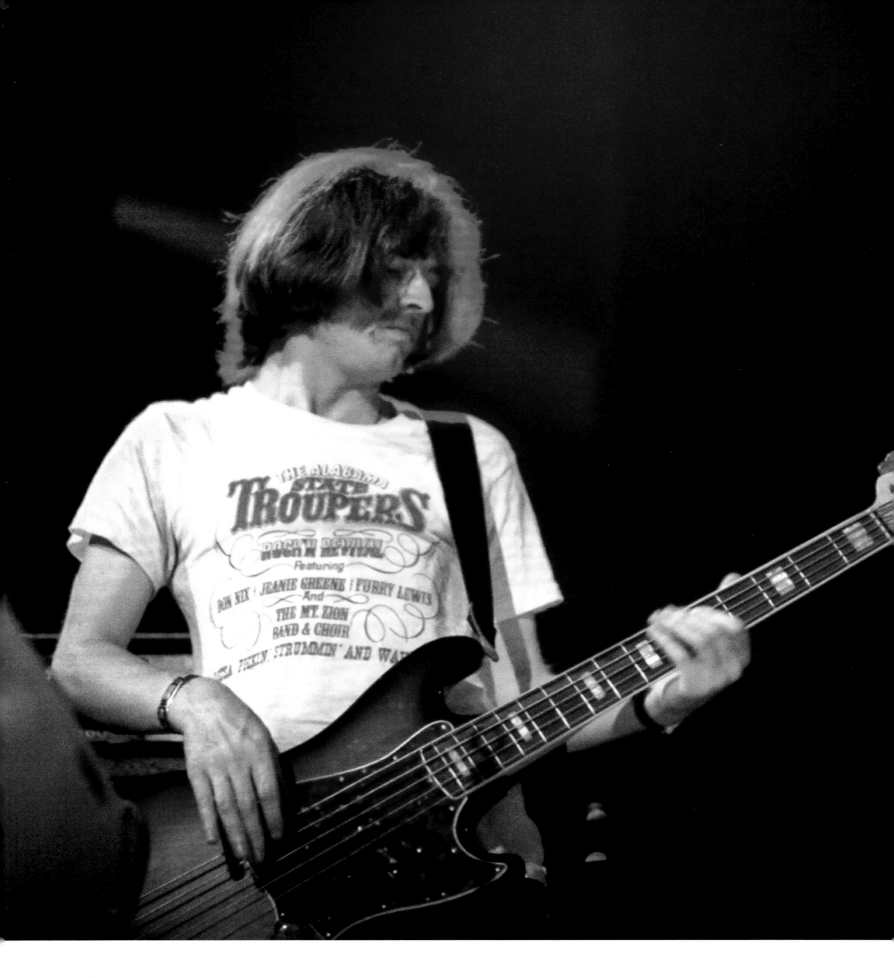

19 MAY 1973

Tarrant County Convention Center, Fort Worth, Texas, USA

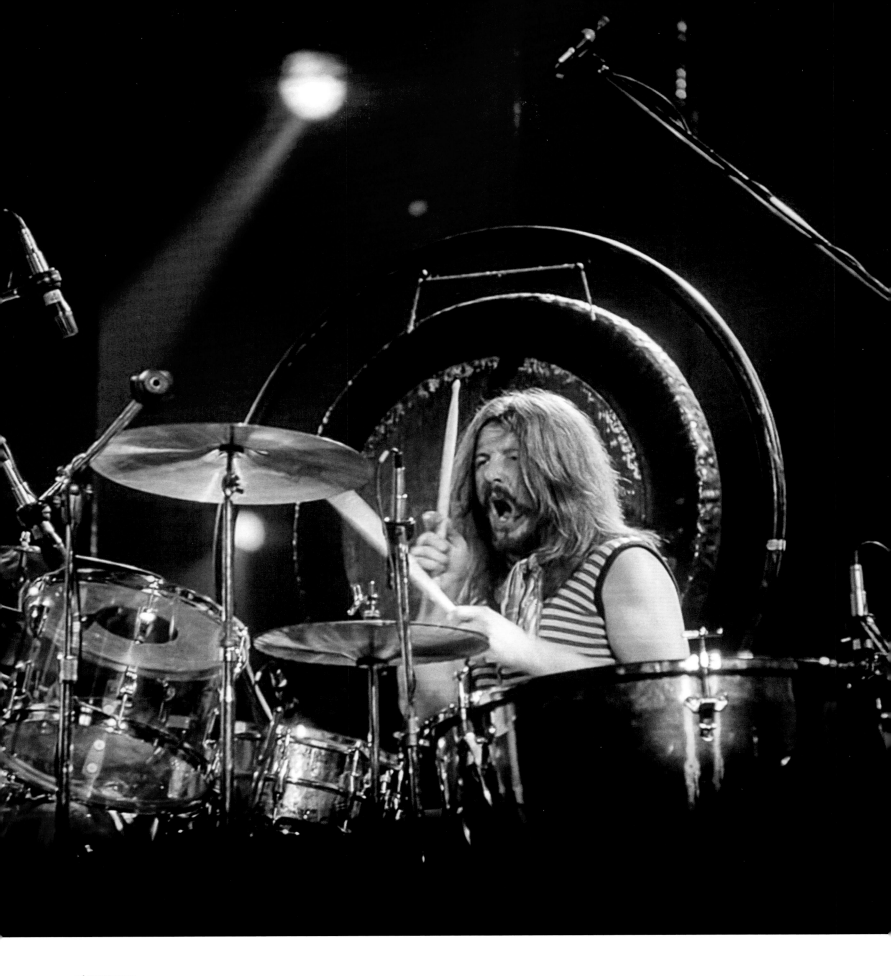

16 MAY 1973

Sam Houston Coliseum, Houston, Texas, USA

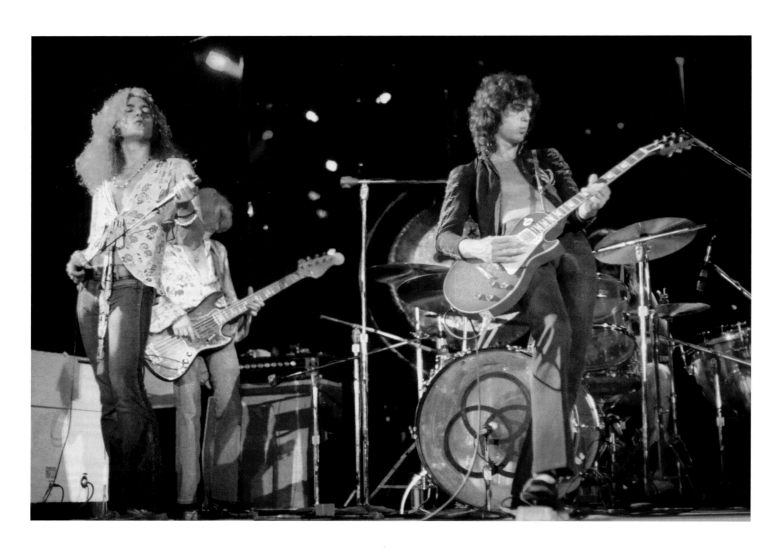

31 MAY 1973

The Forum, Los Angeles, California, USA

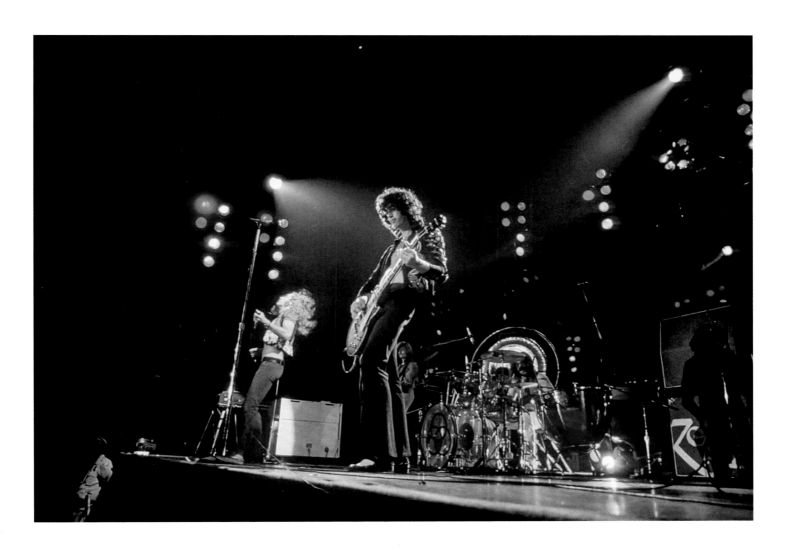

22 MAY 1973

HemisFair Arena, San Antonio, Texas, USA

IN THREE WEEKS' TIME WE'RE DUE TO RECORD AND FILM AT MADISON SQUARE GARDEN. I'M PRAYING THIS FINGER INJURY IS GOING TO RECTIFY ITSELF. WE DON'T CANCEL THE TOUR, I PLAY THROUGH IT ADAPTING MY TECHNIQUE BUT I'M RECOVERED FOR NEW YORK.

2 JUNE 1973

Kezar Stadium, San Francisco, California, USA

[225—233]

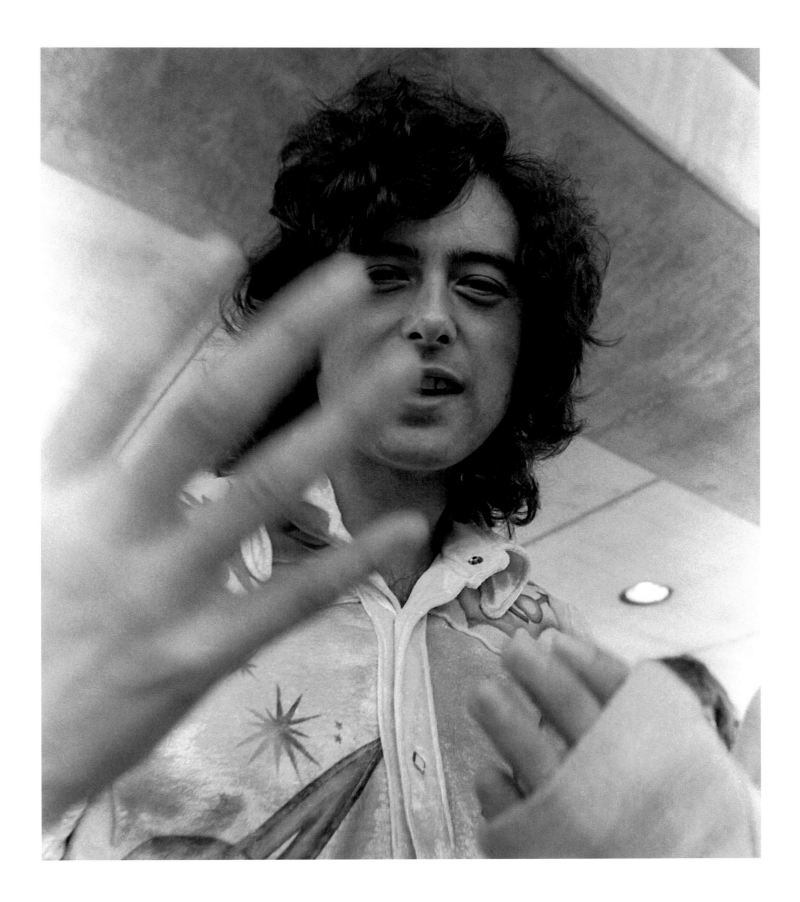

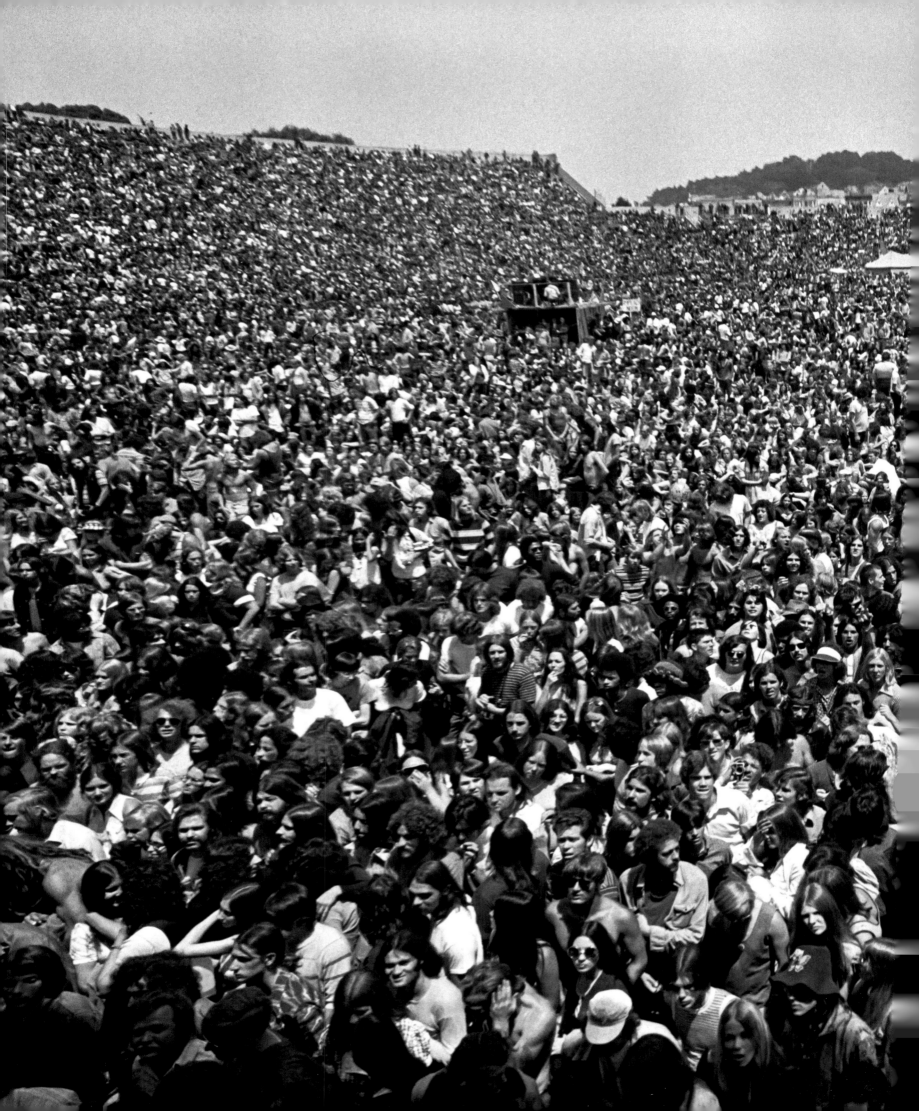

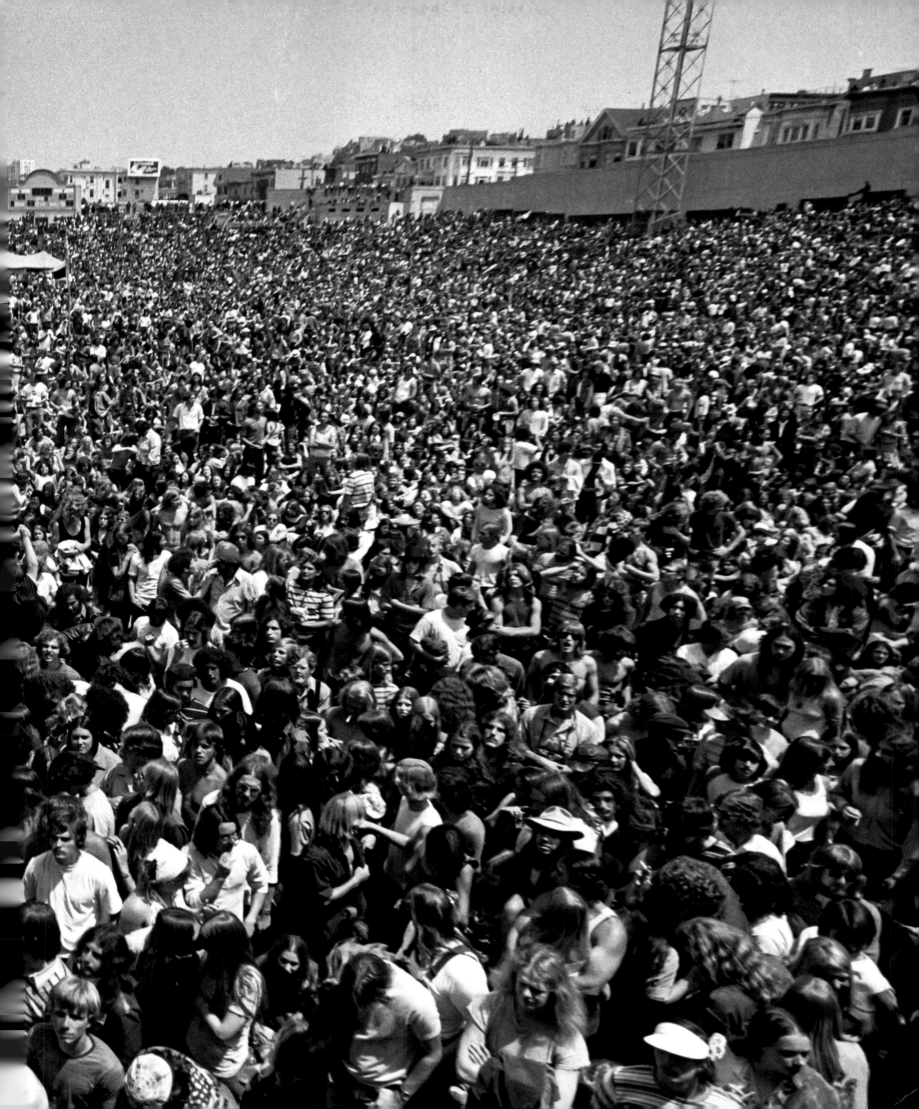

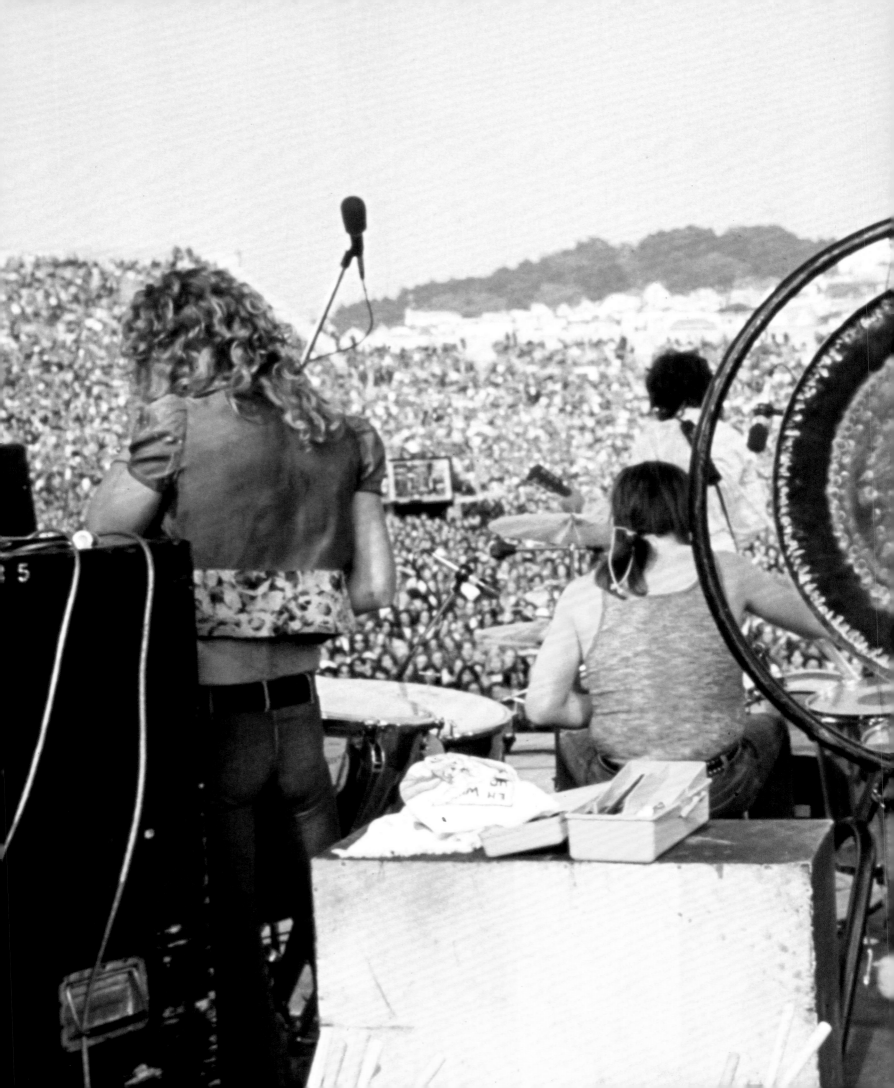

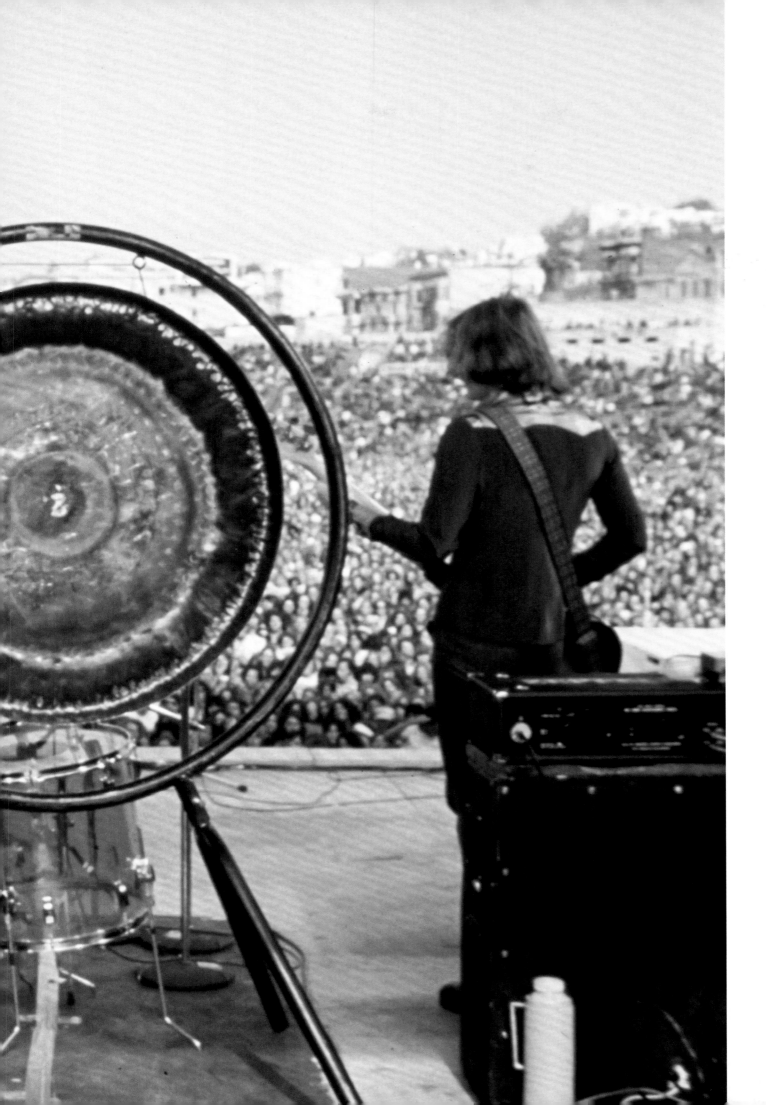

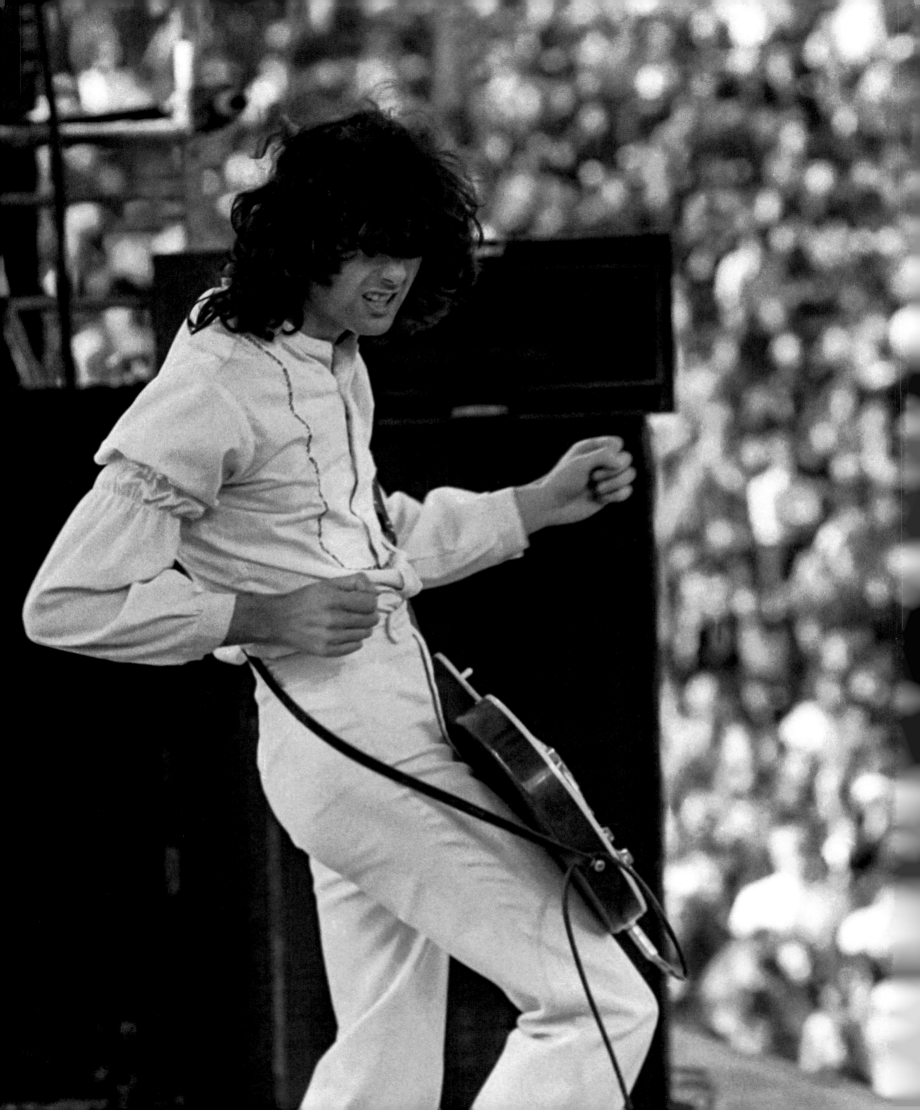

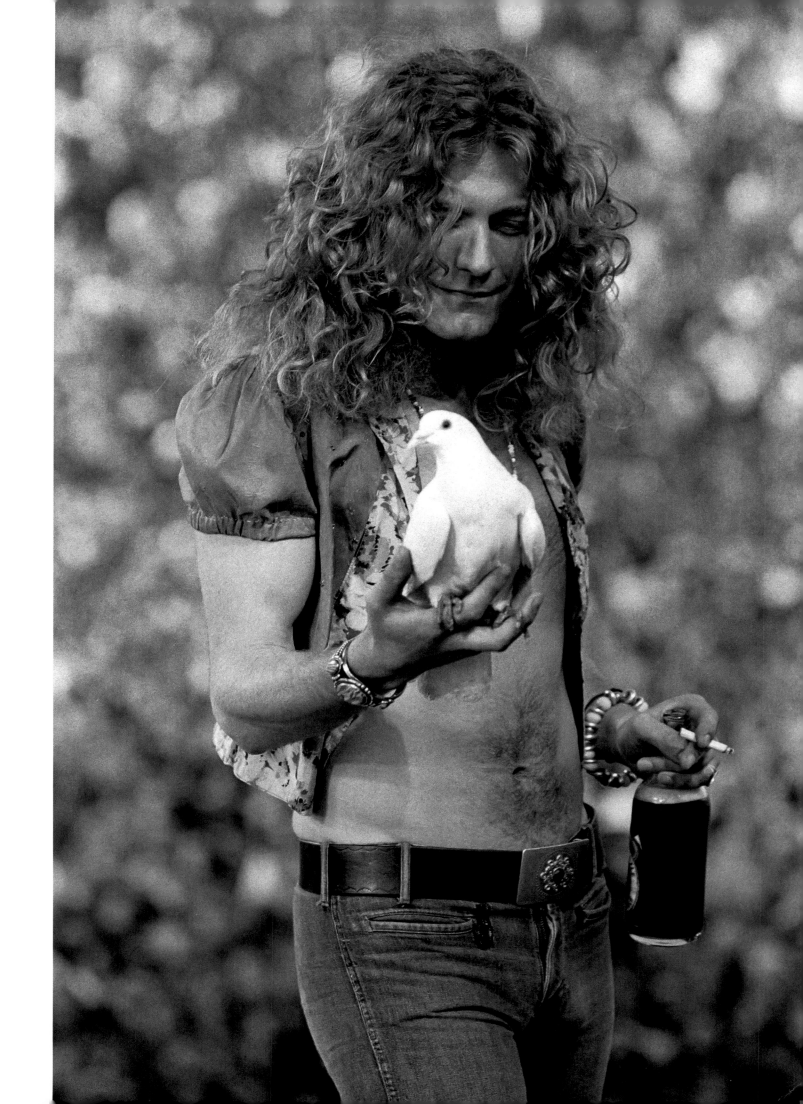

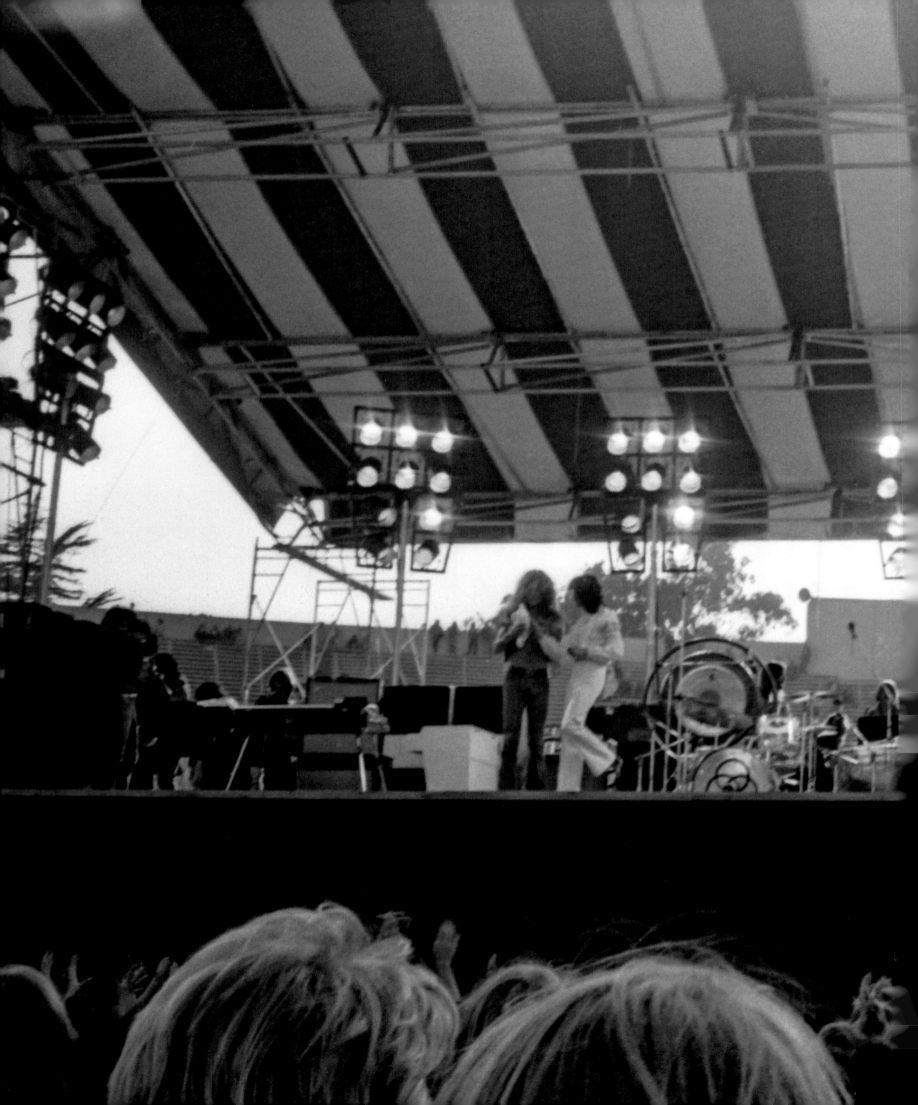

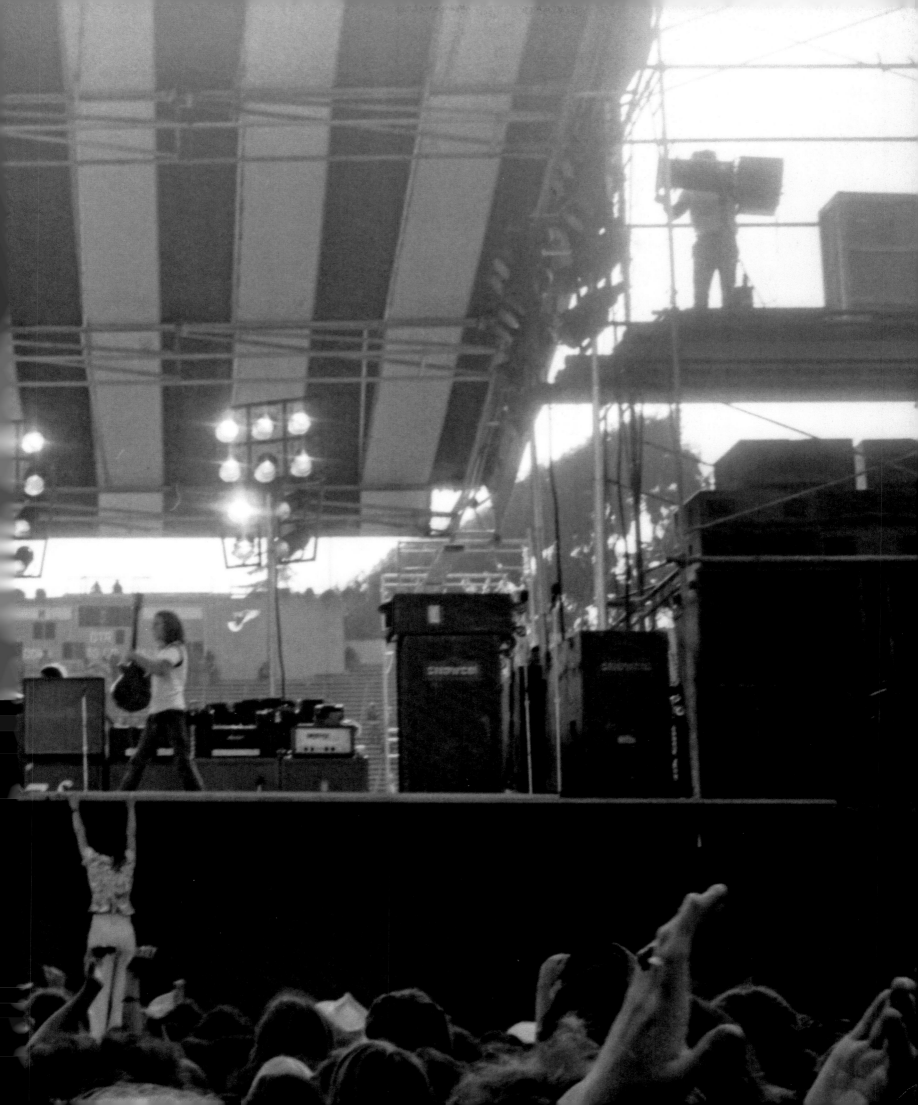

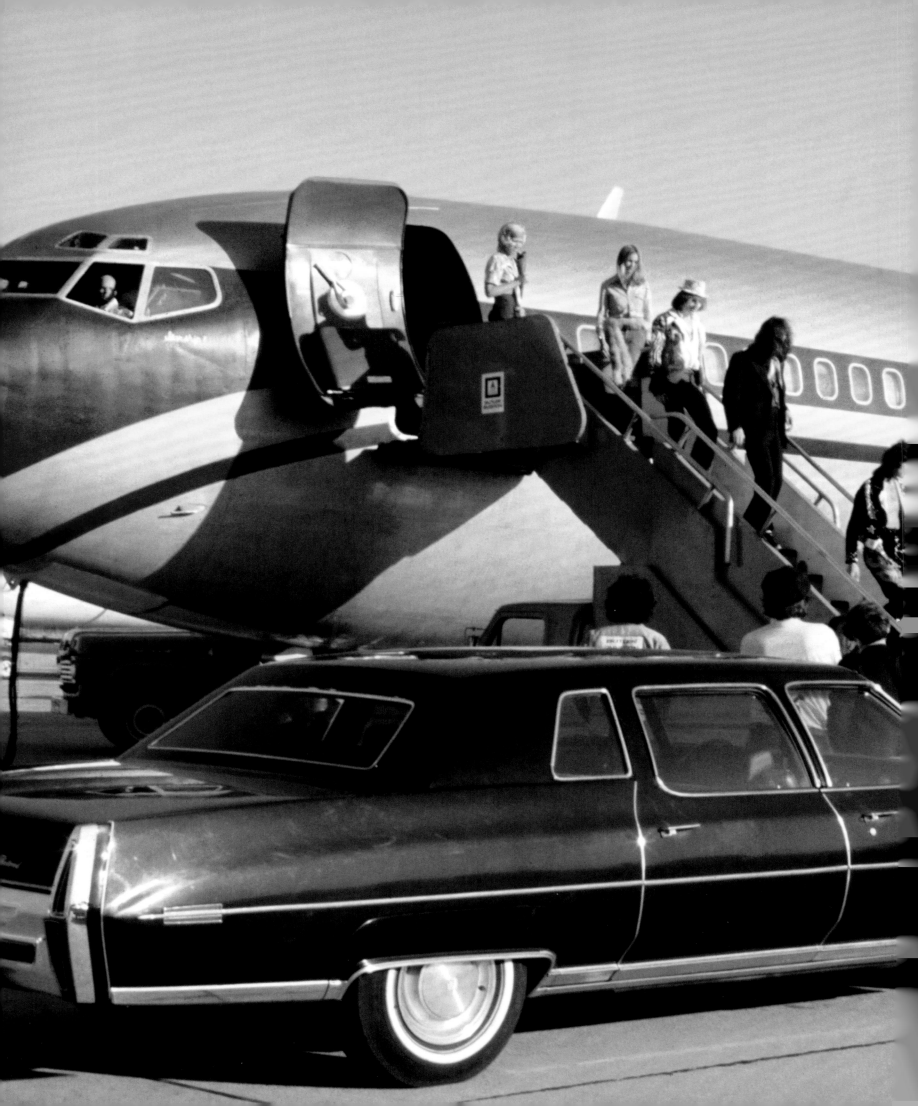

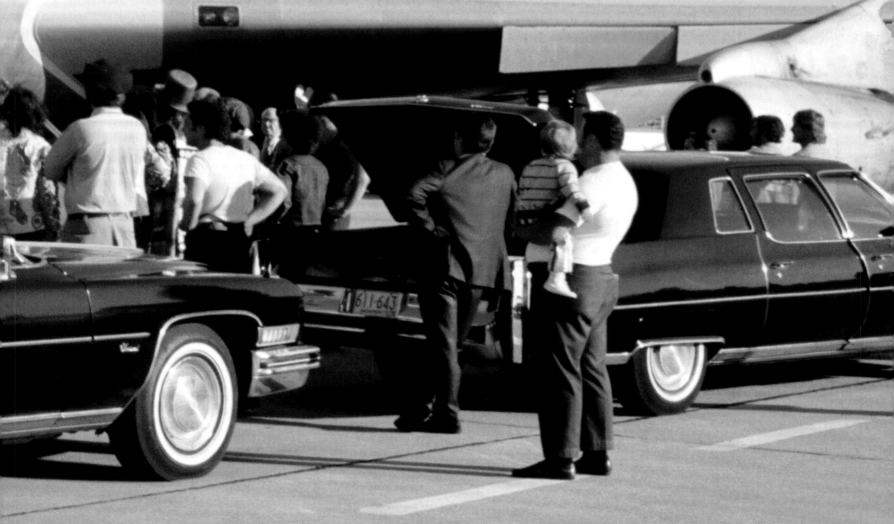

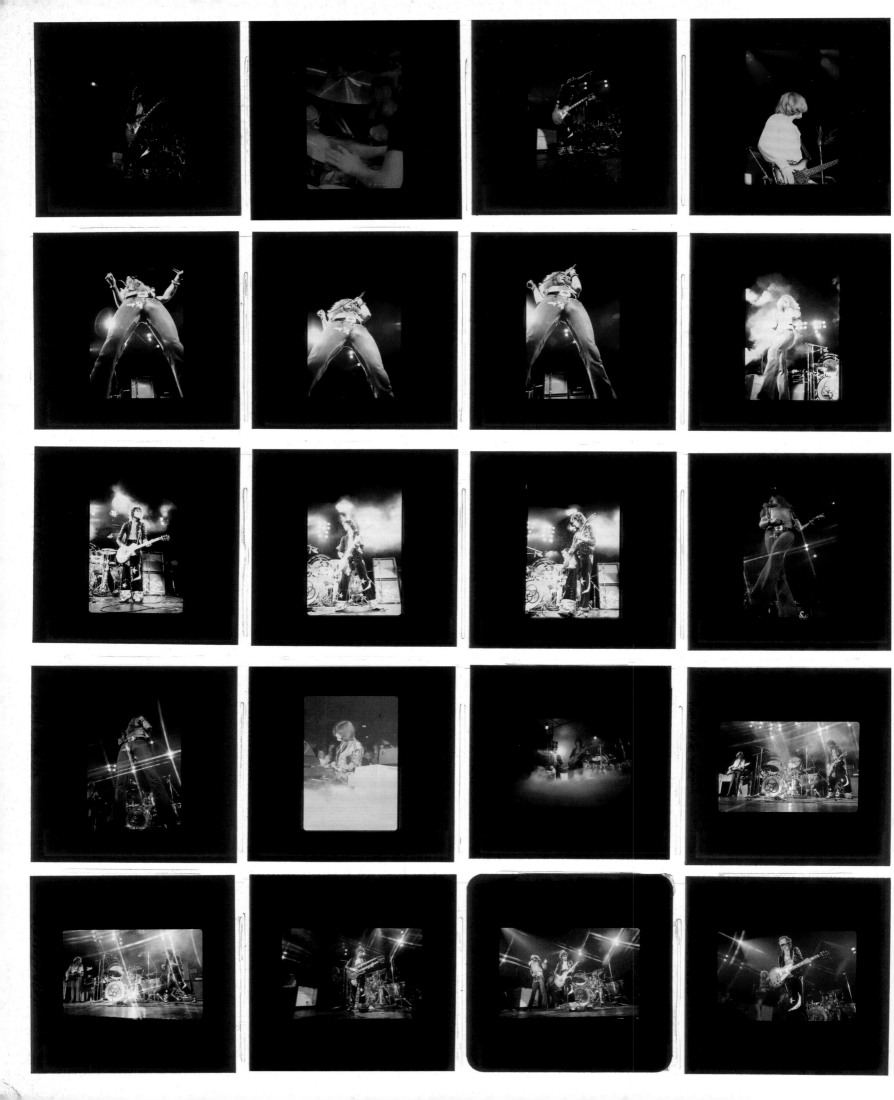

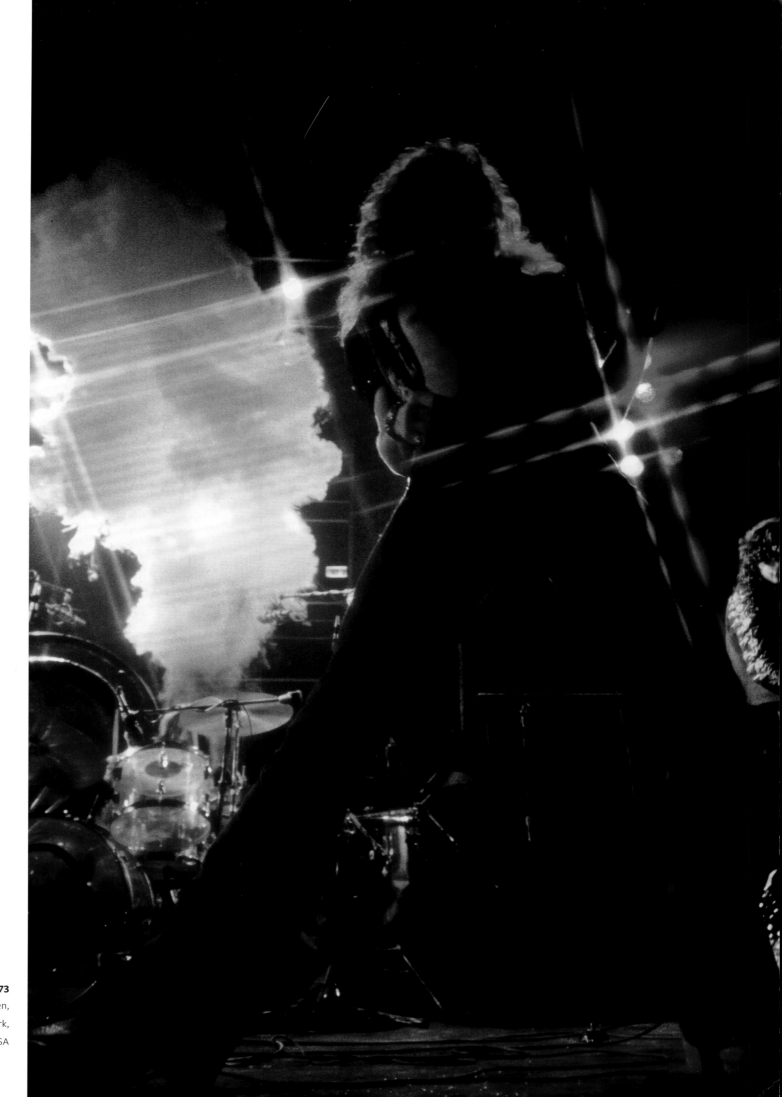

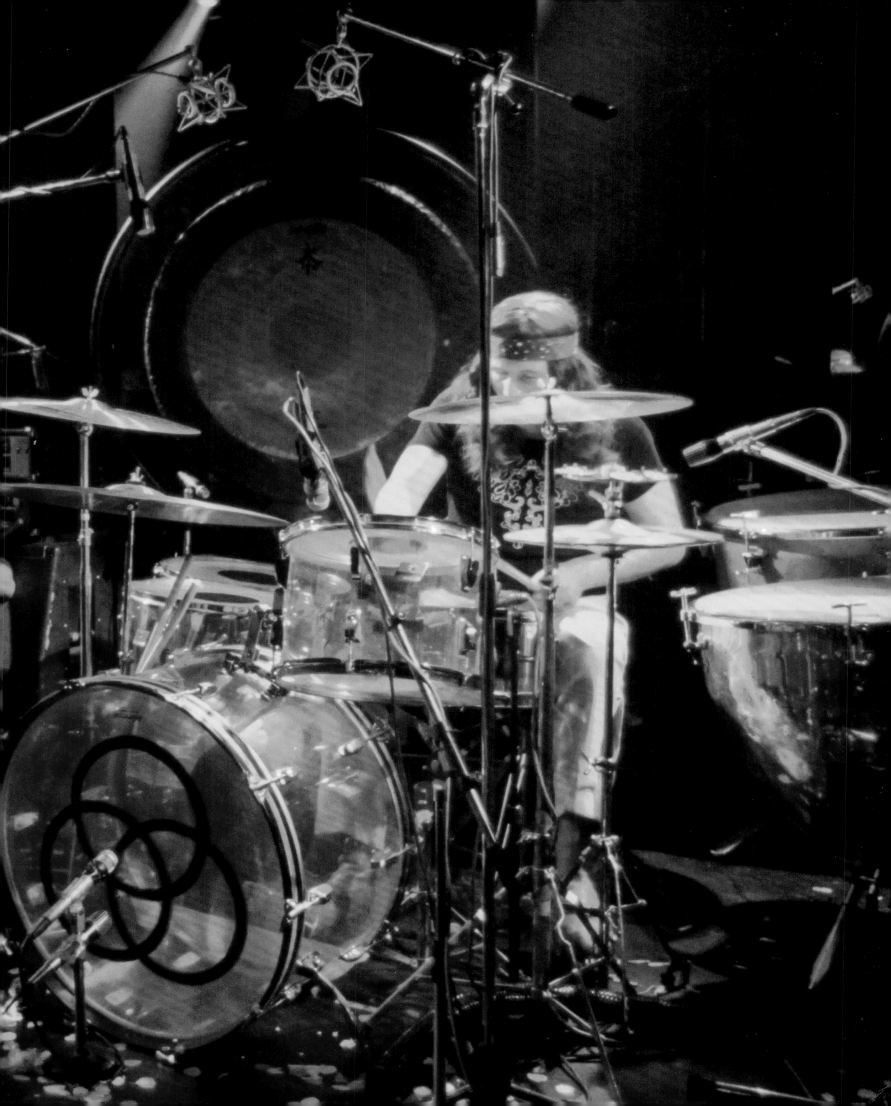

OCTOBER 1973

Warren House, Crowborough, East Sussex, UK

[top-left]

Old Hyde Farm, Cutnall Green, Worcestershire, UK

[bottom-left]

10–11 DECEMBER 1973

Boleskine House, Foyers, Scotland, UK

[top-right and right]

OCTOBER 1973

Lake Vyrnwy, Wales, UK

[bottom-right]

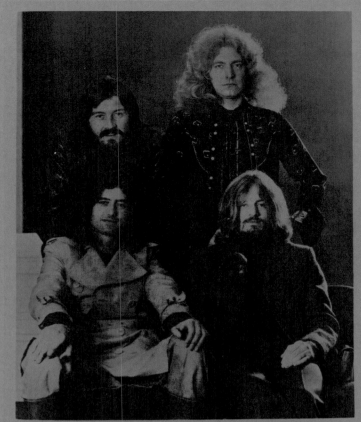

LED ZEPPELIN

LED ZEPPELIN

SH in association with **PETER GRANT**

presents

LED ZEPPELIN

EARL'S COURT 75

OFFICIAL PROGRAMME

LED ZEPPELIN

North American Tour
All Access

LED ZEPPELIN

1977 North American Tour
CREW

LED ZEPPELIN

NINETEEN SEVENTY FIVE

—

SEVENTY SEVEN

19 77

19 — 75 19

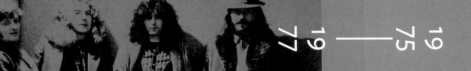

LED ZEPPELIN 1975 TOUR

NEW YORK DATES
madison square garden – feb. 3, 7, 12
nassau coliseum – feb. 13, 14

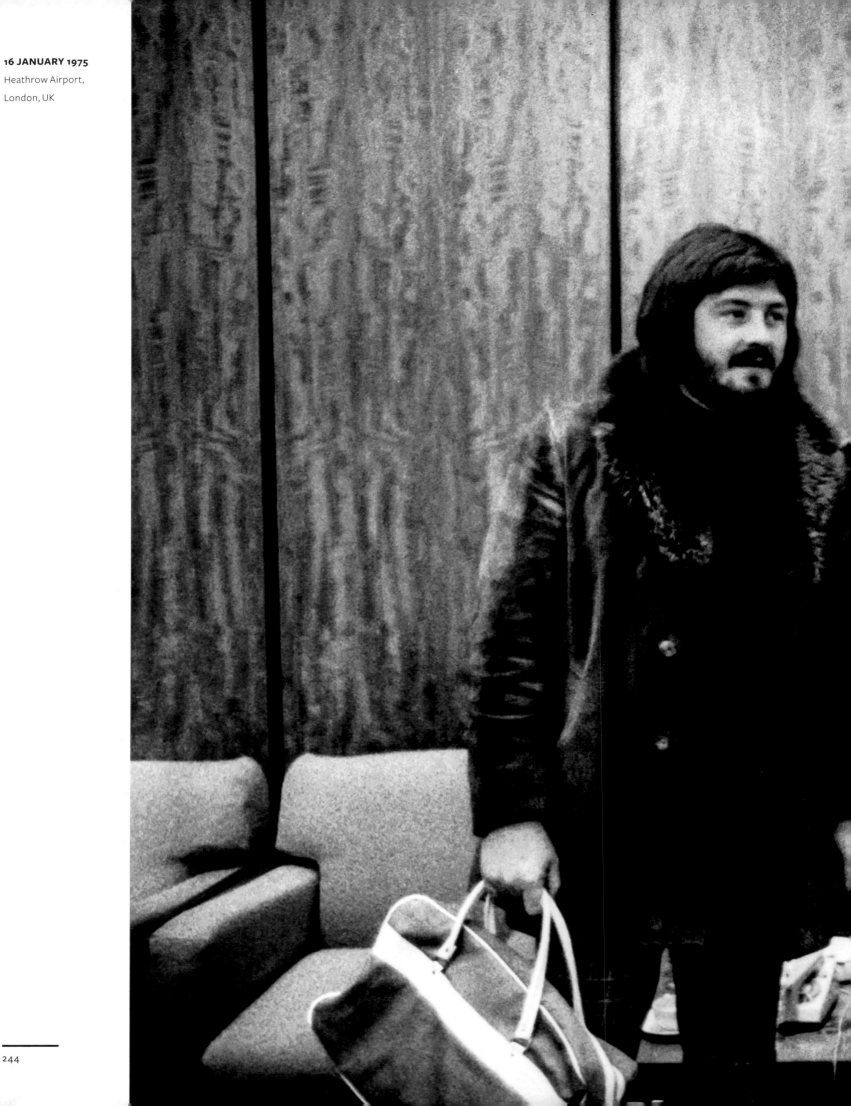

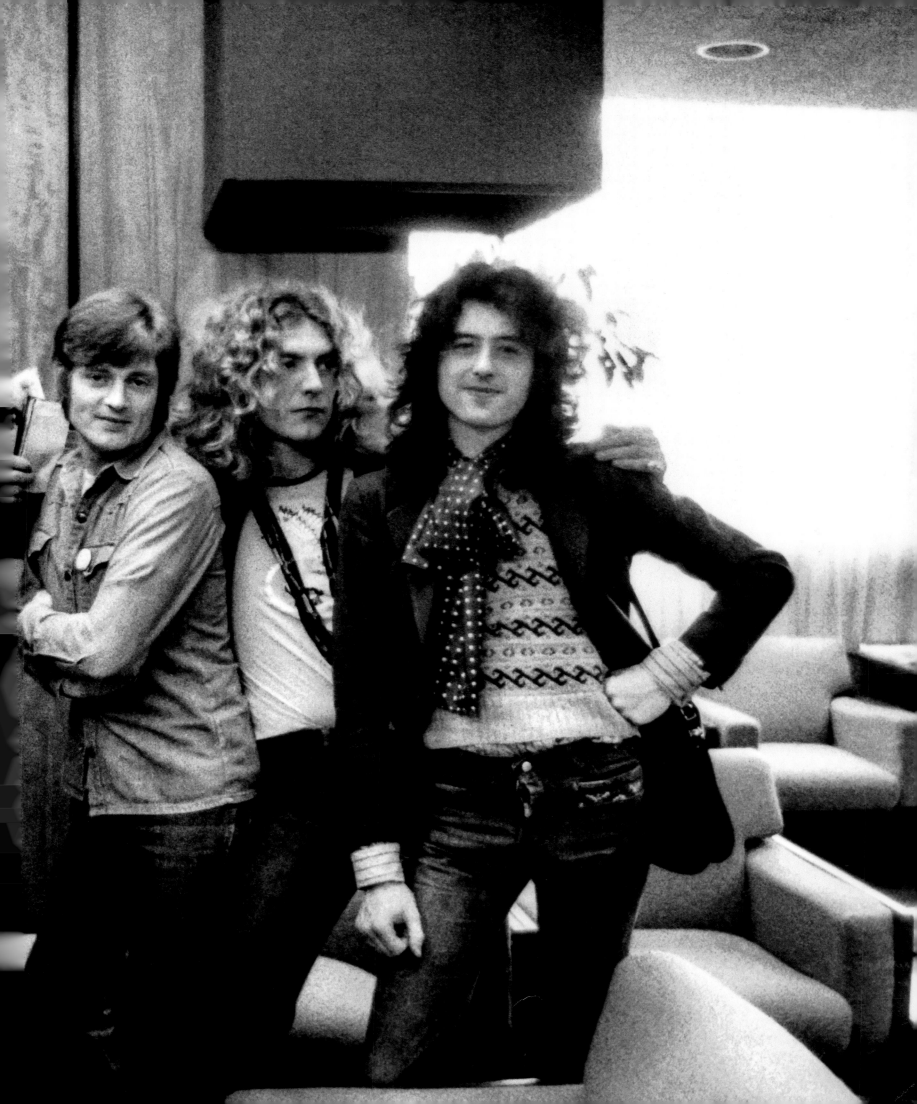

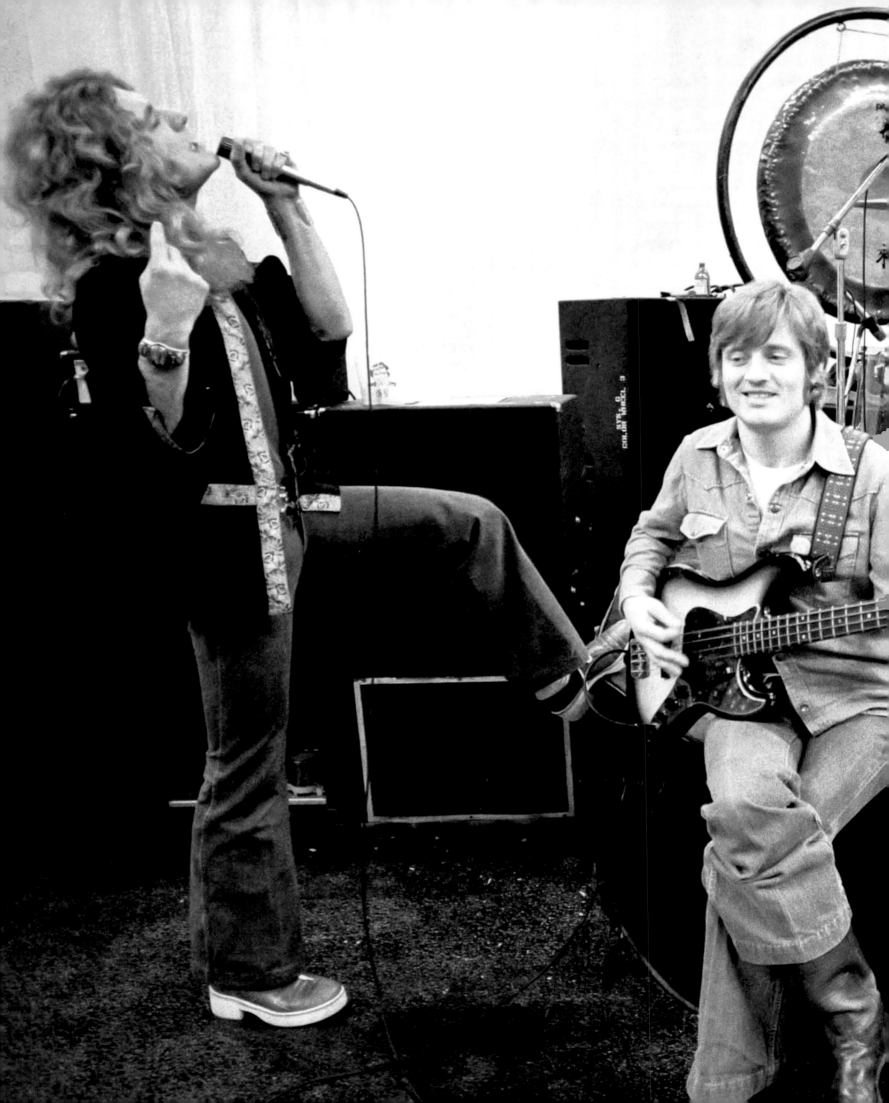

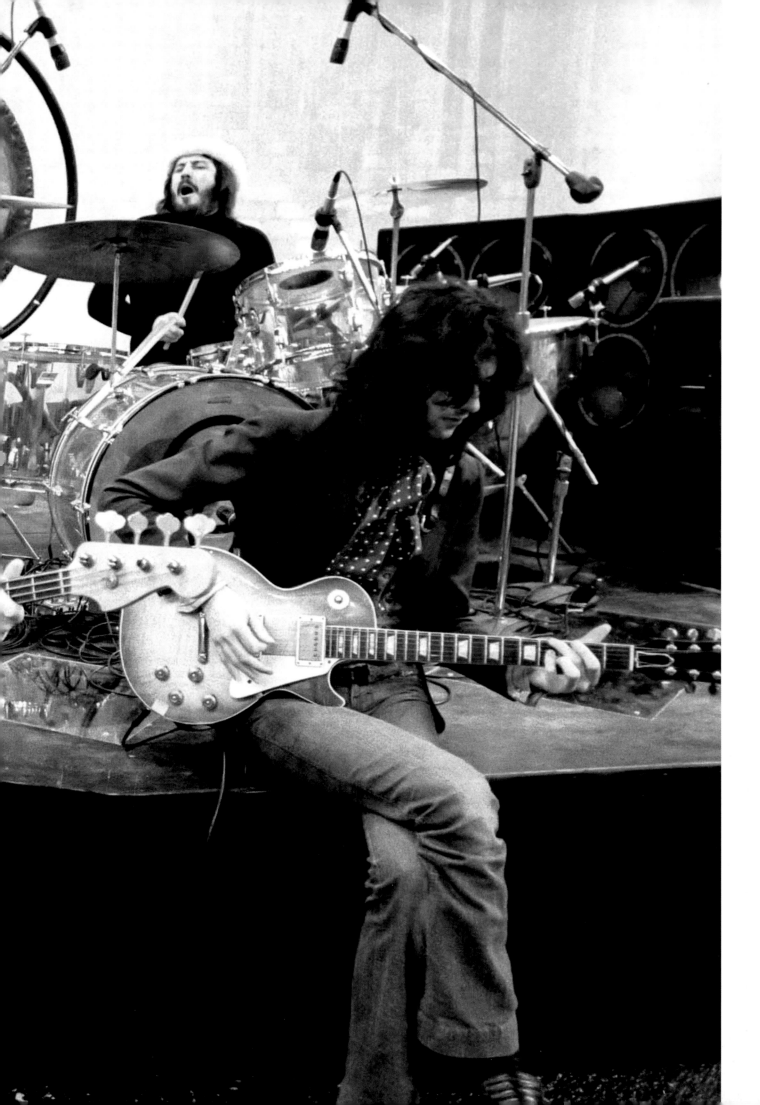

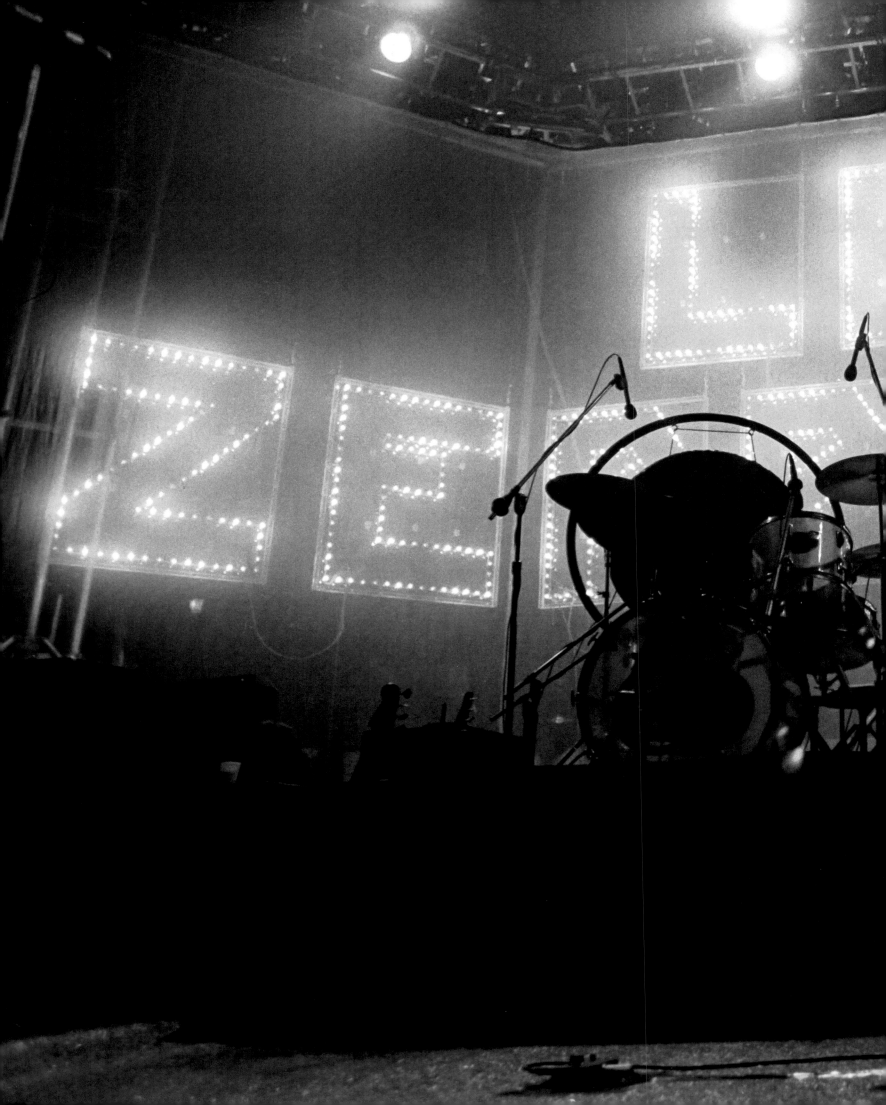

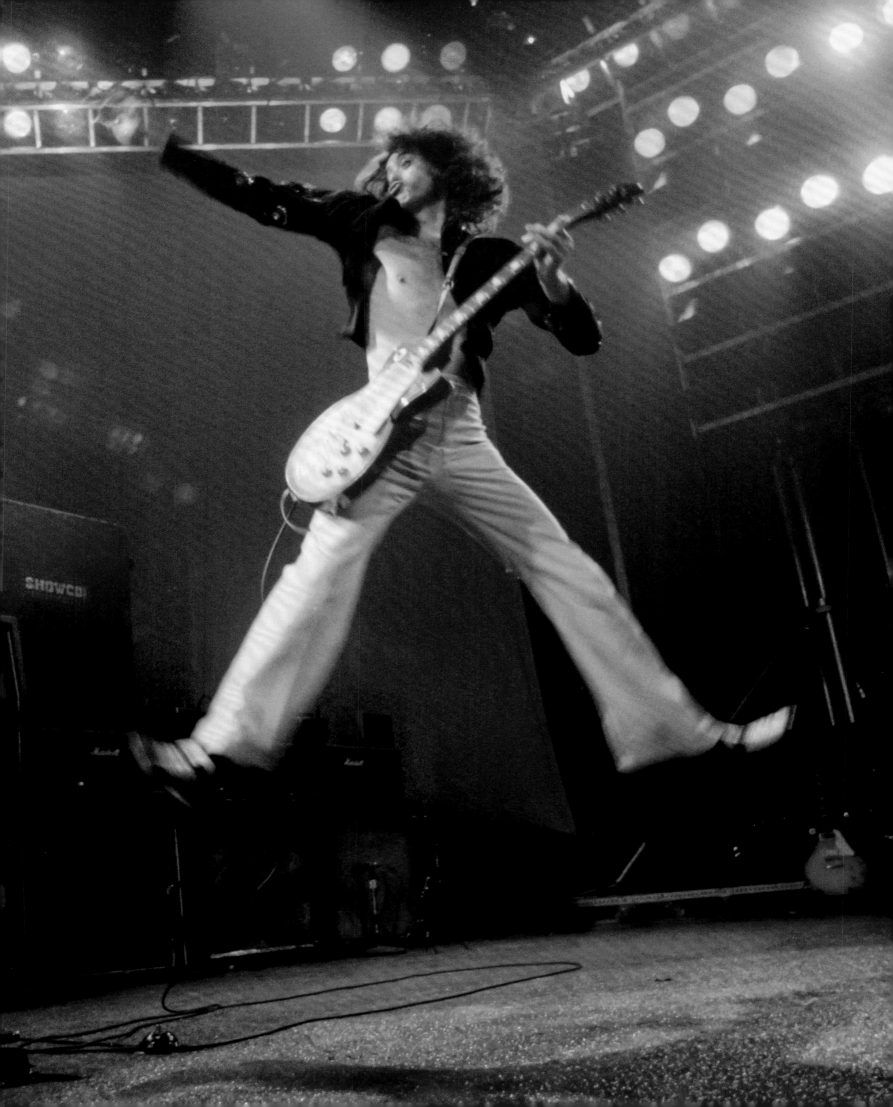

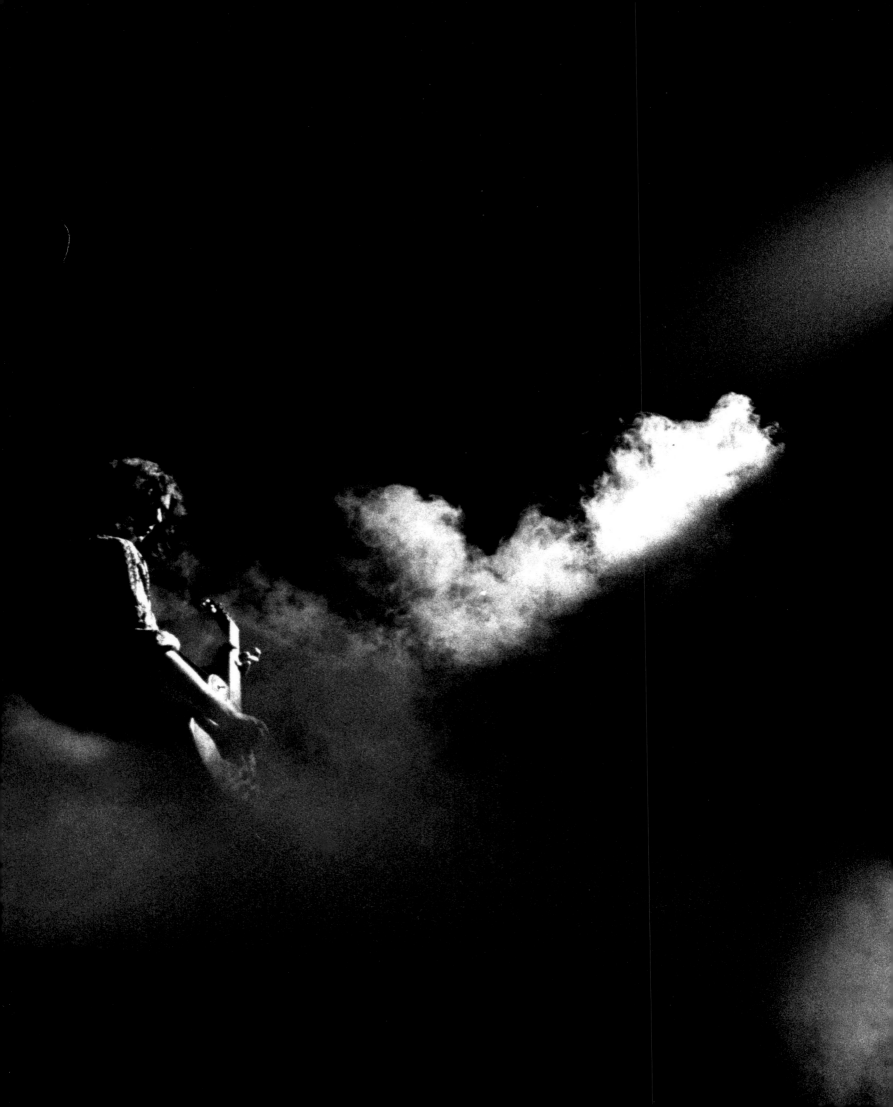

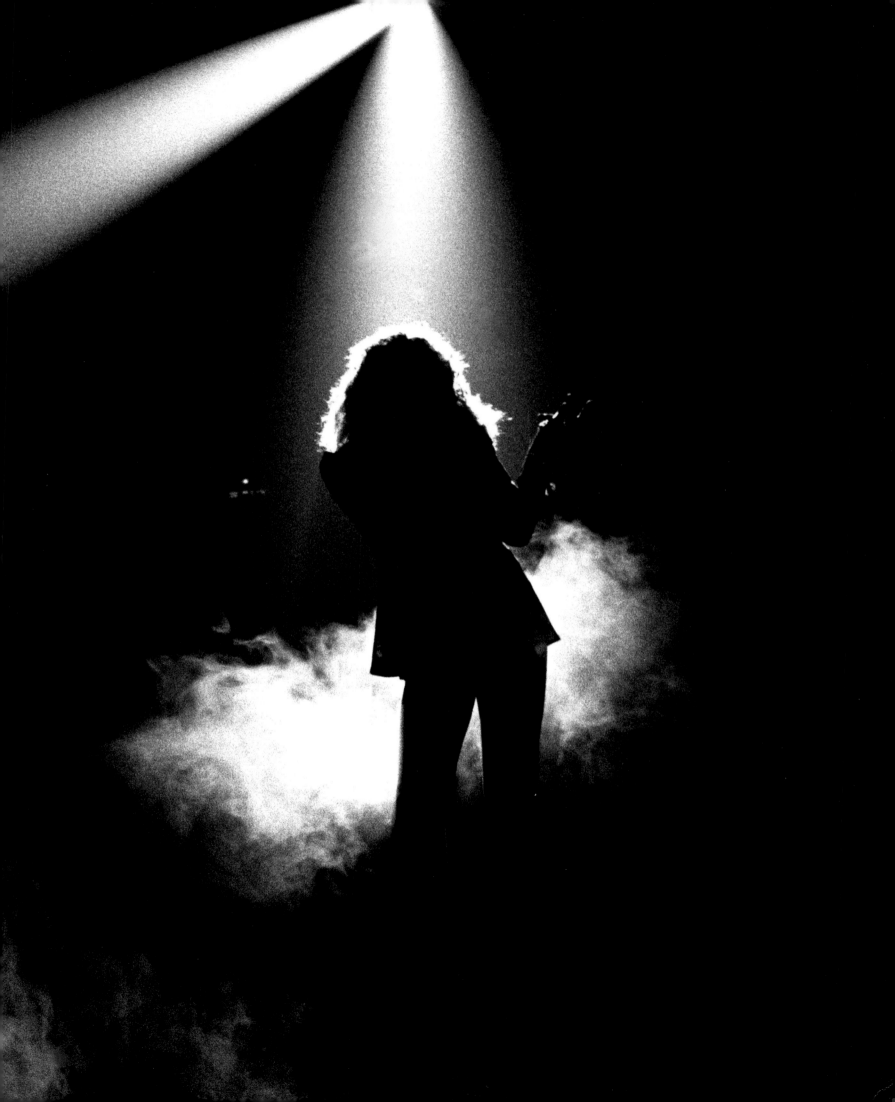

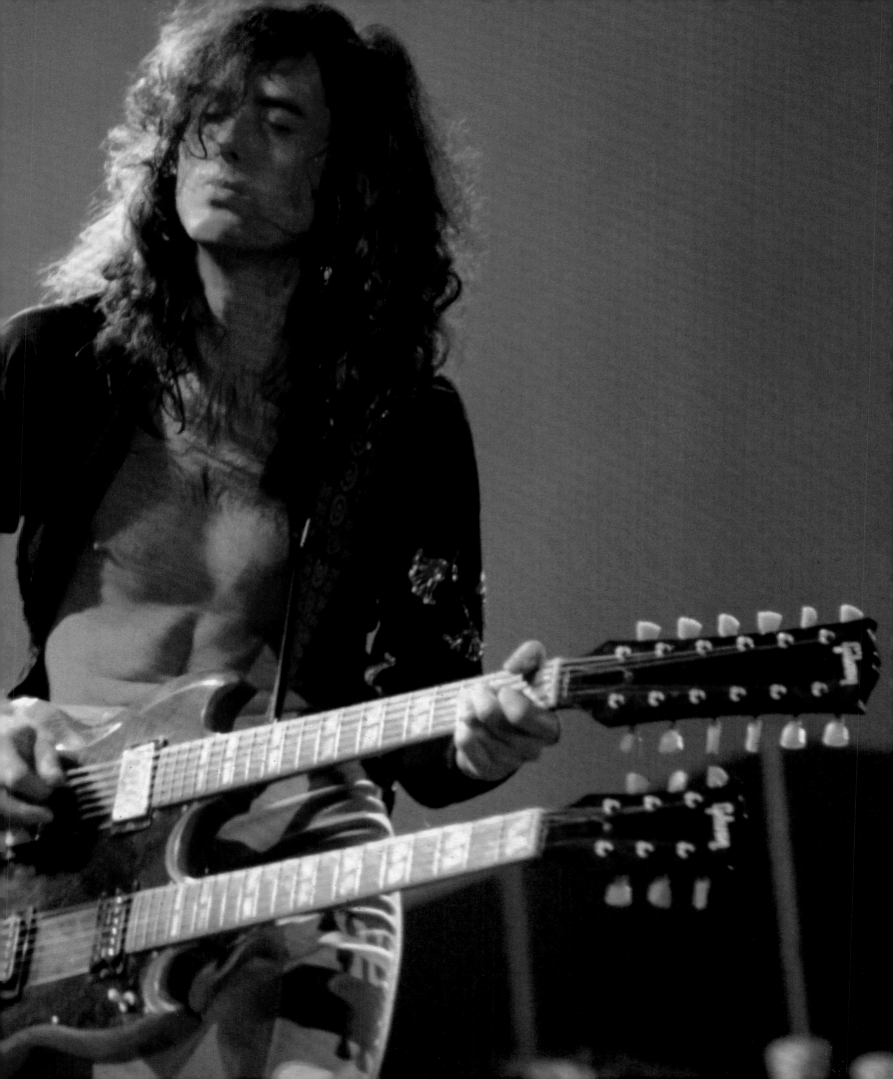

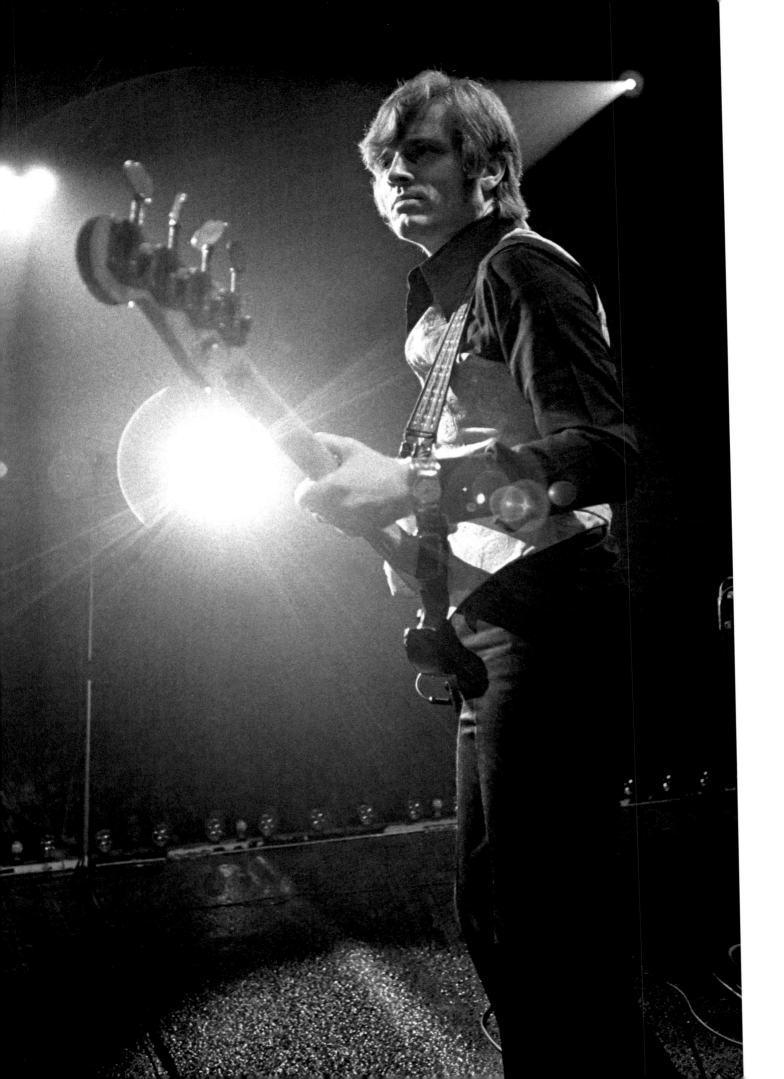

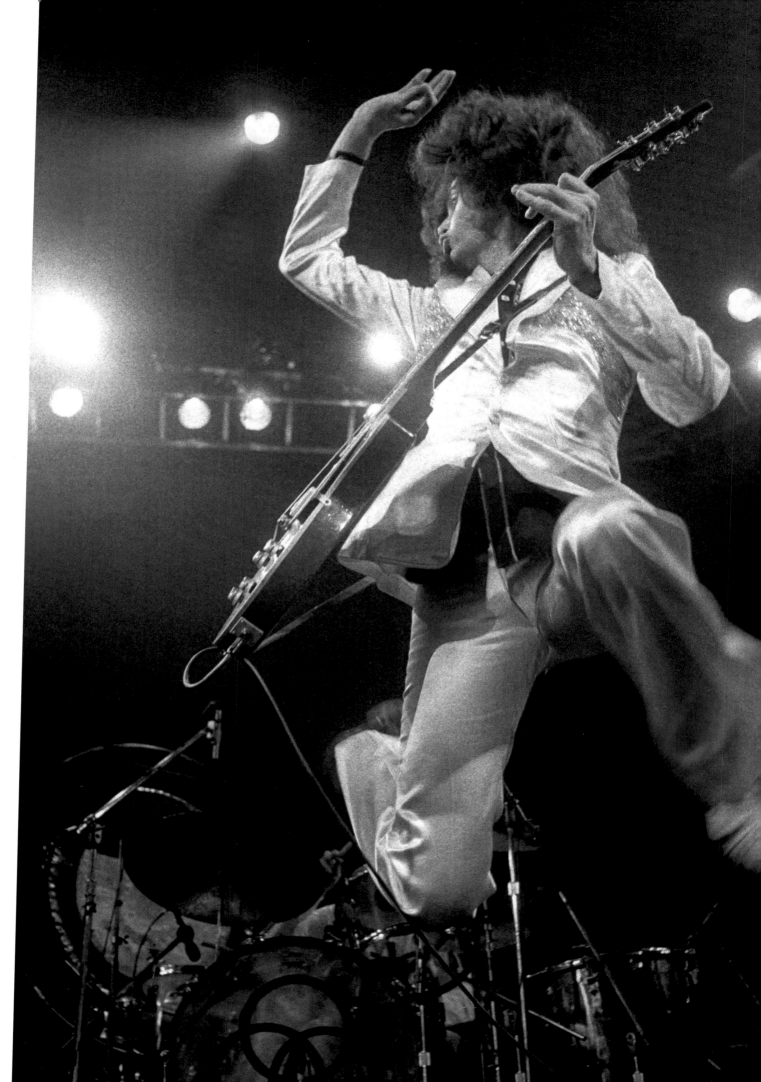

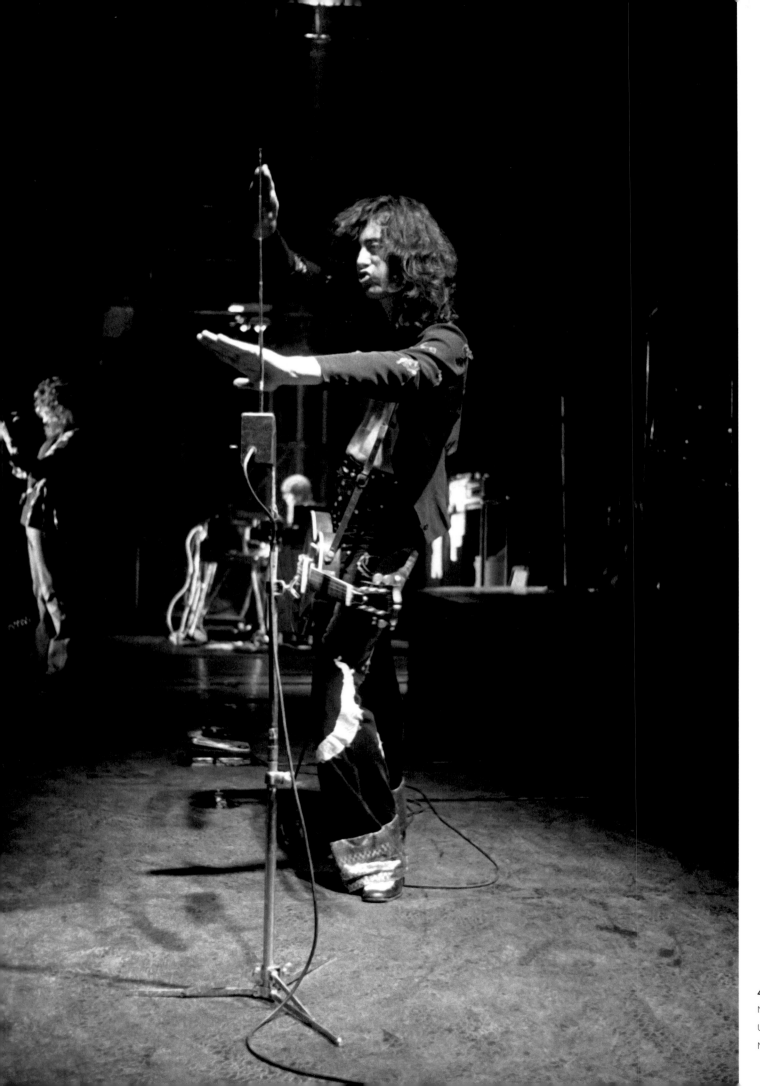

4 FEBRUARY 1975

Nassau Coliseum,

Uniondale,

New York, USA

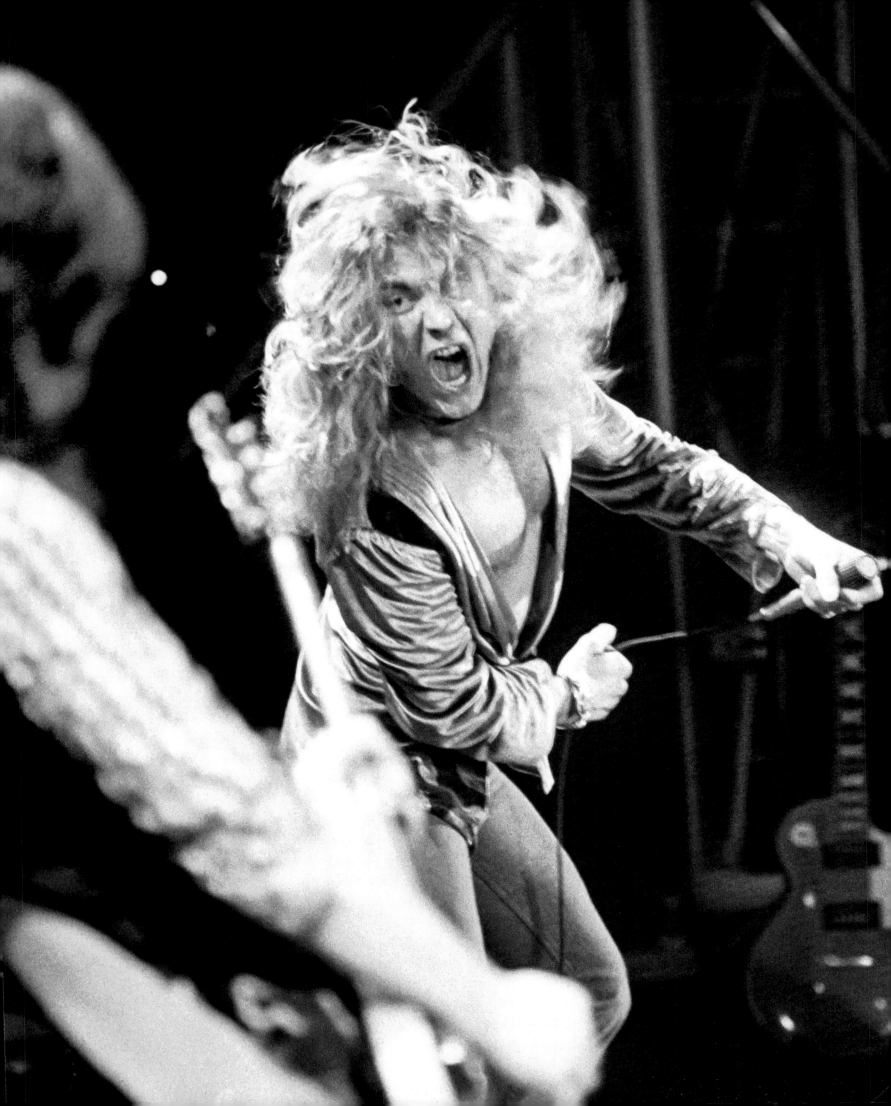

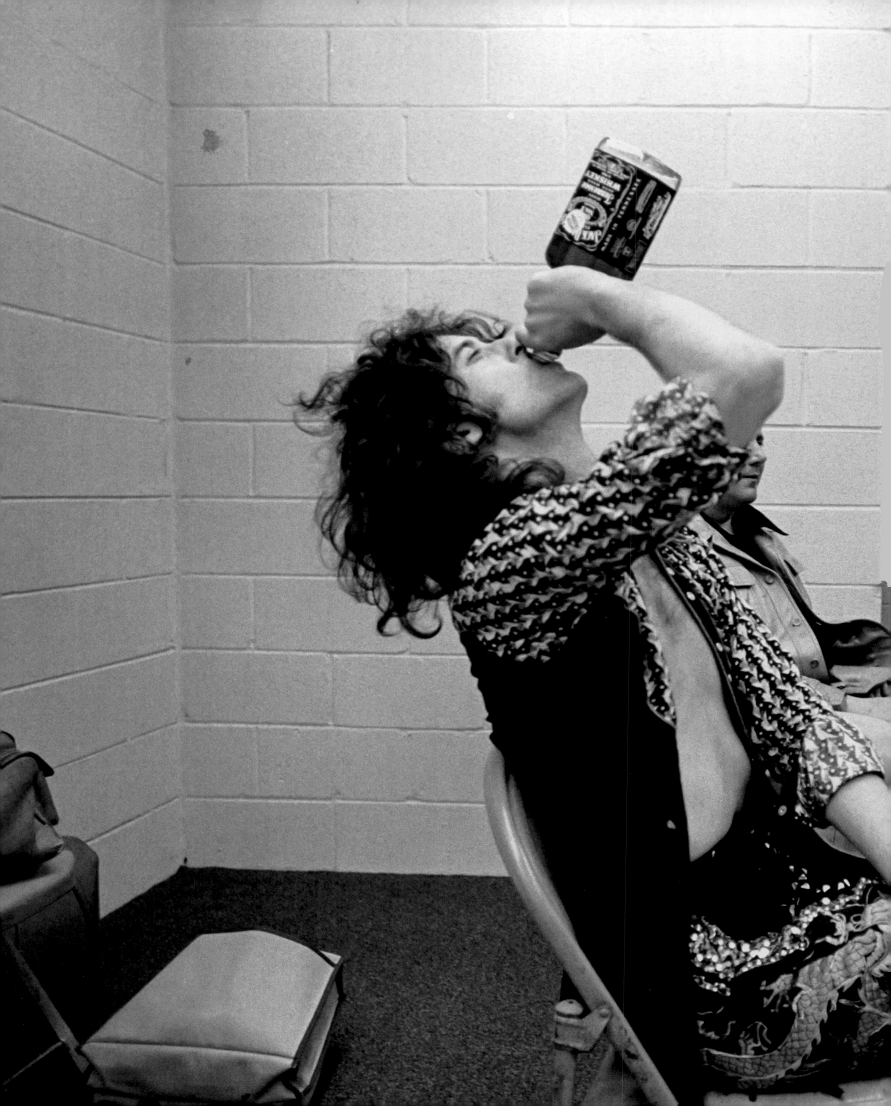

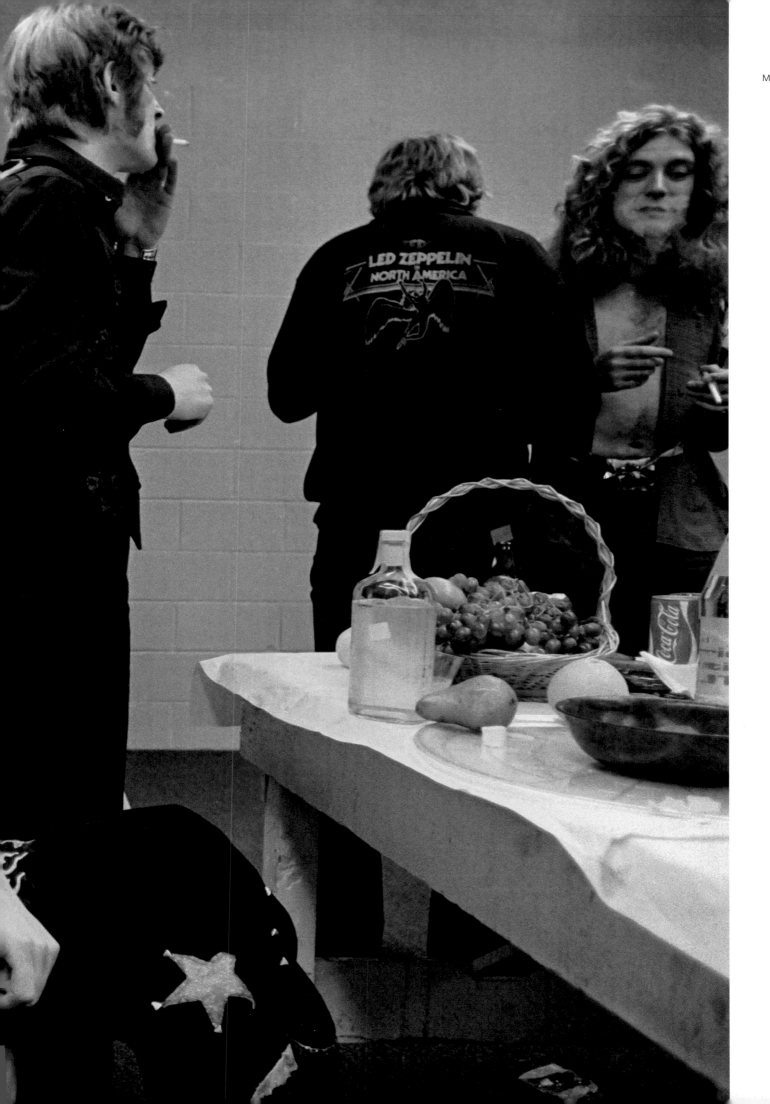

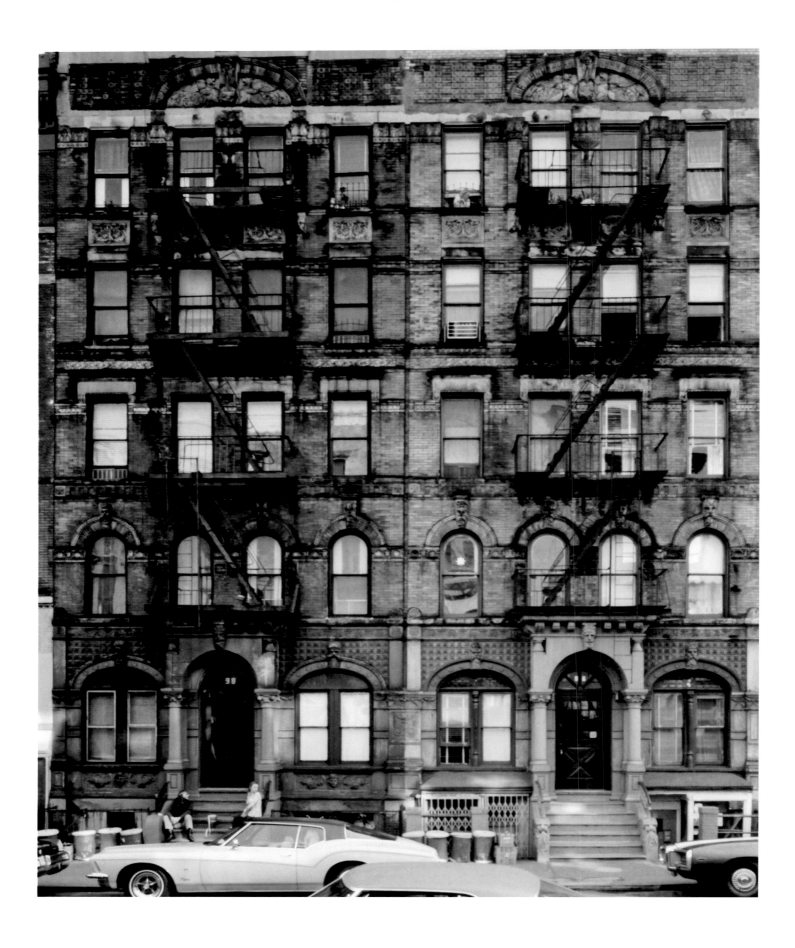

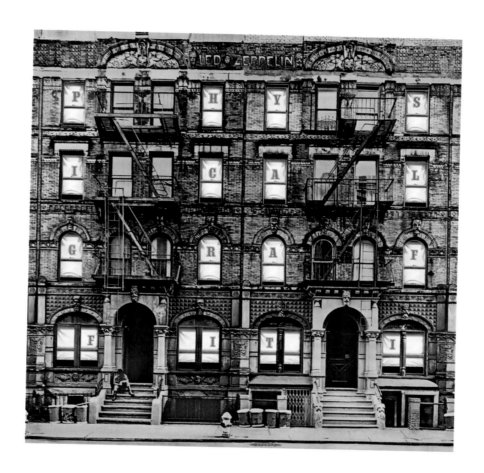

PHYSICAL GRAFFITI

24 February 1975

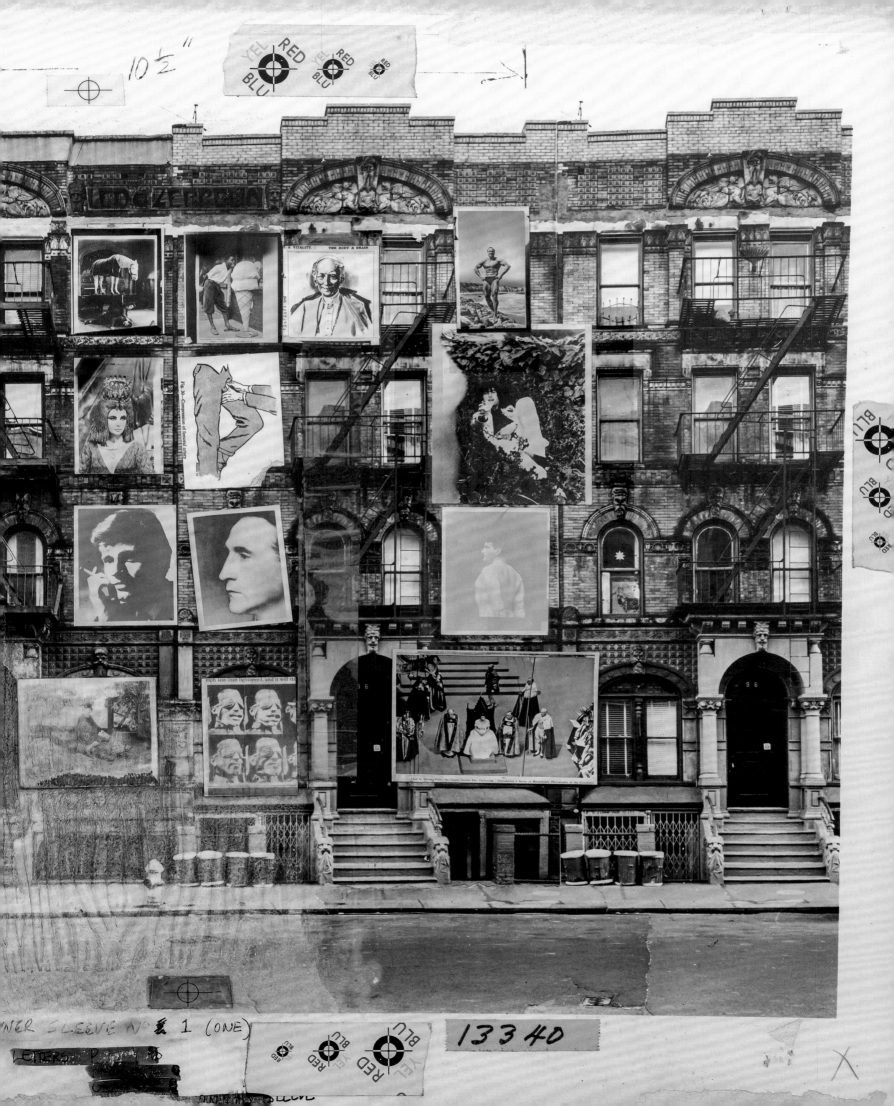

THERE WAS GOING TO BE SUCH A VARIETY OF MATERIAL, MOODS, COLOURS AND PIECES, CHARACTER-WISE, AND IT WAS GOING TO BE THE FIRST RECORD THAT CAME OUT ON OUR LABEL SWAN SONG. I WAS VERY KEEN TO MAKE THE PACKAGING SUPER ELABORATE, SO PEOPLE WOULD TALK ABOUT EVERYTHING TO DO WITH THIS ALBUM.

ANY QUERIES RING US AT:

HIPGNOSIS

01-8... ... W.C2.

4 MARCH 1975

Dallas Memorial Auditorium, Dallas, Texas, USA

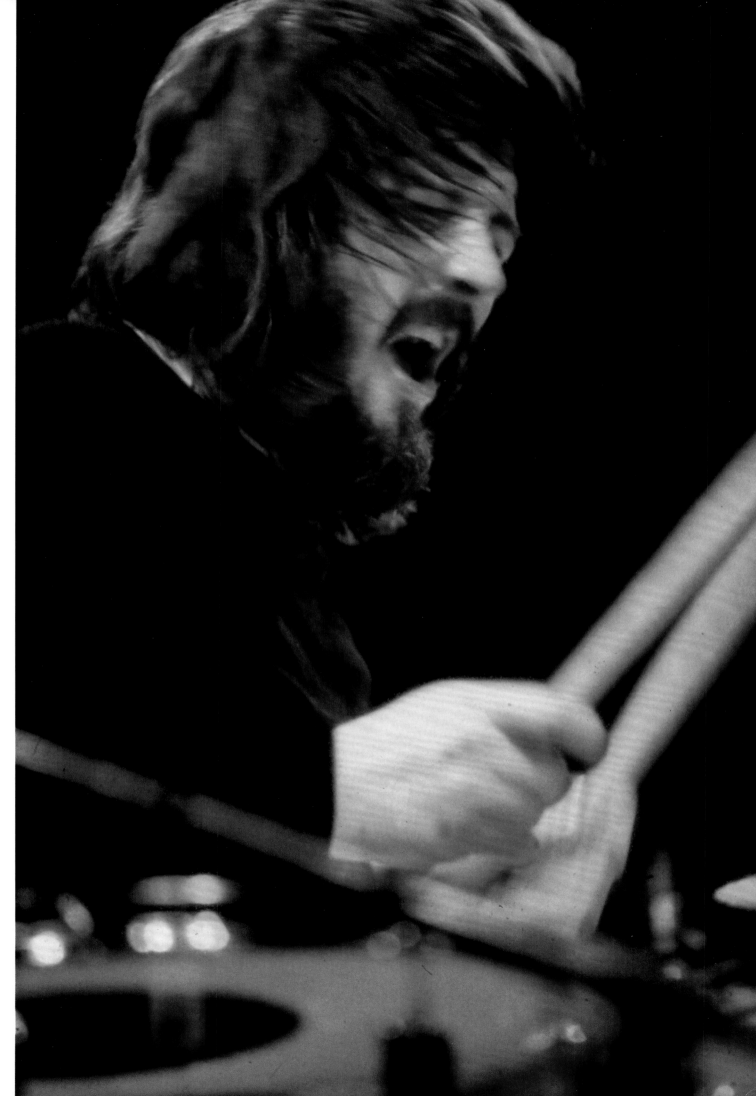

12 MARCH 1975

Civic Arena,
Long Beach,
California, USA

[270—271]

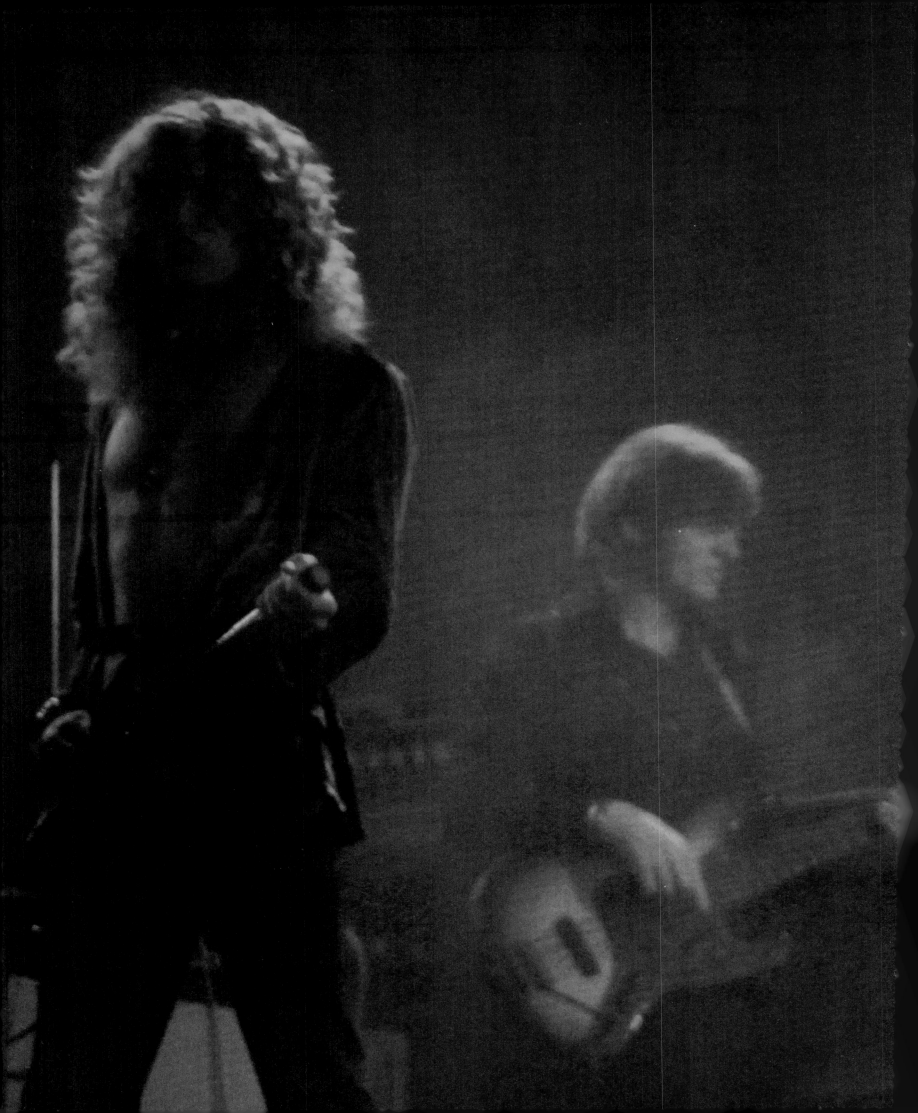

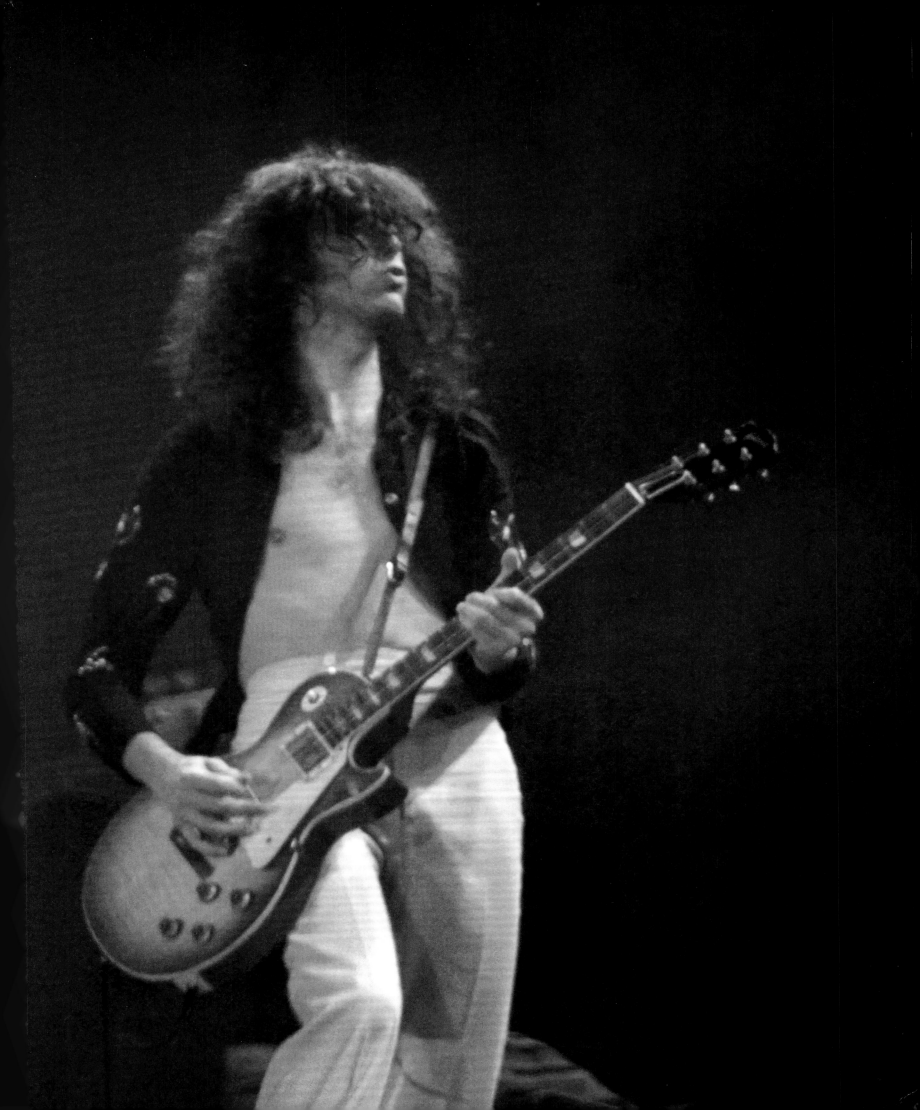

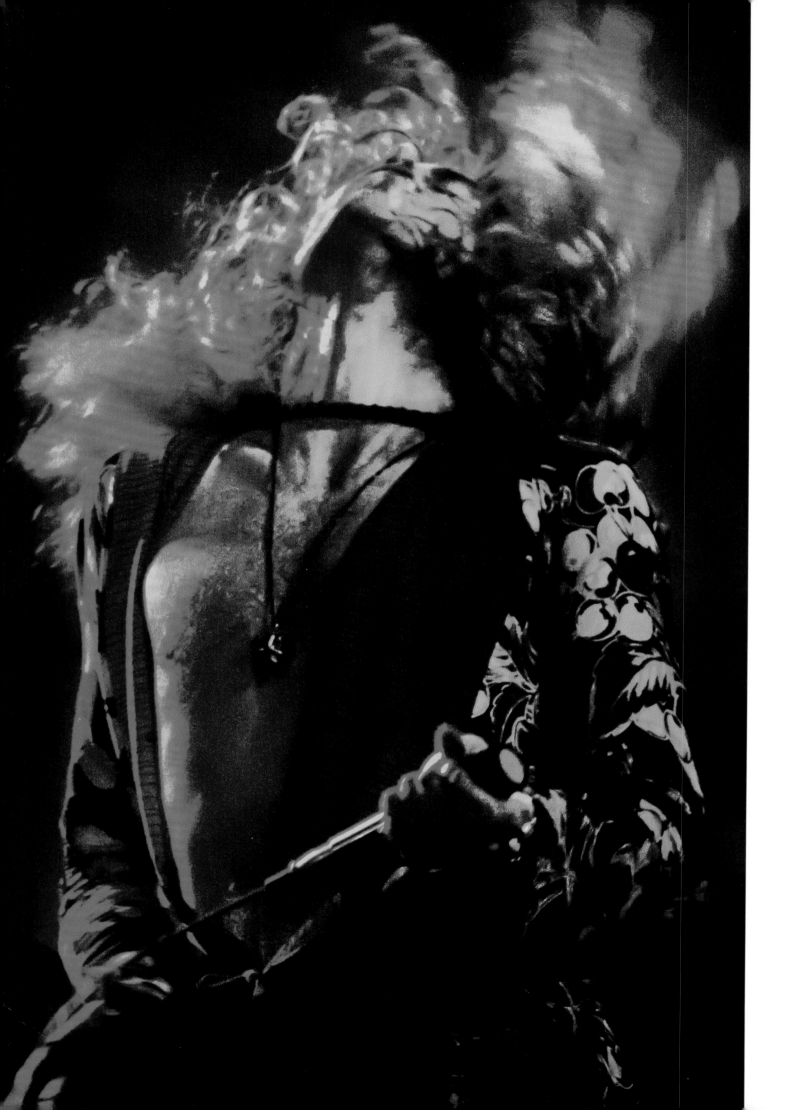

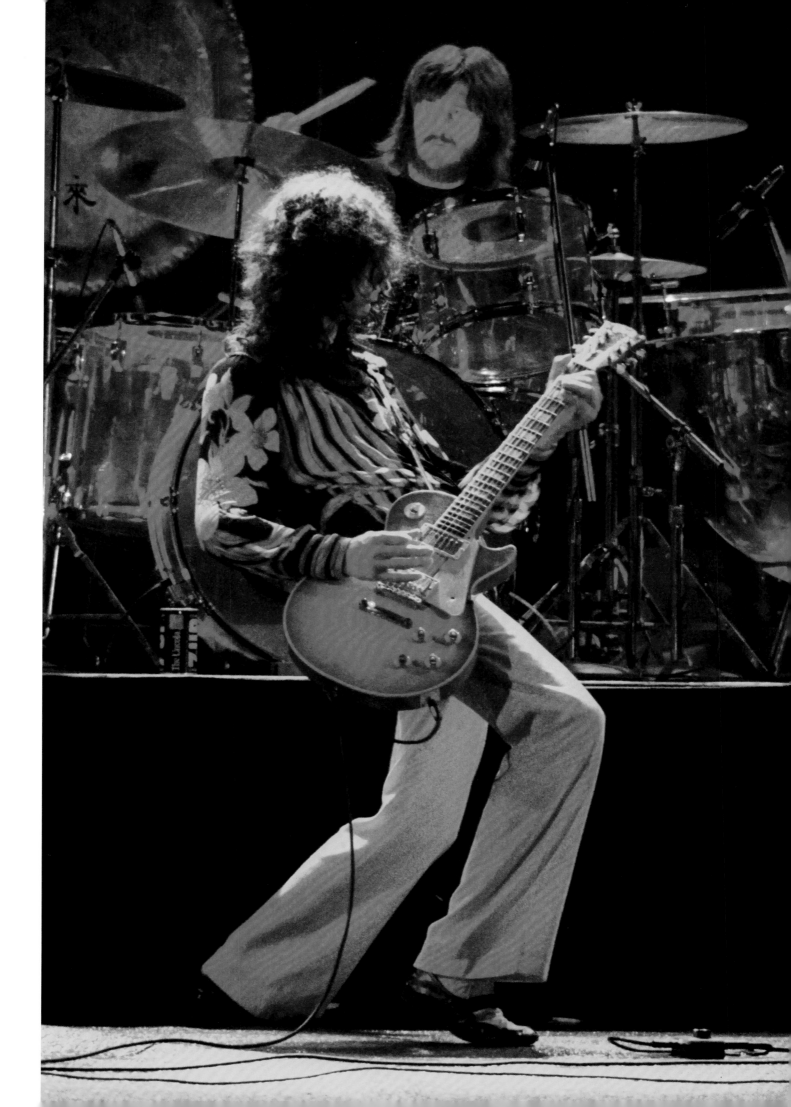

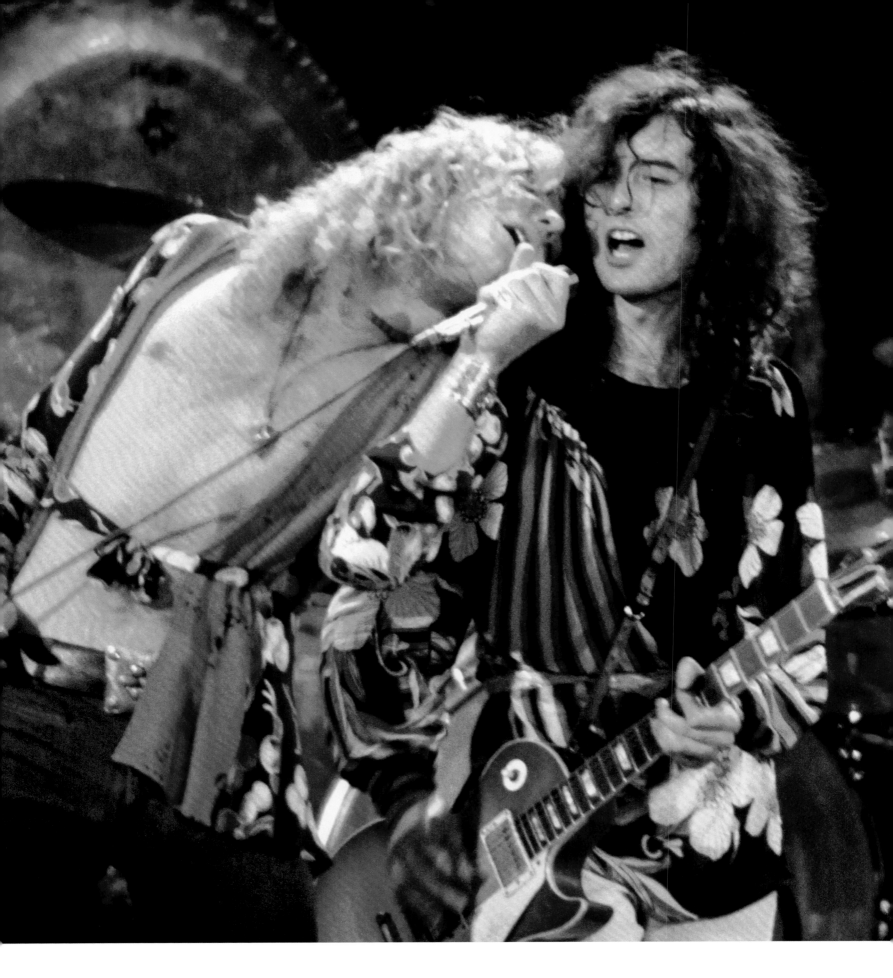

25 MARCH 1975

The Forum, Los Angeles, California, USA

[272—274]

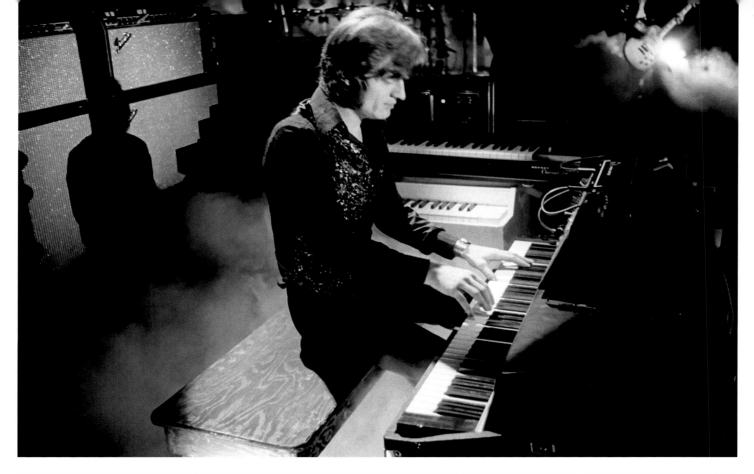

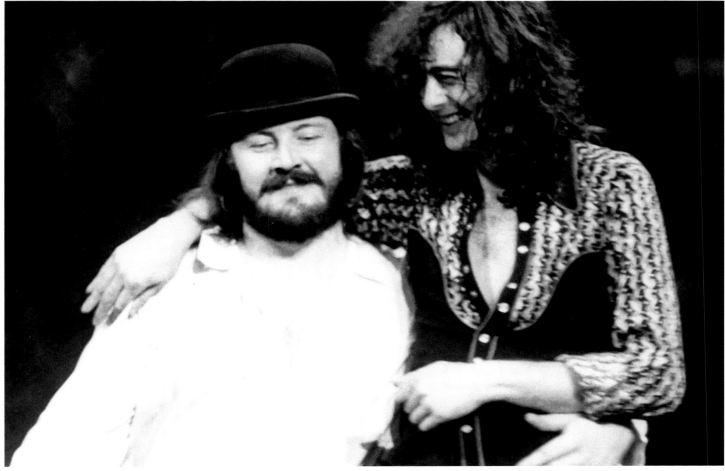

20 JANUARY 1975

Chicago Stadium, Chicago, Illinois, USA

[top]

12 FEBRUARY 1975

Madison Square Garden, New York, New York, USA

[bottom]

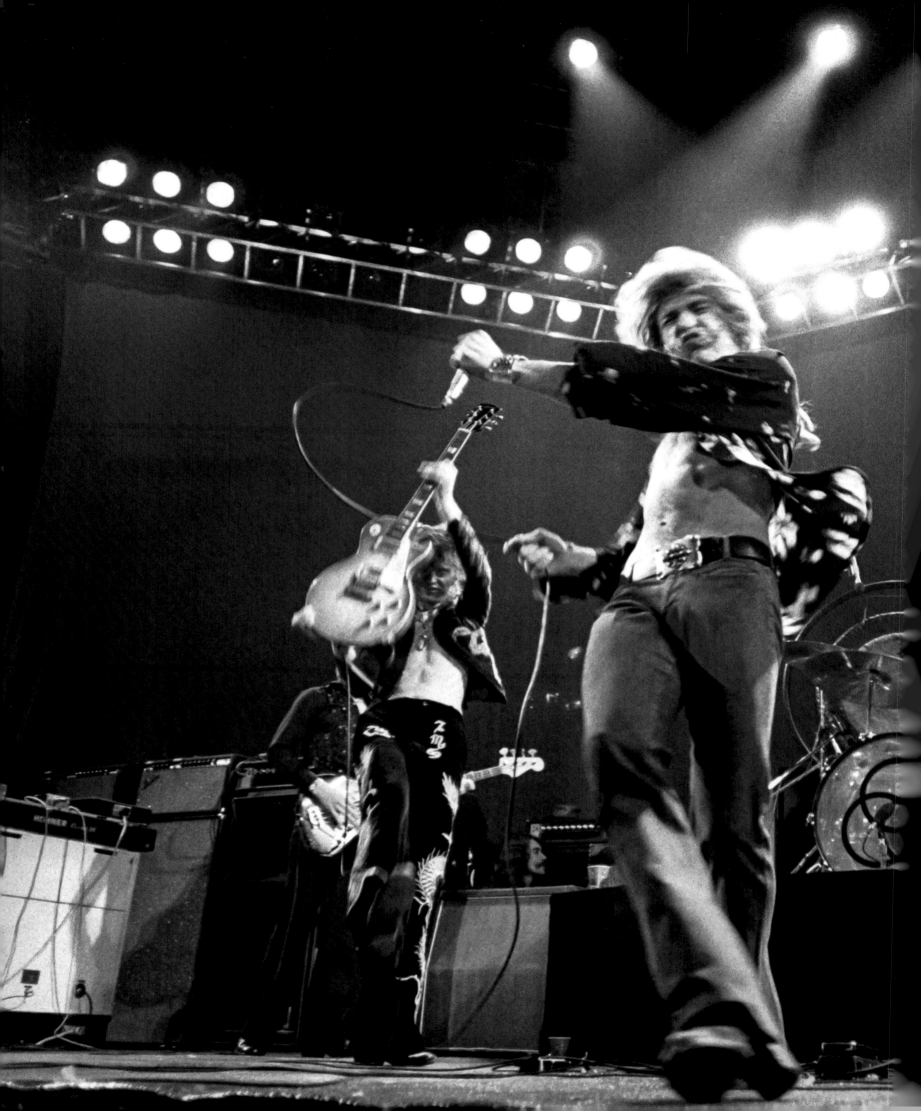

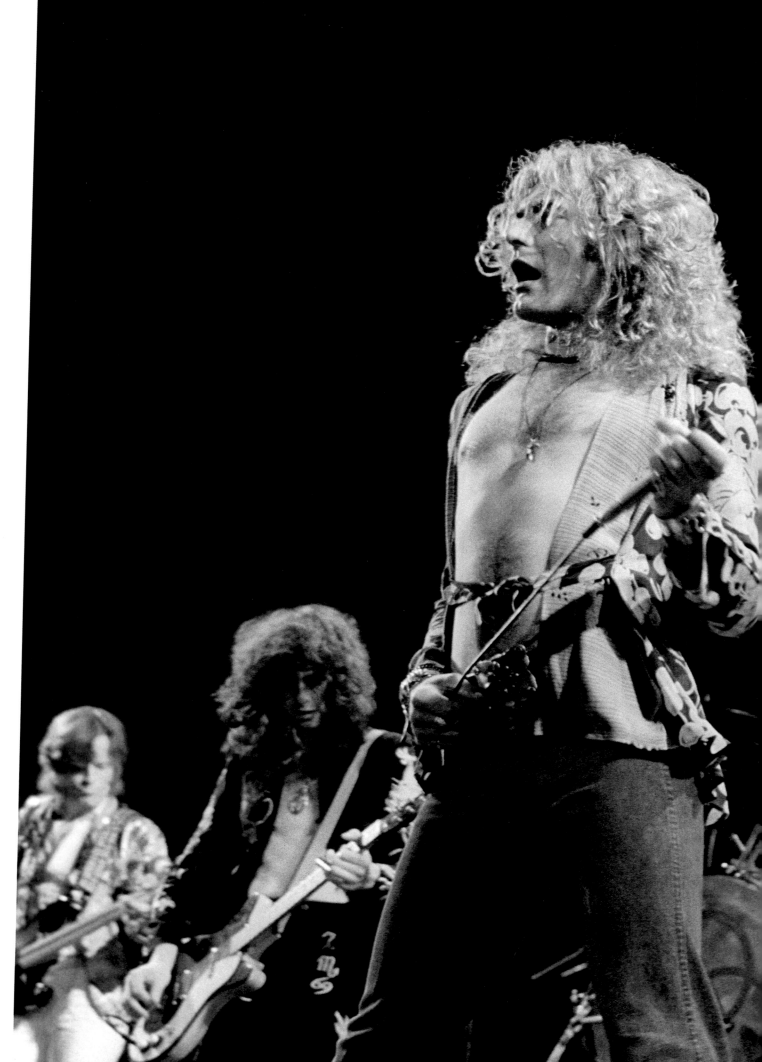

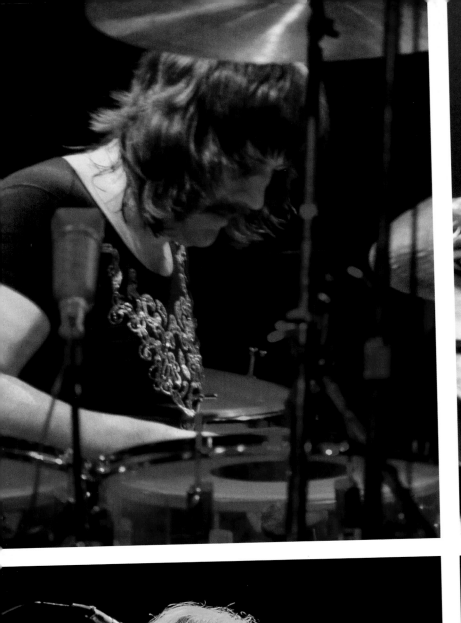
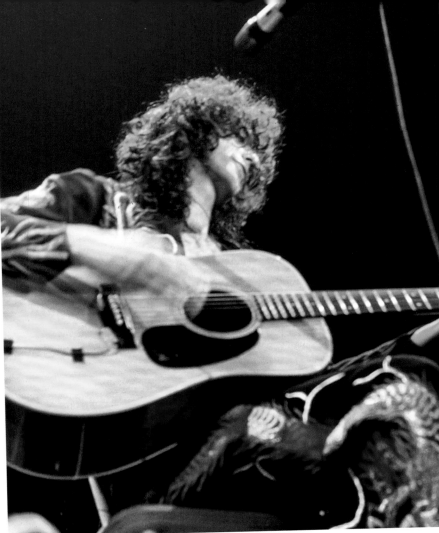
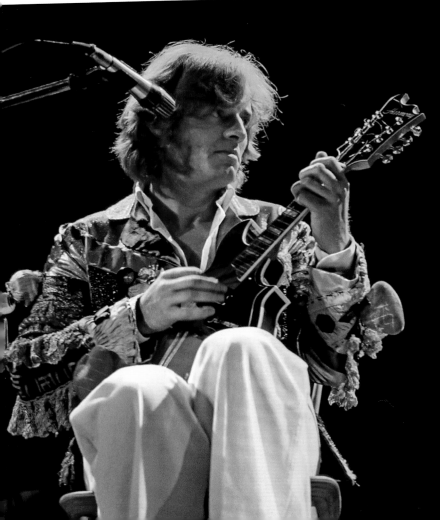
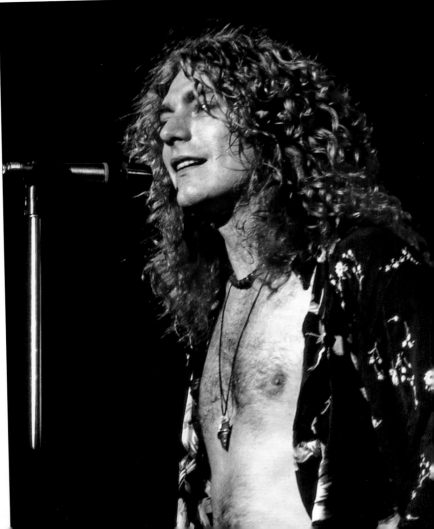

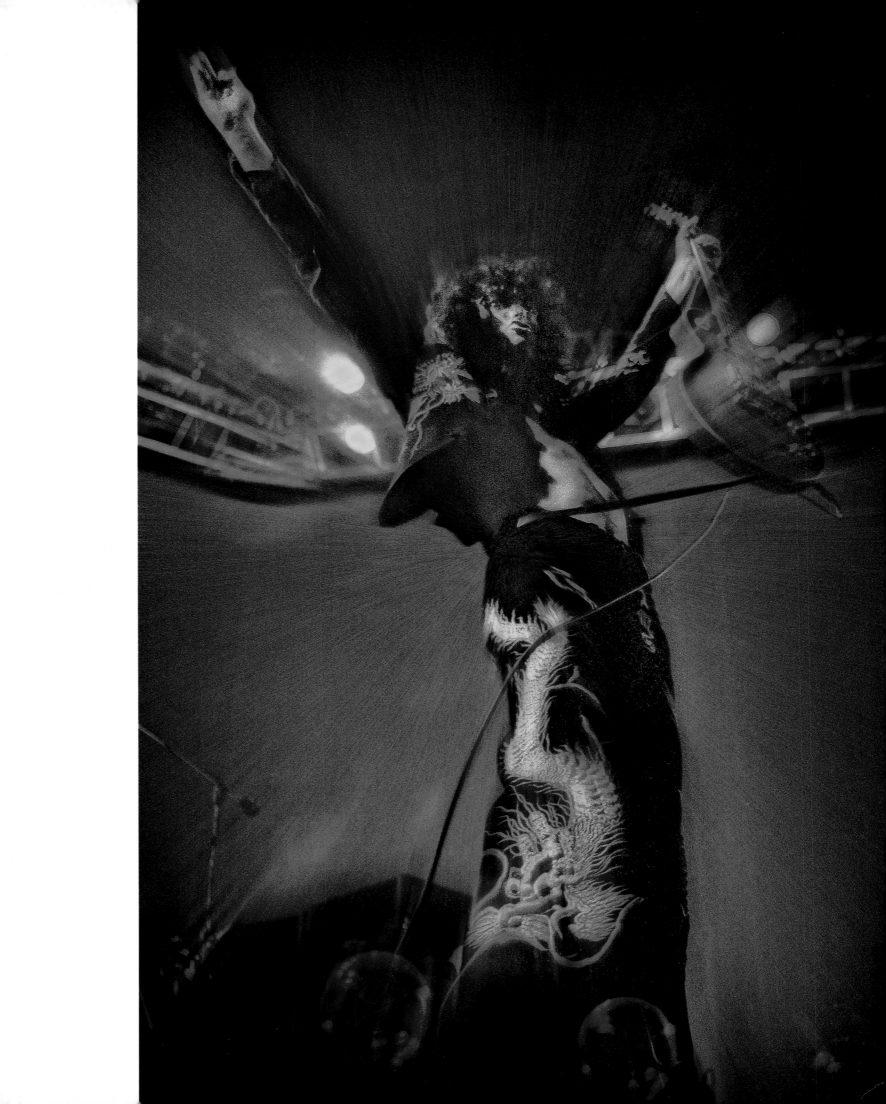

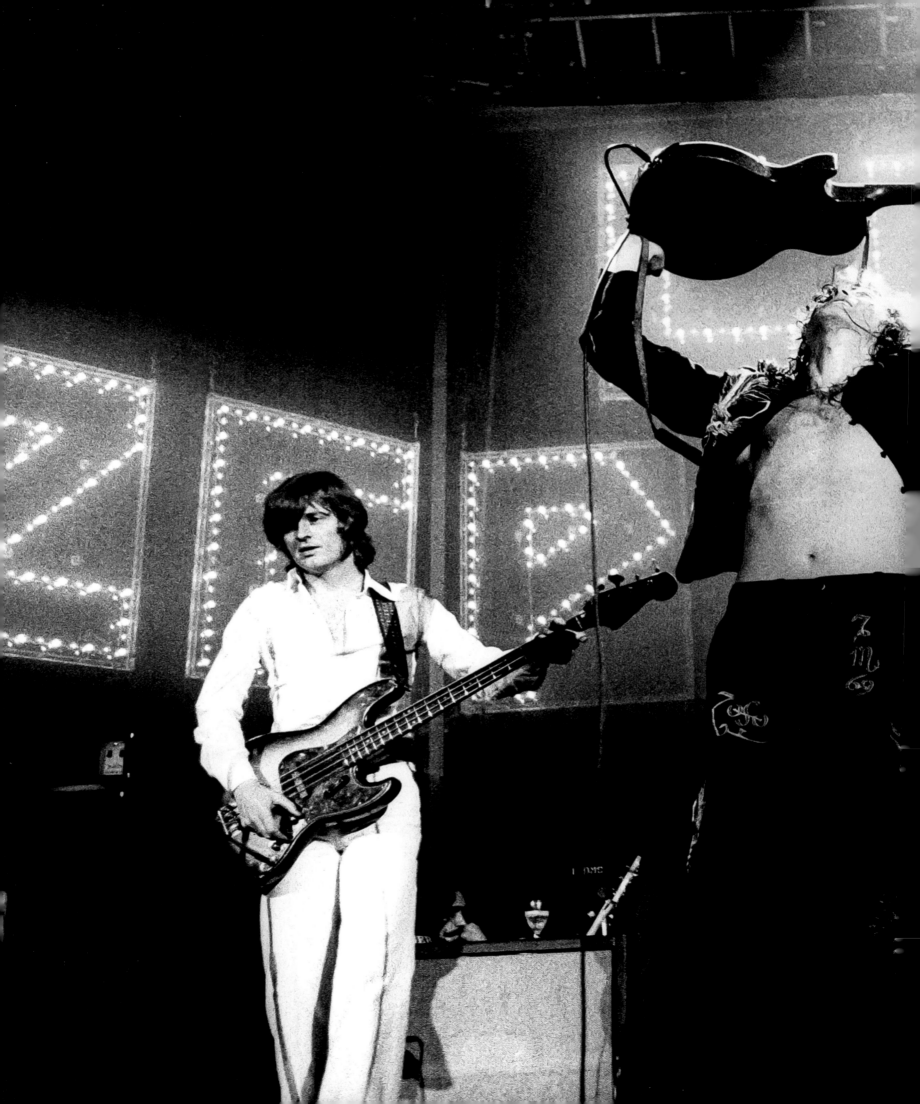

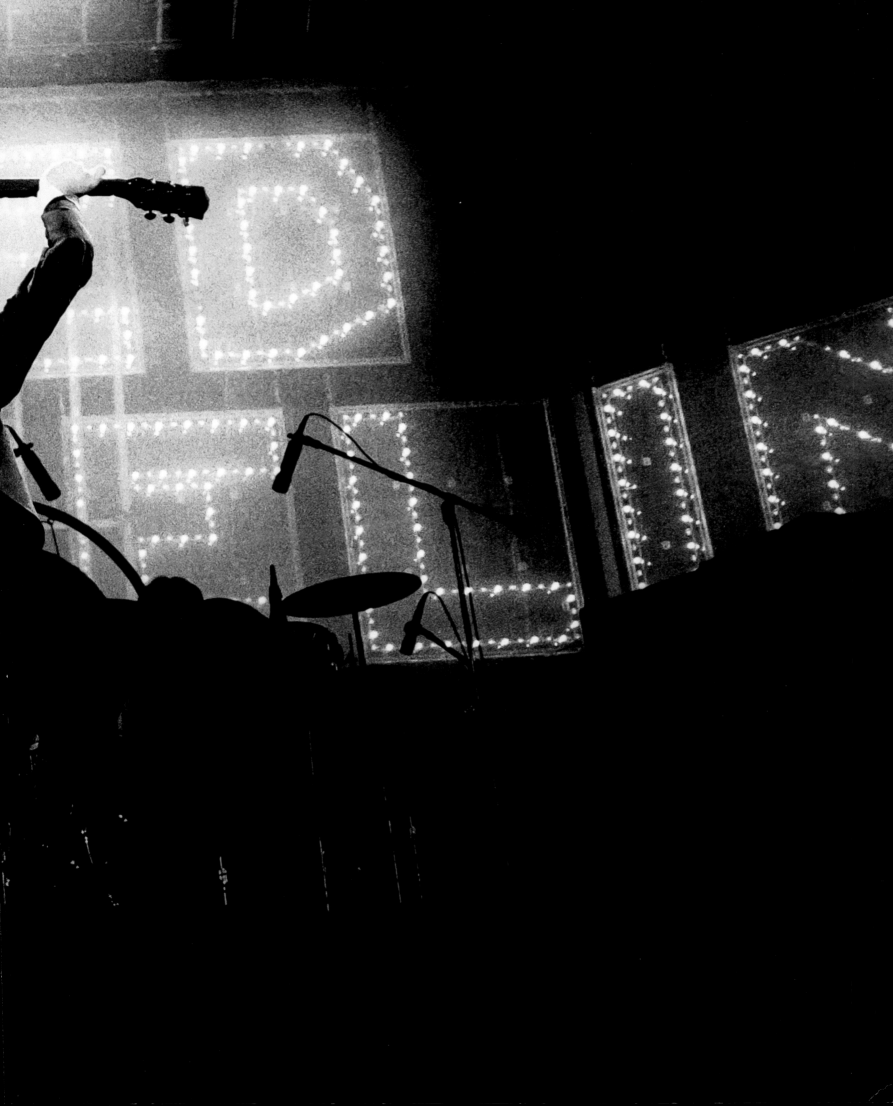

PRESENCE

5 April 1976

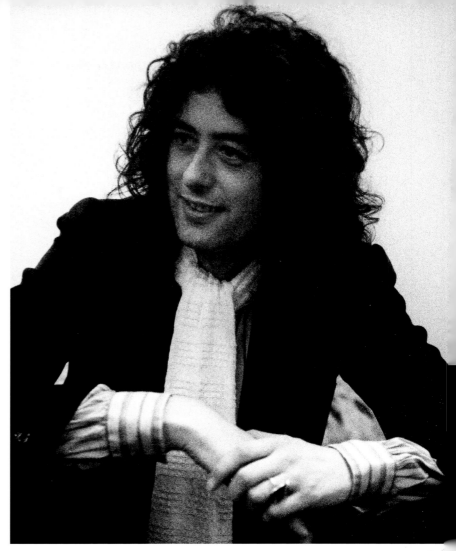
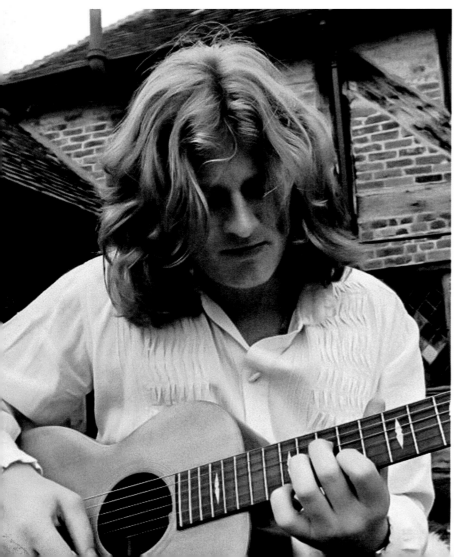
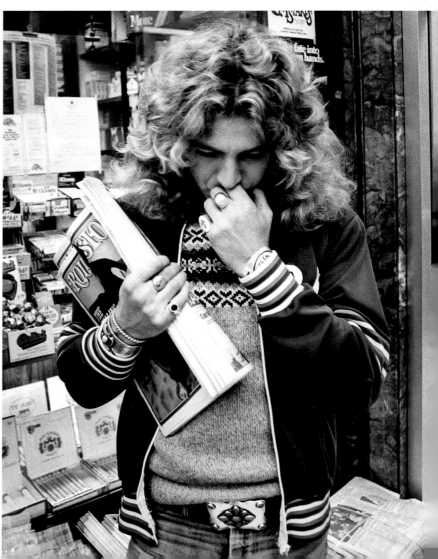

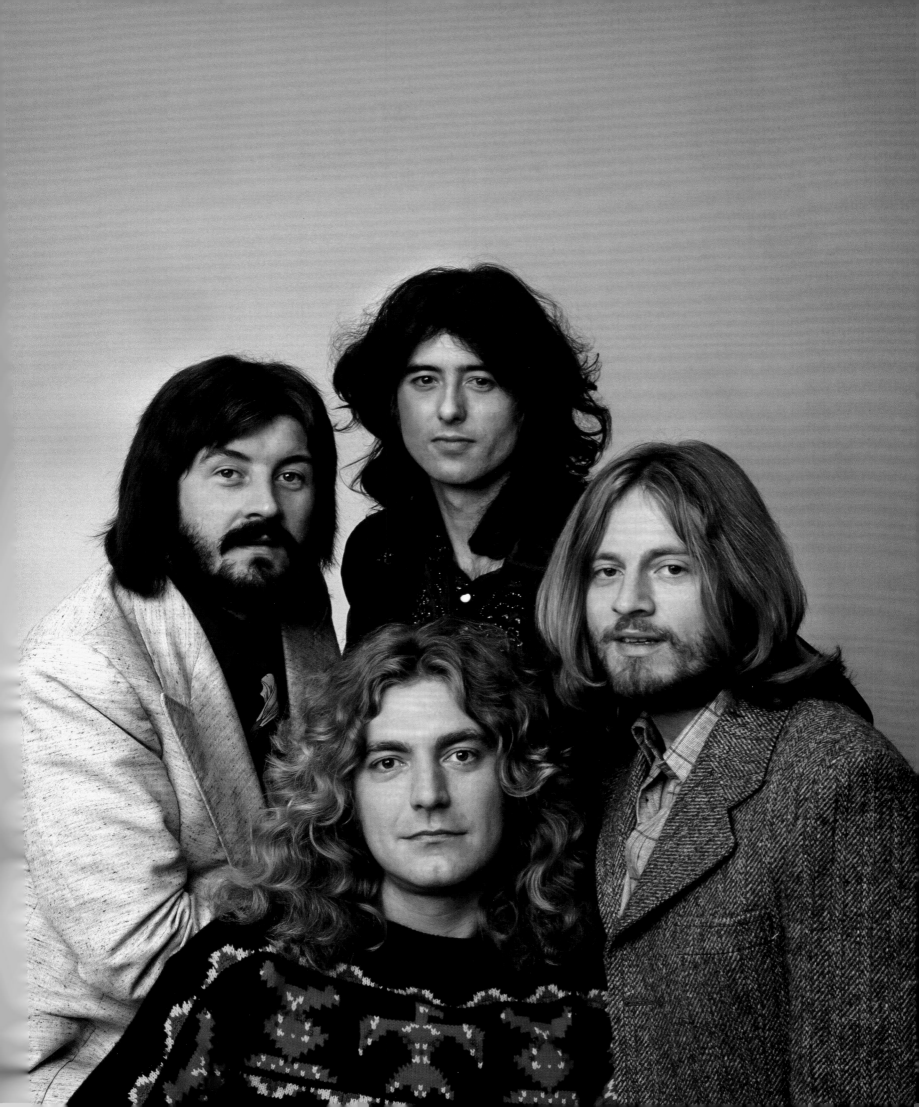

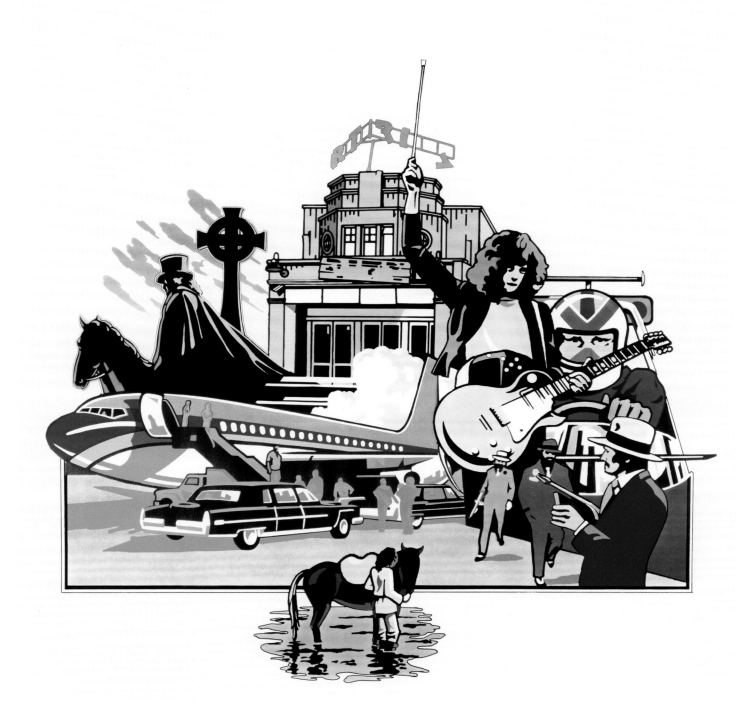

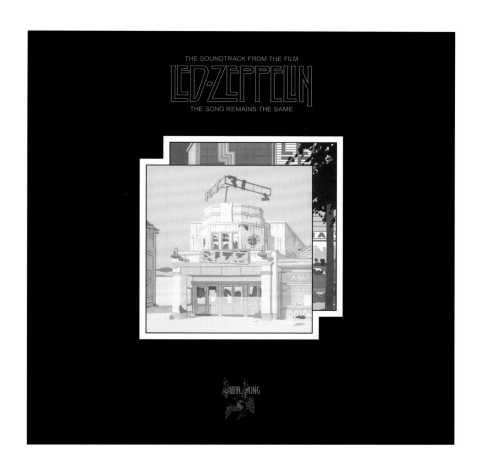

THE SONG REMAINS THE SAME

22 October 1976

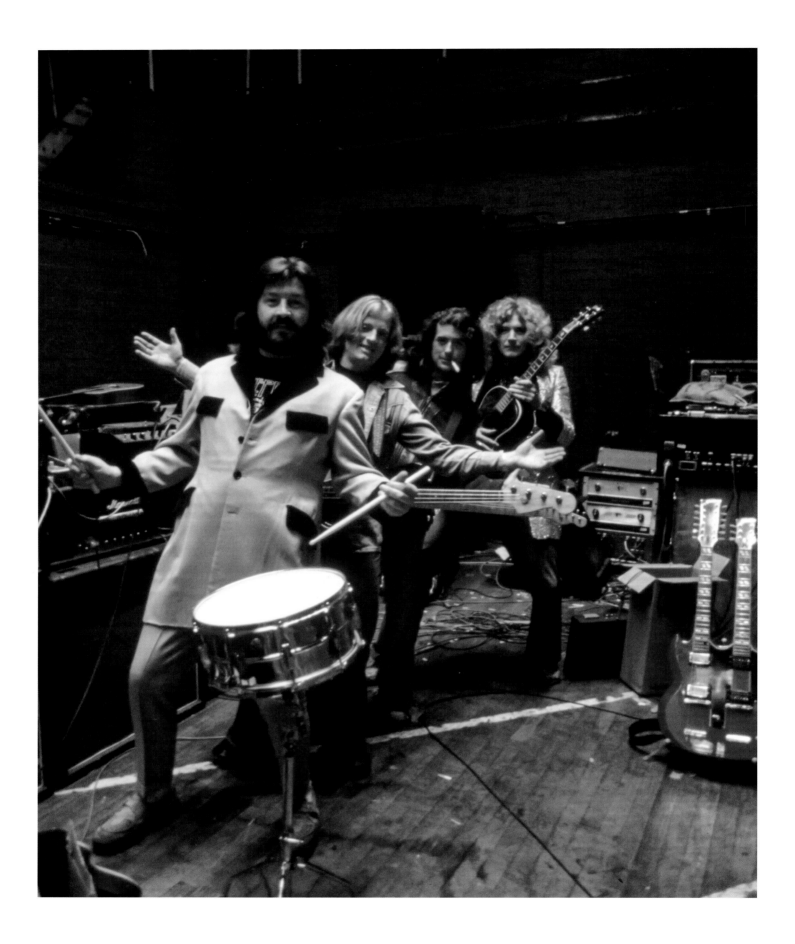

GETTING BACK TO WORK WAS ALWAYS GOOD. WE GOT STRAIGHT BACK INTO IT. IT'S LIKE YOU ALWAYS GO ON HOLIDAY TO THE SAME PLACE EVERY YEAR. WHEN YOU GET THERE, IT'S LIKE YOU'VE NEVER BEEN AWAY, ł WAS BRILLIANT.

JOHN PAUL JONES

21 OCTOBER 1976

Fox Wilshire Theatre, Los Angeles, California, USA

[294—295]

JANUARY 1977

Manticore Studios, London, UK

[296—301]

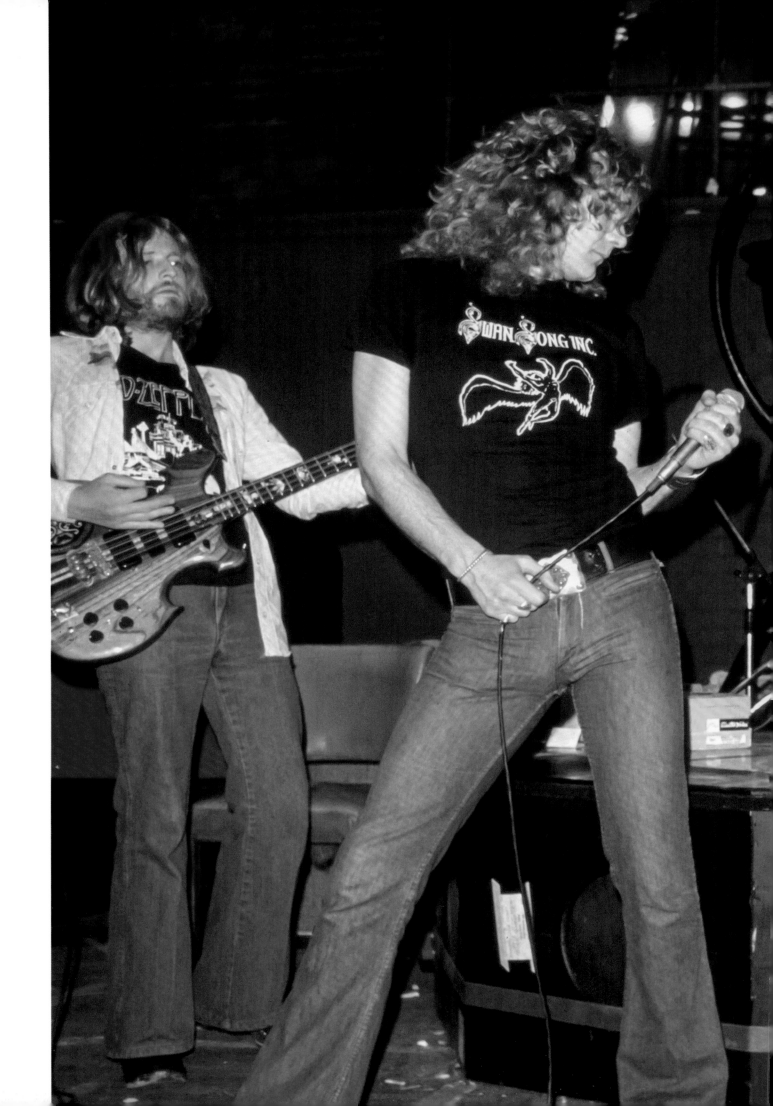

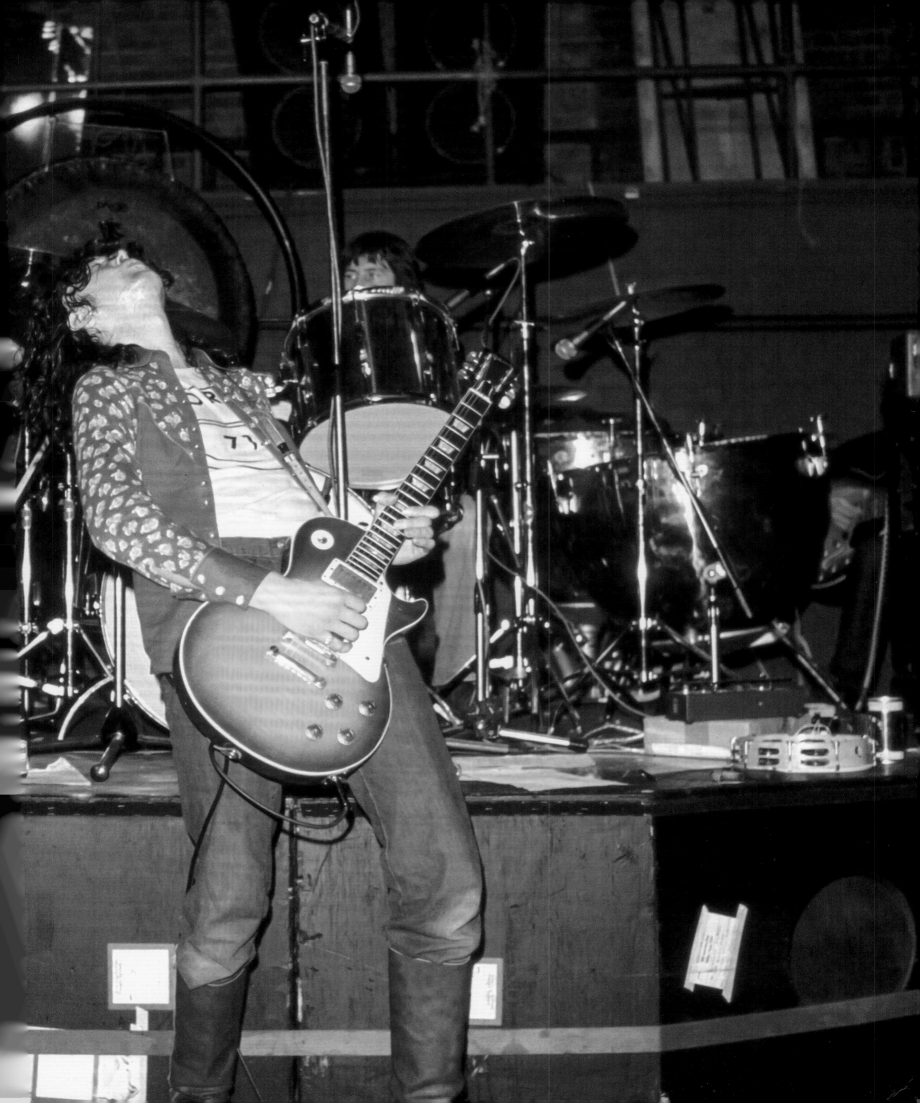

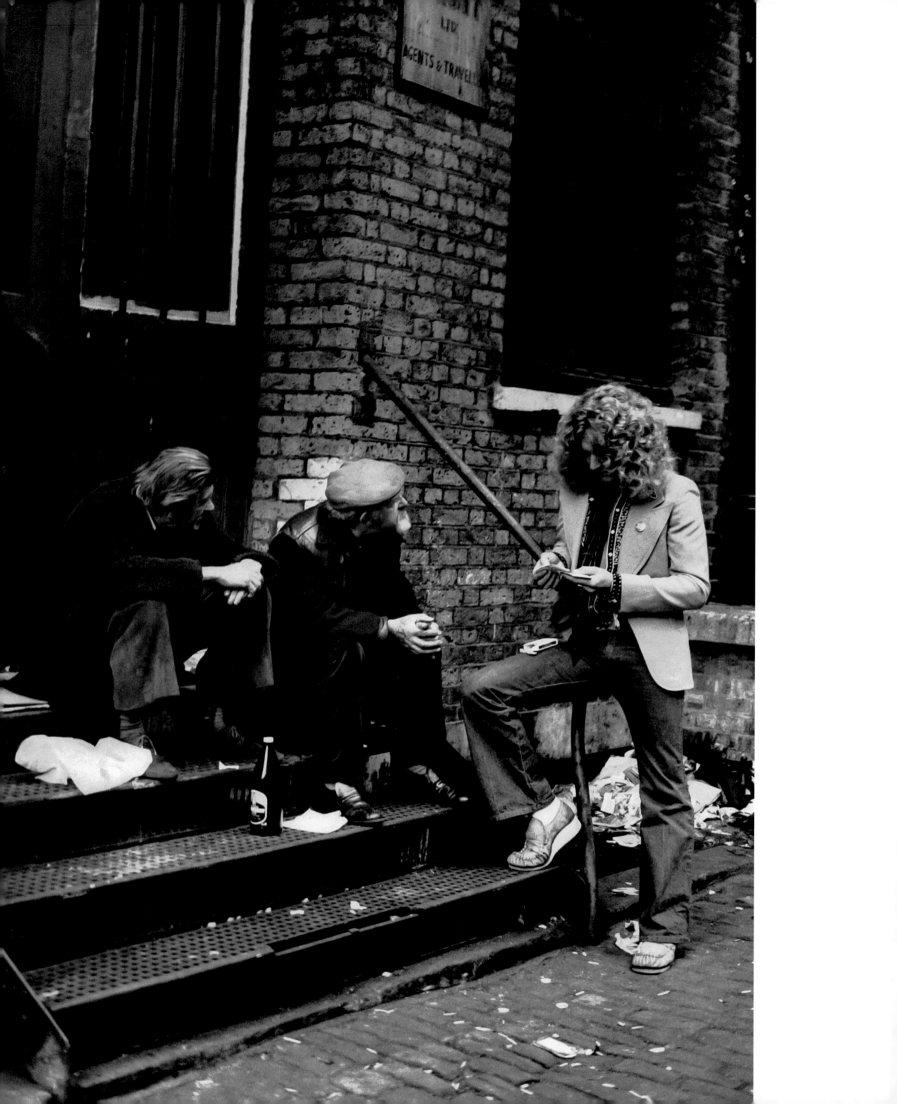

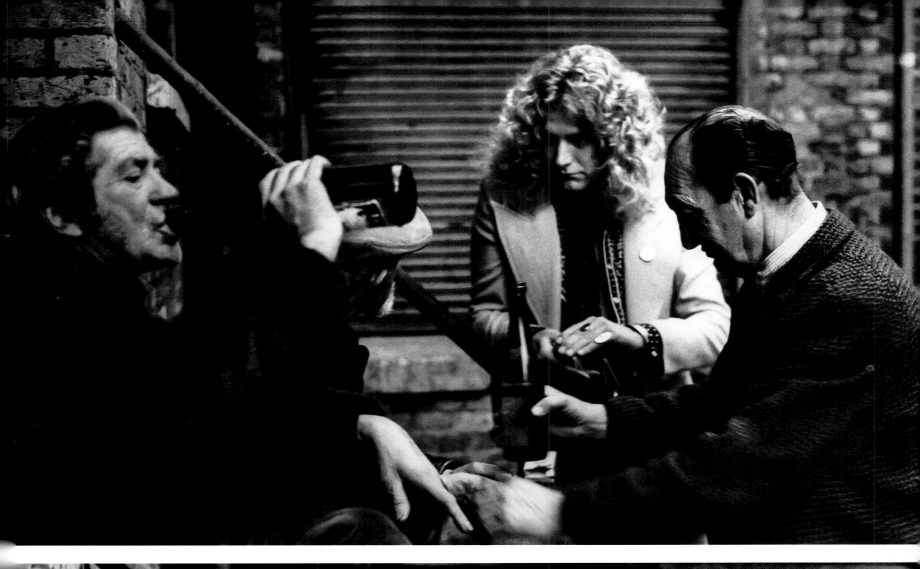

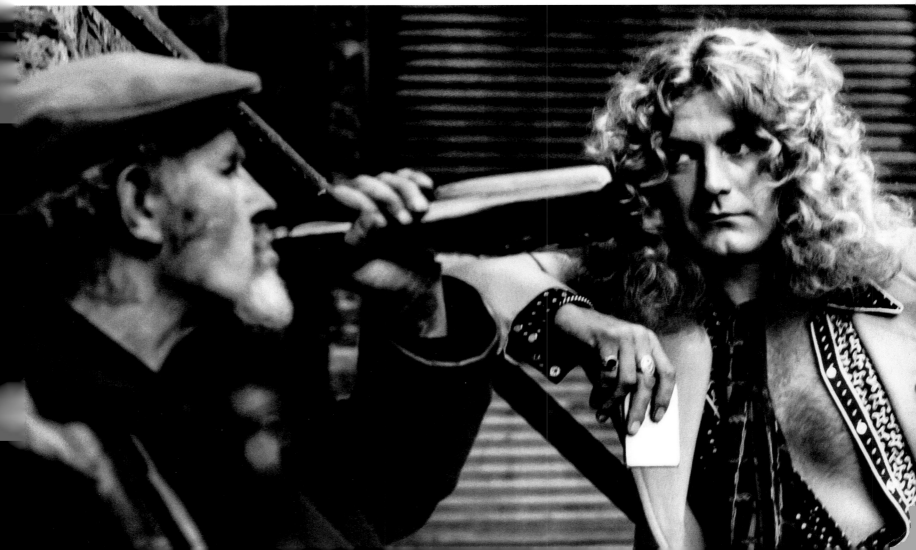

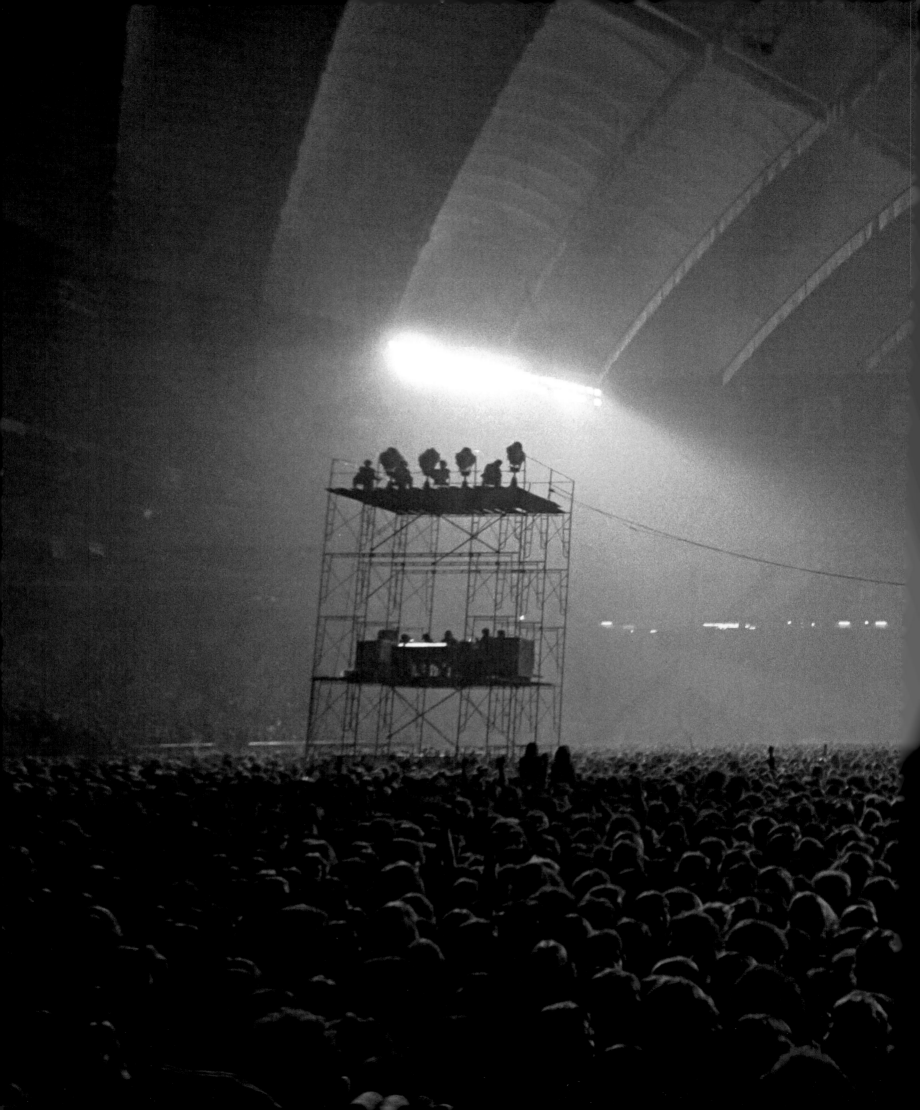

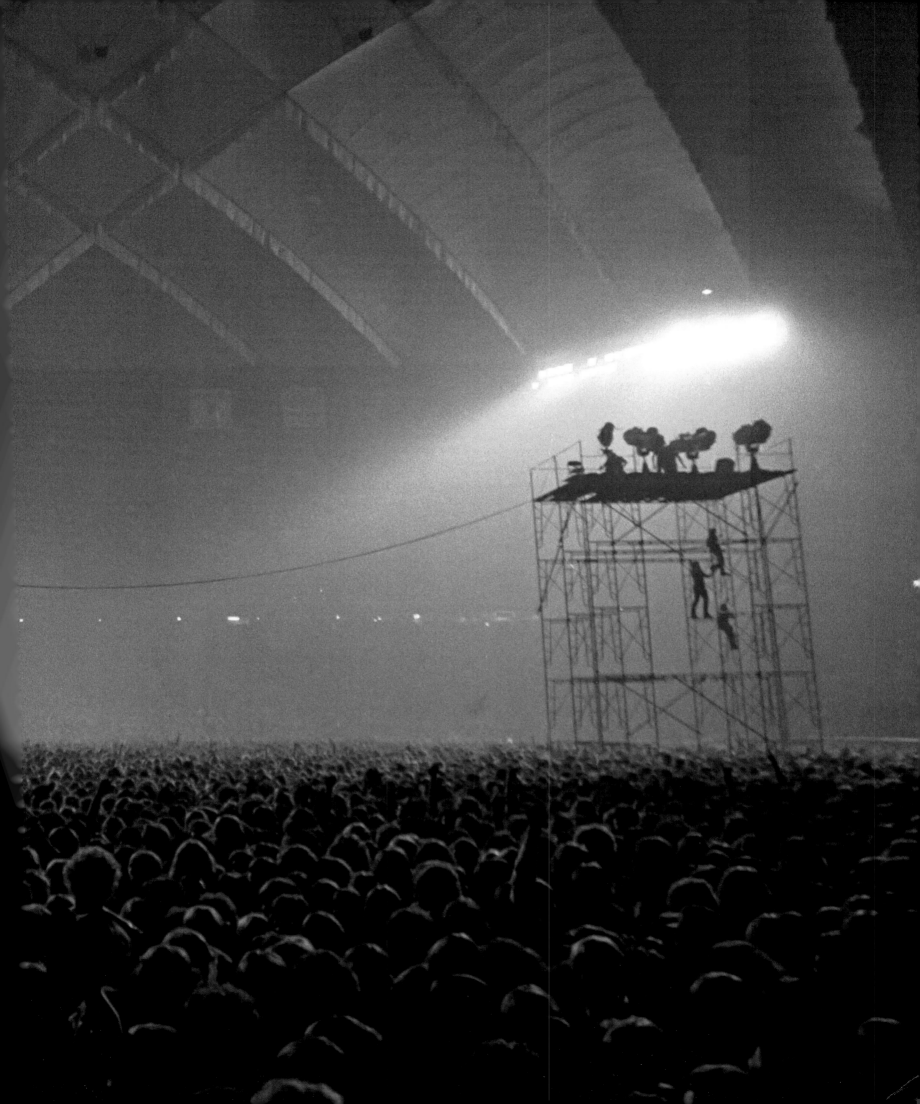

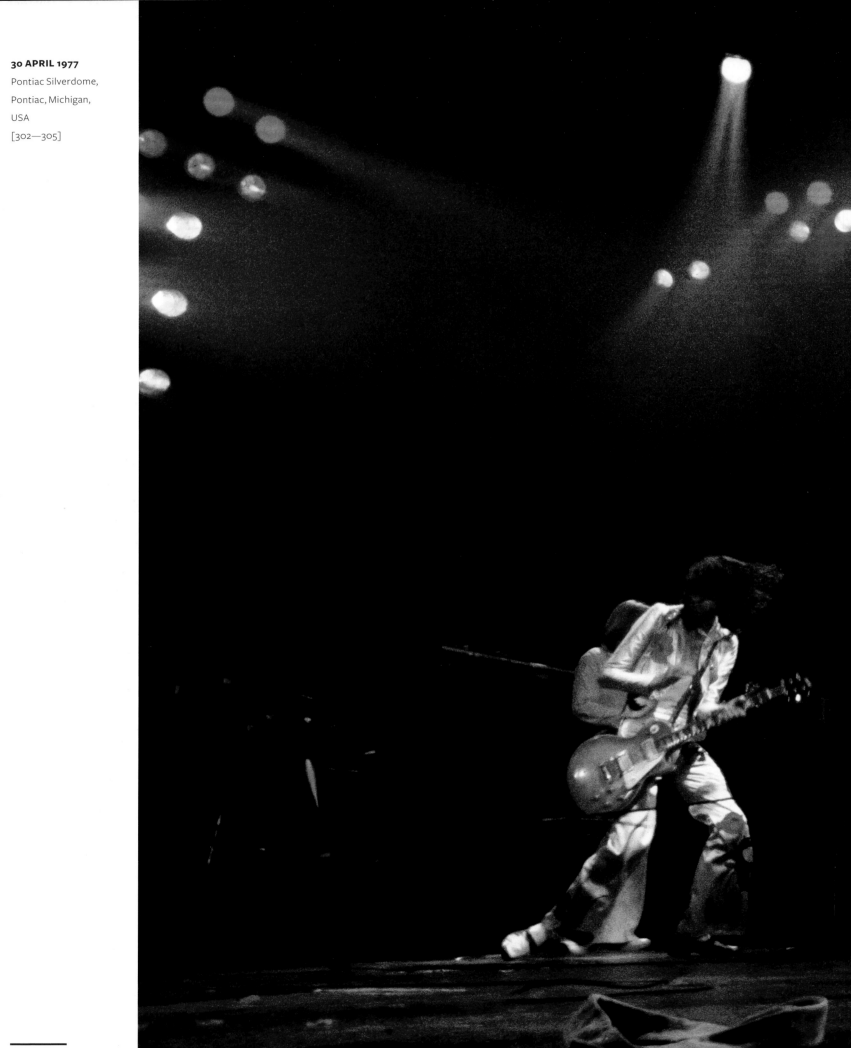

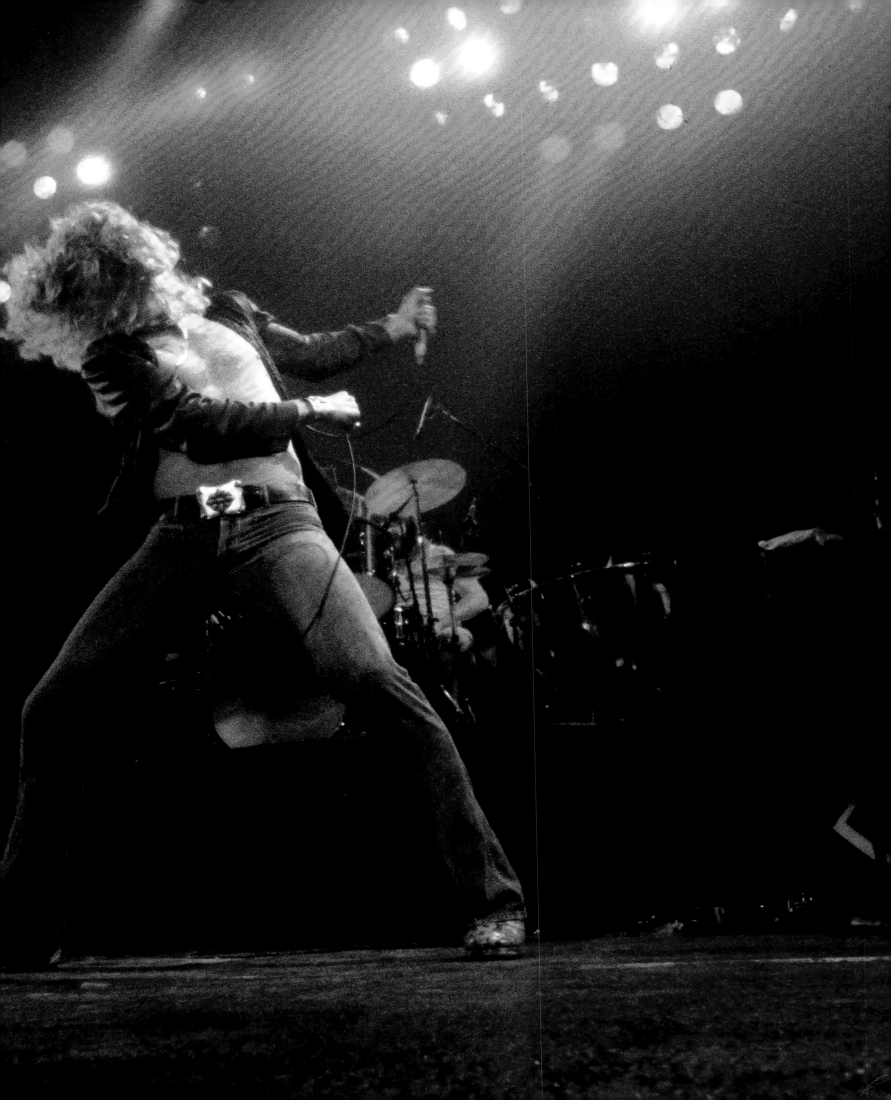

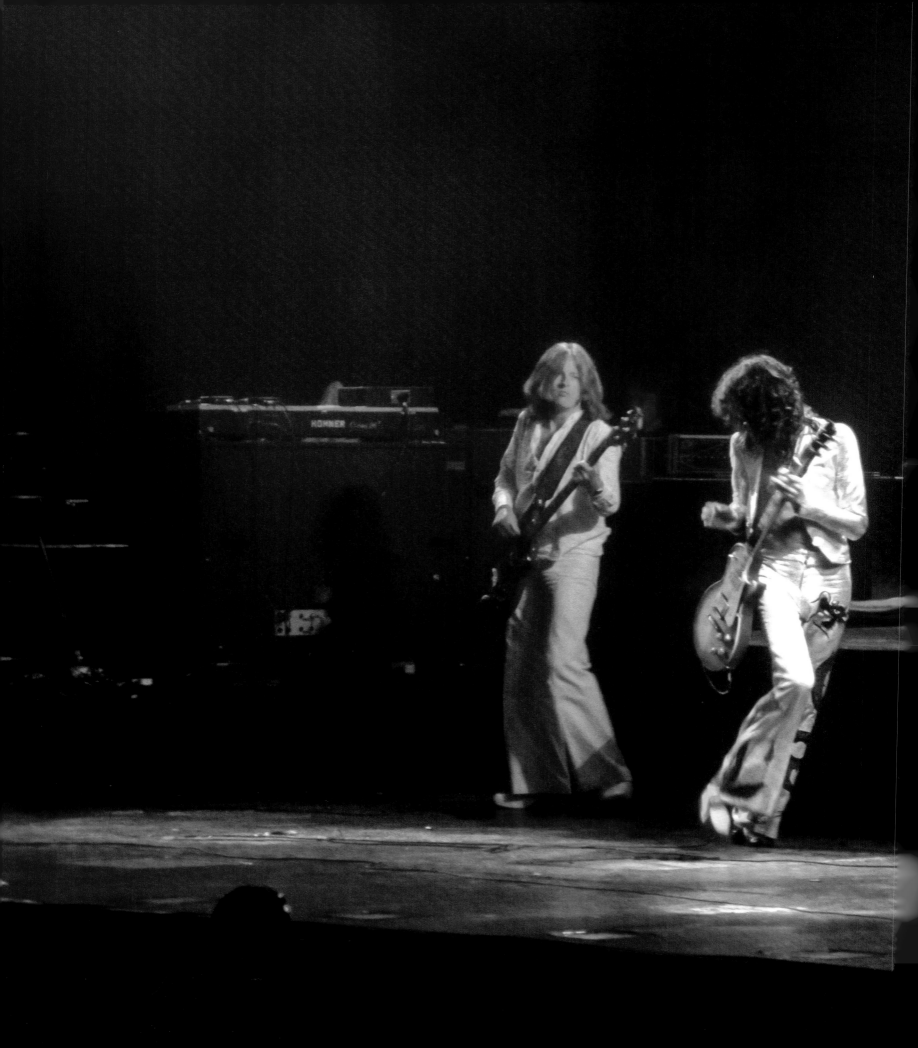

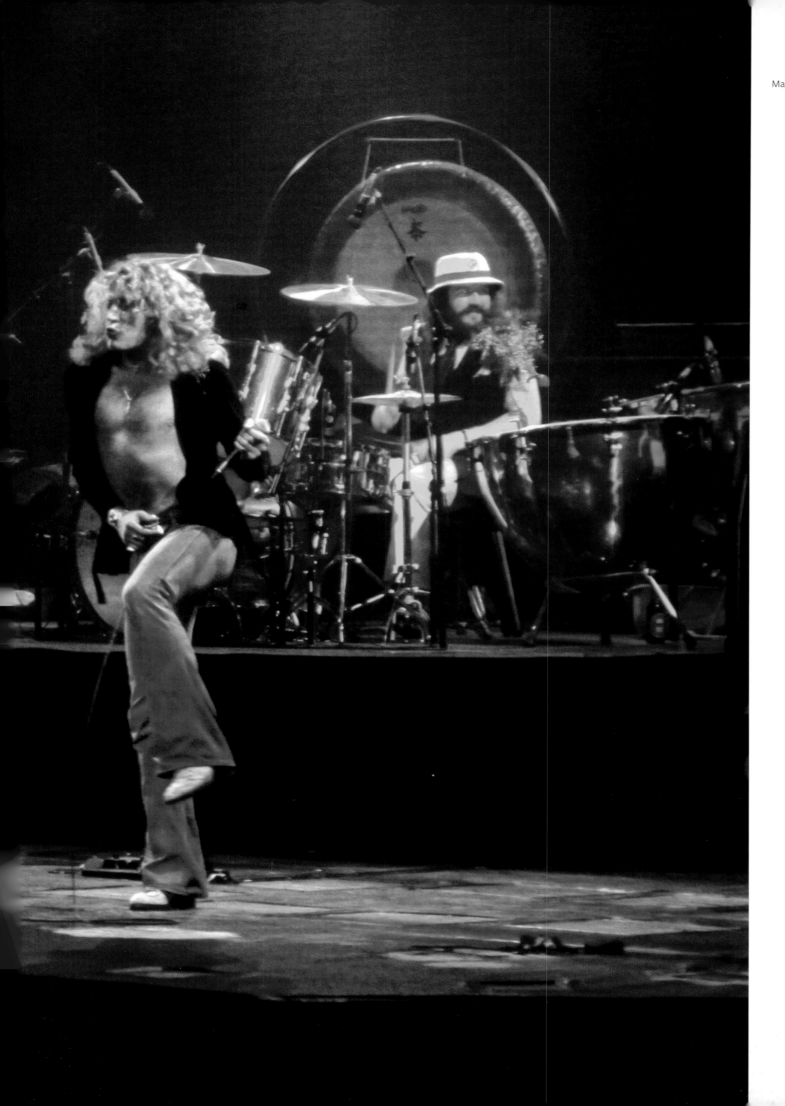

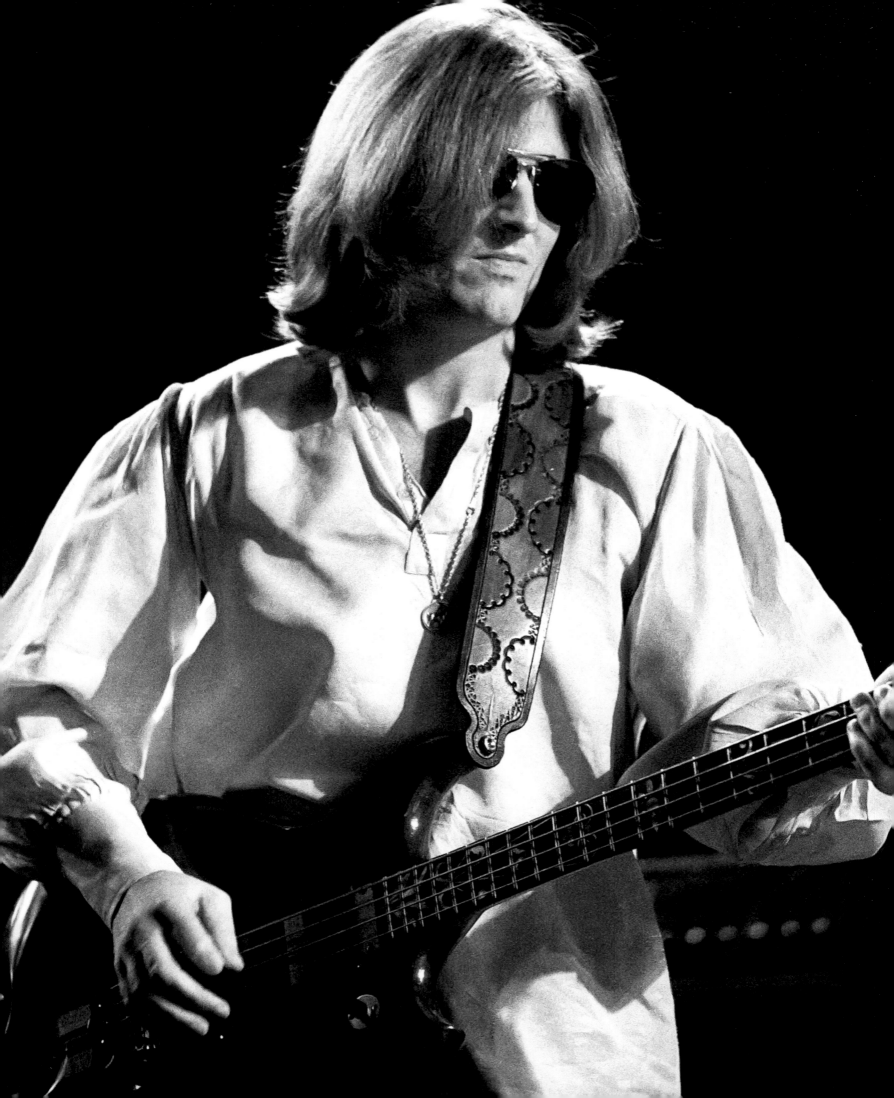

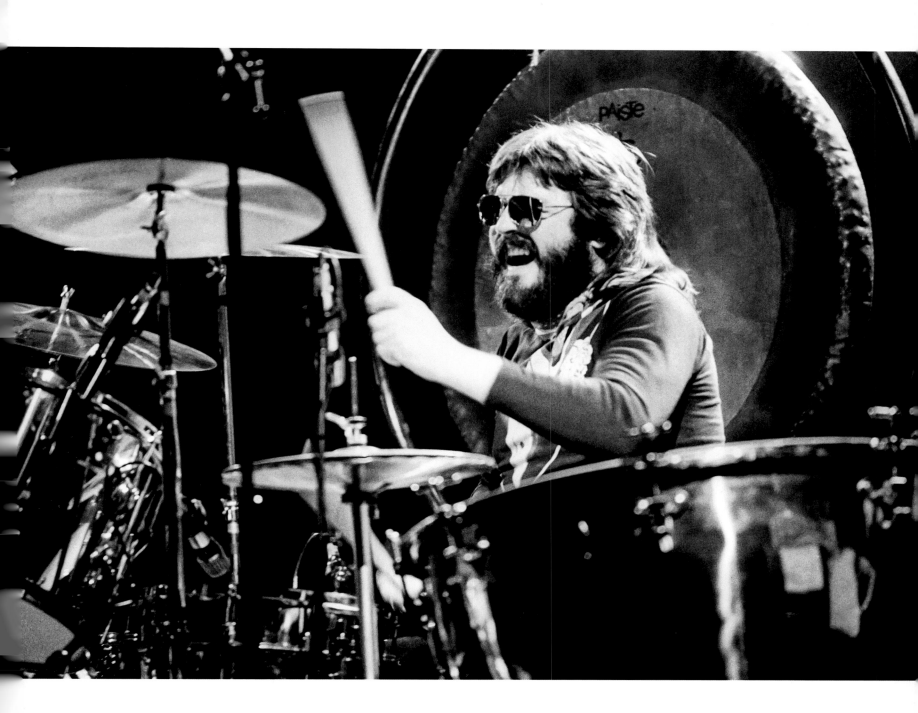

20 APRIL 1977

Riverfront Coliseum, Cincinnati, Ohio, USA

APRIL 1977

Chicago, Illinois, USA

28 APRIL 1977

Passport photo, taken aboard Caesar's Chariot

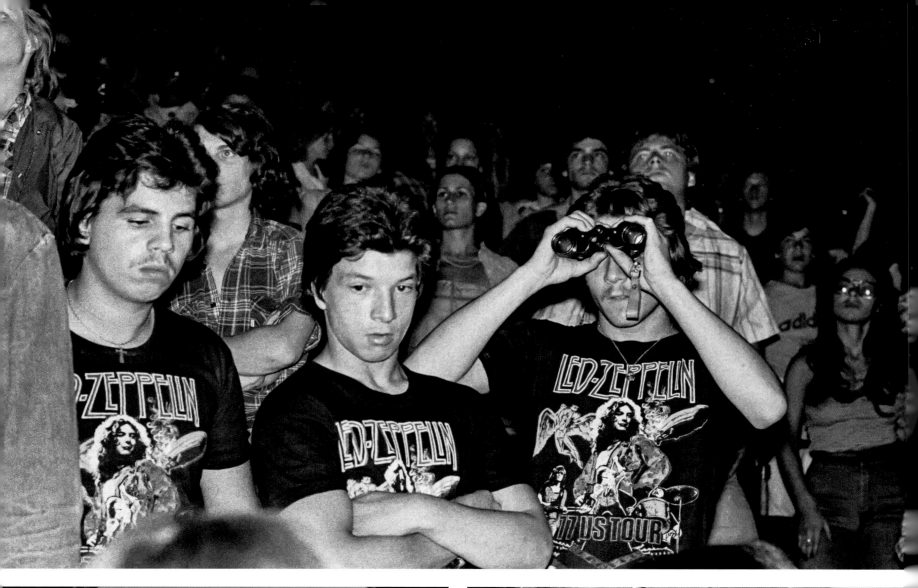

JUNE 1977

Madison Square Garden, New York, New York, USA

[top]

30 MAY 1977

Capital Centre, Landover, Maryland, USA

[bottom-left]

30 APRIL 1977

Pontiac Silverdome, Pontiac, Michigan, USA

[bottom-right]

IF IT WAS A SEATED GIG, QUITE OFTEN YOU COULD HAVE THE FAMILY OF VERY CONNECTED PEOPLE IN THE FRONT AREA WHO YOU DON'T MESS WITH. QUITE OFTEN THEY DON'T EVEN KNOW WHY THEY'RE THERE!

ROBERT PLANT

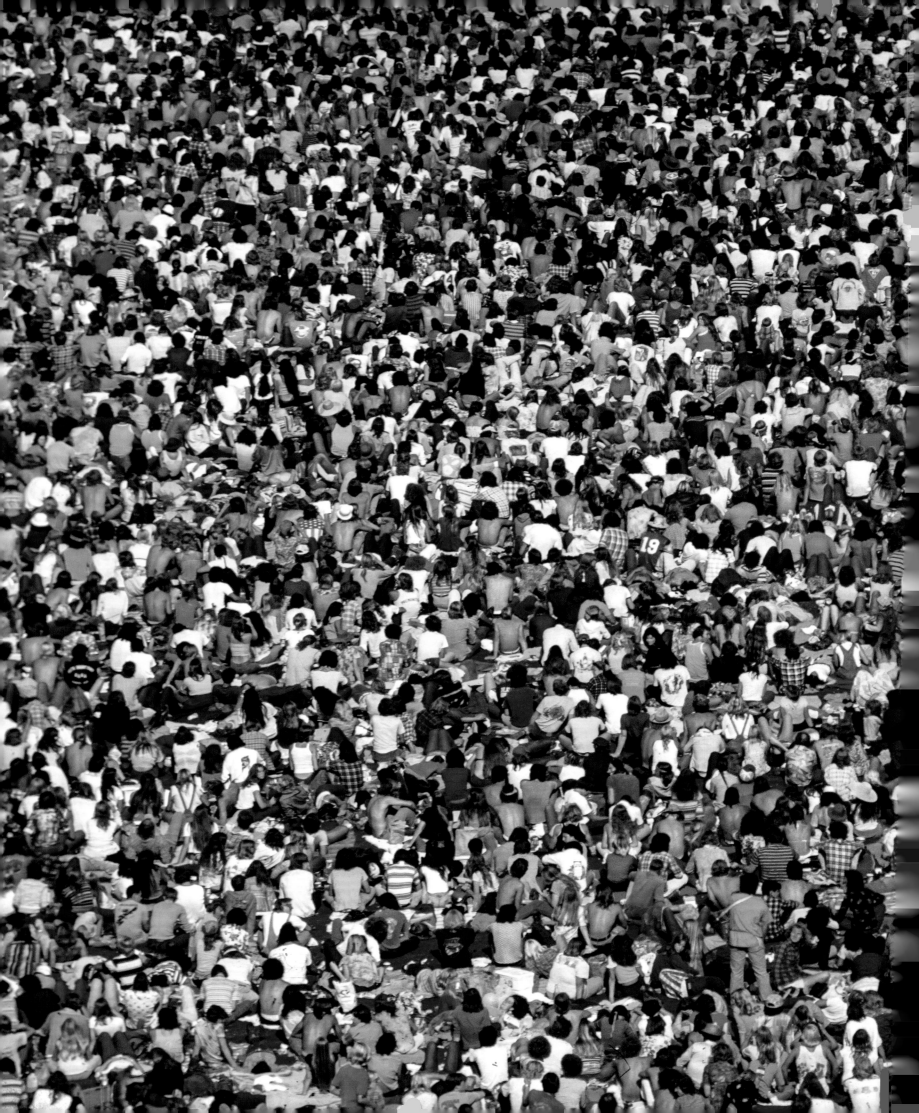

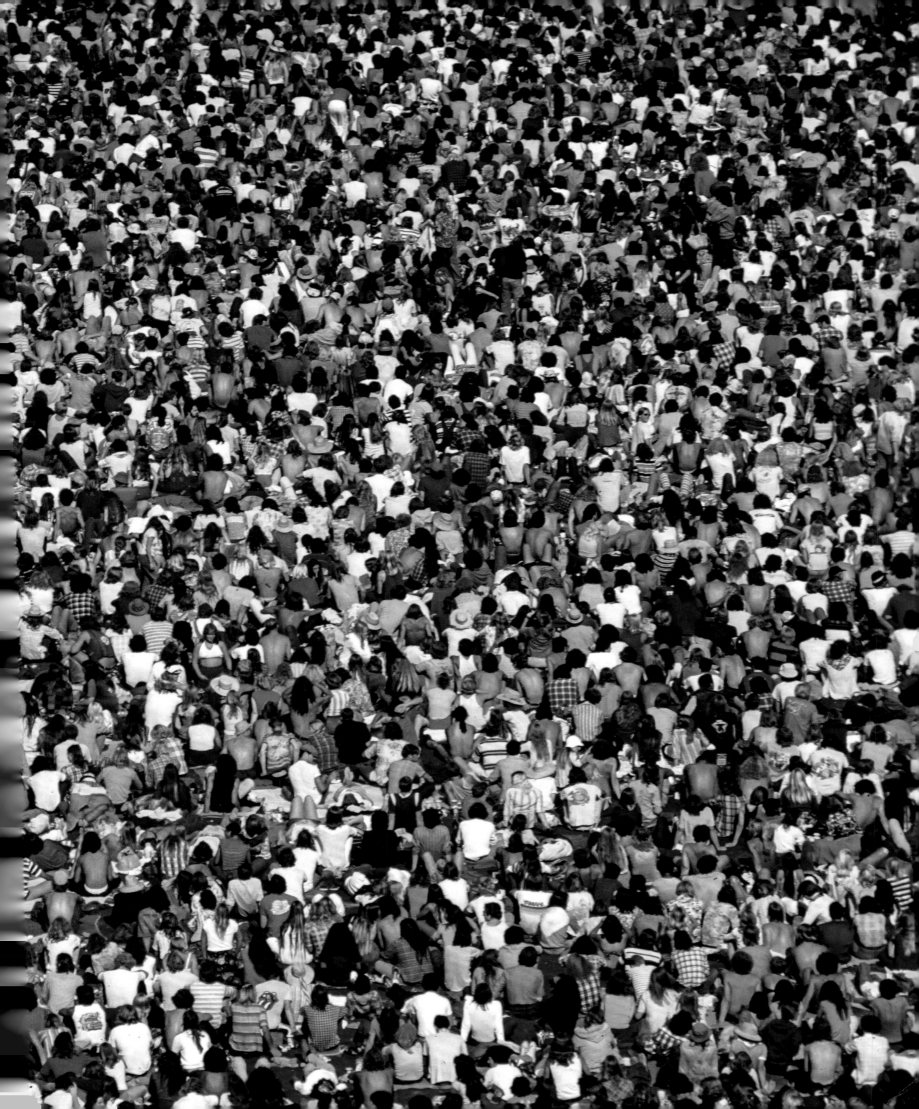

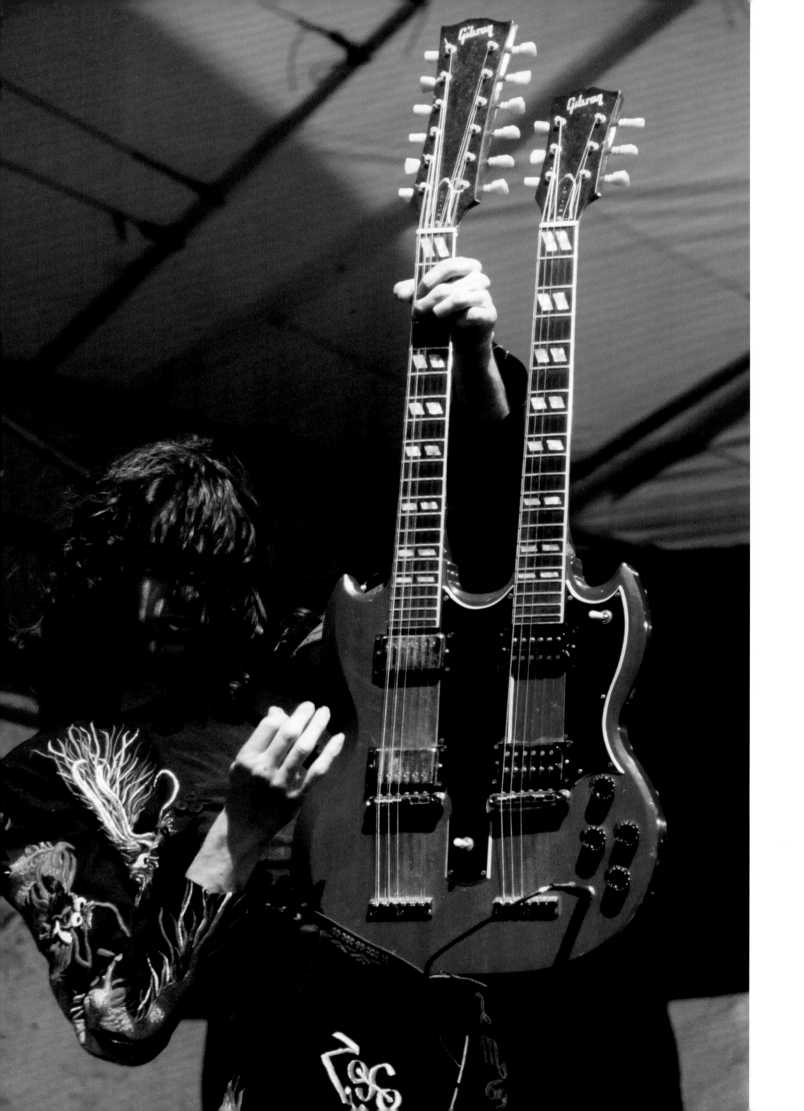

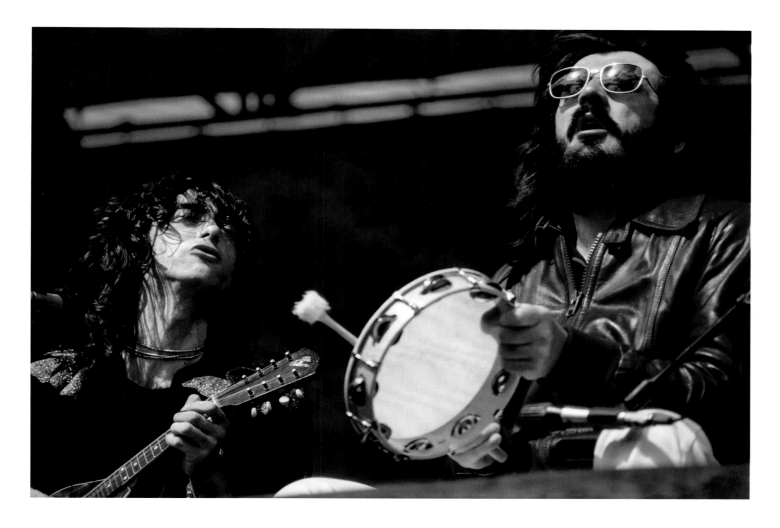

23 & 24 JULY 1977

Oakland-Alameda County Coliseum, Oakland, California, USA

[314—323]

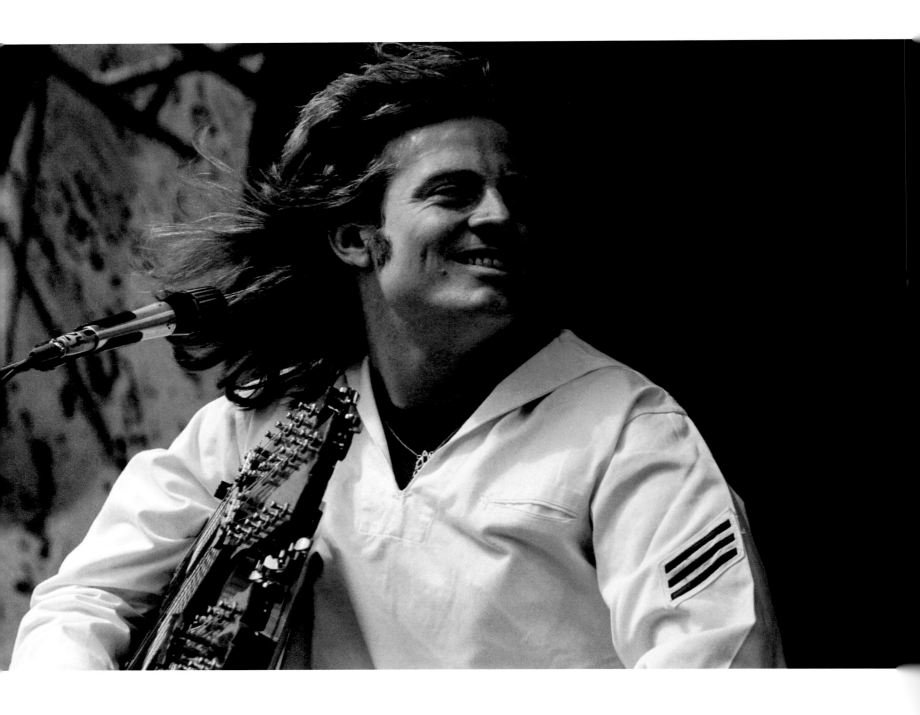

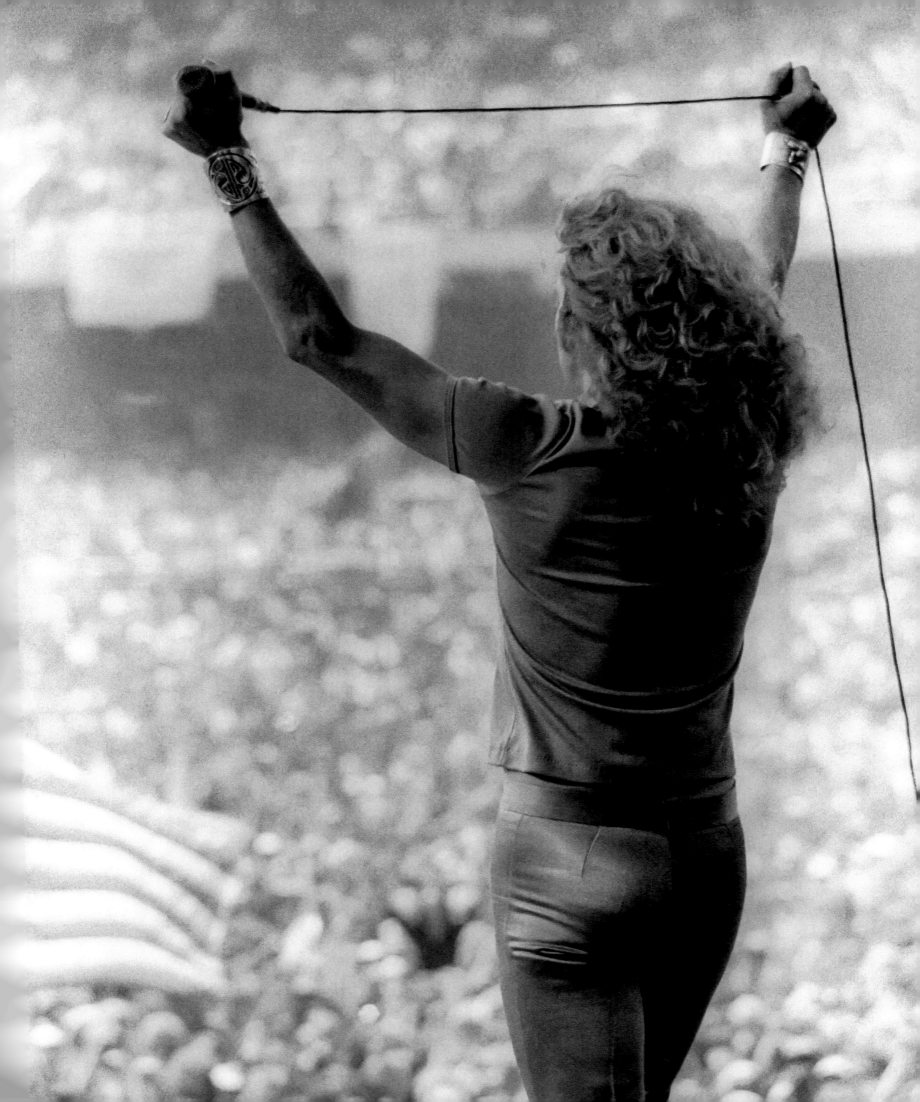

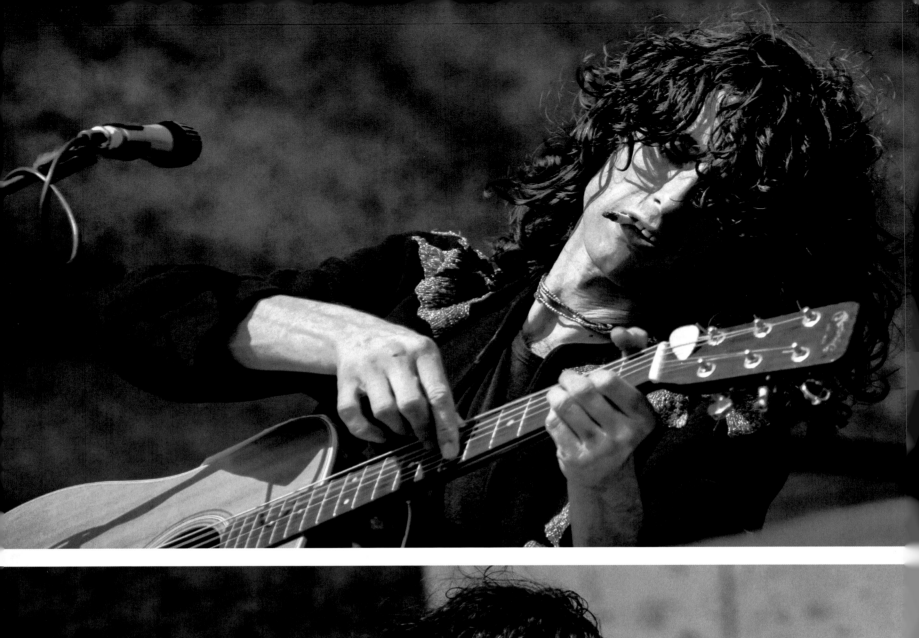
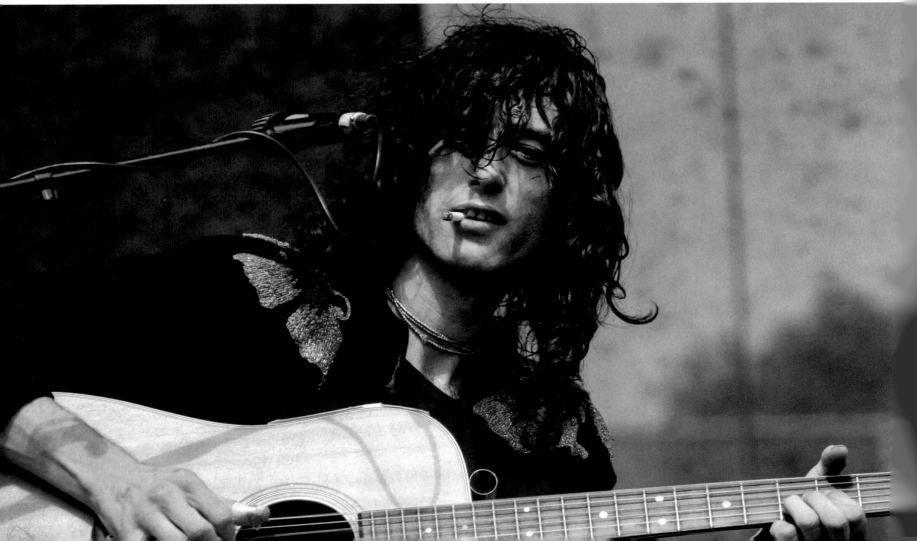

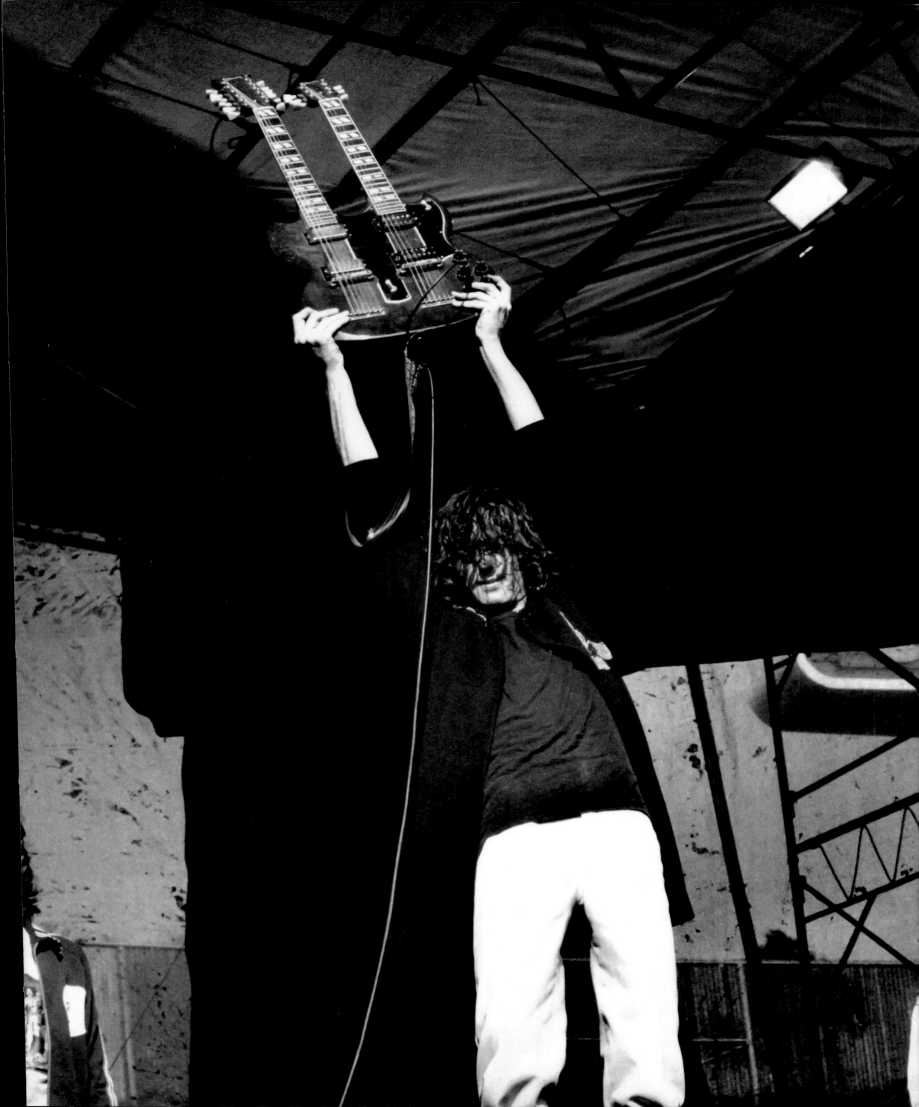

WE BECAME CATALYSTS FOR AN EVENT THAT WAS GOING ON IN FRONT OF US AND SOMETIMES REGARDLESS OF US. NOT ONLY WERE WE PLAYING, AND PLAYING WELL, BUT WE WERE OFTEN WITNESSING A KIND OF ANARCHY.

LED ZEPPELIN
IN THROUGH
THE OUT DOOR

LED·ZEPPELIN

LED·ZEPPELIN
Tour of Europe 1980
GUEST

NINETEEN SEVENTY NINE

—

EIGHTY TWO

LED·ZEPPELIN

19 79

19 82

IN THROUGH THE OUT DOOR

AVAILABLE ON SWAN SONG RECORDS AND TAPES
SS 16002

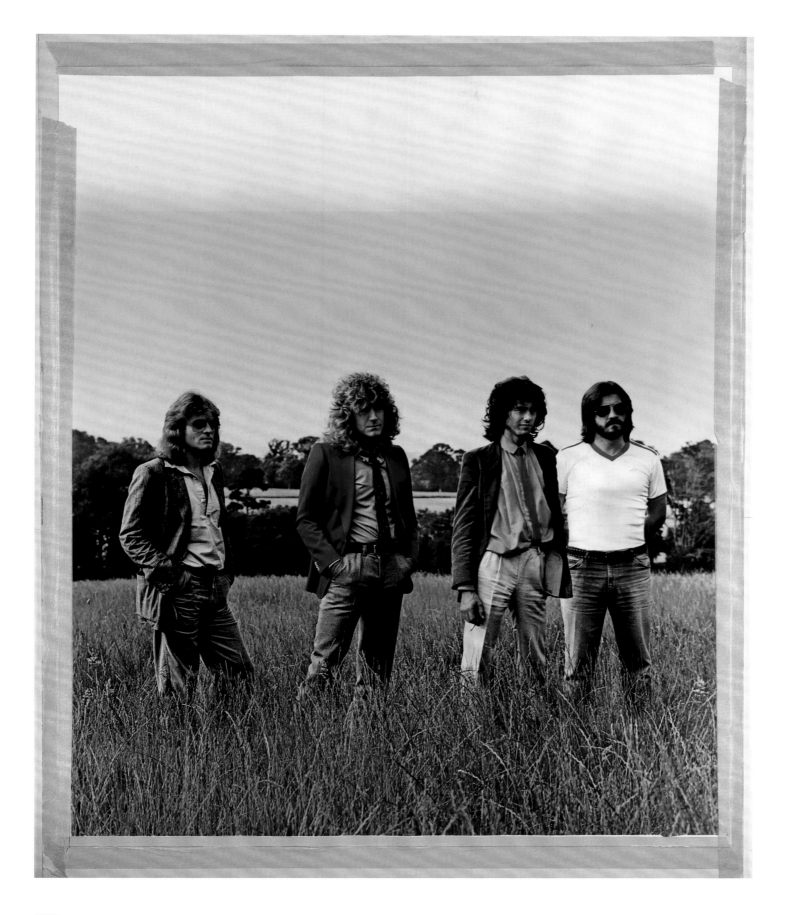

JULY 1979

Knebworth, Hertfordshire, UK

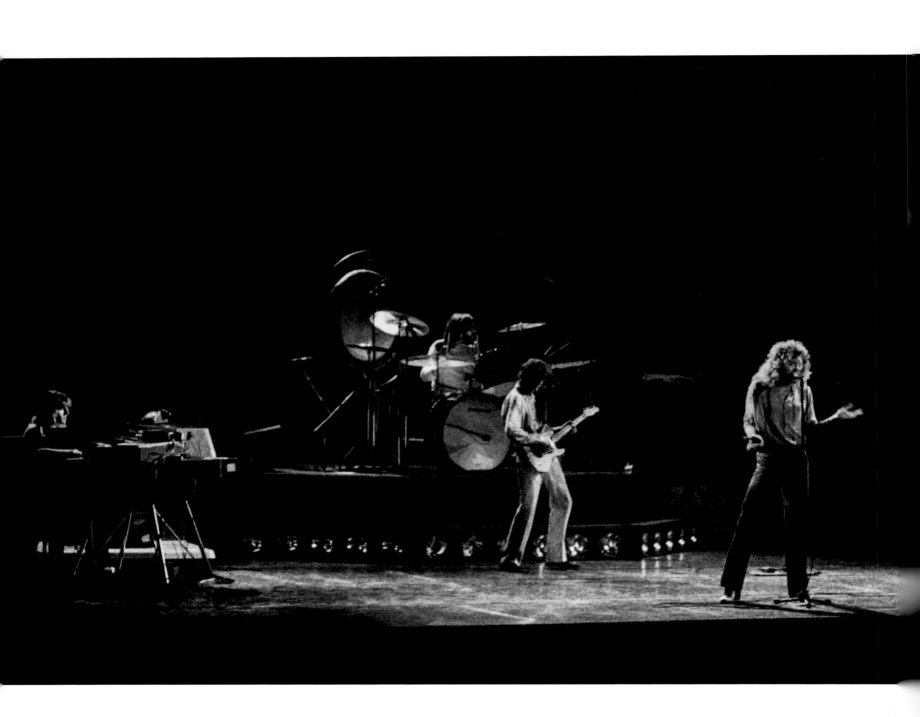

23 JULY 1979
Falkoner Theatre, Copenhagen, Denmark

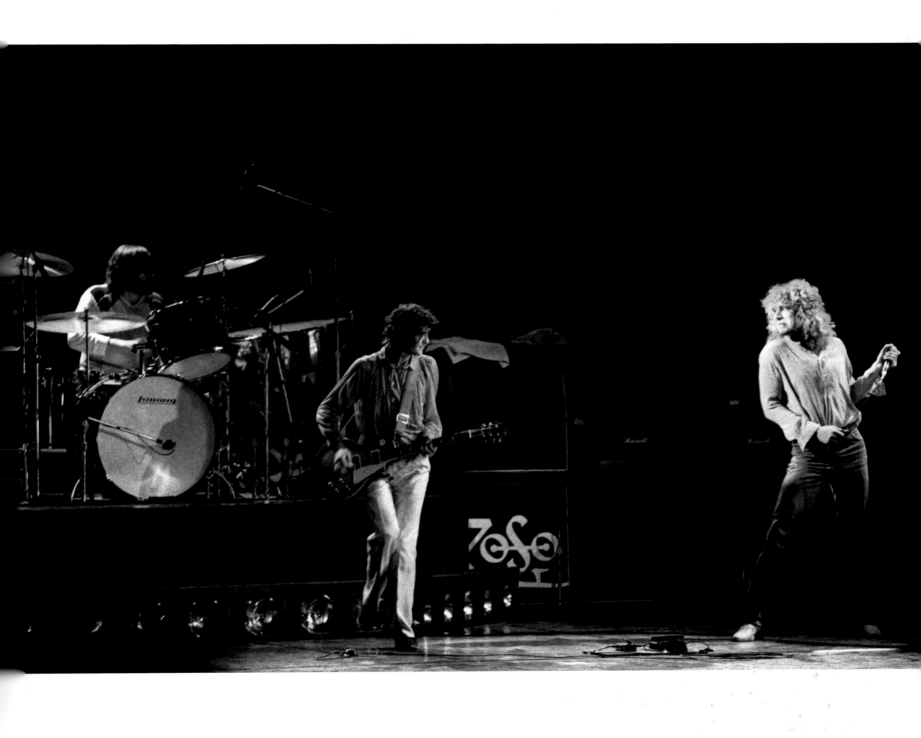

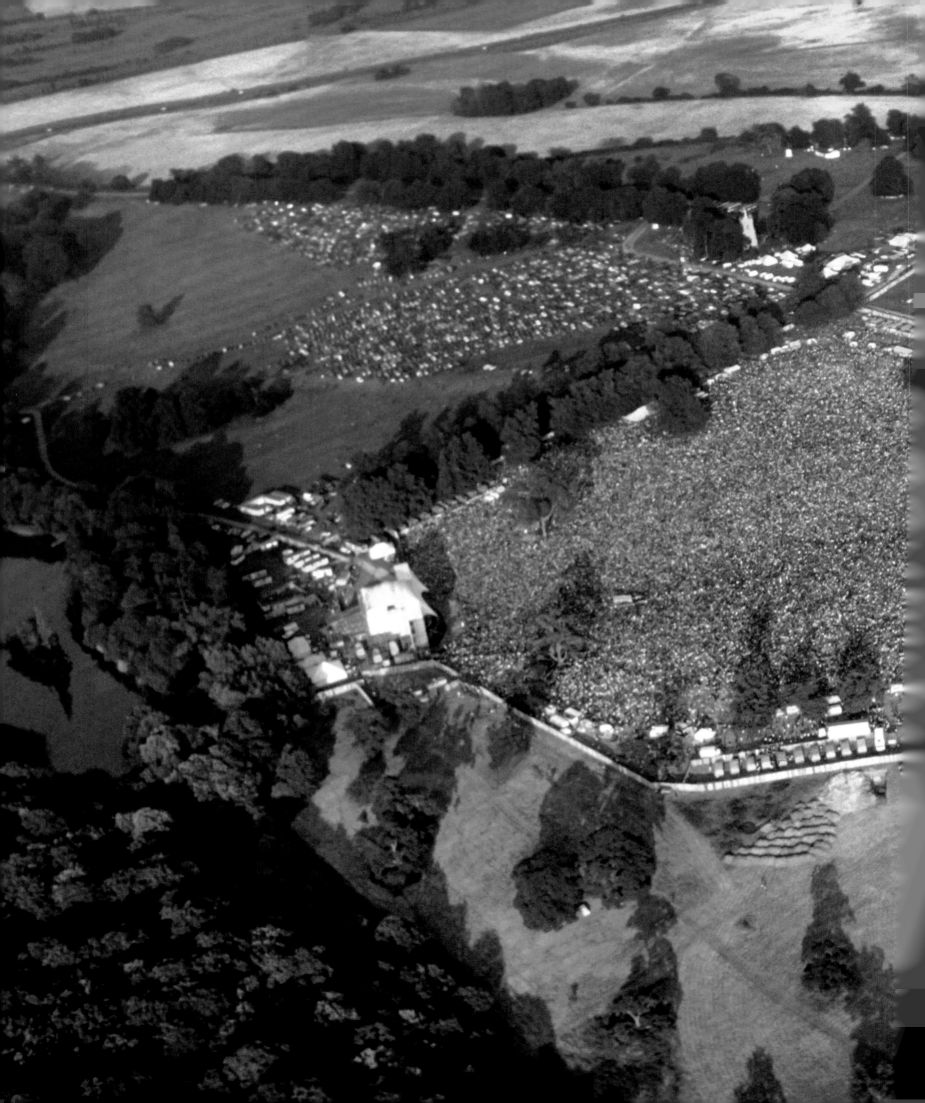

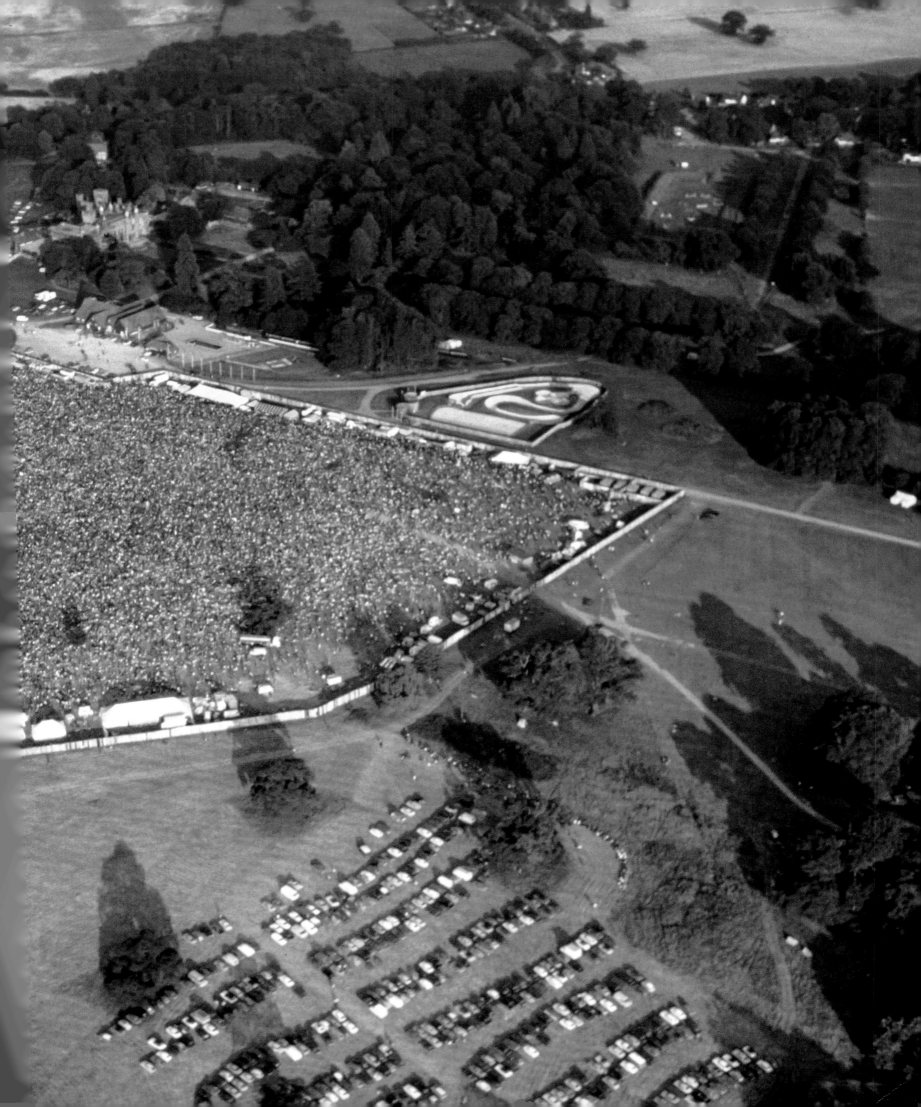

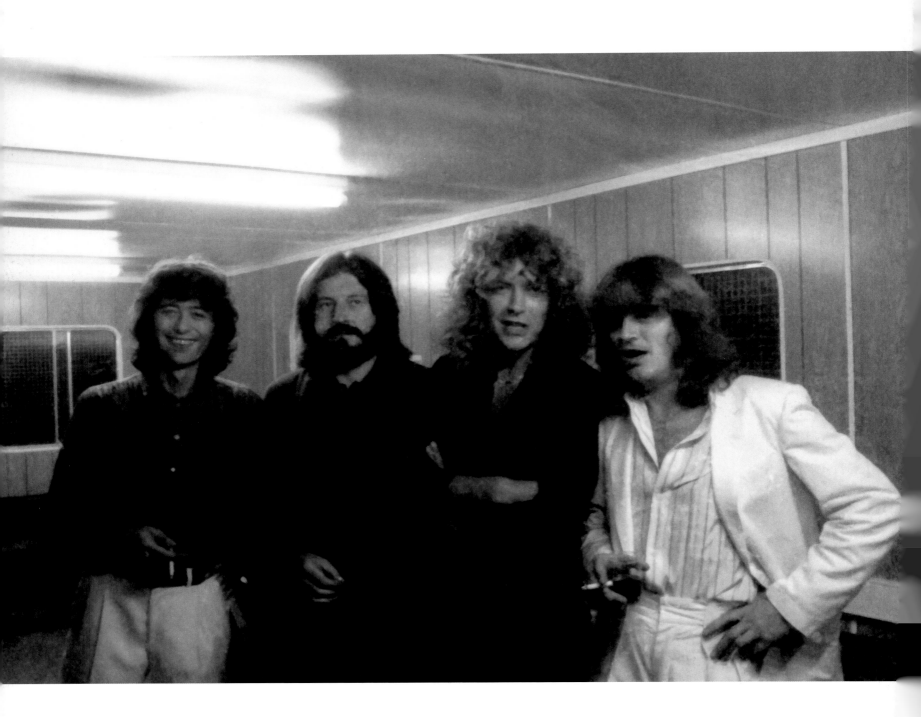

4 & 11 AUGUST 1979

Knebworth, Hertfordshire, UK

[330—337]

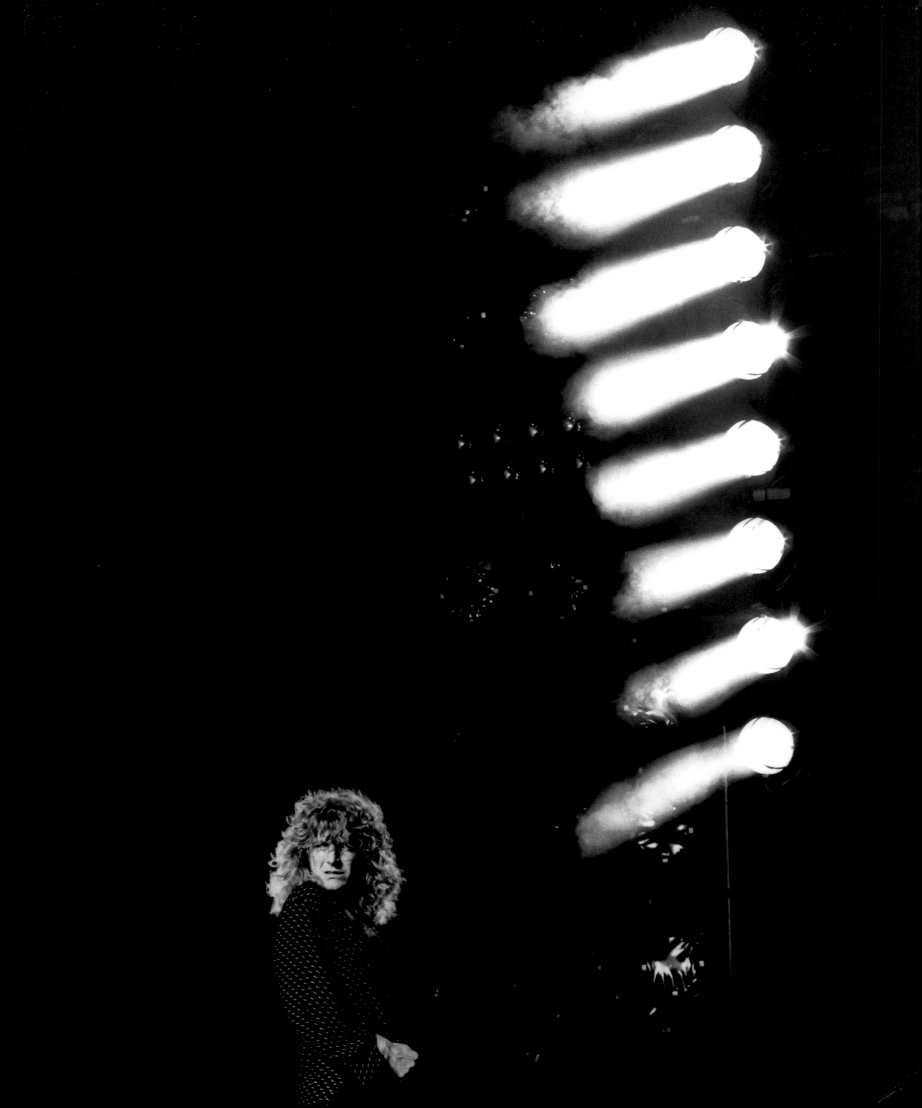

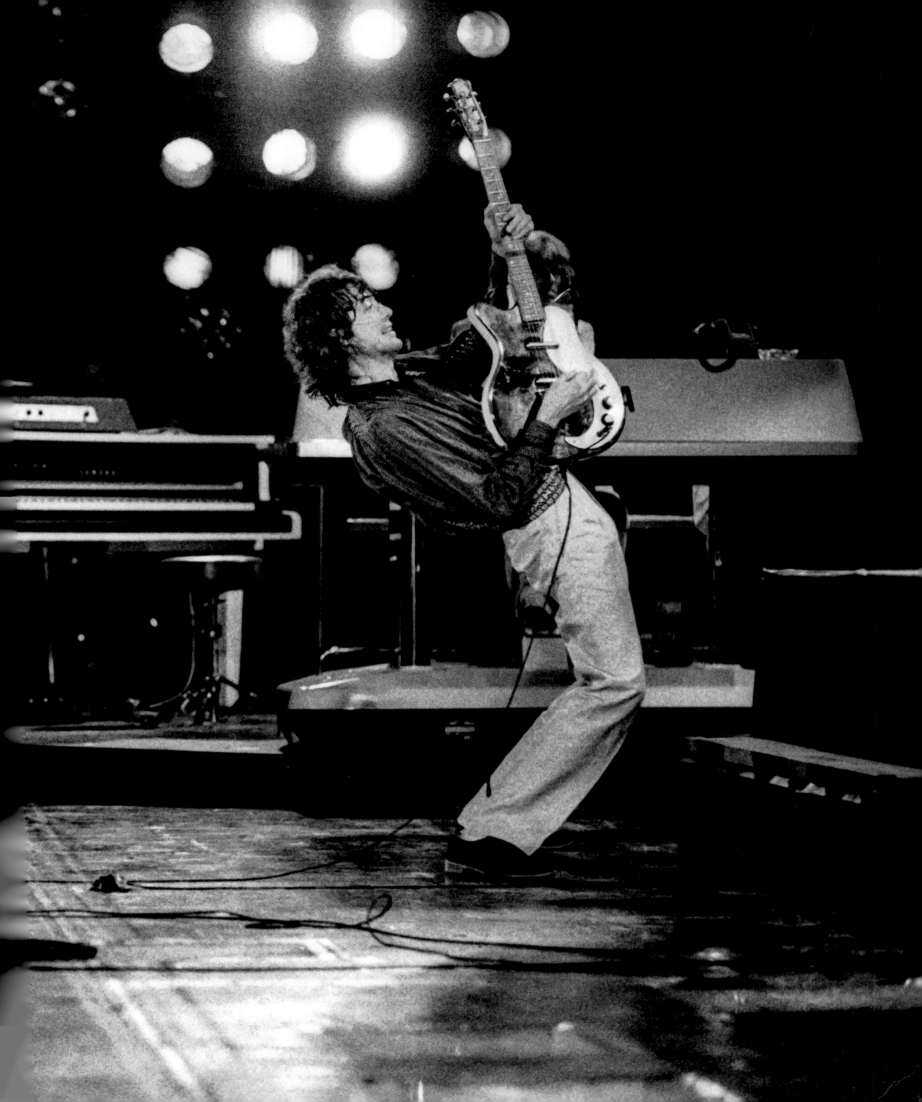

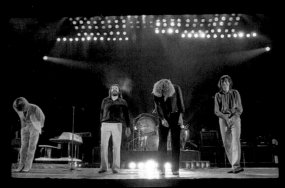 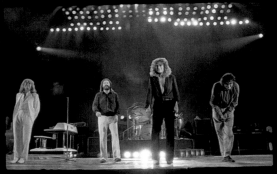 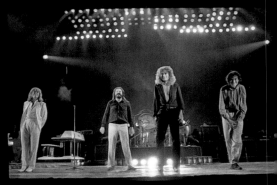

→12 →12A →13 →13A →14 →14A

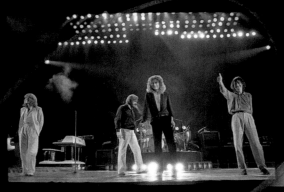 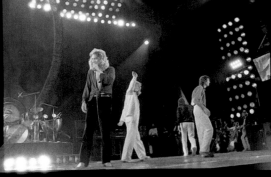 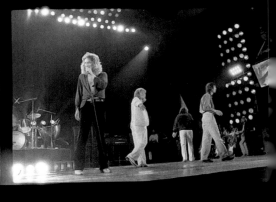

→18 →18A →19 →19A →20 →20A

 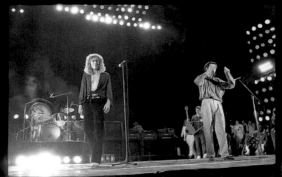 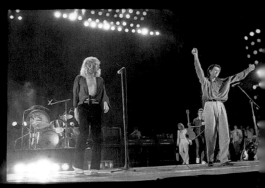

→24 →24A →25 →25A →26 →26A

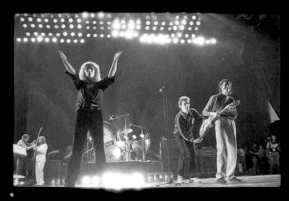 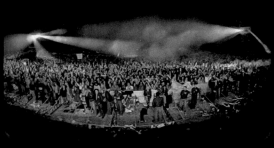 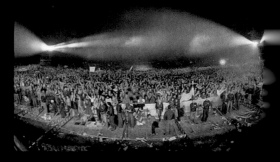

→30 →30A →31 →31A →32 →32A

→15 →15A →16 →16A →17 →17A

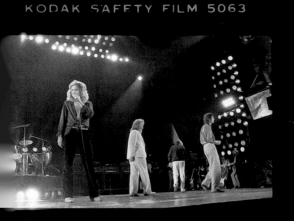
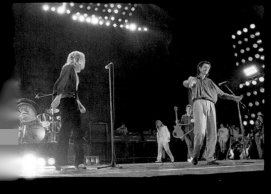
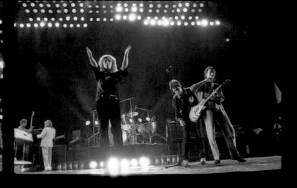

5 →21A →22 →22A →23 →23A

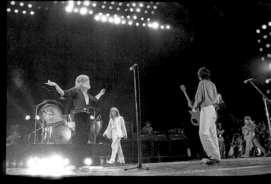

7 →27A →28 →28A →29 →29A

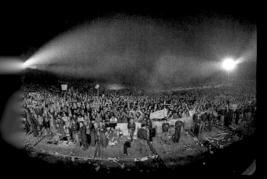
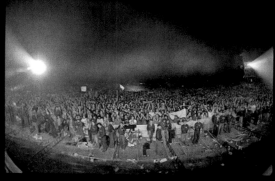
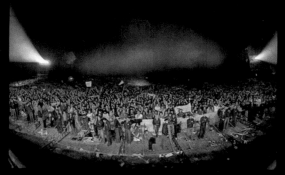

→33A →34 →34A →35

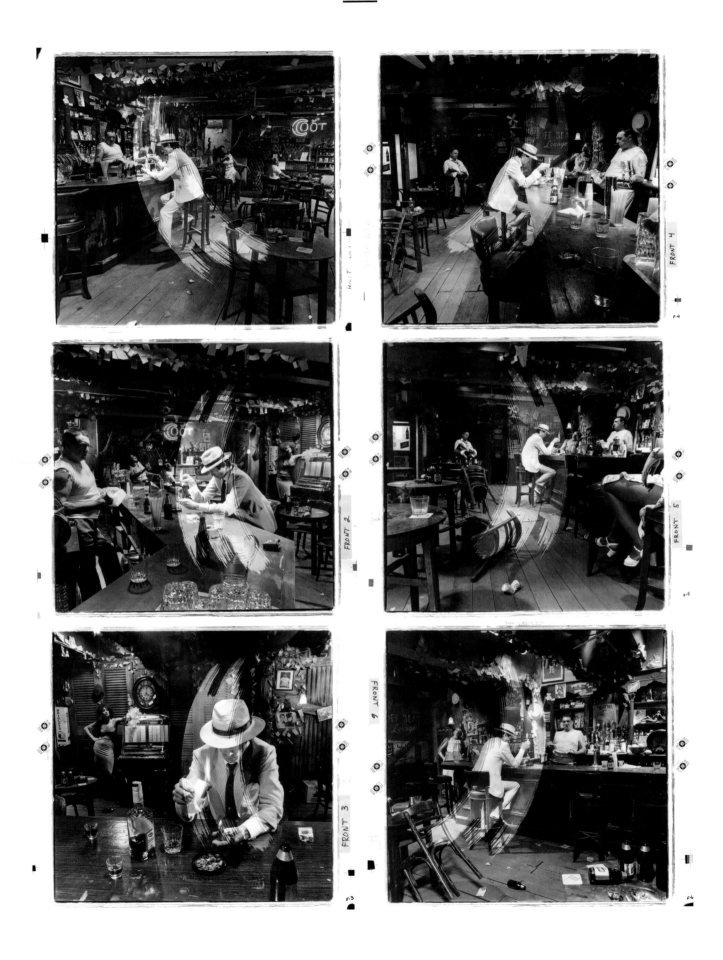

IN THROUGH THE OUT DOOR

15 August 1979

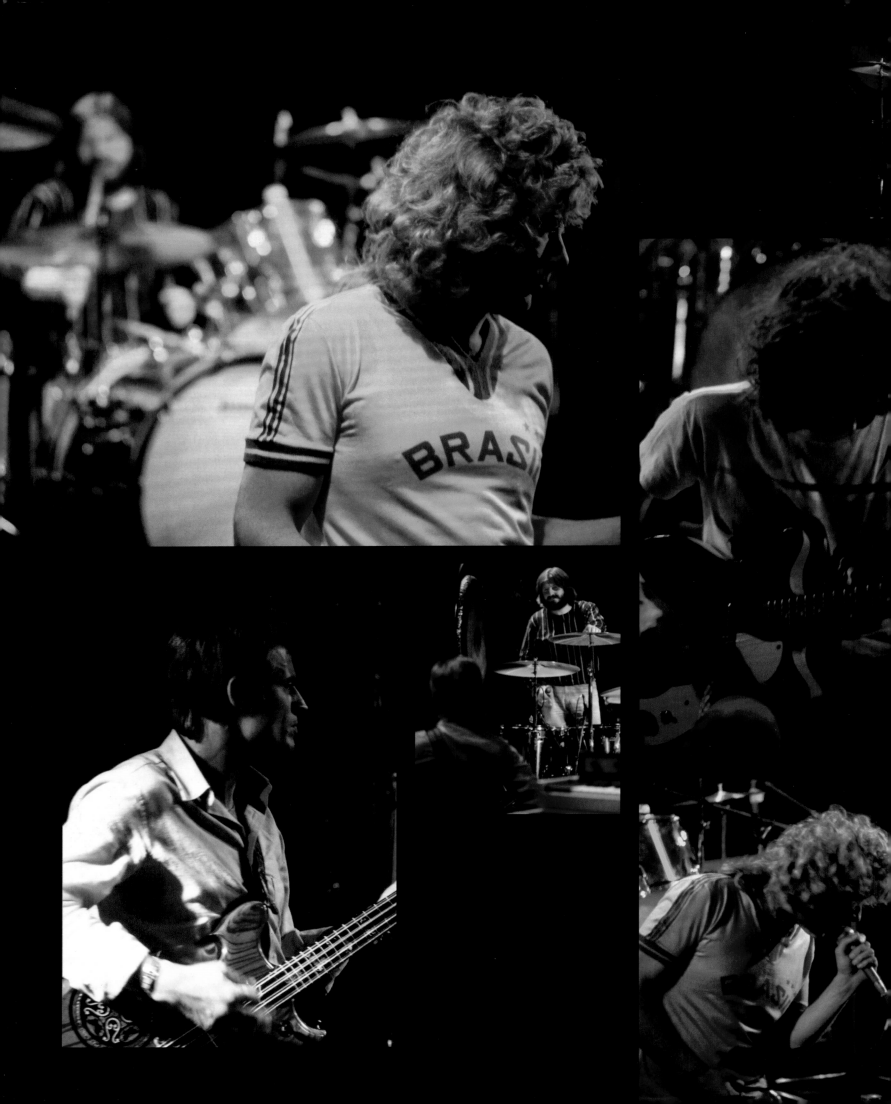

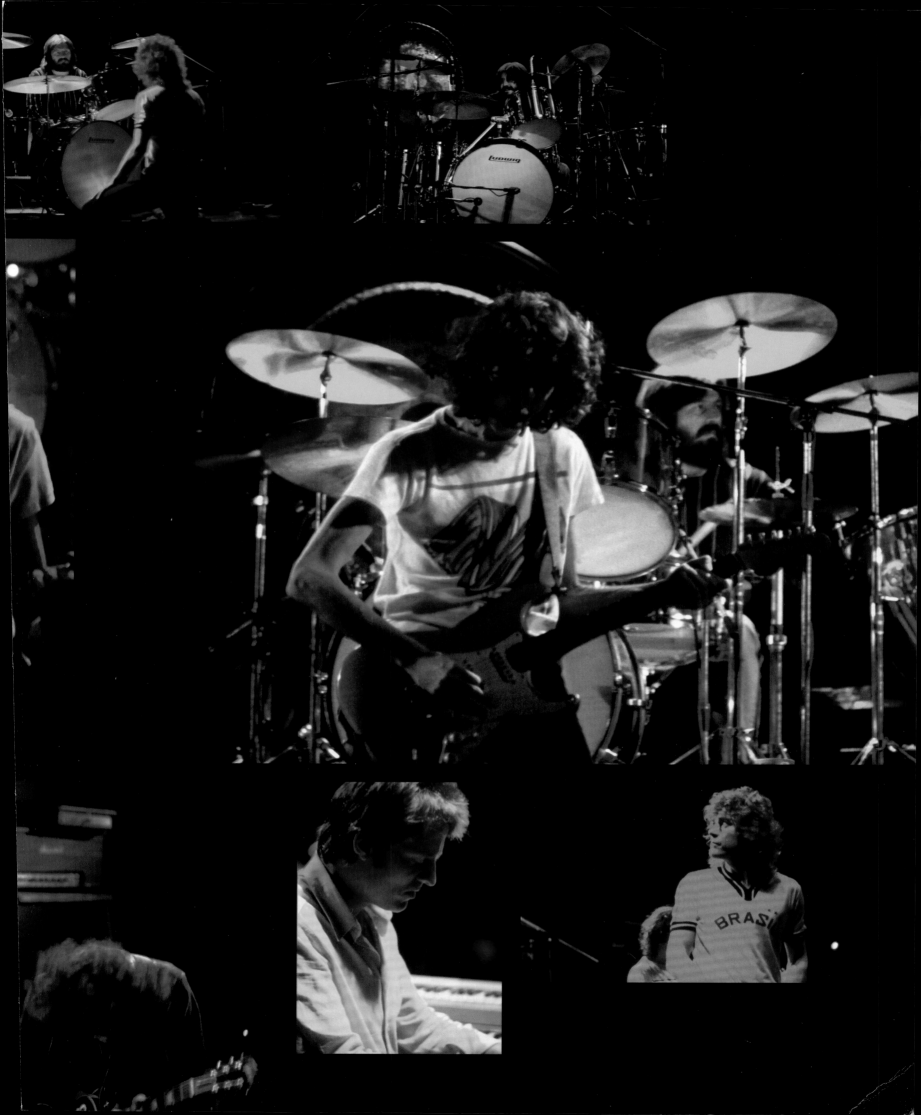

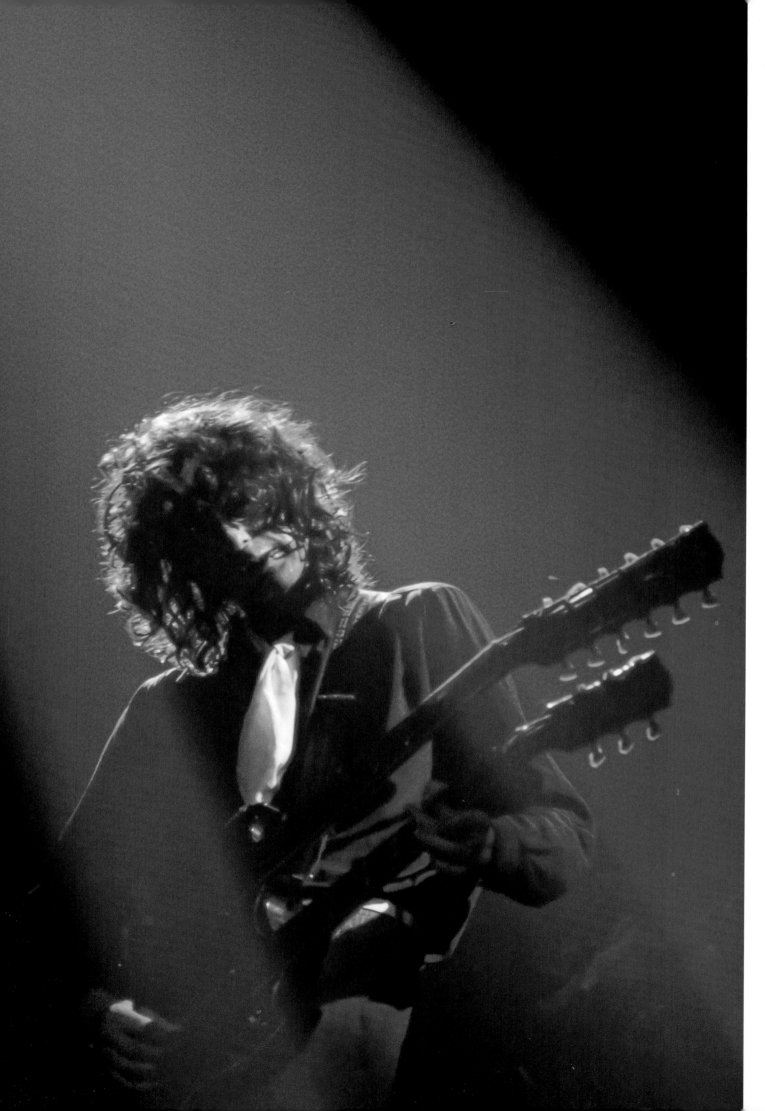

MAY 1980
Victoria Theatre,
London, UK
Rehearsals

[340—341]

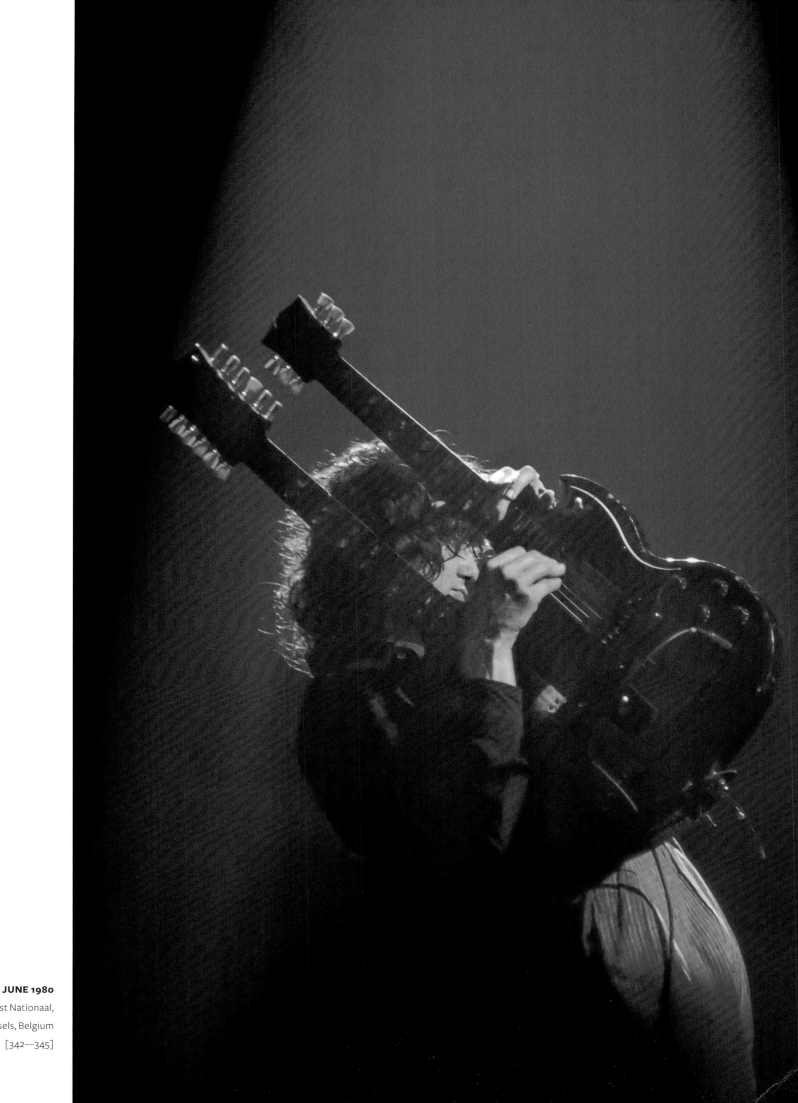

20 JUNE 1980

Vorst Nationaal,
Brussels, Belgium

[342—345]

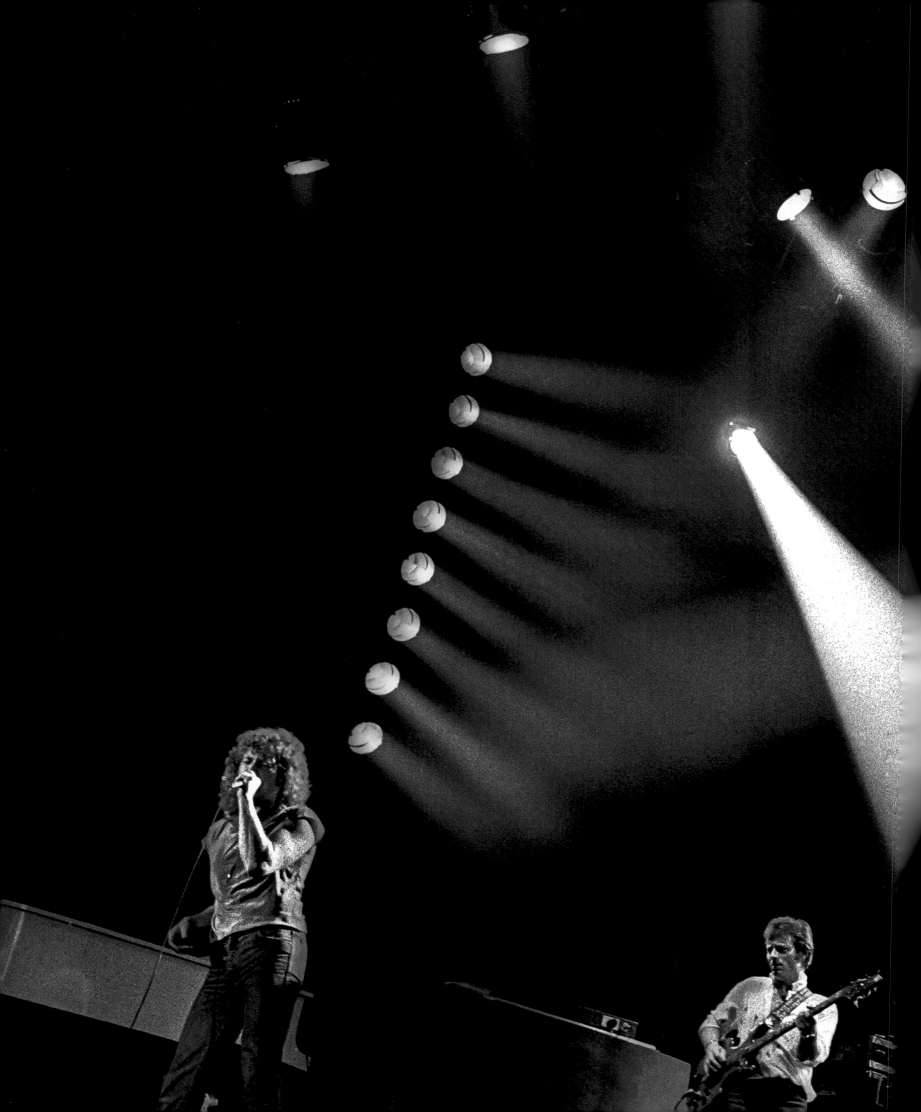

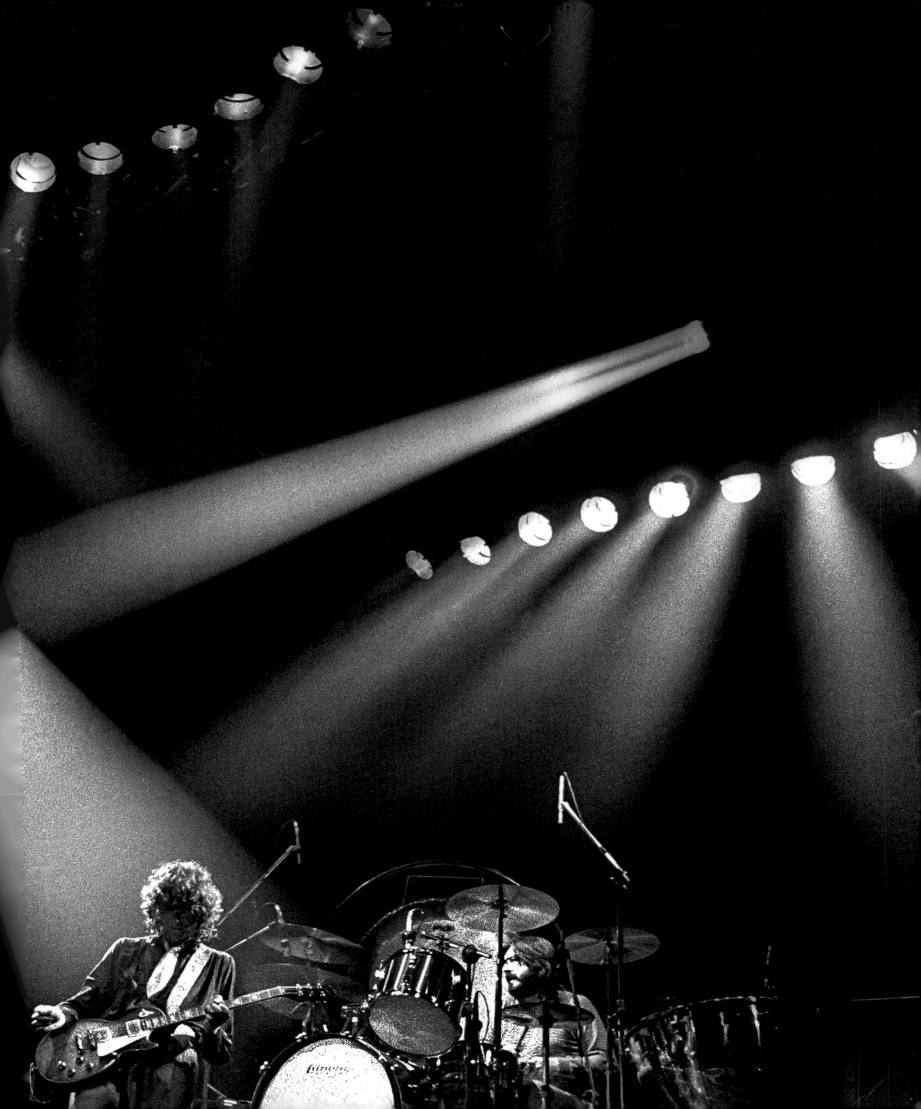

PRESS RELEASE ATLANTIC RECORDS PUBLICITY

FOR IMMEDIATE RELEASE
FROM: BOB KAUS
DECEMBER 4, 1980

 We wish it to be known that the loss of our dear friend and
the deep respect we have for his family, together with the sense of
undivided harmony felt by ourselves and our manager, have led us to
decide that we could not continue as we were.

Led Zeppelin

ATLANTIC RECORDS 9229 SUNSET BLVD. LOS ANGELES, CA 90069

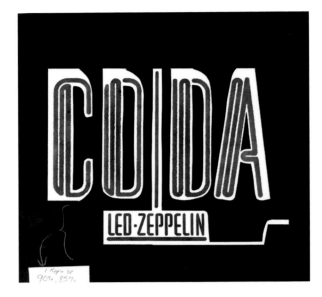

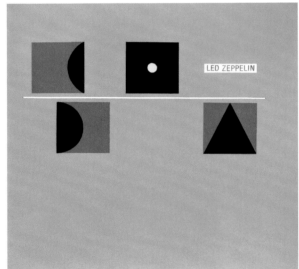

LED ZEPPELIN

CODA

19 November 1982

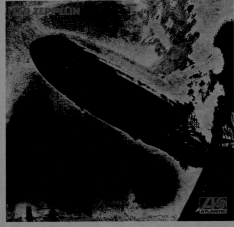

CODA
LED·ZEPPELIN

LED·ZEPPELIN

CELEBRATION DAY

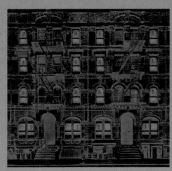

TWO THOUSAND AND SEVEN

— EIGHTEEN

20 18 20 07 20

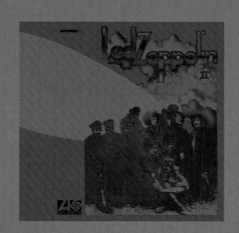

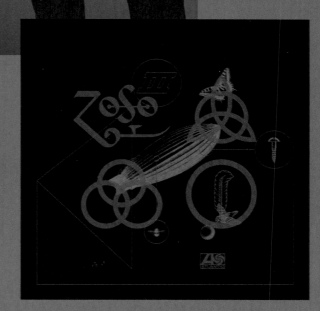

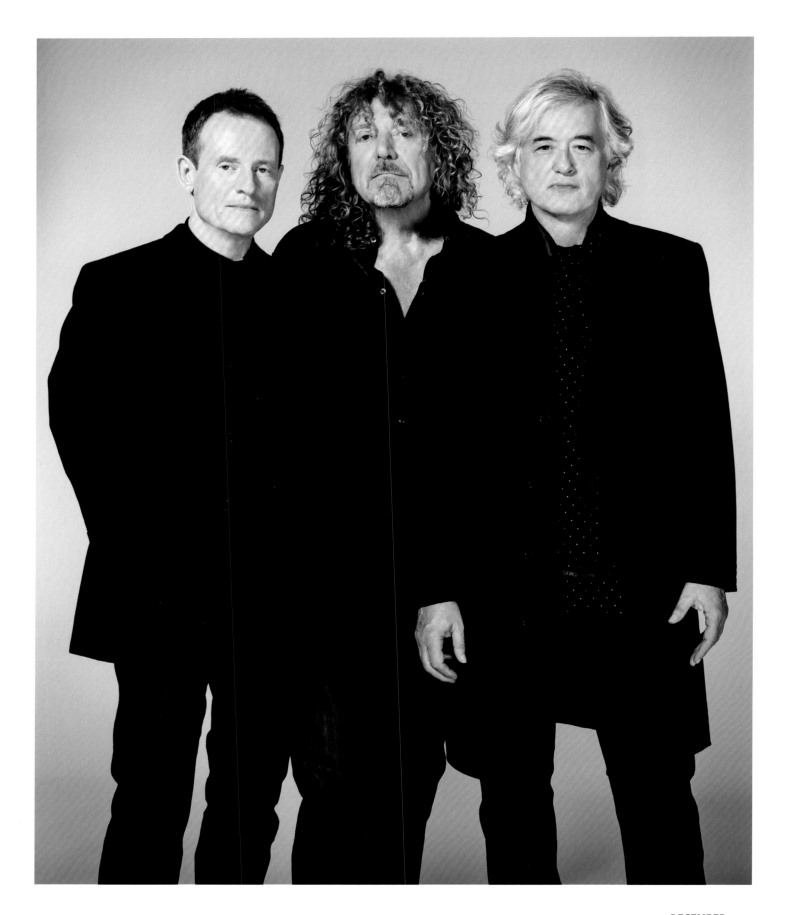

5 DECEMBER 2007

Shepperton Studios, Shepperton, Surrey, UK

[353—359]

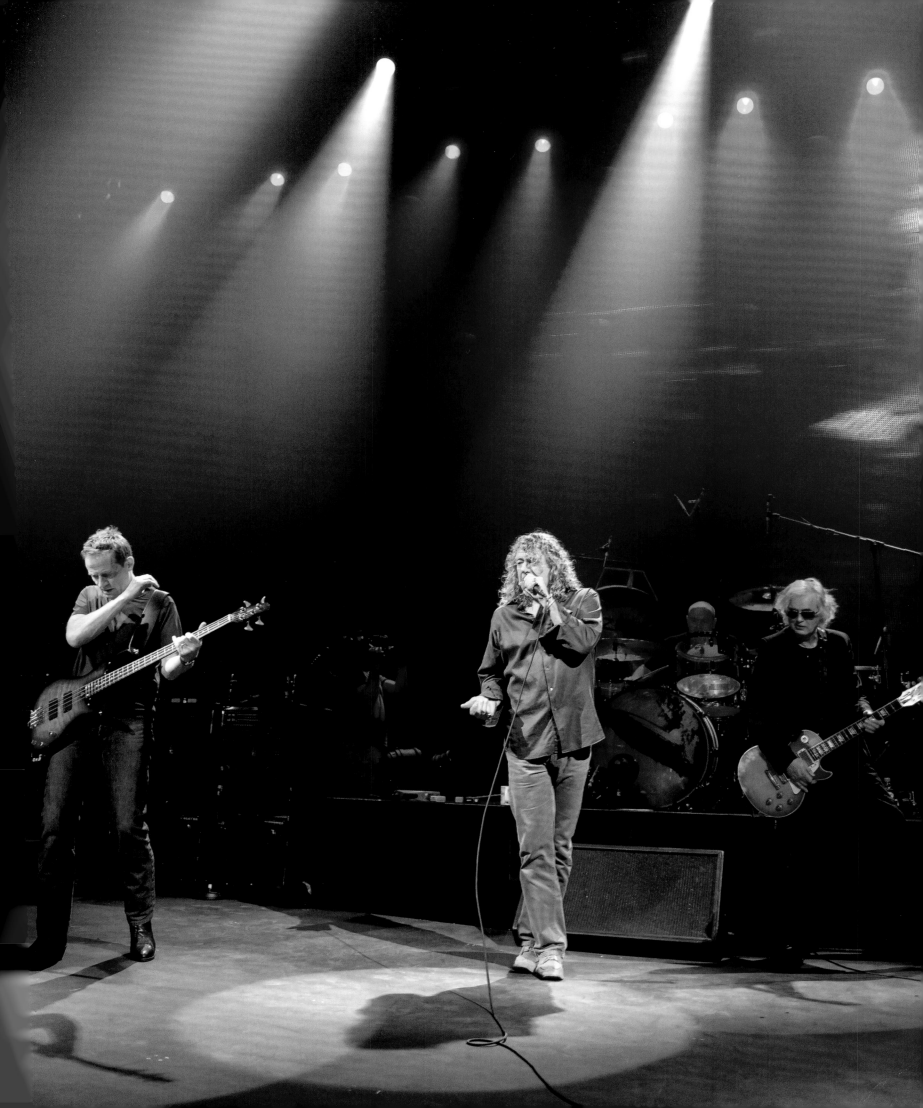

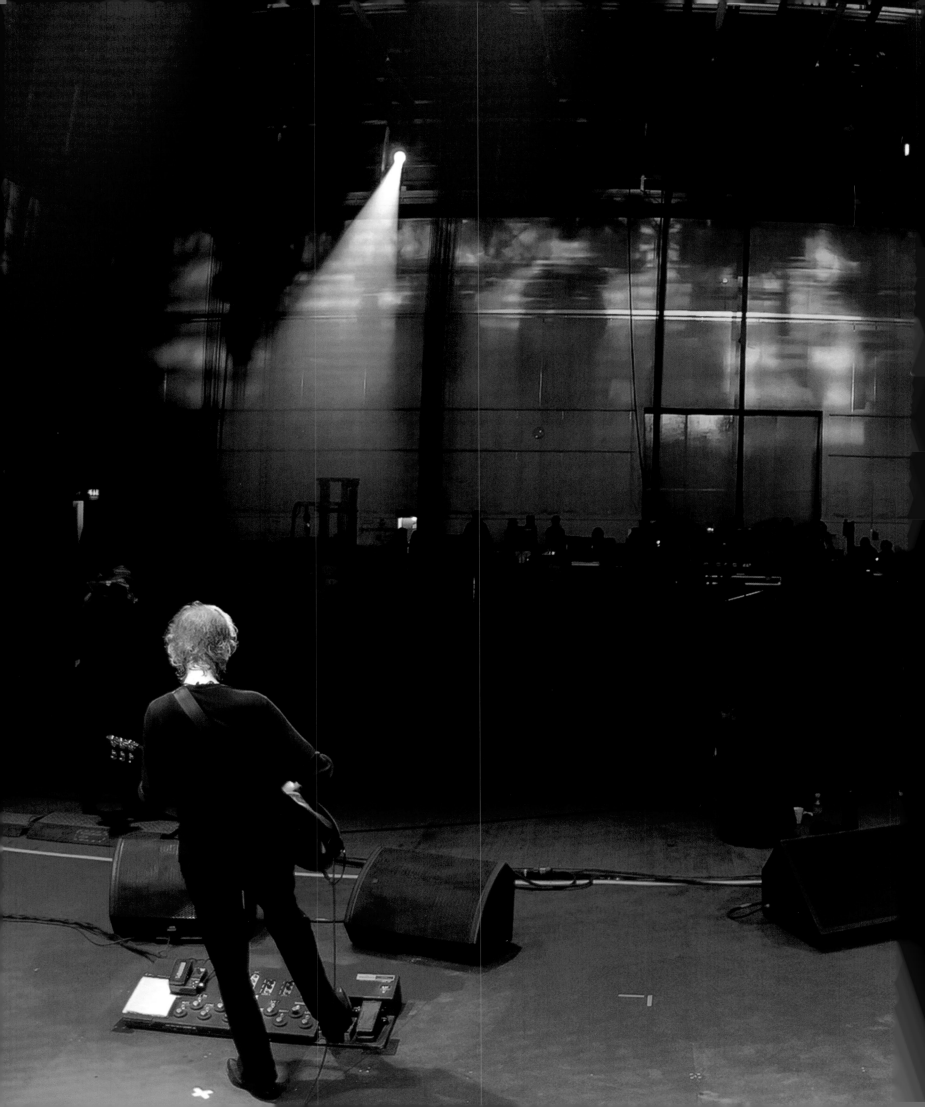

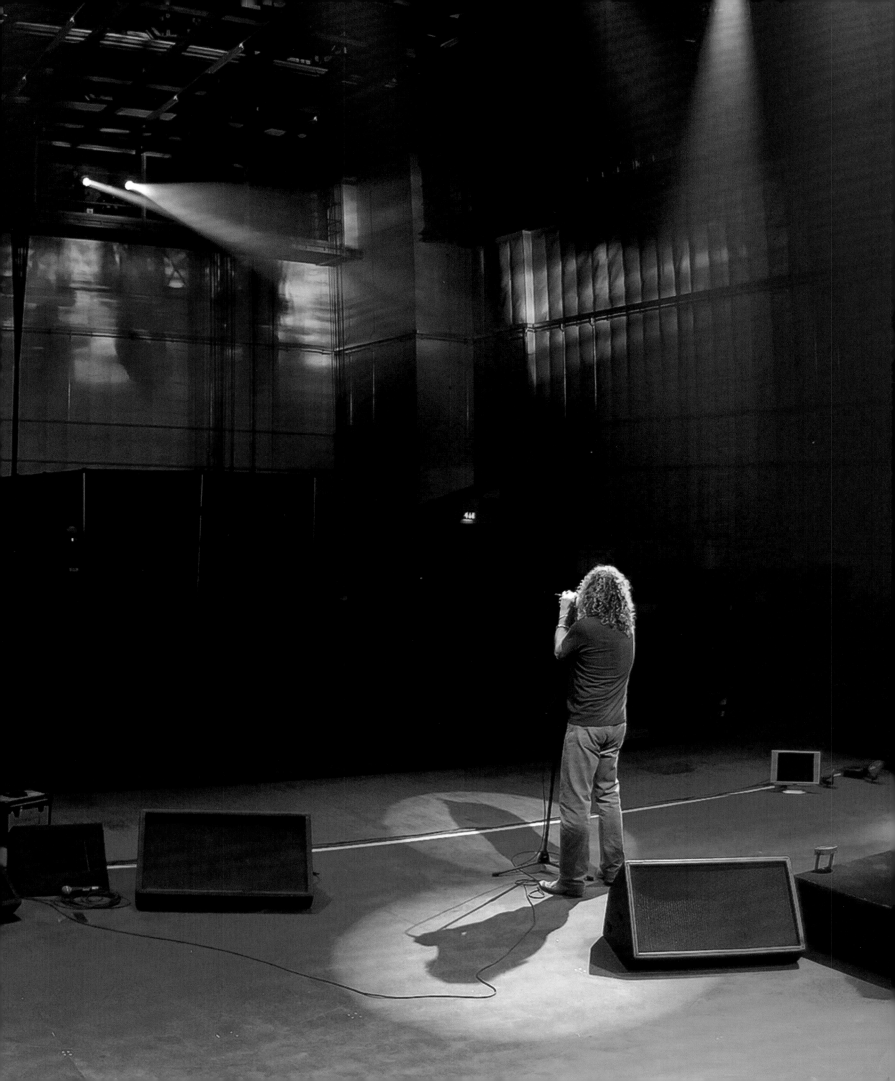

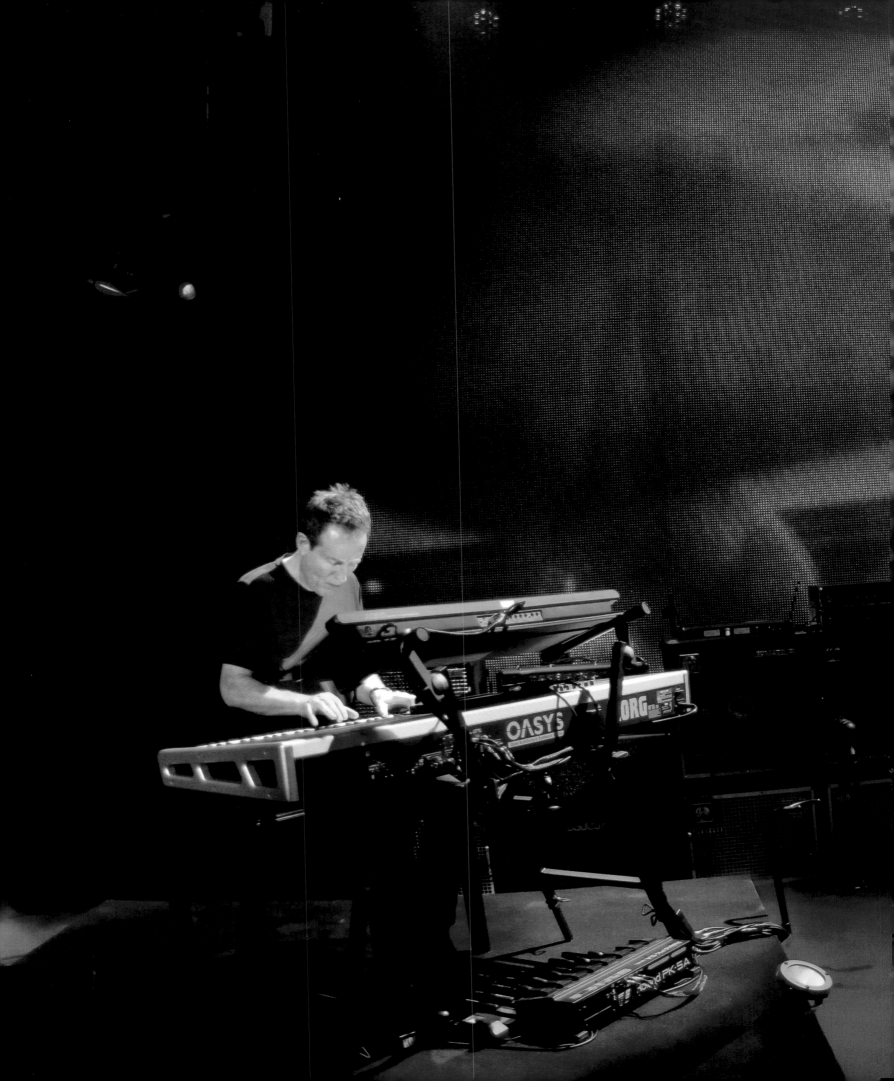

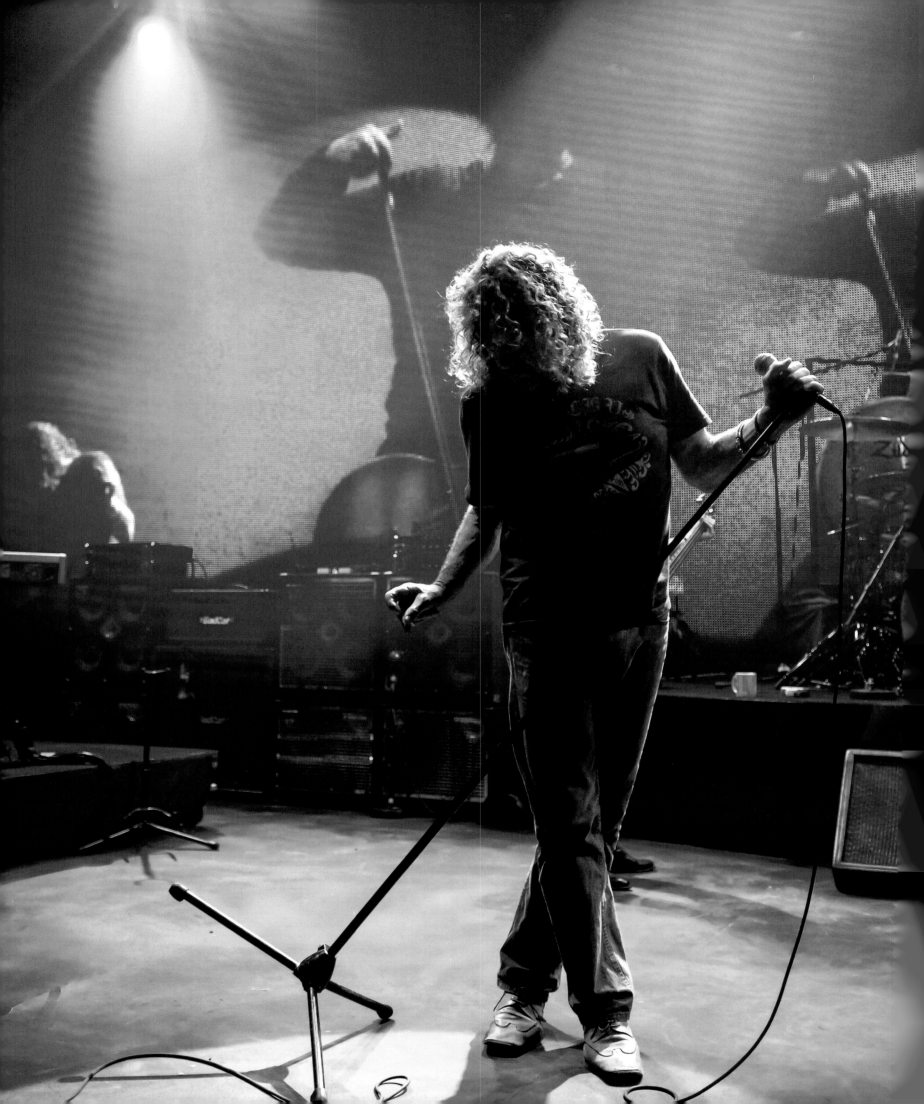

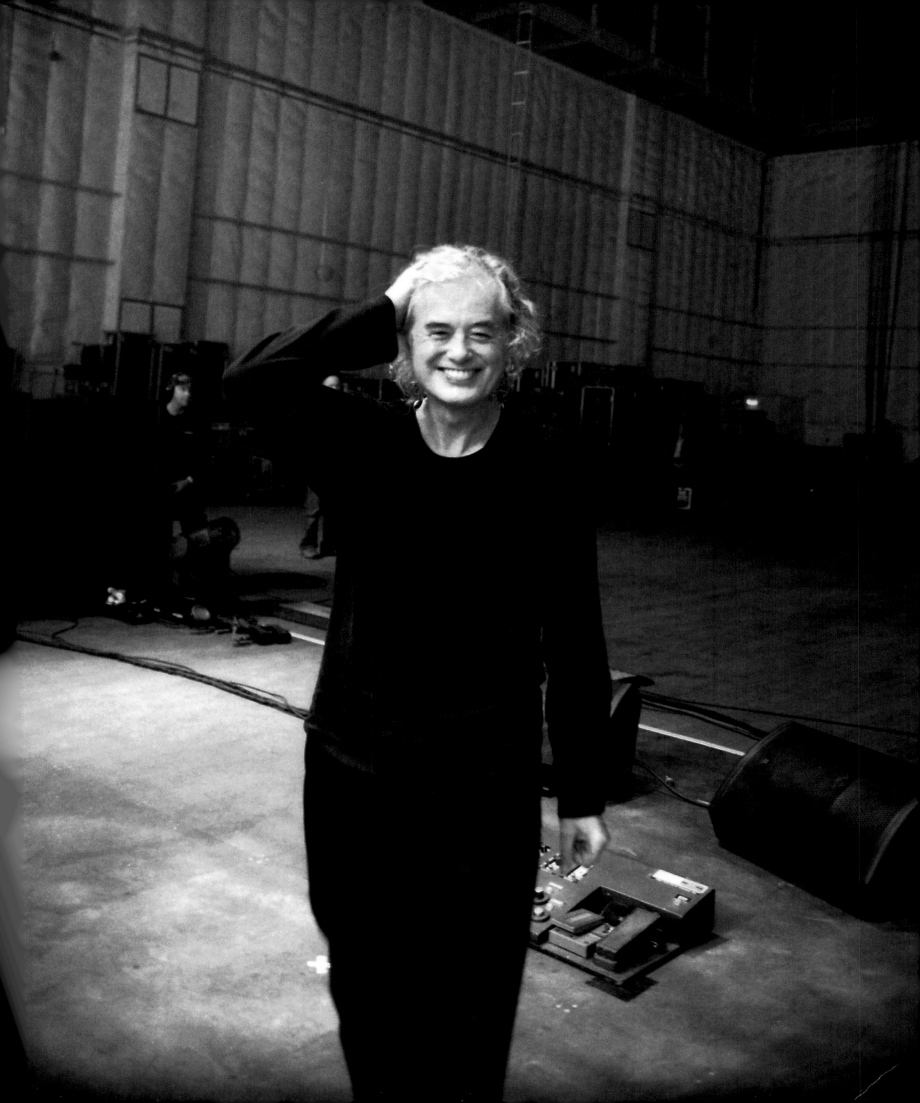

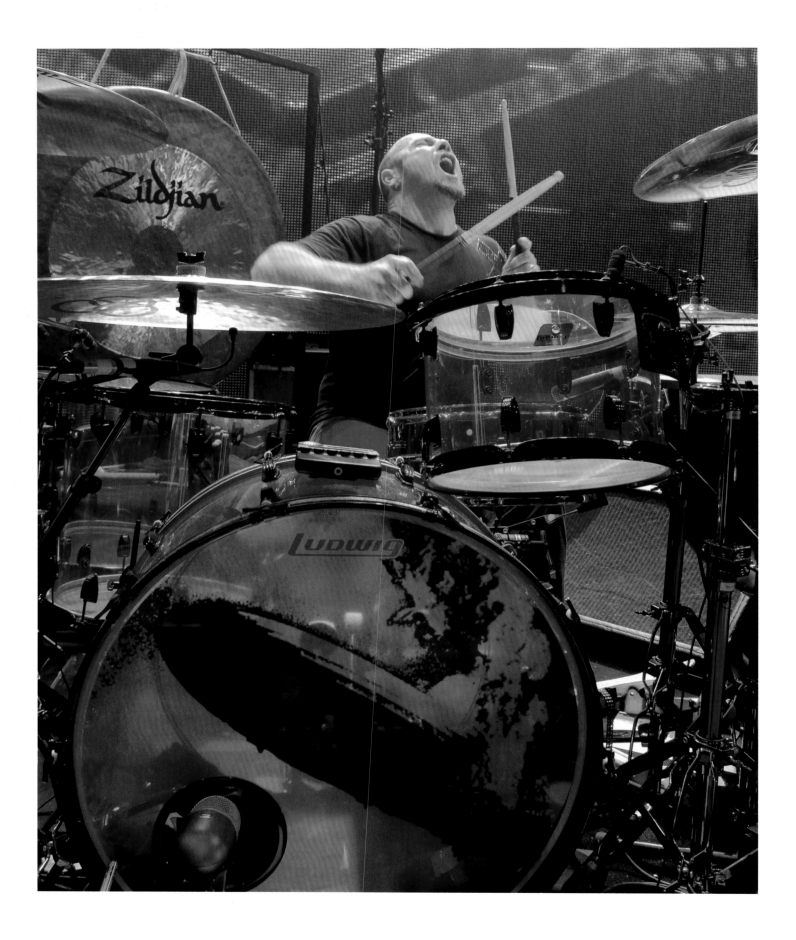

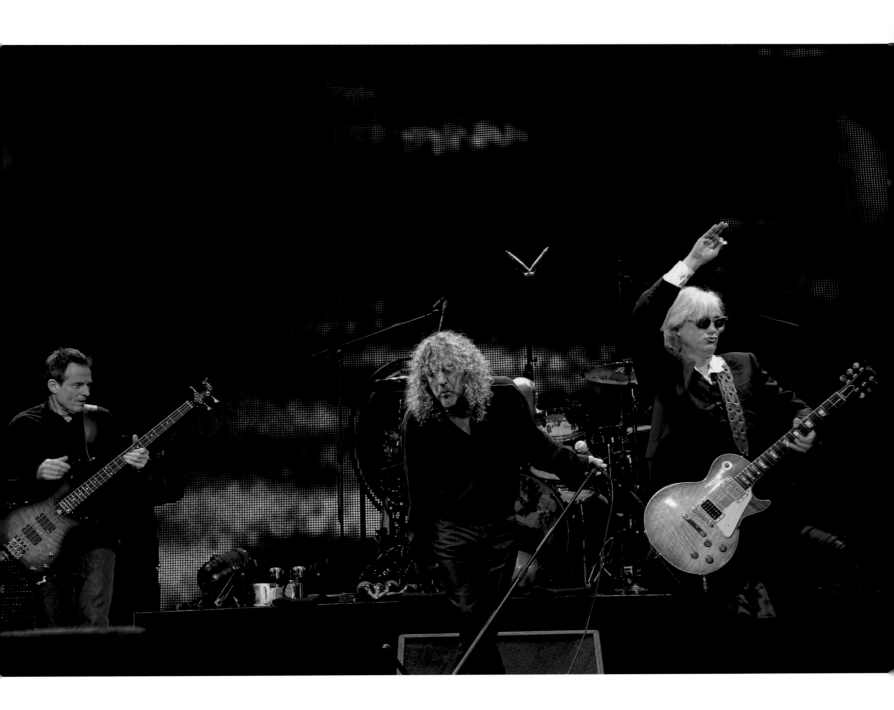

10 DECEMBER 2007

The O2, London, UK

With Jason Bonham

[360—373]

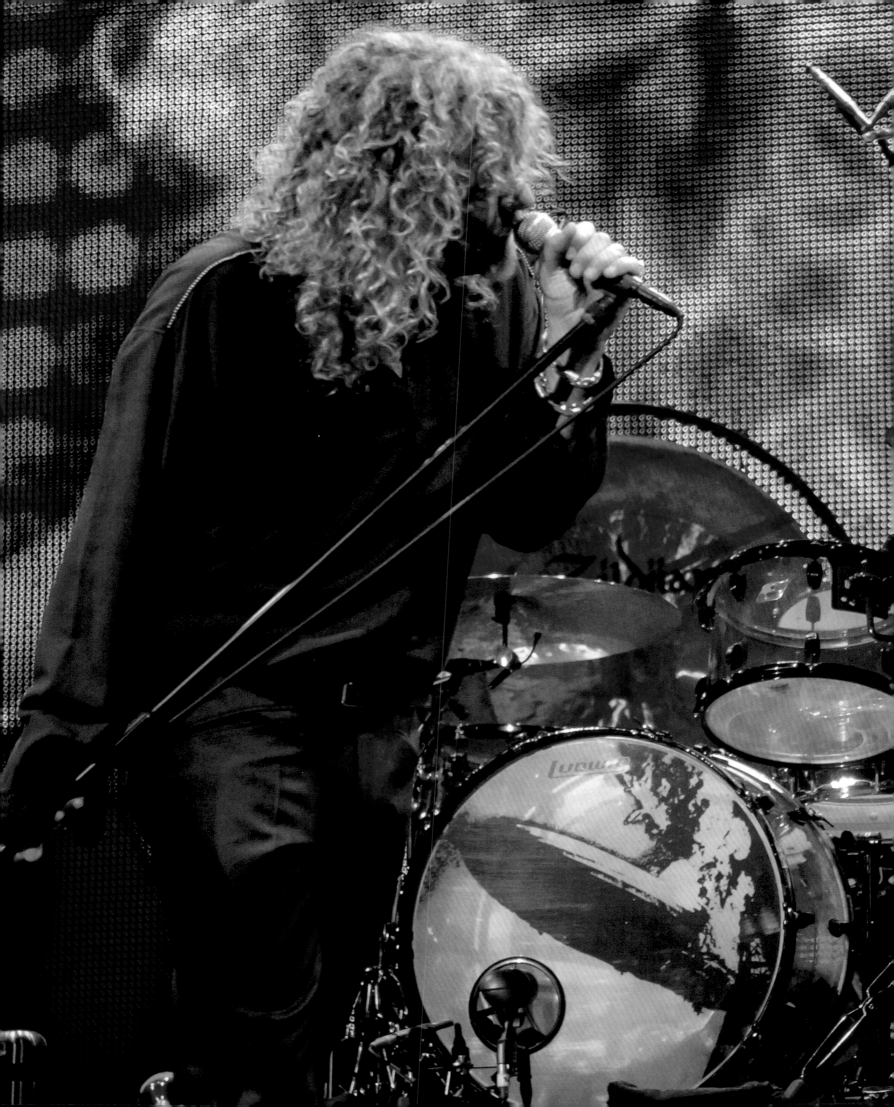

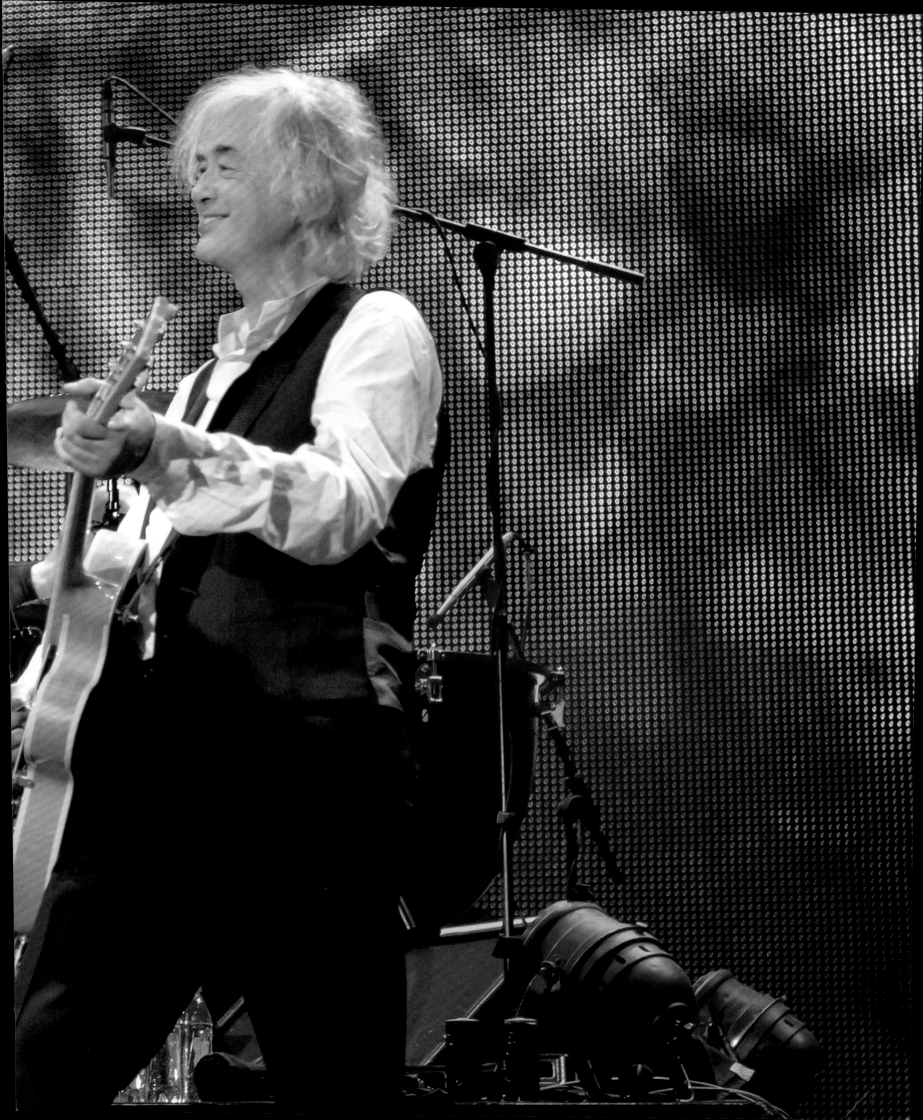

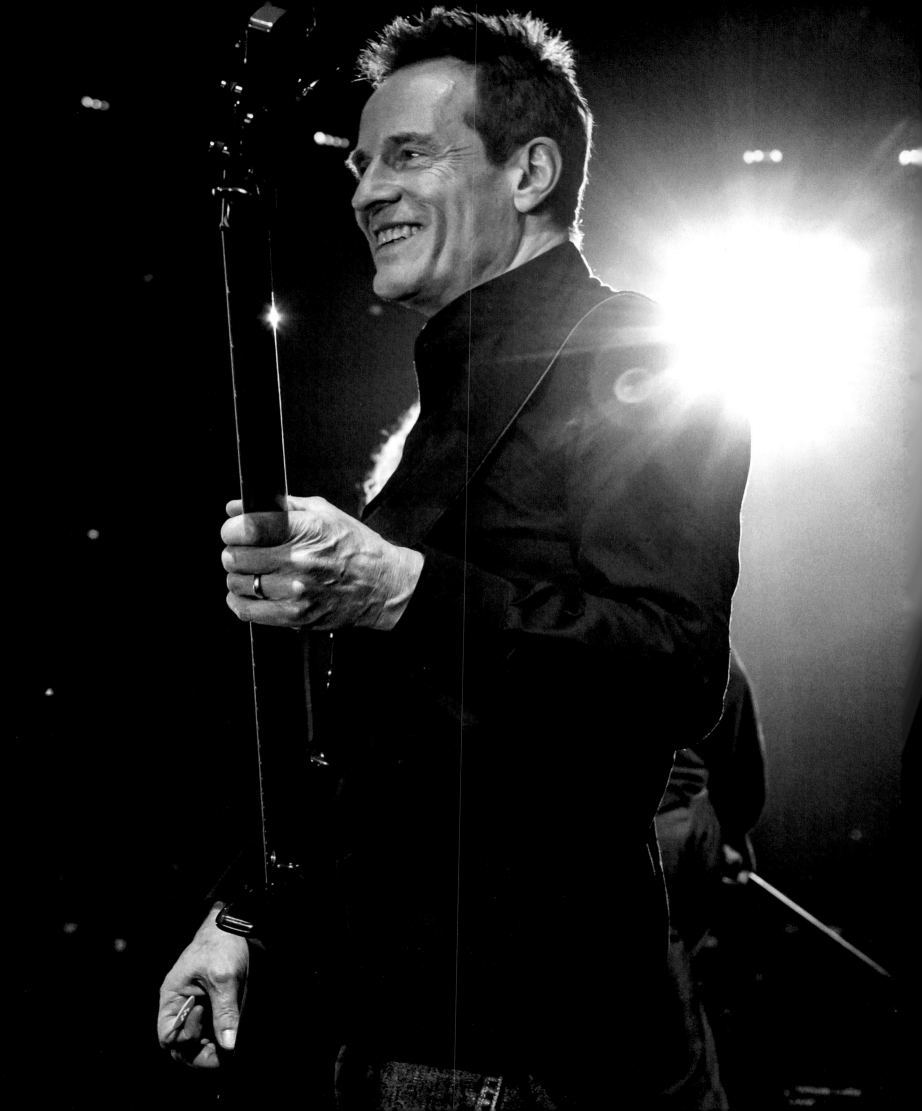

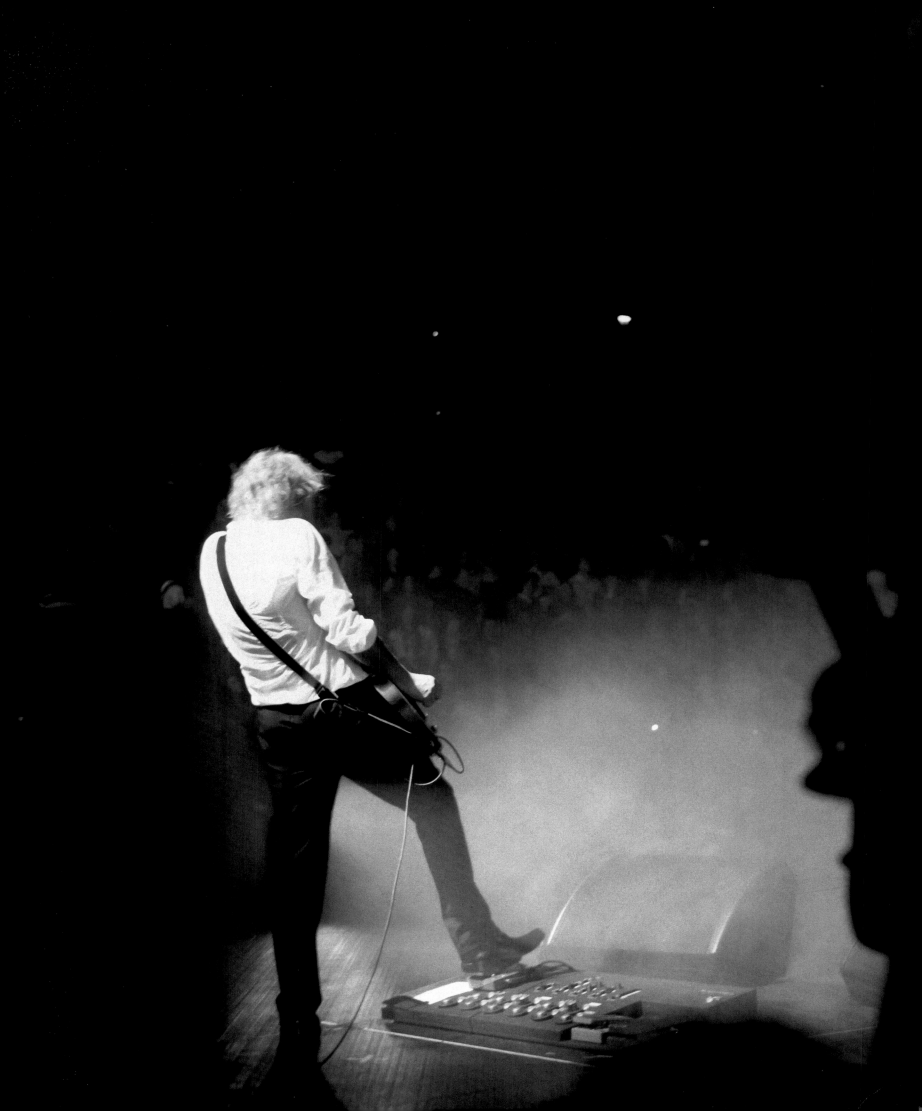

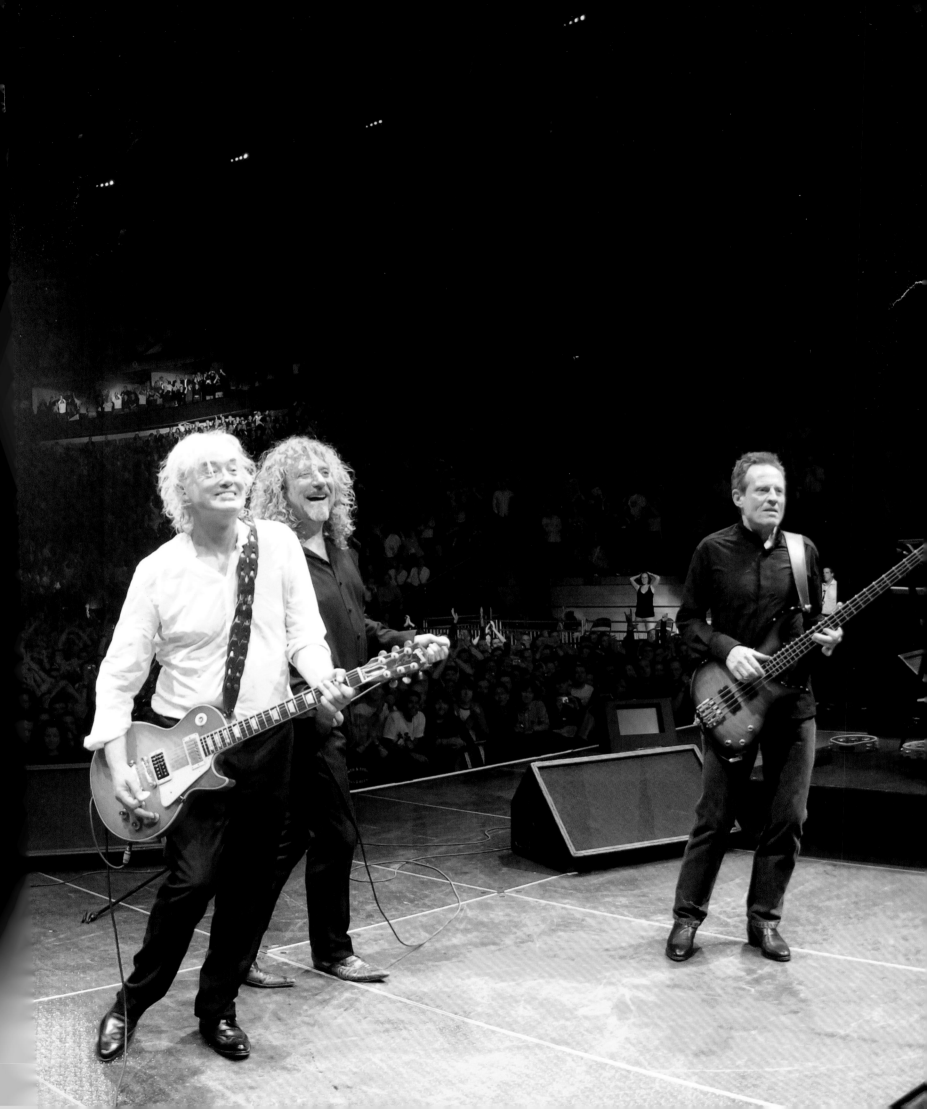

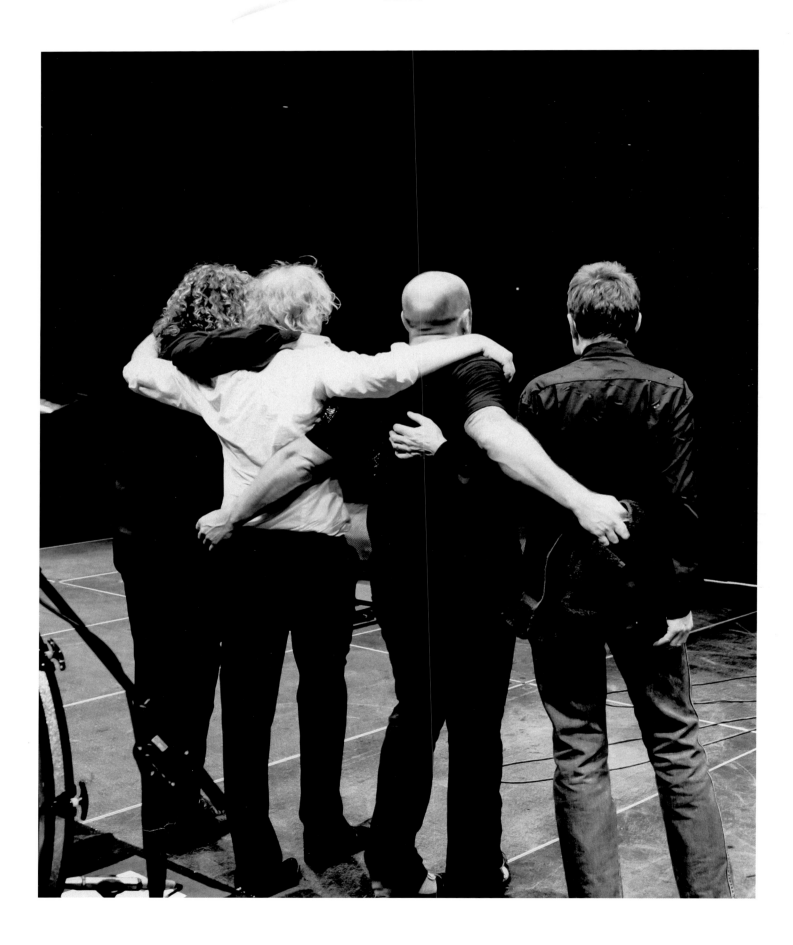

ONLY ONE SHOW, AND WE WERE MAGNIFICENT. MAGNIFICENT IN THE REHEARSALS AND MAGNIFICENT IN THE SHOW.

JIMMY PAGE

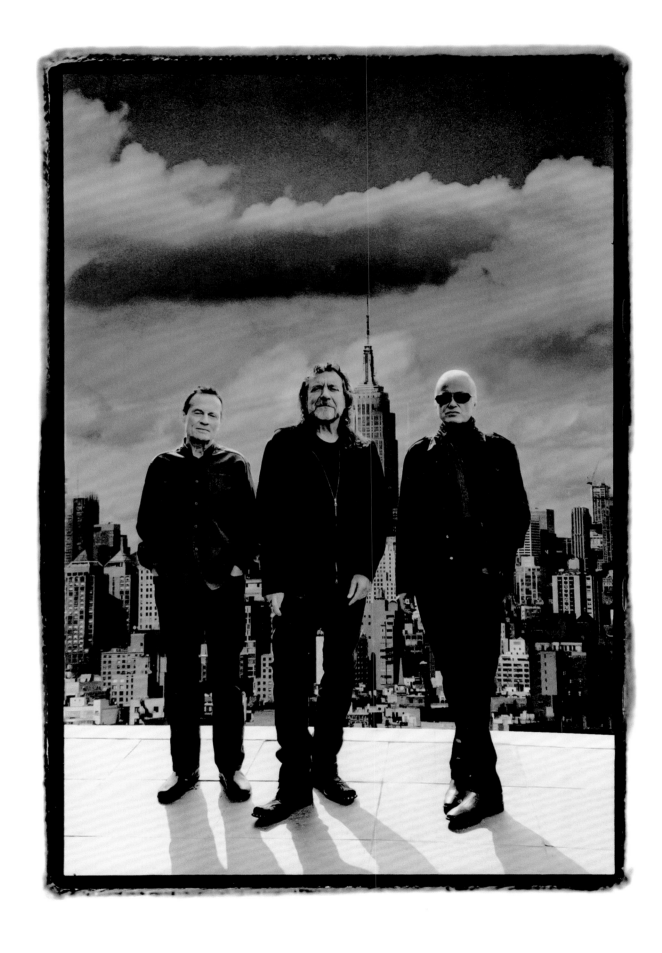

JIMMY PAGE

Epilogue

Throughout the last five decades there have been new fans arriving every day to witness these master musicians. The stories I have heard from people about how the music of Led Zeppelin has affected their lives has been a moving experience. I know how music made an intervention in my life before I was a teenager and therefore the ability to be in a band that changed the course and climate musically, and inspires musicians young and old to this day, is a true lifetime achievement.

ROBERT PLANT
Epilogue

I experienced unimaginable creative peaks and vivid adventure, often played out against a relentless emotional landscape. There were no instructions inside the box we opened, no preparation for the journey, no clues, no destinations.

So rough and ragged, joyous and ecstatic, and gone.

JOHN PAUL JONES

Epilogue

It was all about the music, all of the time.

JIMMY PAGE: My idea was to form and produce a band, to rehearse the band, so much so that we would feel confident to do some shows, then go in and start recording; to manifest what I had learned during my touring and recording time with The Yardbirds.

That process led me to Robert Plant. When I heard him in the Midlands with his band, Obs-Tweedle, I invited him to my house in Pangbourne to introduce him to the material I wanted to do. He was open to those ideas. After a few visits, he talked of John Bonham and that John was touring with Tim Rose. We went to see Tim and John in a London club; I really felt a profound connection with John's playing and immediately I knew he would be perfect. I figured the new band would give John Bonham the chance to play and present John Bonham's playing unlike anything he had experienced before. This would ring true for each of us. John Paul Jones called me up soon after and asked if I was putting a band together and did I need a bass player? I said yes, and a rehearsal was pencilled in.

Following the initial jam session in Gerrard Street, we agreed to rehearse at my house. We developed a set, which included material that I hoped to record for the first album, then did a few dates in Scandinavia, playing in front of an audience. We could really flex our musical prowess, to see whether we'd settled on things in the right way or whether it needed to be tweaked, and also how well it was received.

JOHN PAUL JONES: I was just working flat out doing sessions, making a lot of money but had no time to spend it. I was burning out. My wife, Maureen, saw in a music magazine that Jimmy was forming a band and she thought I really needed to do something different. She said, 'For Christ's sake, call him up!' And that's how that happened.

Our first rehearsal really did feel special. It was in a tiny room. If you're a bass player you want to know what the drummer's like. If the drummer's no good there's simply no point. I immediately recognized in Bonzo a commune spirit and a bloody good drummer. We were immediately listening to each other, working out how we could build. It's a special thing, rhythm sections, good rhythm sections, I listen to the different drums and figure out where I can fit in really well, and he listens to me to accentuate the important parts of the riff. It's very detailed stuff. And when you come across a person you don't have to explain anything to, it's just easy, it's fun and it's very exciting.

I had to develop my own style, especially in a rock 'n' roll situation, because I hadn't actually played in a rock 'n' roll band since I was a teenager with Jet Harris and Tony Meehan. I was more jazz orientated, I spent most of my time doing jazz when I wasn't in sessions. It was pretty much jazz and rhythm and blues.

A lot of the time my playing was complimenting what the guitar was doing, we did a lot of riff-based music and nothing sounds better than a bass and a guitar playing the same thing. Bonzo and I were really into Motown, Stax and RnB so all that came into it as well.

ROBERT PLANT: We all came from different angles, so there was a sort of buccaneer approach. John and I had been so hungry in every respect for so long, this was an amazing opportunity. We had no adult theory, ideology, anything. We were in a band, which was the best band we'd ever been in, and that was it.

We were all into the idea of opening songs up, which for me and for our own individual flair and gift, was an absolute dream. That was the difference from being in a blues band of the time, where you were limited by the form; with Led Zeppelin we were taking in all sorts of other imagery, even at this early stage.

pp.22–23

JPJ: By the time we got to Denmark it was, like, find out how it all works. And yeah, very exciting. It was extremely hot and sweaty, as I think you can tell from the pictures. The clothes were far too hot for the gig, which I jettisoned fairly soon after. I kept the shirts. In Zeppelin, nobody told anybody else what they were going to wear. So, three of us could turn up in jeans and sweatshirts and one of us would be in a suit. That was the way it was forever.

RP: I was barely twenty years old, and it was the first time I'd ever been on an aeroplane. Looking at John's face, that's me and him at any point in the previous three and a half years, exactly that combination of expression and deliberation.

Musically, everything was open. There was a structure but the structure was prompted and edited according to cues. There would be a kind of signature that advances to another part of the song, that's how it worked.

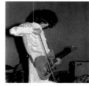
p.25

JP: Outside of anyone who'd seen me play in The Yardbirds, the violin bow was something that was really going to assault their senses. It was meant to be as aggressive as a hard-core electric guitar but as light and caressing as an acoustic guitar within the performance. It was radical in its approach and its dynamics. People had never heard anything like this and I kept developing it all the way through Led Zeppelin. I really considered it to be an important intervention for guitar music.

p.28

JP: I couldn't wait to get into the Marquee as Led Zeppelin. I knew how important it was. It was the equivalent of doing the Fillmore West in the US. It was the London showcase for bands where reputations were lost and found. My first opportunity had come from being in the interval

band in the days of Cyril Davies, when the club was in Oxford Street and I was at art college. That's where I got headhunted to become a studio musician. Then my debut appearance with The Yardbirds on bass at the Marquee, and finally with my own band. It meant so much to me to be able to go in there with this phenomenal band, the likes of which was totally unique to what anyone had heard there before. People had heard great bands but they were going to hear something now that was coming from a totally different perspective.

RP: The difference from the number of times I had played at the Marquee with John with no one paying any attention at all ... and then turning up with this powerhouse. It's the beginnings of the Thunder Quartet!

The audience reaction was amazing. Jimmy comments that we were all in that rehearsal room and we knew. The actual weight of that knowing is phenomenal, you can spend years almost getting there.

JP: It's the attitude. It's the energy level of it. It's the intensity. It's not just a noise, it's the shape of the noise, the length, breadth and depth of the noise.

JPJ: John did hit 'em hard. Health and safety wasn't really in his vocabulary.

p.32

RP: There was a sort of comic element to his stagecraft. He didn't practise or sit around in his room thinking about drumming, he just did it and was magnificent!

JP: Backstage after the show, John said the cut on his face was from his cymbals. That goes to show the passion of that Marquee gig, imagine how we were all playing.

We knew how good we were. The way the alchemy bonded and the way the band was to showcase each of us as a serious musician. When you hear it on the albums you can differentiate what everyone was playing or singing. Certainly the live situation created an extra element. A fifth element.

RP: In the Crawling King Snakes way back, I remember John picking up a stand that was holding the crash cymbal and just hurling it against the wall, the whole lot broke. ... We were unloading once at the Speakeasy, and realized when we went round the back of the van that John had parked against some pub railings back in Dudley to avoid anything getting nicked out the back and we'd driven off and left the handle in the Black Country so we couldn't get the equipment out. I got a shovel off a builder and Bonzo started opening the back door.

Then down the street came a big Rolls Royce and a big, loud 'Fuck Off Madam' came out of the radiator grill, and it was Keith Moon! He's got a microphone with a speaker in the grill and is trying to get people to drop their shopping. As soon as Bonzo realized it was a drummer in a Rolls Royce, he threw the shovel to me so he wouldn't be seen with it!

JP: Peter and I initially went to Reprise, Mo Ostin's label, in Los Angeles but we were really aiming at Atlantic in New York. I had connections through Bert Berns from my session work in England. Bert introduced me to the people at Atlantic in 1966 and that's where I met Jerry Wexler. Bert had done such a good PR job on me personally that they listened to what I had to say. I certainly liked the idea of returning with our album fully done, fully mixed, to be able to put it on and go, 'What do you think of that?'

Because we had the album finished, it's like take it or leave it, which was unusual at that time. Other people were trying to get an advance to do an album. If you go in there like we did then you can start making certain conditions. You can say I'm not doing a single. We didn't want to be caught up in the singles market so every album would be, 'Where's the single? ... Where's XYZ in this new album? ... You know if we don't put out XYZ people won't know who you are.' All that sort of nonsense, just no, not doing that. This is an album market and it's an underground venue circuit. Underground radio is going to make this travel and it did. It's exactly what happened but it was still visionary. All the pieces were there, it just needed to connect up.

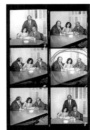

p.34

Jerry Wexler was really keen and invited Peter and I to Miami to go out on his boat, *The Big A*, and go fishing. We both looked quite unlikely candidates for deep-sea fishing but off we did in a jaunty way. Peter only caught a small tuna. I caught this great big swordfish. I had it stuffed and displayed in my house in Pangbourne.

After the release of the first album, Ahmet closely aligned himself with us. Ahmet understood great music. I knew he did all the RnB stuff and Atlantic had some white stuff on there; years ago they'd had Mitch Ryder & The Detroit Wheels. More recently Cream had gone out on Atco, a subsidiary. I said we want to go on Atlantic. To be fair to them, they did get it. They realized how radical we were because they'd never heard anything like it. They'd never heard people play like that. They got it.

Jerry Wexler officially signed the band. This is the only picture showing us signing anything because they didn't photograph the original event. It's a staged photograph for *Cashbox*.

p.35

RP: Peter Grant had a plan. He had a great artist. He represented probably the greatest guitarist that anyone could wish to represent. The development and the way it worked touring with Concerts West & Concerts East with Steve Weiss and the whole deal was unbeknown to John and I. Peter would discuss stuff with Jimmy and I would just say, okay, that's great. I have a gig sheet of the first four gigs on the American tour and after that 'To Be Arranged'. It was brilliant. Who knew where we were going? Maybe they could strike a deal and go somewhere else, just have to get the gear there. That's brilliant, though. Imagine that?!

p.37

JP: It's the first US show in Denver and that is a black brocade jacket, bottle green velvet pants and a white satin waterfall ruffle shirt. It's quite dandyish. And with the painted guitar, it was visually striking. For me there was a conscious decision to appear a certain way on and off stage. I had other clothes to wear off stage that were very different to what other people were wearing too. I wanted to establish a certain style.

RP: Look at that microphone, looks like a Philishave! It certainly wasn't mine, I didn't have any equipment except for a harmonica.

p.39

The energy was very different to the UK. It was based on the energy of the moment, not the past. There were so many freeform ideas that they were playing, the guys around me. The number of albums that we could have actually written had we been able to record what was going on with all the great riffs and amazing time staggers; Bonzo, John Paul and Jimmy … one minute they were playing like Johnny 'Guitar' Watson, and the next minute they were Sly and the Family Stone, using every single influence of everything they loved, and it just flowed off the stage.

JP: On our first handful of dates in the US we were supporting Vanilla Fudge and we didn't get billed. So it's interesting that someone's even got photos to be honest. It might have been a Yardbirds fan!

RP: I didn't have any expectations of America, I was just very excited to be there and that one of my best friends, Terry Reid, should look after me on that December afternoon. I got to his little apartment in the Chateau Marmont and he had two or three Christmas trees set up about the place. Keith Webb, the drummer from Stafford, was there too; he was a real raconteur, a little older than us, and he would assume the role of some knowledgeable elder in the corner surrounded by the ephemera of the time. It was brilliant; someone would be sitting cross-legged on the floor, maybe sewing a rhinestone onto a vest. Sadly old age and cynicism are not good bedfellows so if you look back at it, you'd say it's just another very strange scene in another one of those movies. Everything was justifiably honest so my first impression was hospitality and charm.

Everyone spoke highly of John and I as musicians but apart from a few enclaves we weren't getting very far. Going to California allowed us to relax into the music and the culture, and the life of a musician. Music and the sub-culture was a real living growing entity, an amazing trip. I was being carried along by the will of the time.

pp.40–41

JPJ: Photos were something that had to be done, like interviews. I'm sure members of the Grateful Dead were there being photographed, I think Pigpen had a gun. It's like, 'Oh, welcome to America!'

JP: This coat. It's a good friend. Goes all the way through Bath Festival and beyond. Still got it, actually. I just thought that was a really cool coat. I only had a small suitcase, that's why the overcoat was worn because it's too big to go in the suitcase with the other clothes.

pp.44–45

JP: The first album was recorded in a very short time at Olympic Studios, with Glyn Johns engineering. In thirty collective hours the whole thing had been recorded, overdubbed, mixed and was ready to go. At shows, we were continuing to play our set, getting more confident with what we could do as a band. Stretching the numbers, constantly improvising.

I wanted to use the Hindenburg disaster photo but the Hulton Picture Library said we couldn't because people had lost their lives in the event. But the whole idea of a Zeppelin, the implied phallic imagery of this photograph, I thought we've got to try and get it sorted out. I had a meeting with a graphic designer, George Hardie, at Peter Grant's office in Oxford Street and I told him exactly what I wanted for all of the artwork and the sepia aspect of the back cover photo by Chris Dreja. George said he could do a graphic interpretation of the Zeppelin photograph. It was bloody amazing and, boy, did he pull it off.

RP: The amount of energy in that cover shot was far more expressive of what we sounded like than the picture on the back.

JP: As the producer, with the artwork and the music of the first album, I had a clear vision of how I wanted it to be. I knew exactly what I was trying to do for the group. It was important to have a picture of the band on the back but on the front the whole image of the Zeppelin, that was it. That image is so strong. It's as strong today as it was then.

p.47

RP: From the Whisky to the Fillmore is a leap of people; it just seemed appropriate to play on a bigger stage. Because of my absolute obsession with American music, playing at the Fillmore was like going to the Tabernacle.

JPJ: It didn't feel any different playing a bigger venue, maybe we preferred the pub but actually the Fillmore was a really great experience. Plus, it did have the lights, which I constantly had to stop myself from turning around and looking at!

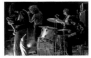

p.46

JP: I don't know how much those guys who did the light projection were inspired by the music, I'd like to think so. It was terrific, though. It's always lovely to see photographs of the light shows with bands of the day because it was just such an ambient part of the evening. Of course you did not get the full visual impact when on the stage. That's a great little photograph.

JPJ: We tended to treat every show as special. It wasn't like, we're playing *here* so let's not bother. Everything was, 'This is a show, we've got to do our best'. To me, it becomes special *after* the show. If it goes down particularly well, you can see the audience really understanding and getting into it and enjoying it, then that makes it special. The actual venue means nothing to me.

pp.48–49

JP: I think that's a really good shot. We're in Thee Image Club in Miami, again I want to stress that this was on the underground circuit. Most of these early shows were performed on the underground circuit. So this is going en route from the Fillmore West to East, the first leg of the America tour, starting off in December '68 and ending February '69.

The band that was supposed to be on at the Fillmore East is Iron Butterfly but they don't show up, they collapse after the first night with us. The photographer Michael Zagaris recently told me a story about the guitarist from one of the headliners at the Fillmore West just standing behind the amps looking lost because he'd never heard or seen anything like it. They all fell apart when they went on stage and then no one came to take it on. I had the utmost sympathy for them.

Underground radio was leaking from the Fillmore West and on the grapevine of that network between radio stations saying, 'You've got to wait for this group to come and they're brilliant and they're tearing everything up and setting everything on fire.' So when we were playing the Grande Ballroom in Detroit a short time later, the place was full and that's how it was working. West coast to East coast, that was it. We had absolutely conquered America, within a matter of months.

JPJ: FM underground radio is what broke us, we went to every shack with an antenna in the desert and just talked to people who really liked the music and got it. It was quite radical, nobody had done it like that before. And it worked. Thank goodness.

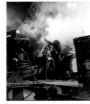

p.53

RP: These moments are particularly seismic, for an audience to see and hear Led Zeppelin play like that. For me, I really had to stay focused on every single element of what was going on around me, so I didn't lose the muse.

In truth it was a hot place to be, cos when all that beautiful musical journey had ceased for a second, and segued into another verse, what the hell was I gonna do? If you think about songs like 'Since I Been Loving You', for example, on the record itself it's just so beautiful; the music is the master, quite often I feel that words and voice get in the way of what's really going on, I almost have to arrive at a diagonal to contribute to the music.

We're not talking about sitting down and playing the four chords of a ditty; it's something else completely, it's almost audacious to think you need a singer at all. I have always felt the same about really interesting, adventurous, creative music on any level. Quite often vocal melody, if it becomes strict melody, curtails the adventure. Now, when I see some of the absolutely sincere vocal lyrical ideas that I came up with as a kid, I'm very proud. It was a reflection of how my parents had steered me through my childhood in the Welsh Marches and into 'The Battle of Evermore'. 'Dazed and Confused' could go through its three or four different time changes and its interludes and when everyone had had enough it was time for me.

I don't know whether or not there were many singers who set the world on fire by not using words but words are pretty restricting. They are syllabic. You can't fuck about with them. It is part of the story yet it almost humanises the experience too much. And then depending upon the quality of the story lyrically, or the quality of the vocal interaction with the music, people either turn off or turn on.

JP: The best part about *Supershow* was it was really well filmed and on a huge soundstage at Shepperton. Everything was set up, so we go on and they've got all of this smoke and light effects and when you view it you see that it's so exciting but we didn't get to see it like that. We didn't see the playback of this for a long time. Otherwise we would have got the people who directed that to come and film Led Zeppelin elsewhere at a later date. There were a number of people on the bill. Eric Clapton, Buddy Guy and Buddy Miles were scheduled, they were very late. The studio was all empty and we did the one number and I thought, 'We've done really well. We've played this really well and it feels really good' and I can tell they've paid attention with the lights and the smoke, it's really dramatic. Perfect for 'Dazed and Confused'. I went to the director and I said, 'That was great' and he said, 'Oh, well done. We got Buddy Guy and Eric coming in.' I said, 'Is he here now?' 'No, no he hasn't arrived yet.'

I said, 'I'll tell you what, we can do another number for you' and he said, 'No, that won't be necessary'. I bet that's a decision that guy regretted and I do too because it's so well filmed. We could have done more numbers because everyone else was going to jam. That one section of us is just phenomenal. It's brilliant.

JPJ: Everyone said we should do TV, but that was not the way we wanted to do it. Special shows yes but not like *Top Of The Pops*.

JP: It was quite disturbing for the audience. There's some footage of us playing on TV in Denmark and of people just sitting there on the floor looking terrified. Which is really good. That's when you can arrive at a change of consciousness. I think they were probably told to sit down and wait for us to come on and they sort of never got up. It was so unworldly and intense, generated by the power of the band ensemble. It was a long set, for TV, it wasn't just one number. Once I started playing a bow and things like that to them, they were just really blown away.

We veered away from television as the recorded sound was so bad. The BBC radio engineers were always really, really good and turned on by what was going on musically with bands of the day. You know, live sessions sounded pretty good on the radio. It was the only vehicle that we had to be heard over here in England, that was why we did so many of them, which later came out on the *BBC Sessions*.

Because of the FM underground radio grapevine and exposure in America, people couldn't wait to see us and were bursting down the doors to get in, so we were starting to do doubles on venues. In the UK we were doing okay, we were doing better than most but the whole euphoria that went with it in America was different and needs to be measured in a different way. We weren't getting radio play over here apart from the few BBC things that were played on a Saturday morning. We made the most of what we could do to make it very clear that we were different to anybody else but the whole thing built in a different way over there in the US.

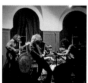

P.55

RP: At the Cherry Tree in Welwyn Garden City, I remember that. It had the world's worst funfair supermarket chandeliers all the way down the room. It was a wedding reception place for people who shouldn't get married.

JP: We listened to each other's playing, that was a really important thing, that's why it could mutate and change the direction within a number at any given point because everyone was there listening and responding to cues. I fuelled a lot of the improvisation on the guitar. We're definitely getting off on what we're doing and the synergy

of it. And if we do that then we know the audience are going to be connected because we're taking chances.

JPJ: We don't feel away from home if we're standing on stage together. Whatever it's for, it doesn't matter because immediately it's just the four of us in a small group playing, and the rest is there or it's not there. That's how we like it, a really small stage. Robert used to say, 'Stand at the front', so the first number I'd be at the front, then immediately I'd be, 'I don't like it here, I want to be near the drums' because that's how you get it so tight.

There's a lot of listening going on in this band. Everyone was listening to make it better. A very detailed band. And most times, especially you see in the photographs, we're standing very close together. I used to live under the hi-hat pretty much, as my left ear can attest.

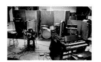

pp.58–59

JP: 'Whole Lotta Love' and 'What Is and What Should Never Be' were two really strong foundations to start off the second album. Unlike with the first album—having to dip in and out of Olympic whenever we could at ten or eleven o'clock at night for an hour or two—we could actually book sessions consecutively this time because Led Zeppelin were seriously on the map now. We went into Olympic with my choice of engineer, George Chkiantz, and we do the tracks of 'Whole Lotta Love' and 'What Is and What Should Never Be,' with some of the overdubs on it, and with more tracks and overdubs to follow in the States because we had a tour booked. The track being recorded in this photo is called 'La La', which didn't actually make it on to the album but more recently made it on to the companion disc of album two. That's me doing the acoustic part on that. Like the first album, the idea was to air the music in front of an audience and then go in and record it. I knew that was a good game plan but this time it would soak up the energy of a tour as well. It's just going to be an incredible album with, again, much contrast but a real driving rock core. Certainly with the proceedings starting off with something like 'Whole Lotta Love'.

pp.62–63

JP: I played this Danelectro guitar during the days as a session musician in the studio. I also played it during the time that I was in The Yardbirds in a DADGAD tuning and then in Led Zeppelin. I bought it in England although it was an American guitar. The whole thing about the Danelectro guitar for Americans was that it was one of the cheapest guitars you could buy; it was a Sears, Roebuck guitar that you get out of a mail-order catalogue of household items. I didn't know this but of course Americans would go, 'How can he play that amazing stuff as solo features on a Sears, Roebuck guitar?' But it helped to make this instrument quite mythical. The design is cool, it's quite futuristic. In the early days if I broke a string on the

Telecaster, that was the guitar that went straight into backup and I'd just retune it into standard and carry on the set. Initially, I would play 'White Summer/Black Mountain Side' and as time went on I do 'Kashmir' and 'In My Time of Dying' on it.

p.64

JP: Joe Walsh showed me this guitar and told me I should buy it. I said, 'No, I've already got a Les Paul' but he insisted. I was quite happy playing the painted Telecaster, which is the one on the first album. Joe said, 'Play it. Just try it out' and I did and it was beautiful. It was so user friendly. It was trying to seduce me so that I would take it home for the night. Joe was right.

I'm doing a bit of a strip, I've obviously swapped back to the Fender to do 'Dazed and Confused' with the bow and I wasn't going to get rosin all over Joe Walsh's guitar if I wasn't going to buy it. I thought that might be somewhat disrespectful. It became the main six-string electric from that night on.

RP: If Jimmy broke a string, I always tried to do 'Fox Chase' by Sonny Terry. Which, of course, is more or less impossible to do unless you are free-standing away from the microphone. It was not a polished moment but we got on with it.

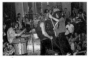

p.67

JPJ: That's a small venue, big bass drum, though. 'Cannons', John used to say.

JP: The Grande Ballroom is such a cool venue. At that time it was the perfect venue to be playing, it was an underground club. I know we're playing 'Dazed and Confused' because I'm pulling the strings from behind the nut.

JPJ: We're not just playing for each other, we're playing for people but we need to be close in order to generate that excitement and energy and also the detail, there's a lot of detail in the music. Surprising each other is part of music making. Depending on the energy of the room and the energy of the musicians, we would play differently, which made it really interesting for anybody who was following the band because nothing was ever the same.

pp.68–69

JP: The Boston Tea Party was one of the bastions of the underground circuit that all bands used to look forward to.

We didn't need a PR company or anything. Danny Goldberg, who worked for Swan Song, also says that in his book. He's so respectful that I was really moved by what he said. I'd said we're not going to need anything, the group is going to go on its own merit, it's going to travel by word-of-mouth and, bloody hell, did it. So you can see it's all full on. Everything that we're doing is at full capacity.

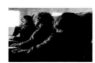

pp.70–71

JPJ: Travelling around America at this time was pretty bloody intense. There was no comfort at all. The small towns we'd stay in would be closed by the time we got off stage, there was nothing to eat anywhere, we'd have to go to bed so hungry, wake up in the morning and just have the biggest breakfast we could find, and that would take us through to the next morning.

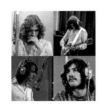

p.72

JPJ: We knew what we were doing in the studio. Especially Jimmy and I who had spent the last four, five years working. The label people weren't allowed anywhere near us, generally. When we went to New York we would go and visit them, and they would tell us that they really liked it, and that was more or less it. They were music people. Atlantic was a music label. I know it sounds silly to people who don't understand but it really was, the whole label was built on the love of the music.

When you're a session musician you obviously get a great sense of discipline instilled in you, you have to be there a certain time, you have to get to grips with the track and figure a way of performing it to the best in a very short time; you do two, three titles in a three-hour session.

JP: I was trying to focus on the music so the least amount of interruptions that you have or people saying, 'Oh, can you do a photograph over here but don't play that guitar, put the other one on?' is totally counterproductive, which is why there are not that many photographs of us in the studio. That's why I never wanted visitors, I really kept it down to a total minimum of the most important people who needed to be there when I was working. This is overdubs being applied to 'Whole Lotta Love', the track that was done in London.

Every studio had a different room and had a different sound perspective and ambience to it. It was all an exciting discovery. Clearly, for me, it was hands on for all of this and a bit later we even put on the vocal overdub for 'Bring It On Home' in Canada in some little hut. But also there were established studios where we were doing our recording. We went to Mystic, which was the old Del-Fi Studios where Ritchie Valens and Chan Romero had recorded and Bobby Fuller did 'I Fought The Law And The Law Won'. The room was really live with reflective surfaces. We did 'Moby Dick' because it was great for drums and we did 'Lemon Song'. We did a couple of tracks in there and that was really cool.

Stage and studio are two different worlds as far as I am concerned because there is discipline in the studio, you commit to a recording for repeated listening and live you can improvise all the time. The studio is more measured as to what you're doing and each overdub is relative to a purpose of the track construction. What I would do was build

the track with these guys and then I would start layering the guitars on top. Generally, I would put the solo on last if I could, once all the vocals were done. There is a whole section of recording in New York at A&R and Groove Studio with engineer Eddie Kramer, doing 'Ramble On' and 'Heartbreaker', though 'Bring it on Home' is done at Atlantic Studio, the only time we recorded there. We did 'Heartbreaker' in A&R and then I did the guitar break in the other studio with a totally different sound. I thought, let's over-pump the difference of sound for the middle solo guitar and it'll just be like someone who's been in the studio, opened a door, and then this thing goes like that, and shut the door again and we're moving on in rhythm.

I returned to New York on my own to do the mix of Led Zeppelin II with Eddie Kramer. I was happy with the production, I knew this album was monumental. I overdubbed a detuned guitar, which becomes the underlying bed of the middle section of 'Whole Lotta Love', it was meant to, and it does, sound like an elemental force!

pp.74–75

RP: Brilliant. Cannons! Those expressions. It gives me so much joy because John was such a cheeky little bugger. And brilliant. When he knew he was doing something particularly good, he was showboating, that's what it was. John was convinced that he got something going on that was really special, and he was right.

JPJ: And I know most of those looks too. As John got cockier, it made for more exciting music.

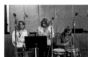

p.76

JPJ: The middle bit of 'Whole Lotta Love' was sort of my idea, but didn't end up in any way as I thought it was going to. I thought all the drums were going to be really right at the front, and they weren't, but the outcome was good.

JPJ: Starting to get a bit of mystery.

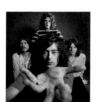

p.79

JP: Ron Raffaelli was a superb photographer. I liked him very very much. He was going to do a brochure for the American tour so he came along and did various photographs and he did group portraits of us in different positions, swapping positions, and did some very good live ones too.

The programme was great, I put it in the second album reissue box set because it captures the energy of the time. A brilliant photographer and great portrait shots of everybody. Absolutely stunningly beautiful. You want to look as strong and impassioned as the music that you're playing.

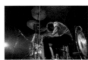

pp.82–83

JP: God, look at that, it's fabulous isn't it, Bonham playing with his hands. This was a chance for John and Robert to play on their home turf to friends, musicians and family, to show exactly what they could do now.

JPJ: That was a good gig. I finally got really good amplification, it was loud. In those days there wasn't much that really worked for bass. There were loads of good guitar amps but no good bass amps, and that's the first bass amp that really, really worked. Because PA equipment was so limited, we tried to get as much coming from the stage as possible and just hope it went further. Robert had to sing over that but he was a young lad with strong vocal chords!

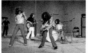

pp.86–87

JP: With a television studio you're up against another thing altogether, technicians who are used to doing light music and game shows and things like that doing the sound. It can be a bit of a disaster, the sonic quality and the balance were just so bad. Some of the French ones, like *Tous en scène*, were just absolute disasters. It was horrible.

JPJ: The whole set-up was really sterile, the audience was a long way away and the sound wasn't that good, but somebody said we needed to do it so we did it. We still gave a good performance. When we found out we didn't have to do TV, we thought let's not.

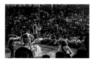

pp.88–89

JP: This is the first Albert Hall Pop Proms, where John is standing on the drum kit urging the audience on. This is really interesting because this night overruns as it isn't a Led Zeppelin show, other bands are on. They cut the power off and the road manager, who is really quick thinking, gets the plug out the wall, rewires it and puts it into the footlight socket and we carry on!

RP: John's having a laugh. I think we're getting people to clap along by the look of it, not that that was something we did very often but I think there are signs of people getting involved!

JPJ: These flowers went flying through the air at the end of the show and consequently we got banned from the Albert Hall. Just look at it, whose idea was that? Bloody Chelsea Flower Show! My mum and dad are in there somewhere, it was a London gig. It was still about what we did rather than where we did it but, I mean, you can play the Albert Hall, can play Carnegie Hall, it impresses everybody else. Generally, places like that didn't really sound any good so they weren't my favourite places to play.

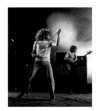

p.92

JP: Newport was a jazz festival and they kept saying on air that we weren't turning up. They were concerned because so many people were descending upon a jazz festival. Remember the Newport Folk Festival and someone doing something alternative and playing an electric guitar? 'Oh my God at Newport! NIMF!' [Not In My Festival!]

RP: George Wein was the guy that booked us, he wanted people to pay to come in to see us, but he didn't really want us there so he went on the radio and said that Plant's ill and we heard it. We pulled over into a Howard Johnson's with a number of quarters and I called the local radio station and said, 'Hi, it's me, we're on our way, we'll be there in an hour!' There was a surge and the fences came down. ... I've still got those slacks, sadly.

JP: All these jazz fans were there and suddenly hordes of people coming and they're terrified in case it turns into Woodstock. I thought that was all rather interesting at the time. Those jazz elitists must have loved it when I played my guitar with a bow.

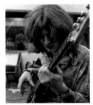

p.94

JPJ: We've got a day off, let's find a studio! So not a day off. Sort of a day off. Days off are quite often harder than playing days. We're musicians so to go into a studio, we're really interested in music anyway. We might go and see another band but it'd be better to play together. That's what we do. That's why we're there. So more opportunity to play is better.

The main mentality from sessions was not to waste time in the studio. You rehearse in the rehearsal room and you record in the studio, which seems obvious, but so many bands would rehearse and write songs in a recording studio, which is madness. It always felt wrong to be writing in the recording studio. Things would happen in the studio but you wouldn't waste time thinking, 'Oh, what shall we do next? I've got an idea.' Do that in a little room that costs a hundredth of the price. It's ingrained in you not to waste time in the recording studio.

We always wanted to be able to perform what we played. I put keyboards on things but then I could play them live. I wanted to play more keyboards—get to sit down for a start—but also when I played keyboards I also played bass with my feet. I'm in charge of the harmony, which is great, but it didn't seem to require endless overdubs. We overdubbed what we needed, what we felt was good for the arrangement of the song. Obviously later we had the recorder for 'Stairway' and strings but everything was performable, that was still a thought. We didn't want to have children's choirs or brass bands or anything like that because, firstly, there was no point and, secondly, we couldn't afford it.

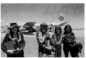

p.103

JP: On the road, between recordings with Led Zeppelin. This is great because it shows the Olympic tapes in transit and it does make an interesting photograph rather than everyone just standing there with their hands shuffling around.

RP: I think that's an amazing moment. We've got the masters, a defunct airline … never mind security, there were girls on the runway!

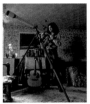

p.108

JP: I acquired my first house in The Yardbirds. The Riverside Lounge at Pangbourne, where I was doing music and putting my ideas on tape. 'Whole Lotta Love' and 'What Is and Should Never Be' were routined here. There was a particular energy about that house. It was the location for rehearsals for the first tours and album. It was quite a catalyst for everything that went on. As before, we do rehearsals for the second album. There is my acoustic guitar that the songs were written on and 'Stairway to Heaven' is played on a year later. The telescope was used for celestial, equatorial and visionary purposes.

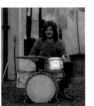

p.109

Downstairs there was a slipper stern launch and I used to be able to go out at night and just cruise up the river on my own. I absolutely loved it. I didn't want to live in London but as it was I lived out there in the countryside, literally on the river, and it was just paradise. The setting is a good representation of my bachelor days.

JPJ: [laughs] That's such a good shot of John.

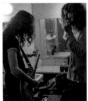

p.117

RP: Tuning up backstage: it's a really good thing because it epitomised everything and brought us together before we went on. It was sad when tuners suddenly arrived out of nowhere; the whole idea of the harmonica and the guitar, the whole deal of tuning seems to be quite beautifully antiquarian as you look at it but at the time it was commonplace.

pp.118–119

JPJ: Things are getting weird.

JP: Montreux was always a really cool place to play because Claude Nobs, the organiser of it, was such a music freak. He had all this archive footage of all the Montreux Jazz Festivals. He had a great viewing theatre and you could just go in there and watch his archive stuff then play a gig as well. He always had the most up to date hi-fi equipment.

It was a spiritual experience for some people, it was like a religious experience for others, everyone's transfixed. Look at how they are staring.

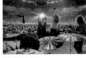

pp.120-121

JPJ: I always liked playing the LA forum, it sounded good there, it was always a good show. I don't know what it was, it wasn't that big, I suppose, but it was bigger than you'd think. We played there a lot, we were like the house band.

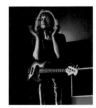
p.124

JPJ: What was I doing? I think I was clapping, actually. Weird. Sunburst all over, guitar and player.

JP: We can see what it was for them. They weren't used to having music in Iceland really, were they? It's so good to have people just transfixed by the dynamics. But then, the thing is, it would be really so quiet they'd have to listen out intently to it and then whack! Come back at them and really start putting their emotions and senses through a maelstrom.

pp.128–129

JPJ: We went off and there was utter silence, they didn't know what'd hit 'em. It took a good three, five minutes before anyone started applauding. They'd only had The Tremeloes before us, I suppose, there wasn't much they could do.

JP: Bath was so cold even though it was in June. It was really bitterly cold. I thought I'm not even going to take my coat off. People in the front rows were all covered up with tarpaulins, sleeping bags and eiderdowns.
p.132

JPJ: I arrived by helicopter. Everyone else took hours and hours from London and I left it too late and I called up Denham Aerodrome who said, 'Oh, you can have a helicopter.' I said, 'How long will it take? ... about an hour? ... Sounds great to me!' I went with Julie Felix and my family. They said you can't land too near to that many people, you'll have to be a couple of fields away. Just as we're settling in to land, I see all these Hells Angels roaring in on bikes and go, 'Oh, wait a minute'. And the lead Angel arrived and said, 'We're your transport'. So I arrived at the gig on the back of a hog with a cowboy hat, just roared in. One of my better entrances.

JP: 'Immigrant Song', that's the first number we go out with here. I thought this powerful riff is just going to be so mantric and it's got so many dynamics with the banshee vocal, it's like, 'What the hell is this?' That's what you need to do. You want to go out there and prove to people that you're not like anybody else. And that's it, that's what we did.

pp.142–143

JP: After being at Bron-Yr-Aur, certain things materialized. One of them was the hat. The other was the beard.

JPJ: I bought a mandolin in a thrift shop in Evansville, Indiana. I think I'd heard some Fairport Convention so I learned a couple of their tunes. It was nice to sit down and just be acoustic. Jimmy wrote most of his electric riffs and all the songs on that acoustic. It was a drastic change of pace in the show but by that time we were opening for ourselves. Those that wanted to go to the bar could, it was hard shutting them up at first, but then people really enjoyed it and it became part of the set.

I started travelling with the mandolin everywhere because it's small. I love it. To this day I carry a mandolin wherever I go.

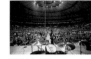
pp.144–145

JPJ: It was a bit frustrating. Not so much that the music press weren't getting it, that's kind of understandable. They seemed to be quite spiteful. I've never known why they really took against us. There were even other musicians saying that. I remember at Bath Festival, somebody said we've got piles of new guitars and amplifiers we've been given by Atlantic. I said, 'You're joking, I've had one bloody bass from being a teenager, which I managed to pay for on the never never, by playing the church organ', which is all I had until halfway through this band, just one bass. And the same with Jimmy, he had his guitar, nobody gave us anything. Bought all my amps, my Hammond, and a lot of people just try and say it's all hype. Just listen to it, how can it be all hype? People used to say, 'Who's playing bass? There must be somebody else on stage.' Which is why in the film, *Celebration Day*, I told somebody to make sure you've seen where the bass playing is coming from … so they shot my cowboy boots!

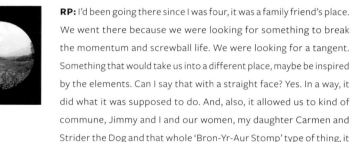
p.152

RP: I'd been going there since I was four, it was a family friend's place. We went there because we were looking for something to break the momentum and screwball life. We were looking for a tangent. Something that would take us into a different place, maybe be inspired by the elements. Can I say that with a straight face? Yes. In a way, it did what it was supposed to do. And, also, it allowed us to kind of commune, Jimmy and I and our women, my daughter Carmen and Strider the Dog and that whole 'Bron-Yr-Aur Stomp' type of thing, it worked. It didn't separate us from John Paul and Bonzo, it just meant that we could work as we had started to do, just the two of us, and take ideas on. That whole idea of a commune thing worked a few times. We went on to Headley Grange and we went to Stargroves.

p.153

Writing lyrics is all a melange, it's a soup. I was really impressed with how American artists and musicians were able to comment on their environment. Especially with Vietnam and it wasn't that much longer after the riots of '68. Everyone that was part of this thing was holding the flame to create awareness, trying to contribute, be part of the movement. That was my whole deal and still is really.

JP: I had written some music in Pangbourne and went to Robert's house to rehearse with John Bonham and with Robert. My musical connection with Bonham was such that when I played the riff of 'Immigrant Song', which was tailor made for his style and our band, he beamed. I played 'Friends' and he immediately started playing the congas, really happy to be playing together again and the two of us came up with 'Out On The Tiles'. Not a bad start to the proceedings. I believe John Paul Jones joined us the following day.

p.154

JP: I knew Zacron when he was a student at Kingston Art College and I heard he got headhunted straight out of college to teach at Wimbledon. He was a friend and I'd actually bought some of his artwork way way back before Led Zeppelin. I knew that he was very talented and I knew that his work was quirky. I commissioned him to do the third album cover.

There used to be gardening calendars where you would turn a wheel and it would say when to prune things and when to plant and all the rest of it, probably to the lunar calendar. I asked him to do something that was designed like a wheel that would reveal other imagery in all of these cut-outs. He took photographs for it of everybody but then it took forever finishing off. I was calling him, Peter Grant was calling and he was going, 'Just need a little bit longer'. It was taking longer and longer. I thought, 'Oh my God, I hope he's done it. I hope he's going to pull it off,' I had recommended him. Then he delivered and it was like, 'Wow, this is great. This is absolutely amazing.' It just really is so cool graphically throughout.

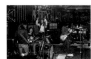

pp.158–159

JPJ: Jimmy had a couple of tone pedals that he changed but I never did. I had a bass that I changed for one or two songs but that was it. I never touched anything, I always thought that pedals tend to dilute the bass, once you get a really good bass sound you want to stick with it, so it's consistent through the show. If it sounds good with the bass drum, I didn't mess around.

JP: There's a sonic construction going on, moving between utilising the pedals, the sonic wave, my Echoplex and guitar chords while they're rocking up, getting some sort of groove going.

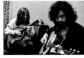

p.162–163

JP: That's the 'Stairway' guitar. It's consistent from the session days, The Yardbirds and all the way through. The writing tool for the first four Led Zeppelin albums.

JPJ: Still in agricultural mode there I can see. But it was great times, everybody was doing it, getting together in the country and this sort of thing. It's our saving grace that we never really got it. I mean, we stayed out in Headley Grange and that sort of thing but we never lived with each other. Which was the end of many a band, especially in those days. We wouldn't socialize much. Then at the beginning of a tour we'd see each other and say, 'Hey, great to see you, let's go and make some great music' and I think that's one of the things that kept us going.

p.165

JP: Milan was seriously heavy. There was no immune area, the police released tear gas into the audience. So we make it to the dressing room, which was also filled with smoke, and they were smashing windows and it was horrible. The equipment disappeared into the night.

p.170

JPJ: That was my second bass. It was purple when I got it. Someone had dipped the whole instrument in a purple tank, sort of aubergine purple. It was a '51 and I just used it for 'Black Dog' and maybe one other thing, it was a real twangy sound. So that was two basses I was touring with, then I got a third, eventually, that had eight strings.

JP: If we weren't on the road I was writing. I lived it, it was my life. The energy of doing concerts and the frantic pace of being on the road, to come home was like the other extreme, the contrasting balance, it kept the scales in an equilibrium. I continued writing all the time, I was always thinking about what was going to come next and what would be good for the next album.

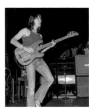

p.172

JPJ: Japan was fantastic, completely different, another planet. Probably still is. But it was great, we love Japan.

JP: It was an extraordinary place to go, tomorrow's world, quite futuristic. The streets were flooded with people. I'd been in major cities in the world but I'd never seen such a dense amount of people coming towards me. And, of course, you look totally different to them and they look totally different to you, there weren't too many Western tourists walking about in those days, so you really stood out and it was pretty interesting. We got this award for *Hit Parader* magazine for group of the year or strength of the albums or whatever. But then in Hiroshima we did a free concert and that was one of the better things we could have done. The mayor gave us commemorative medals as well.

JPJ: I saw the mayor's face when we played, they'd put him in the front row. As soon as we started, the shock on his face … poor bugger, we felt sorry for him. Bloody loud. I think they went after a couple of numbers. Bonzo was really loud so we had to be above that. I don't think it was excessive, it was more than other bands at the time, perhaps. It wasn't loud for loud's sake. If the dynamic of the song meant to be quiet, then quiet it was. And then you have the acoustic set.

RP: I bought a black Nikon F in Japan from the Motorboat company. I did take shots in India, Japan, Australia and home but it was a lumbering thing. I never set about chronicling anything, though.

p.179

RP: I bought this picture in a junk shop in Reading with Jimmy and someone stole it. I had it in my farm up in Wales. It's not a super-duper secret thing but it's just, like, a personal thing. And it went. It was great, a hand-tinted painting. A great photograph. Po [Aubrey Powell from Hipgnosis] did the shoot somewhere near Winson Green.

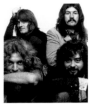

p.182

JP: Looking a bit mischievous on this, I like it.

JP: There was a stage and then there were barriers all the way back and the audience seemed miles away and in the end they just got the fence down and came through. On this tour I shaved the beard off between shows after Adelaide, I went unrecognized for twenty minutes at the press conference in Melbourne.

pp.184–185

JPJ: Generally, everywhere new that wasn't America they absolutely went wild about it. They hadn't had that much, as well, so when something of that quality turned up, a lot of people really got it and really loved it.

I changed amps and upgraded to Gallien-Krueger. I did that because my acoustic amp had the amp in the bottom of the speaker cabinet, and at the Boston Garden during the last number, right at the end, it caught fire. Flames appeared and everyone was like 'YEAH!' Perfectly timed.

pp.188–189

JP: This is where Johnny Lark, a member of the road crew, does filming with everyone's movie cameras that were recently acquired in Japan. Everyone's saying, 'Do a bit on my camera, put it on my camera, do a bit on mine'. If you see the clip for 'Immigrant Song', the music's from LA but the actual visual imagery is coming from Australia and he's the one who shot it.

The good thing about concert recordings not being instantly available in those days was that we could put anything in our set, numbers that we'd only just recorded or that we were going to record. We felt totally safe because it wouldn't travel from the night; they hadn't got into the bootleg vinyl scene in a big way yet, so you could improvise and develop things in a truly creative way. You weren't restricted, it was total freedom.

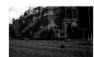

p.190

RP: I think the thing about location recording is that there is no time restraint, you can be creative and inventive, you have the equipment there indefinitely.

JPJ: Different circumstances for different tracks, generally the idea was to combine the process; you would have the space to write stuff in and to work stuff out. The idea was more of a writing thing. It was more relaxed and more collaborative, previously there were some ideas that people brought in preparation, but generally this was more collaborative, riffs came out of jams, it was a lot of fun, actually, as you can see by the pictures. We would have ideas, then you'd put them together and someone would say, 'I like this idea, or that idea's good, maybe we'll try them together.'

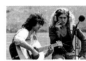

JP: We're going to be recording the songs 'The Song Remains the Same', 'The Rain Song', 'D'yer Mak'er', 'The Rover' and others with Eddie Kramer. Every track was supposed to sound different and so was every recorded album. So we're changing, we'd already done Headley Grange but this is Stargroves, Mick Jagger's house, and that's The Rolling Stones' mobile, curiously enough. We used it as a location to try the recording. I'd actually been to check Stargroves before as a rehearsal place; The Who were rehearsing there and I popped in to say hello. I was looking for places after the Headley experience. I thought this would be a good thing to do again because it's fun and these rooms are just really so good for making the instruments breathe, like Headley.

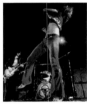

pp.192–193

And that's recording 'Black Country Woman' because it's the harmonica and the guitar on the lawn.

JP: LA Forum and Long Beach Auditorium were an experiment, a chance to try the Wally Heider mobile recording truck with Eddie Kramer. I thought it should be the first thing to check before committing to filming a concert, which we did in fact do the following year at Madison Square Garden. Eddie did that recording too.

p.195

JPJ: I don't think we'd recorded much beforehand. I don't think the shows in LA and Long Beach were recorded with a view to releasing them, I think we just thought we ought to document something.

RP: These bigger venues, like the Forum and the Garden, didn't operate as gigs before. I don't know when the first acts played the Garden but it wasn't yet in our remit. We had been playing municipal auditoriums.

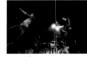

pp.196–197

JP: I'm shaping my look in a different way. You wouldn't necessarily guess it but this is the same shirt that I'm wearing in *The Song Remains the Same*. The detail on this was so striking that rather than have highly decorated trousers jumbling it up, I had the black jeans to go with it, to emphasize the shirt.

p.200

JP: In the studio in Bombay in 1972. Knowing how many stops you had to make in those days to refuel coming back from Japan or Australia, coming through Thailand and India, I thought that it would be really clever to do a tour or a set of dates whereby from London to Australia, for example, you go to Egypt and you record with an Egyptian orchestra, then go to India and do the same incorporating Indian musicians. The idea is absolutely sound, nobody's even done it now. I wanted to know how easy it would be to actually go into a studio and direct via the guitar, so the only communication to the musicians is just going to be the music from the guitar.

I went in there with Robert; the musicians were the equivalent of what we would now call Bollywood musicians, who would do all these film sessions. I asked for the instruments that were there that evening: mridangam; tabla, that's two sets of drums; violins; a sarangi, which is a bowed instrument; and a shehnai, which is a reed instrument. It was all assembled, I had a translator who was not a musician, I was the musical director and I went in there and said, 'This is what I want to do' and I started playing 'Friends' to them.

Bit by bit it's coming together and ready for Robert to sing. In the space of an evening we do 'Friends' and it's so good I don't want to stop. We only had two or three hours and I said, 'I want to do another one and I want to do 'Four Sticks'' because I'm curious to hear how the percussion would deal with it. They were absolutely astonishing with the technical level at which they approached it. They'd never heard Led Zeppelin, I don't play them a record, I'm just playing them the guitar and they said, 'Right, if you want a fifteen-beat introduction, would you like this, do you want that?' They were really helpful. 'Yeah, okay, just follow the guitar' and that's the whole structure. They have trouble with 'Four Sticks' because they said all Indian music, classical music or pop music never had two time signatures that changed from one into the next and then went back to the original one. They'd never had something like that but they still got it.

They were absolutely magnificent to work with, it was great. That's exactly how it was and that session was really magic. I'm thinking this would be really great to be able to do in line with playing in different countries. Let's see? The only time we ever really managed to pull this sort of thing off was probably a bit later when Robert and I do *Unledded*. These Bombay recordings appeared some forty years later on the *Coda* companion disc.

RP: A very intimate session, certainly wasn't thought of as something we would put out. It was exploring, it was pushing out there. Whether I sang well or Jimmy played well was secondary to the fact we were able to do things like that. It was about adventuring. That's what it was.

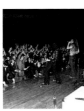
p.203

JP: I've got my black and white shoes there, they came from a shop in Miami. I thought they're so cool, like Mafia shoes or the shoes Presley used to wear and that's right back to Rock 'n' Roll for me. That's why I'm wearing them, a real homage to the fifties footwear.

Apparently, there was some trouble here because the crew nailed the speakers into the polished corporation dance floor. Another time at a similar 'corporation' venue I was there early in the day setting up and Bonzo's road manager was knocking these great nails in to stop the bass drum from moving forward. This guy comes up and he says,

'Ah, no, no, no, no, no, you can't bang nails in the floor. That's corporation, you know.' And the road manager came back with a line that was so slick and so confounding. He said, 'Oh no, mate, they're French nails. They don't leave a hole.' 'Oh, alright then.' It was absolute magic and I actually witnessed that. French nails!

pp.206–207

RP: The Isle of Staffa within the Inner Hebrides, beyond the Isle of Mull, was for sale and upon it is Fingal's Cave and the Causeway. I hired a fisherman to take me through the Atlantic swell, it was wild. The boat broke down on the way, with the fisherman, me, sheepdog, bobbing up and down in this ridiculous scenario. We finally landed and it was unlikely I would wish to cross that sea again but at least I photographed it and brought pictures back for image ideas and submitted it to the band and Hipgnosis.

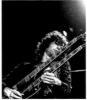
pp.208

JP: I'd often been asked the question, 'Why did I play a twin-neck guitar?' The answer comes from 'Stairway To Heaven'. The original studio recording has an acoustic six-string guitar, two electric twelve-strings guitars and a six-string electric to do the solo. The solution to live performances of this song lay in the double-neck, whereby I could approach all the guitar parts without changing instruments. It was the song that demanded the guitar, I don't think anyone had applied it like this in a live situation and made it so iconic.

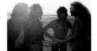

pp.212–213

RP: Well this is great because it's candid.

JPJ: Having our own plane was practical, literally just to get around, which would have been impossible on a commercial aircraft. Also, it made more sense for us to work out of bases rather than staying in a different town every night.

It had to be enjoyable as well, also it did make it a lot easier because you didn't have to pack and re-pack every day because you stayed in the same hotels; the bases were New York, Los Angeles, Chicago, New Orleans and from there every plane ride was around half an hour away. You could leave your hotel late-ish, get on the plane, do the gig and get back, then you wouldn't have to check-in, check-out, get on the road; all that sort of stuff. Because it would have been completely impossible to play as many places as we did.

There's a quote from the guy in the Duke Ellington Band, 'We play the music for free, we get paid for the other 22 hours'; travelling and hotels.

p.217

RP: This old lady telling me off for having long hair, that's at the Drake Hotel.

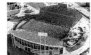

pp.218–219

JP: On this particular tour, we began outdoors at Atlanta then we played Tampa, both on massive scales—Tampa breaking The Beatles' Shea Stadium record, which was a big deal at the time—then the rest of the tour we're back in auditoriums, all sold out! It was difficult to estimate just what crowds we could have played to on that tour but it was clear that we couldn't supply the demand. It's come a long way from the Whisky a Go Go and Marquee clubs!

JPJ: If you're playing a baseball stadium, it's great for baseball, I guess. And don't get me wrong, it's brilliant to see 10,000 people turn up for a show, and seemingly enjoying themselves. But sound-wise, it was hard work. It's not so much just sound, there was a lot of nuance and subtlety in the band, and the bigger the place got, the less would be heard and the less you could perform, because you would just disappear in this great, booming sound.

p.220

JPJ: That was my third bass, it was a five-string Fender and the ugliest bass guitar in the world. It was horrible but it had a high fifth string and I got into it for a while but it was unbalanced, and I don't know if it even sounded that good. It was so ugly I couldn't go on stage with it anymore.

There wasn't that much amplification around so once I found a good sound, I kind of stuck with it. I think I made one major change, for Gallien-Krueger. I had a fretless bass later on, a Fender fretless bass, which I still use. I actually used it at the O2. And then I moved into eight-string basses and Alembic basses, so that was more of a change. Much later on I unfortunately changed to an Alembic bass, which everybody now hates because they hear the bootlegs that were taken from the desks, and of course all you hear is the treble end of the Alembic that went direct, and they say, 'Everybody must have hated the bass sound that John had.' No, it sounded huge in the room but if you take the bootleg from the desk you hear this horrible noise. That's one of the sad things about the internet, I think.

p.225

JP: I don't know how I got a finger injury in LA but I've got it, tendonitis or strain, these things happen and I don't want to cancel anything but we're going to be playing Kezar Stadium in San Francisco and it's really playing up.

Also I know that in three weeks' time we're due to record and film at Madison Square Garden. I'm praying this finger injury is going to rectify itself. We don't cancel the tour, I play through it adapting my technique but I'm recovered for New York.

JPJ: The show doesn't necessarily need to be in the dark with smoke. You can do a really good show in the open air in the daytime with the sun shining, I didn't mind that at all.

p.231

RP: In these daylight gigs when you've got so many thousands and thousands of people, I had an opportunity to focus on the expressions of people and to lock in a face; I'm trying to find where it's at for them at a moment in time. I'm a communicator, on whatever level it is, it's whatever it is, but that's the moment where you really know why you're there.

Especially in San Francisco, it was otherworldly; there was a sub group of people who would dress remarkably, and it's fantastic. I was already a set piece, but I was marvelling at those people, I loved to look at them. It's all the blurred lines that make us anything. Because we can't play to a nightclub crowd, we have to play here, the connection with and the anticipation and the encouragement and the fusion between the spirit beyond the footlights and what we do. So we were so lucky, that's when the link was genuine, absolute and finite.

p.237

JP: The plan was to film a concert. We had to reshoot some of it because the cameraman got stoned and didn't cover everything they were supposed to catch, like the vocals. We had to re-enact some of the concert at Shepperton and we did it really quite successfully.

JPJ: Communication wasn't that organized in those days. Some people knew we had to wear the same thing every night, and I thought we were just being filmed on the last night. I thought they were practicing, I don't know. As soon as I started playing, I forgot we were being filmed. In fact, I forgot we were being filmed anyway because I turned up in a different shirt every night. It was like, 'Oh yeah, right.'

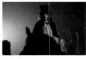

p.240

JPJ: The horse was supposed to stop outside my window but it either stopped twenty yards before or went roaring past it. The whole film was like a Horse of the Year show.

It was supposed to be a concert film but it had all these silly fantasy things, mainly because somebody turned the camera off as they were frightened of using film, so there were all these big gaps and we had to think of something to fill them. Everybody said, 'Oh, it's your fantasy': no it wasn't, it was my necessity. I thought it would be great. I was going to use footage of pirates racing across terrorizing peasants and all that sort of stuff from the Disney film *Doctor Syn*, and then I'd just walk through the door at the end, that was my idea. So you'd have just half an hour's shooting. But we couldn't get the footage, Disney wouldn't allow it, so we had to get horses and all that bloody stuff, right across Kent terrorizing peasants. I don't know, it was nothing to do with the music. I wasn't really interested.

RP: I didn't feel conscious of the cameras filming, I just tried my damnedest not to overdo it. I couldn't imagine what it must look like.

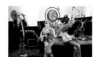

pp.246–247

Even now I never look at anything after the event, I just do it and it's done. I didn't want it to be too exaggerated but, of course, as it turns out, it was. And there were lots of miscalculations by the film crew.

The horse I was riding was a seventeen-hand Arab stallion, still intact, so I walked him up and down and up and down on the shores of Lake Vyrnwy for an hour, me with the water up to my hips, and him a little bit scared. I got his fetlocks wet, then after about forty-five minutes, I swung him around and he went on the outside in the deeper water, then I jumped on his back, and did this shot of him coming out of the lake slow motion with all the water coming off his hind quarters. So I'd walked him into this thing that he'd probably never forget. There were some fantastic moments with this animal that show the affinity we developed and the depth of his beauty.

JPJ: It was always important to have a setlist that worked with a proper dynamic in the show. I know a lot of bands say, 'Oh, we just make it up as we go along' but I never believed in that. And I don't think any of us did. We liked to work out what would make a good show, a good order, and then we'd stick to it. That's how you do a good show. If you have a good solid framework, which you've thought about and worked out, then you can be free within that framework. Because you're not wandering around on stage saying, 'Oh, what should we do next?', which all the San Francisco bands used to do. You'd see 'em just wandering about, the whole energy of the show was dive-bombing while they were looking at each other thinking, 'What shall we do?' We came along and just gave 'em a really good, energy-filled show.

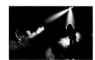

pp.252–253

RP: We employed Ian Knight, who was known lovingly as Ignite because things were always blowing up accidentally around him. We had incendiary pots underneath the stage that had some charge that could be ignited by an electrical spark and I remember somebody threw a lighter or an incense stick or something at me, and I was lecturing him, and as I did it blew up right up my back. Very funny. We had obviously reached the point where we had to start doing more than just playing our repertoire.

JP: As John Paul Jones is on the keyboard it's safe to assume that's the theremin of 'No Quarter'. There's no dry ice yet but he's on the keyboard and the dogs of doom are howling low and I used to do this 'woooo'. It's on the record but I used to emulate it on stage.

p.258

JPJ: Weirdly, I was the Jack Daniels drinker in the band. It was probably my bottle that he'd just half-inched, I thought he used to drink Johnny Walker.

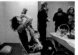

pp.260–261

RP: The really remarkable thing about writing lyric and melody is that you're never really finished. There's always a little bit of something that you can move around with each take, a syllable or a different word to create more of a lilt … to weave it more. And the musical part of it, once that was in the right place, quite often a lot of the vocals had already gone down at the same time as the original idea. Sometimes I'd peaked already by the time we got the right take. With *Physical Graffiti,* I can hear bits and pieces where I know I was nuancing the idea. On 'Wanton Song' and 'Custard Pie' there are things that I can hear that are almost unfinished. Hindsight is a cussed bedfellow but it's great to fly in the face of it all and meld something tangible, a kind of union between the intent of the music and some sort of vocal release. Quite often it did work. Songs like 'The Rover', for example, everything worked. The marriage between my lyrical intention, the way I sang it and the way those guys played, there were many times like that. I thought it all worked, there couldn't have been any more that I could have added, or more that I could have taken away to make it work as a consummate finished article. Some songs are finished, some songs aren't. Even now.

JP: We go to Headley Grange to begin the recording for the sixth album. We arrive at different times, Robert, John Bonham and I jammed some old rock 'n' roll songs to kick things off, then I start presenting some of my riffs. We played 'Wanton Song' and 'Sick Again' and I had a particular idea for a mantric riff with cascading overdubs. I started playing the riff with John Bonham and we just locked in and played it non-stop. It was so infectious, such a delight and just so *us* I overdubbed the electric twelve-string to what was later the brass parts; I had visualized this piece as being mighty, orchestral, even threatening. When I heard the playback of myself and drums, I knew this was truly innovative. This is the birth of 'Kashmir'. John and I had a profound empathy between us from the first days of rehearsals, right through Led Zeppelin's career. We were both fans of Led Zeppelin.

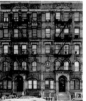

p.262

Physical Graffiti was a double album involving material that we recorded at Headley Grange and other locations. There was a substantial amount of recording that was done that clearly was an overspill for one album, so it became a two album project. We had material that we recorded at Headley Grange that was not on the fourth album and there had been a surplus to *Houses of the Holy*. There was going to be such a variety of material, and moods, colours and pieces, character-wise, and it was going to be the first release that came out on our label, Swan Song.

I was very keen to make the packaging super elaborate, so that people would talk about everything to do with this album; the material that was on the first disc, the material that was on the second disc, the way that

it was sequenced, the album cover, again the way that the album cover was constructed so when you took the inserts out and put them back in you'd be presented with different images in the windows. It was an ambitious cover but then so was the music. I had contacted John Kosh Associates and was dealing with Peter Corriston; the idea of having the building was put to them, having the windows that would show various images appearing in them depending on how you replaced the internal parts, the albums and the information sleeves. It was an idea that was a direct follow on for me from the third album, where we had a wheel with information that showed up in various cut-outs. However, all of the detail was never shown in those windows so on this I wanted to be really precise.

This time there were some marvellous images to include in those windows. I think this cover is absolutely extraordinary, and they just really delivered the most amazing package. It was a wonderful graphic image. A lot of people say it's their favorite album, because they get to access so many areas and moods within the group. It is a phenomenal album, so it needed a phenomenal package, in a very dominant fashion.

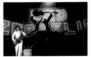

pp.284–285

JPJ: Earls Court sounded like you were playing in Paddington Station! I have my piano there. I took it into Steinways for refurbishing and then to Earls Court, which was rather nice. Plus, I had that great jacket that everybody takes the piss out of. I thought it was fantastic. I had a couple of those jackets, they were made by an artist, and I think Jimmy commissioned his dragon suit. I loved those jackets, and everybody moaned, 'Why is he wearing these stupid clothes?'

There was a story where I went to the Drake Hotel, I think. Mo and I had a really hard day's shopping in New York. It was a hot and sweaty August and we went into the bar and I just had T-shirt and jeans and the bloke said, 'You can't come in here, you don't have a jacket', so I went up to my room, put that jacket on, walked back into the bar, he took one look at me and one look at the jacket and said, 'Where would you like to sit, sir?' I've still got it.

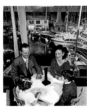

p.286

JP: The cover concept for *Presence* comes from Hipgnosis. The idea of old *National Geographic* magazines that you'd find if you went to the dentists or the doctors, with photographs from the fifties, even though this was in '76. There would be something that was an everyday, familiar object that had now disappeared, yet was present in those photographs, within these various settings. I can now put this in current context for transistor radio; I recently heard there was a group of kids, about fifteen years old, and a transistor radio was brought in the classroom and they didn't know what it was.

The album was recorded in Munich. I wanted to use Keith Harwood, who I had mixed the *Physical Graffiti* album with, we had a great connection. There were rehearsals in Los Angeles and we arrived in Munich, staying in a hotel near the studio. It was a very uncertain time as Robert was recovering from his leg injury but somehow this created an atmosphere of solid determination and camaraderie and made extraordinary music for this record. We allotted three weeks for it and when we laid down the tracks it was clear to be a guitar-featured album, so much so that the overdubs for the guitar orchestration on 'Achilles Last Stand' and the solo were done in one evening. It felt like I was channeling during that time. 'For Your Life' and 'Tea For One' appeared during the first week in the studio, there was even a lone piano number called 'Pod', it was really quite beautiful and it surfaced on the companion disc. So this album was completed, overdubbed, mixed and sequenced in three weeks. After the group had finished their parts and returned to England, I made a pact with the engineer that whoever woke up first in the morning would wake the other to make our way to the studio to continue on as time would be tight. Somehow I always ended up waking him! It was perpetual motion only broken by sleep.

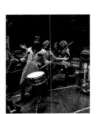

p.296

JPJ: Getting back to work was always good. We got straight back into it. It's like you always go on holiday to the same place every year. When you get there it's like you've never been away, it was brilliant. And there's my eight-string bass I used on 'Achilles Last Stand'.

I went to see Rick Turner, who had a guitar workshop on a chicken farm in Petaluma, Northern California. This one was already there and I went, 'Ooh, that looks good' so I bought it. And he made my Alembic.

RP: So, *Presence* was out and gone. It'd been a long time since we played together. I had a car wreck in August '75 and I took my first step unassisted at the George V in Paris seven months later with Benji Lefevre, who was our sound guy, Ignite's mate. I took one step then I fell on the floor and Benji wrote on the skirting board, 'PLANT TAKES ONE SMALL STEP and has another drink'.

pp.302–303

JPJ: Shows on the US tour just got longer and longer. Any band of that size or stature has to balance the old material with the new material. What do we do? What do we drop? What makes a good show? That's what you have to do.

pp.304–305

RP: We became catalysts for an event that was going on in front of us and sometimes regardless of us. Not only were we playing, and playing well, but we were often witnessing a kind of anarchy, which made a lot of these shows really quite uncomfortable. It's almost as if the

pressure was building up out in the land and everybody seemed to be there for one or two or three reasons other than just entertainment, and that's what you got.

RP: If it was a seated gig, quite often you could have the family of very connected people in the front area who you don't mess with. Quite often they don't even know why they're there!

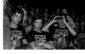

p.312

RP: There was so much time in between shows, there was a sort of heaviness. Coming out of the wheelchair into this, coming from spending a lot of time on my own, working on lyrics and so on for *Presence*, with quite a lot of personal, slightly shrouded disenchantment in the lyrical content, I was just feeling it. As I came out of it and started performing again, I began to feel that the times were changing so quickly that having spent so much time inert, inanimate, incapable mostly of any participation in life at all, and being away from my family, by the time I was able to move again, I felt that there were the beginnings of the Distress.

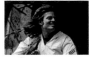

p.318

JPJ: For the acoustic set and also for 'Ten Years Gone' I used a triple-neck acoustic. Somebody saw me changing guitars and wandering around the stage all the time and said, 'Oh, I'll make you a three-neck, just sit in one place'. But I still had to play bass pedals, and had to sing. Okay then, 'Jonesy will do it!'

In 'The Battle of Evermore', we used a horrible Eventide harmonizer. There's footage of me singing the first part, and then it cuts to Robert and this horrible, horrible harmony suddenly happens. Everybody thinks it's my singing but it's the machine.

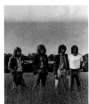

p.326

RP: There was a huge amount of responsibility that I felt to actually try and match the anticipation in the audience. We'd been away since Earls Court, nearly four years away, so the amount of anticipation I had was probably way higher than anybody in the crowd. We were good in Denmark for the warm-ups and on 4 August and 11 August. We were *good*. We were almost willed into greatness. To live up to it, to be more than it could have been before, is a real tough order. There was so much hanging on Knebworth and it was magnificent, there's nothing you can do except do it, so do it. It was a hell of a deal. And we survived it. The love that was coming at us, and the weight of responsibility that we carried, made for a very strange equation. By that time I'm thirty-two years old. I was nineteen when I met Jimmy and John Paul. We'd been through all that stuff that people go through. We were all family men, we were parents, we were everything. But we were also this other thing.

PP.334–335

JPJ: That's my grand piano with the Yamaha stuck inside it. That was great, a couple of scenery people at Shepperton were watching us rehearse and they said, 'Would you like us to knock something up? You know, we could make that look a lot better.' It was a tiny short-arse keyboard, so they knocked me up a flat-pack white grand piano, which I slid my little keyboard into. I have never seen a picture of it, that's great. I had bass pedals on the floor. People thought, 'They must have a guy off-stage playing bass'. 'No no, I play it with my feet.' But that's great. The flat-pack piano. I wonder where that ever went?

The show was bigger but once you get on stage you're back again and you just get lost in it. I thought the shows were good. I don't know if anybody else shares that opinion. Everybody is everybody's harshest critic but we remembered all the stuff and there were some good moments.

That telephone became a mascot. Somebody put it on my keyboard one day, and it was kind of funny because it looked like it fitted this huge Yamaha synthesizer, and I just kept it. It probably looked more enigmatic than it actually was.

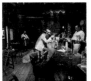

p.338

JPJ: For the sessions at Polar Studios, there was a writing time, with Robert and I. We wrote what we could and then, consequently, it was probably dominated by our stuff. I'd just got a new Yamaha GX-1 keyboard and it was the first time I'd actually written stuff on it. It had replaced the Mellotron; I had finally got rid of my adversary on stage, it was great when it worked, it just rarely worked. So this sounded fantastic. I had it at rehearsal and just wrote stuff with Robert.

'In the Evening' was written on that keyboard, with the drone—it was a synthesizer, not just a keyboard—I did the intro that Jimmy added guitars to. A lot of people didn't like it but we were experimenting. We were moving into the eighties, seeing where we could go. We weren't changing, we were still a rock band but we just wanted to see what else there was.

p.349

JP: As the producer, I was told by Peter Grant we still owed an album to Atlantic after losing John ... *Coda* was a good chronological collection of outtakes and it gave an opportunity to feature Bonzo's Montreux, the drum instrumental that he and I had worked on together.

The *Coda* artwork was done under the umbrella of Hipgnosis. This was an album that was very difficult to actually have to work on, from my point of view, at that point of time. However, in retrospect it was a good album under the circumstances. I gave two companion discs to it when *Coda* was released in 2012.

RP: The rehearsals for the O2 were very emotional. In fact, that was the greatest part about the whole thing. Opening the account again for a limited engagement. There was nothing beyond that, no one ever thought about it being more than one show. After all, by that time who were we?

And did I take any of what I felt from the past into that? I'm afraid I did. Some of it brilliant and some of it questionable. But it was very emotional, and I was so glad it was, if it hadn't been I would have walked away from the rehearsals, I would have gone. Because you gotta believe it, it's either gotta be real or not. By the time we got to Oakland in '77 it wasn't there, but it was there at the O2.

JPJ: We rehearsed very hard in order to get back to where we were. The rehearsals were alright. We had to do a really good show. We didn't want to plod through and just make it, we wanted to be really good.

JP: We had solid rehearsals with Jason, this shot [p.359] was taken on the completion of the production rehearsals in Shepperton. Next stop, the concert.

JPJ: The show itself was enjoyable. More enjoyable than the rehearsals. And Jason was an absolute star that night. In his position I don't know how well I'd have done. But it was a good night. It really was. And I'm glad we did it, and I'm glad it got filmed.

RP: The weight of expectation for this concert was far greater that at Knebworth but I think we were better equipped for the O2. It was kind of a reckoning, because I knew that we could do it.

This was incendiary music. I wanted it to be a bit more like the Marquee. I love the idea of accident and stuff like that, because out of that comes some magnificence. I think we were able to handle that show better than I had imagined. It was a great gig.

JP: Only one show and we were magnificent. Magnificent in the rehearsals and magnificent in the show.

—

Jimmy Page, Robert Plant & John Paul Jones

London, May-July 2018

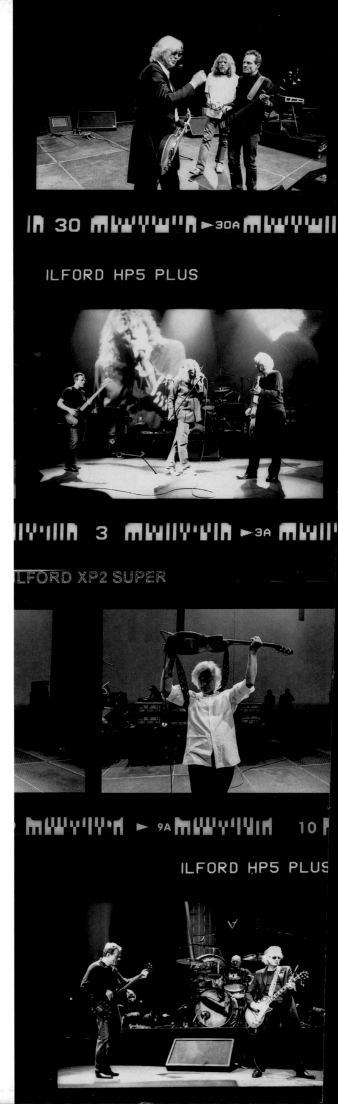

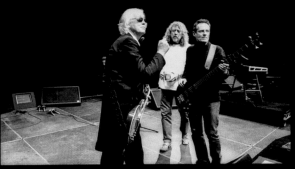

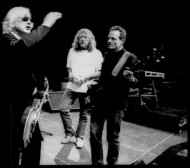

D HP5 PLUS ILFORD HP5 PLUS 1013 ILFORD HP5 PLUS

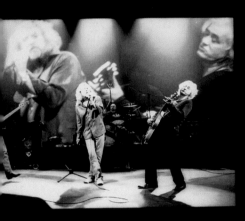
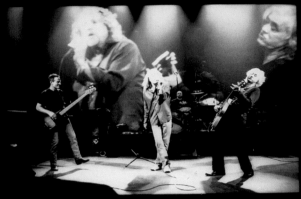
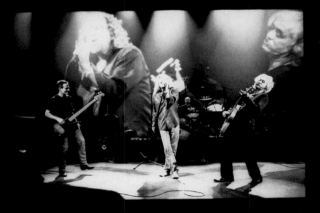

ILFORD XP2 SUPER ILFORD XP2 SUPER

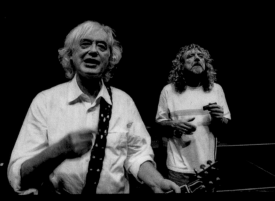
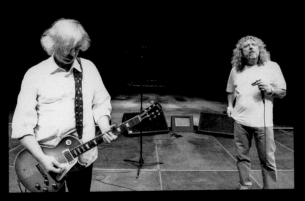

ILFORD HP5 PLUS ILFORD HP5 PLUS ILFORD HP5 PLUS

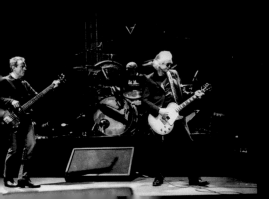
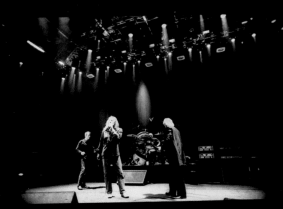

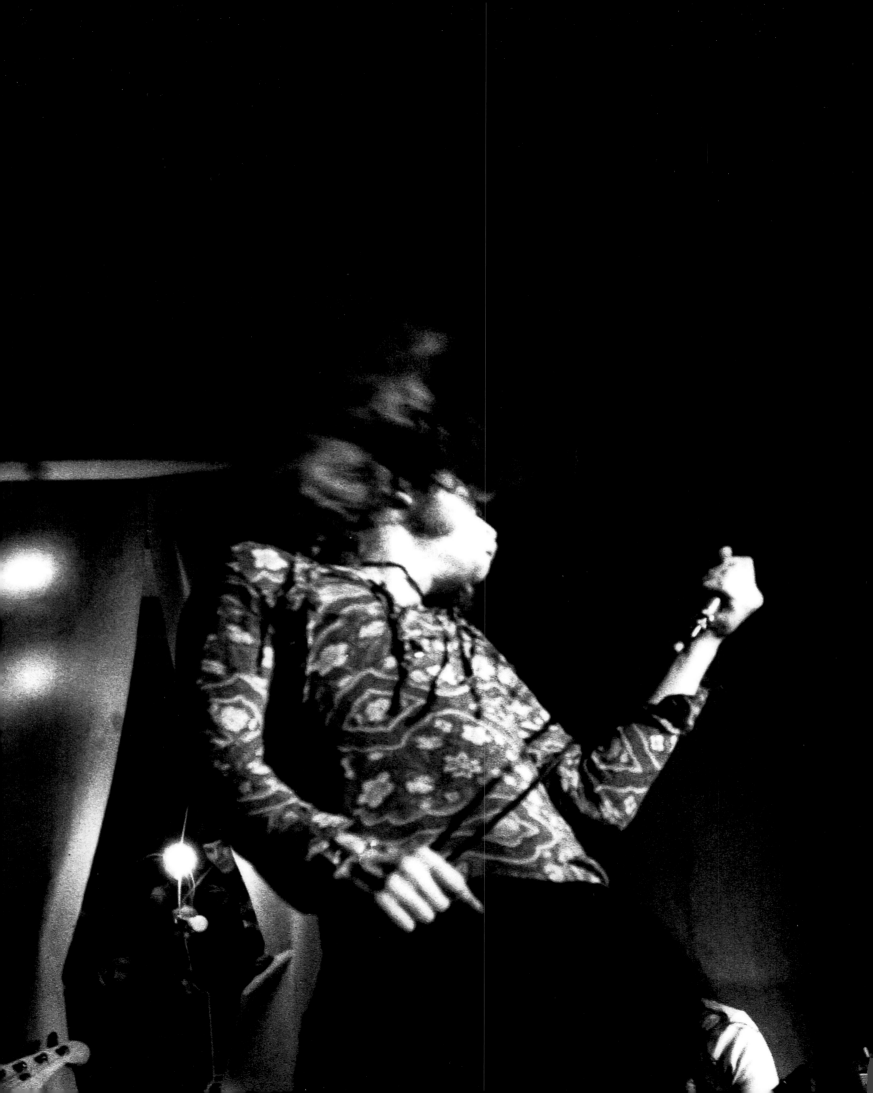

PHOTOGRAPHY CREDITS

—

Editor: Dave Brolan
Art Direction and Design: Studio Fury

Editor in Chief: Tony Nourmand
Head of Editorial: Alison Elangasinghe
Production Manager: Steve Rose
Editorial Associate: Rory Bruton

Archive Consultant: Sam Rapallo

Pre-Press: HR Digital Solutions

Reel Art Press would like to thank:

Led Zeppelin

Carl Dunn, Leonora Forrester, Dan Fuller, Leslie Gardner, Evelin Georgi,
Ross Halfin, Richard Harris, Grace Hocking, Stephen Kennedy, Andy Penny,
Ollie Pereira, Chris Vranian, Warner Music Archive and Ian Whent.

Special thanks to Ralph-Jörg Wezorke

REEL ART PRESS

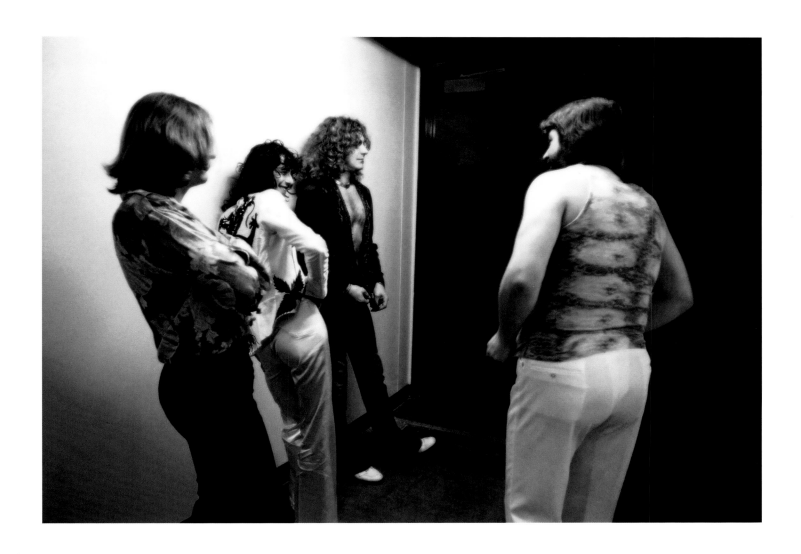

First published 2018 by Reel Art Press, an imprint of Rare Art Press Ltd., London, UK

reelartpress.com
ledzeppelin.com

First Edition 10 9 8 7 6 5 4 3 2 1

ISBN: 978-1-909526-50-1

This book is printed on paper Condat matt Périgord, ECF, acid free and age resistant. The Lecta Group uses only celluloses from certified or well-managed forests and plantations. Specially produced for *Led Zeppelin by Led Zeppelin*.

Printed in Italy